CEZANNE
The Early Years 1859-1872

D1337453

Royal Academy of Arts, London
22 April – 21 August 1988

Réunion des musées nationaux/Musée d'Orsay, Paris
15 September – 31 December 1988

National Gallery of Art, Washington
29 January – 30 April 1989

CHASE

Sponsored by The Chase Manhattan Bank

The Royal Academy of Arts is also grateful to Her
Majesty's Government for agreeing to indemnify the
exhibition under the National Heritage Act 1980 and to
the Museums and Galleries Commission for their help in
arranging this indemnity.

CEZANNE
The Early Years 1859-1872

Catalogue by Lawrence Gowing

With contributions by Götz Adriani,
Mary Louise Krumrine, Mary Tompkins Lewis,
Sylvie Patin and John Rewald

Edited by Mary Anne Stevens

Royal Academy of Arts, London, 1988

Catalogue published in association with

Weidenfeld and Nicolson, London

Copyright © Royal Academy of Arts, 1988

British Library Cataloguing in Publication Data
Gowing, Sir Lawrence, *1918–*
 Cézanne: The early years 1859–1872.
 1. French paintings. Cézanne, Paul -
 Biographies
 I. Title II. Royal Academy of Arts
 759.4

House Editor: Emma Way
Designed by Harry Green for
George Weidenfeld and Nicolson Limited
91 Clapham High Street, London sw4 7ta
Printed by Jolly & Barber Ltd, Rugby

Contents

Sponsor's Preface

I am delighted that The Chase Manhattan Bank N.A. is sponsoring the exhibition *Cézanne: The Early Years 1859–1872* at The Royal Academy.

Cézanne exerted the greatest single influence on the generation of French artists who emerged at the end of the 19th century and his early career provides a major point of reference for the development of 20th-century art.

Thus, Chase's involvement in this exhibition is particularly relevant; of the 9,000-plus items in our own collection, begun in 1959, about 70 per cent are works of modern art. The collection is a demonstration of our commitment to gaining knowledge of the many cultures in which we do business and has been of benefit to the corporation in many ways.

I believe the collection is clear evidence that the Chase Bank is very much a part of the world in which it exists. It provides the sense that art is something to be used, loved, understood, integrated into our everyday work lives – not revered as something beyond our grasp.

By relating to art as an integral element of our work-place, Chase people have come to gain respect for the creativity, the thinking, the imagination and indeed the hard work that artistry requires.

WILLARD C. BUTCHER
Chairman
The Chase Manhattan Bank N.A.

President's Foreword

For many who believe themselves familiar with the work of Cézanne, this exhibition may come as a surprise and a revelation. It is devoted solely to the artist's paintings created in the first twelve years of his career and are assembled here for the first time in a comprehensive exhibition.

The young Cézanne, as the fierce, yet introspective *Self-Portrait* from the close of the period, reproduced on the catalogue cover suggests, is the archetypal, non-conforming artist of both his and indeed our own time. Throughout his career, his work proclaimed a commitment to his own peculiar vision. This brought to painting radical approaches which looked forward to the art of our own century. His early work suggests specific affinities with a subjective expressionism not to be found until several decades later in the art of Munch, Vlaminck and Nolde. These are not names which are generally associated with Cézanne, the artist who is more usually thought of as the precursor of Cubism. Indeed, when one reflects on the very last works of Cézanne – for instance, the expressive black portraits of the gardener Vallier – they seem almost to return to the style of his earlier work. This he apparently rejected in 1872 when he chose to work with Camille Pissarro in order to acquire the secrets of Impressionism. Yet all the familiar themes of his later career – portraiture, still lifes, landscapes, bathers – were invented and wrestled with in his early work. Knowledge of these pictures will surely transform our perception of the great work (equivalent to a profound philosophic investigation) that was to follow.

Norman Rosenthal, Exhibitions Secretary, first suggested this exhibition several years ago to colleagues in the Musée d'Orsay, Paris and the National Gallery of Art, Washington, as being an exhibition that would be of great interest in its own right and of the greatest relevance to our reflections on many recent developments in art. It was an idea enthusiastically endorsed by them both. Without the support of these two institutions and the Réunion des musées nationaux, it would not have been possible to realise this exhibition. Here in London, Professor Sir Lawrence Gowing and MaryAnne Stevens have directed the work, with great support and advice from many people, most notably John Rewald, Distinguished Professor Emeritus at the City University of New York and doyen of Cézanne scholars and his assistant, Jayne Warman. Lawrence Gowing has once again shown his magisterial command of the chronology of the master's work and has provided insights into the technical brilliance displayed by so youthful an artist. Professor Götz Adriani, Professor Mary Louise Krumrine and Dr Mary Tompkins Lewis have generously contributed material from their research which has enabled the reconstruction not only of many of Cézanne's unknown sources but also the intellectual climate from which his work sprang. Our gratitude goes to the lenders, both public and private, in France and elsewhere, whose generosity has been overwhelming, perhaps in response to the fact that this subject has not until now been the occasion for a public exhibition. Such generosity has enabled us to bring together works of the highest order not seen together before. To our sponsors, the Chase Manhattan Bank, we owe a special debt of gratitude since their support has made the exhibition possible. All involved with the exhibition believe that it will be a major success with artists, art historians and the public, all of whom will rejoice in this newly revealed aspect of one of the greatest European artists.

ROGER DE GREY
President
Royal Academy of Arts

List of Lenders

Australian National Gallery, Canberra

Museo de Arte, São Paulo

Museum of Fine Arts, Montreal

Nationalgalerie der Staatlichen Museen zu Berlin,
Hauptstadt der DDR

Insel Hombroich

Musée Faure, Aix-en-Bains
Musée Granet, Aix-en-Provence
Pierre Malbos
Cabinet des Dessins, Musée du Louvre, Paris
Musée d'Orsay, Paris
Musée de la Ville de Paris, Petit Palais

Civica Galleria d'Arte Moderna, Milan

Museum Boymans-van Beuningen, Rotterdam

Foundation E.G. Bührle Collection, Zurich
Kunsthaus, Zurich
Kunstmuseum, Basel

The Syndics of the Fitzwilliam Museum, Cambridge
The Provost and Fellows of King's College, Cambridge

The Trustees of the National Gallery
National Museum of Wales, Cardiff
The Trustees of the Tate Gallery
National Museum and Galleries on Merseyside,
Walker Art Gallery

The Art Institute of Chicago
The Bakwin Collection
Cincinnati Art Museum, Cincinnati, Ohio
J. Paul Getty Museum, Malibu, California
Jim and Mary Lewis
Los Angeles County Museum of Art
Metropolitan Museum of Art
National Gallery of Art, Washington
The Henry and Rose Pearlman Foundation
Picker Art Gallery, Colgate University
Saint Louis Art Museum
The Sam Spiegel Collection
The Ian Woodner Family Collection, Inc.
Vassar College Art Gallery, Poughkeepsie, N.Y.
Yale University Art Gallery, New Haven

Leningrad, The State Hermitage Museum

and those lenders who wish to remain anonymous

Acknowledgements

We would like to thank the following who have contributed in so many different ways to the organisation of the exhibition and the preparation of the catalogue:

Charles Allsopp
Eve Alonso
Joseph Baillio
Armelle Barré
Evelyn Barron
Ségolène Bergeon
Béatrice de Boisséson
David Bottoms
Alexis Brandt
Harry Brooks
Isabelle Cahn

Jeannine et Edouard Chapet
Mme Adrien Chappuis
Lucy Dew
Bruno Ely
Gennady Fedosov
Pierre Giannadda
Jacqueline Henry
Paul Hering
Amanda Kiddy
Annick Lautraite
Giuseppe Liverani
Gabriele Mazzotta
Karin Meyer
Peter Nathan
Boris Pietrovsky
Genrikh Popov
Stephanie Rachum

Judge Raya Dreben
Anne Roquebert
James Roundell
Herr Rudolf
Elisabeth Salvan
Patrice Schmidt
Julien Stock
Michel Strauss
Philippe Thiébaut
Patricia Tang
Eugene Thaw
Isabelle Volf
Jayne Warman
Martin Wyld

and those who wish to remain anonymous

Photographic Acknowledgements

The exhibition organisers would like to thank the following for making photographs available. All other photographs were provided by the owners of the works.

A + B Photographic Services Ltd Figs 1, 2, 4, 5, 7, 8, 10, 11, 12, 13, 14, 16, 17, 18, 19, 20, 23, 27, 28, 34

Acquavella Galleries, Inc., New York Fig. 21

Douglas Baz (New York) Cat. 8

The Chrysler Museum, Norfolk, Virginia Fig. 3

Bernard-Yves Cochain, Paris Cat. 3

W. Drayer, Zurich Cat. 13

Mike Fear for White Bros (Printers) Ltd Cat. 59

Foto Saporetti, Milan Cat. 41

Foto-Studio, H. Humm Cat. 48, 50

Lynton Gardiner Cat. 42

Professor Sir Lawrence Gowing Fig. 6

Tom Haartsen Cat. 69, 82

Mary Louise Krumrine Fig. 15

Kunsthalle Mannheim Cat. 73

Kunsthalle Tübingen Figs 29, 30, 33, 35

Robert Lorenzon Cat. 49

Metropolitan Museum of Art, New York Cat. 83

John Mills (Photography) Ltd Cat. 34

Musée de la Ville de Paris
© by Spadem 1987 Cat. 1a-d

Museum Insel Hombroich, Kunstparellel zur Natur Cat. 11, 28

Pollitzer, Strong + Meyer Cat. 19, 29, 61, 85

Service photographique de la Réunion des musées nationaux Figs 9, 22, 24, 25, 26, 31, 32, 36, 37, 38, 39, 40, 41, 42 Cat. 2, 6, 14, 15, 20, 23, 25, 26, 32, 33, 39, 40, 46, 51, 52, 53, 62, 63, 78, 80, 81

Sotheby's Cat. 9, 10

Bernard Terlay Cat. 68

John Webb Cat. 60

Editorial Note

The literary and exhibition references were provided by John Rewald, New York, who is preparing a new catalogue raisonné of Cézanne's paintings with the help of grants from the National Endowment for the Humanities, Washington, D.C. He is assisted in this work by Mrs Jayne Warman.

The catalogue is in three sections: oil paintings, watercolours and drawings. The works within each section are arranged chronologically.

Titles are given in English, followed by the French original in brackets. In a few cases, e.g. *Le Déjeuner sur l'herbe* (cat. 51), no translation has been given.

All paintings are in oil on canvas unless otherwise stated. Watercolours and drawings are on white paper unless otherwise stated; their medium is always specified.

Dimensions of all works are given in centimetres (cm) and inches (in), height preceding width.

Very few works executed by Cézanne in the period 1859–72 can be firmly dated. Where external evidence exists to permit a firm date within a given year, the date is given without qualification, e.g. '1866'. Where stylistic and/or external evidence suggest that the work was probably executed within a given year, the date is preceded by '*c.*', e.g. '*c.*1866'. Where stylistic and/or external evidence suggest that the work was executed within a longer period, the extent of the period is denoted as follows: '*c.*1866–8'.

For the three catalogues raisonnés of Cézanne's paintings, watercolours and drawings, the following abbreviations are used:

V. = L. Venturi, *Cézanne, son art, son œuvre*, Paris, 1936.

RWC. = J. Rewald, *Paul Cézanne, The Watercolours*, London 1983.

Ch. = A. Chappuis, *The Drawings of Paul Cézanne: A Catalogue Raisonné*, 2 vols., Greenwich, Conn., and London, 1973.

Each work is given its catalogue raisonné reference followed by its number, e.g. V. 20, RWC. 4, Ch. 81. Where a work is not listed in the relevant catalogue raisonné, the abbreviation is preceded by 'non', e.g. 'non-V.'.

When the history of a painting is uncertain, a (?) precedes the name of the collection or the sale through which the painting may have passed.

Exhibition references for paintings are listed chronologically. Certain major exhibitions have been abbreviated with town preceding institution and date, e.g. 'Paris, Orangerie, 1953'. Full details of all exhibitions are given in the *List of Exhibitions* on p. 220. Where an exhibition takes place in more than one location, a dash follows the date and catalogue number and precedes the subsequent location, e.g. 'Edinburgh, Scottish Royal Academy, 1954, no. 7 — London, Tate Gallery, 1954, no. 7'.

Bibliographical references for paintings are given in chronological order under BIBLIOGRAPHY. Where a reference occurs frequently in the catalogue and in the essays, it has been abbreviated to the author's surname followed by the date of publication and page reference(s), e.g. Rivière, 1923, pp. 240–41. Full bibliographical details are given in the *Select Bibliography* on pp. 221–3.

For works on paper, full provenance, exhibition and bibliographical references for each work can be found in the relevant catalogue raisonné, RWC. for watercolours, Ch. for drawings, for which a number is also given.

Some works cannot be exhibited in London, Paris and Washington. Where a work is unavailable for exhibition, its catalogue note is prefaced with the initial of that city, e.g. 'L' = London, 'P' = Paris and 'W' = Washington, D.C. Where a work is exhibited in one city only, it is designated with two initials, i.e. 'LP' = exhibited in Washington, D.C. only. A work with no designation is exhibited in all three cities.

Introduction

JOHN REWALD

There is nobody today who has a more intimate, more intense, and more lucid concept of Paul Cézanne's work than Lawrence Gowing. A painter himself, he has developed over many years a burning passion for the master. But Gowing is also a historian, with an extraordinary range of interests, experience, and, hence, knowledge. Thus he is able to see Cézanne's achievements within the context of past centuries and to distill the specific nature that sets them apart from those of his peers. As a painter, Gowing approaches Cézanne not with the idle questions of why he did what he did, but with the professional curiosity as to how his accomplishments were attained. And it is this 'how' that offers one of the keys to the master's work. Cézanne's paintings, to Gowing, are less subjects for cold dissections or hazardous interpretations as they are sources for constant wonder, where the penetration of the artist's means of expression becomes an irrepressible spring of delight. Yet, he does not content himself with merely experiencing this delight; in the most graceful prose he expresses what he sees and feels, thereby communicating as well as this unique bliss, the mysterious felicity released by the contemplation of a masterpiece.

Gowing's delight, his warm and enthusiastic response to Cézanne has helped him reach an unequalled familiarity with the artist's style. As a result, not only the most subtle variations of expression but also every single brush stroke and every nuance of colour are seen as telling elements of the artist's slow – and sometimes hesitant – development. Under these circumstances no one has been better qualified than Sir Lawrence to study what is certainly the least well-known phase of Cézanne's evolution: his early work.

Throughout his life, Cézanne provided few facts or dates that might help establish a sequence of his paintings; and – at close scrutiny – even some of his rare 'guideposts' turn out to be unreliable. This is where the intuition, knowledge, and experience of a painter–historian such as Gowing render signal service. For the Cézanne of the formative years, the Cézanne before the mature Cézanne, was a man of major achievements, an artist who would have left a name even if he had not reached the glorious mastery of his subsequent, especially late, years. Yet, this early Cézanne – despite the number of overpowering works that sometimes appears almost unrelated to those of the older man – has remained practically unexplored, and never systematically separated from the one who emerged step by step after the Franco-Prussian War, an event that coincided with his encounter with nascent Impressionism.

Indeed, Cézanne's formative years ended when, under the impulse of Camille Pissarro's example, he began to 'develop his sensations in contact with nature'. The change was such a radical one (though not at first necessarily for the better) that it not only justifies the cut-off date selected by Gowing, the change actually imposes itself as a stylistic break of tremendous consequences.

If Cézanne, then in his early thirties, had been killed during the war of 1870–1 (as was Frédéric Bazille), or had he died before the age of forty (like Raphael, Mozart, Géricault, Seurat or Radiguet), we should not know such canvases as the *Arc Valley with Mont Sainte-Victoire*, *Old Woman with a Rosary*, or *The Great Bathers*. Still, we would recognise an ebullient young genius who, from the beginning, followed a road of his own and did so despite the various influences to which every beginner is exposed. We would, in other words, admire not merely promises contained in his first paintings, but also their astonishing realisation; for he has in truth left us landscapes of dramatic moods and contrasts, still lifes of serene equilibrium and of boldness, portraits of fascinating penetration and impetuous expression, as well as imaginary scenes of vibrant intensity and unconcealed eroticism. Indeed, there is nothing among the works of his contemporaries that can be compared to the uniqueness of his sometimes frenetic output or to the awesome variety of his subjects and his approach to them.

The very diversity and splendour of Cézanne's works dating from before or during those war years seem to mock all attempts at classification. The young painter tackled countless problems, as though testing the limits of his genius which was unlimited. Undeterred by these difficulties, Gowing has ventured to establish some kind of order, even though he knows full well that what may appear logical to us may not necessarily conform to the artist's own validity. As a matter of fact, Cézanne did not – and probably did not care to – follow a strict line of progress. Did he not paint in Auvers, during his initial contact with Impressionism, some still lifes that are surprisingly inferior to still lifes executed previously? Like every artist, Cézanne is entitled to his inconsistencies, the more so as he was frequently dissatisfied with his paintings, and in such cases he may have looked left and right or even backward before taking a step forward. His insecurity may actually have been the ransom of the over-abundance of his gifts, the almost disturbing richness of his 'sensations' that left him hesitant before deciding which road he should follow.

Nevertheless, Gowing's minute scrutiny of Cézanne's early work has enabled him to establish a certain succession, to detect elements of continuity that reduce what would otherwise appear to be capriciousness. He allows us to follow the young master in the conquest of his own personality, in, one might say, the harnessing of his unruly temper. But there still remains a factor of uncertainty that even Sir Lawrence's gifted insights cannot elucidate, namely, the unquestionably numerous works – major as well as minor – that were destroyed by the artist himself (or possibly even his father) or have simply been lost. With them has disappeared many a link that might otherwise have completed the chain of Cézanne's evolution. To mention this does not minimise Lawrence Gowing's achievements. It serves rather to illustrate some of the insurmountable problems he encountered in the pursuit of his heroic task. Fate notwithstanding, what we are offered in this exhibition is an unexpected glimpse at the formative years of one of the giants of art who, without actually wrapping himself in a cloak of mystery, stubbornly refused to leave us anything but his masterpieces.

This foreword was written, not so much for this catalogue with its multiple contributions, as for Lawrence Gowing's specific introduction.

The Early Work of Paul Cézanne

LAWRENCE GOWING

The first image that we have of the youth of Paul Cézanne and one of the first drawings by him that we possess is on the last page of a letter (fig. 1) written in 1859 when he was twenty to Emile Zola, the literary son of a great engineer and his inseparable friend, who had been at school with him in Aix-en-Provence.[1] Another friend, almost equally close, was Baptistin Baille, a physicist by inclination destined to become head of a firm of optical instrument makers. In the letter the three are shown bathing together under a great tree on one of their idyllic expeditions into the country around Aix on which they would climb and swim, exchange romantic poems and discuss their hopeless amours, while Paul emerged from the shadow of his formidable father. The nostalgia for those days stayed with Cézanne. To the end of his life the sense of comradeship and the countryside remained 'the sentiments stirred in us by the good sun of Provence.'

The three friends had more poetry and romantic fantasy in their heads than painting, although Cézanne had won a prize for painting at fifteen and went on to

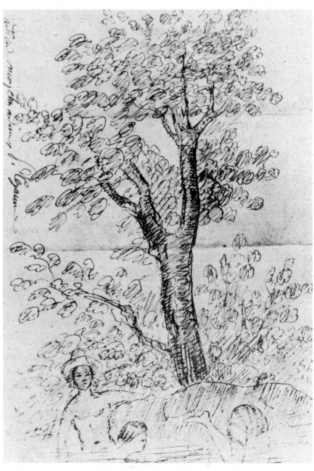

Fig. 1 *Bathing*, 20 June 1859 (Ch.38), pen drawing in a letter to Emile Zola. Private Collection.

draw at the Academy in Aix after passing his baccalaureate 'rather well' in Greek, Latin, Science, Mathematics and History at his second attempt in 1858. Zola (whose mother had taken him to Paris after his father's death the year before) failed his baccalaureate altogether. Cézanne wrote to him on 9 April 1858:

'Do you remember how that pine tree standing beside the Arc tossed its hirsute head over the abyss yawning at its feet – that pine whose foliage sheltered our bodies from the fierceness of the sun? Ah, may the gods preserve it from the dread stroke of the woodsman's axe!'[2]

The passionate involvement in nature and the loyalty to a native countryside were incorporated in Cézanne's later attitude to painting and increasingly essential to it in his last years.

So much must have been a common legacy of Romantic boyhoods. The personality in which Cézanne's friends delighted was described by Baille in a joint letter that they wrote to Zola in 1858, referring to 'that poetic, fantastic, bacchic, erotic, antique, physical, geometrical friend of ours . . .'.[3] It is hard to know which epithet we could spare.

The passions of Cézanne's involvement with nature contained from the beginning an element of self-immolation. In the next year he sent Zola a nightmare poem of pursuit by demons entitled *Une terrible histoire* which culminated in a dread invocation! '"*Terre, ensevelis-moi! Rochers, broyez mon corps!" Je voulais m'écrier: "O demeure des morts, Recevez-moi vivant"*'.[4] These feelings of his boyhood contributed to the intensity which Cézanne eventually brought to painting from nature. But the pictures that he began to paint in his twenties seem on the surface to have had no part in it. The reason for looking closely at what Cézanne did before 1872, when he joined Pissarro and developed rapidly into the painter we know, is that it constituted a separate and unparalleled creation. Its relevance to its surroundings and sequels was marginal. Oblivious of opinion, it held meaning in its own passionate right and in the uncouth conviction of the painter.

Cézanne's work found shadow while other painters, his Paris friends, sought light. Its emotional expression was often grievous. Death and mourning were its common states. Love in it was inseparable from violence. Its caprice was ungoverned and its reason eccentric. Its portrayal of his world can now be recognised as often brilliant, sometimes grotesque, yet as often crudely grand, nearly always unquiet and seemingly haunted by a spirit that is unexplained. Its movements writhed like snakes. Its stillness built a solidity into paint as no painting before had ever been built, as if paint could be as monumental as masonry. Before Cézanne's way changed in 1872 and his ferocity was sublimated under another star, these first works culminated in a group of masterpieces to which opinion has still hardly allowed their deserts, yet which now speak

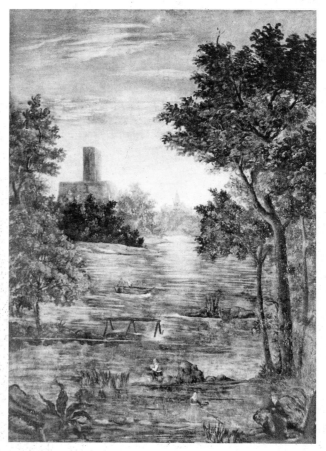

Fig. 2 *Landscape with a Fisherman*, c.1860–62. Formerly Jas de Bouffan, France.

very directly to us. So we have thought it none too soon to look at Cézanne's first works for their own sake.

Cézanne had all the troubles that domineering fathers give their passionate sons. Louis-Auguste Cézanne was a banker – like the father of Degas; unlike the tolerant Parisian family, he did not welcome the appearance behind the counter of a morosely determined painter-to-be. But there must have been a good deal of understanding between them. In 1859 Louis-Auguste bought the seventeenth-century mansion of the Jas de Bouffan outside Aix and within a year or two the salon was being decorated in a way that a lesser man might have found disconcerting. The *Landscape with a Fisherman* (fig. 2), which was until recently on the left hand wall of the salon, was a blend of conventional and romantic idioms. Another decoration (fig. 3) in the picturesque manner was transformed later by the insertion of a male nude in a position suggested by the notorious *Bather* by Courbet – though it is not clear that Cézanne knew the actual picture which Napoleon III had struck with his whip in 1853. It is doubtful whether any of these decorations was painted before June 1860, when Zola could still write to Cézanne about 'big panels such as you want to do at home'.

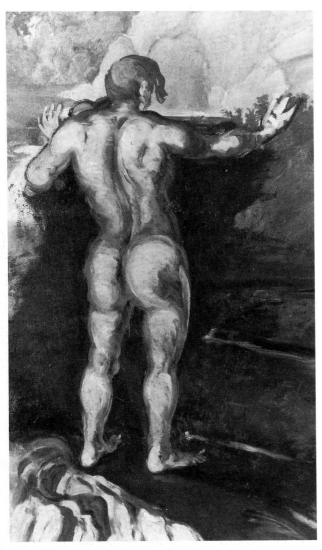

Fig. 3 *Bather and Rocks, c.*1860–62 (V.83). The Chrysler Museum, Norfolk, Virginia, Gift of Walter P. Chrysler, Jr.

near Salon, the family home of Granet's friend, the Comte de Forbin, with extensive grounds that were and are a favourite resort of families from Aix, the boudoir of Pauline Borghese's apartments on the second floor is decorated with a set of *papiers peints*, ascribed to Granet, with full length figures of the Seasons in a formal neo-classical style that has no resemblance to Granet's habitual *style troubadour*. Whoever designed them, the subject was at least current in Provence. But Cézanne seems to have been aware of the tradition that descended ultimately from examples like the *Seasons* then ascribed to Botticelli, which were bought, it is not known where or when, but Paris in the 1860s is a likely guess, for the Rothschild collection at Mentmore in England and sold again by Lord Rosebery at the end of the decade.[5] An engraving of them might conceivably have reached Aix, by way of Zola who had been established in Paris, however uncomfortably, for three years. But the simplicity of the decorations should not obscure the possibility that they reflect direct experience in Paris and thus do not date from before 1861.

They are unlikely to have been painted all together. The placing was odd: *Spring, Summer, Winter,* then *Autumn.* It must have reflected two phases in the work – firstly the painting of *Summer* (cat. 1a) and *Winter* (cat. 1b) in the major positions, and then the addition of *Spring* (cat. 1c) and *Autumn* (cat. 1d) rather later. They are big pictures and the ambitious scale is sustained with a confident touch and clear colour, but there is a sardonic note; all are signed and *Winter* is inscribed and dated INGRES 1811. This is a reference to the most important nineteenth-century picture in Aix, the *Jupiter and Thetis* by an artist who was always repugnant to Cézanne – and whom it may have occurred to him to mock on the fiftieth anniversary of the picture. Later he added to the scheme a paraphrase of a Lancret of

The most remarkable parts of the scheme at the Jas de Bouffan were the famous panels in the alcove of the salon (fig. 4), now in the Musée du Petit Palais, Paris. These have usually been regarded as the earliest works by Cézanne that we know, on the assumption that their plain clear colour and innocent drawing were merely ignorant. It now seems, on the contrary, that they represent a serious and creditable, indeed rather able, amateur's attempt to recapture a character of Renaissance painting. *Winter* (cat. 1b) suggests that he had seen, if only in an engraving, one of the starry skies in this mode by Tintoretto and the whole series must have been suggested by some prototype of a kind that might not have been easy to find in Aix. There was one series of single-figure allegories of the Seasons by one of Cézanne's favourite artists and that he might possibly have seen. At the Château of Barben,

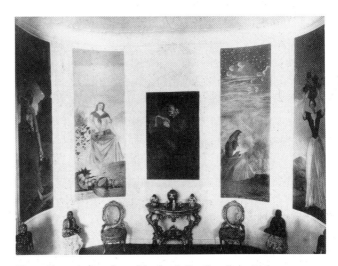

Fig. 4 Alcove in the salon of the Jas de Bouffan. *Portrait of Louis-Auguste Cézanne, Father of the Artist* in the centre, flanked by *The Four Seasons.*

Blind Man's Buff, which fulfilled more conventional expectations, and still later a portrait of Louis-Auguste in the middle (cat. 4). These first decorations must all be understood as to some degree ironical, with the facetiousness of adolescent vulnerability. They give no sign that, as a letter from Zola implied, Cézanne regarded himself as a realist.[6] In this kind of delayed artistic adolescence styles are so many disguises, but there is a romantic spirit in the air with which Cézanne flaunts them and then lets them drop. He was a passionate dreamer, and the hopeless nocturnal lust for style was a part, with his macabre and sensual poetry, of the dream-world that sustained him. In 1870 Zola found a charming confession in a letter of Cézanne's that is lost to us and sent it on to Baille: '*Je suis en nourrice chez les illusions*.'[7] It was evidently in 1861–2, possibly during an unrecorded return to Aix in the summer, that Cézanne painted the last of these early decorations, the whole-hearted tribute to Louis-Auguste which is now in the National Gallery in London (cat. 4). It has an obsessional consistency that is all his own, and an insight into the essential *lumpiness* of the modelling in heavy paint which was the conventional hallmark of Courbet's influence. This same assertive lumpiness, pleated and convoluted into simplified and forceful patterns, marks what must be among the earlier of Cézanne's paraphrases of fashion plates.[8] By hindsight, one can see that there is an originality in the naïve frankness of his conviction that style is the intrinsic force with which a visual statement is propounded. Conventional criticism has been quite wrong in regarding a picture like the paraphrase of a fashion plate in Russia as merely maladroit. The actual execution is in its own way rather adept – the hands, for example, show him adopting all the delicacy of tonal modelling of which the *style espagnole* was capable in the early 1860s – when his commitment to an extreme formulation allowed it. There was an evident pre-disposition to a passionate reaction to every situation, a reaction that was predictable only in its invariable force.

An inconclusive, but forceful portrait of Zola may well be one of those that were worked on, deleted and started over again in summer 1861.[9] Also in 1861, Cézanne had his photograph taken (fig. 5), and the sombre self-portrait that he made from the result was carried out in a quite unprecedented style (cat. 2); it is photographic in its iron grey tonality, but also – in the accents of unmitigated vermilion which mark the emotive features – less restrained by convention, in fact less photographic than anything else in the painting of the time. The picture portrays very clearly the brooding conviction which is echoed in everything we know of him at this time.

Two little pictures, a landscape and a view of Rome, which have appeared on the market in recent decades, seem to me entirely acceptable as Cézanne's work. The trees are the kind of inconspicuous production that Cézanne might have had refused at the Salon and hung at the Salon

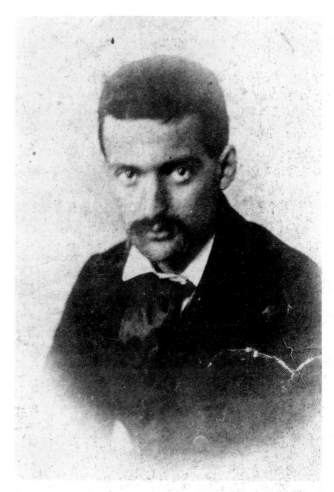

Fig. 5 Photograph of Paul Cézanne, 1861.

des Refusés in 1863. The view of the Colosseum (fig. 6) echoes the arch-form of the trees, as one might expect of the painter whose later works made the intrinsic shapes of a formulation into the essence of art. But these pictures are revealing in another way; they reflect homesickness for Aix. *The Colosseum* is in fact a paraphrase – reversed and dependent on an engraving – of a famous picture by the greatest of Aix artists, F.-M. Granet (fig. 7), which had been bought by the state and added to the Louvre in 1806. Cézanne did not understand that Granet's picture was a view *within* the Colosseum across the arena. But he got from it a quality of the South, and a reminder of the large collection of his works that Granet had bequeathed to the Aix museum when Cézanne was ten in 1849. Emile Bernard supposed that Cézanne's admiration for Granet was due simply to local patriotism, but in fact the example was in his mind throughout his life. Granet, who was, among other things, the greatest exponent of painting in the open air from nature who had ever worked in Provence, virtually discovered Cézanne's rocky motifs and his frequent subject was the Mont Sainte Victoire.

In these years Cézanne's blend of the method of Courbet with the matter of Barbizon had often an overtone of Granet, who was devoted to the arch-form. But Cézanne's attitude, if not immediately his style, was more affected firstly by the study of Renaissance art, and life drawing in the manner derived from it, and secondly by Camille Pissarro, whom he met at the Académie Suisse. Claude Monet was working there too. Pissarro, who had made his debut at the Salon in 1864 as a pupil of Corot, was working in a more refined, sophisticated style. The attenuated purity of the landscape vision of painters in this mode, and the hint of social message, to judge by more than one cartoon of Daumier's in 1865, seemed to the older generation slightly ridiculous. Certainly the robustness of Courbet had more immediate appeal to Cézanne. Cézanne gathered knowledge of the traditional skills of figure drawing at the Académie Suisse in the company of Pissarro. But, unlike Pissarro, he soon built his studies into Romantic and lusty pictures free from the archness of J.-F. Millet, the nearest forerunner among the older artists whom the circle respected. The fresh iridescence of the colour is exceptional and one can understand the admiration of Pissarro who owned *Women dressing* (cat. 28) and drawings for it, but these pictures had more conventional sweetness than suited their painter.

In the artistic climate in which Delacroix had observed that the best effects often came from breaking the rules, Cézanne was distinguished by a native recklessness and an urge towards the major historic categories of subject matter that Pissarro never possessed. It is quite wrong to think of him at his most impulsive as unskilled or clumsy in any usual sense, even in his twenties. In 1864, he wrote

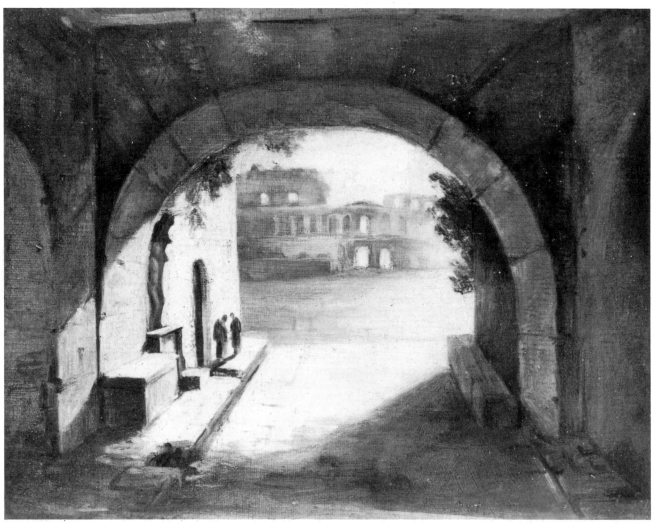

Fig. 6 *View of the Colosseum, Rome, after F.M. Granet,* *c.*1863–5. Present location unknown.

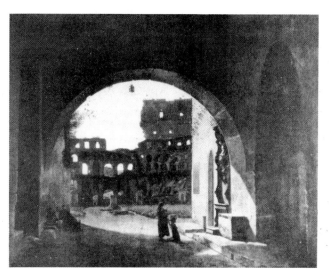

Fig. 7 F.M. Granet, *Interior View of the Colosseum, Rome, c.*1806. Musée du Louvre, Paris.

that he had done no more to his [. . .] after Delacroix; the word is illegible, but he may have been speaking of his copy of the *Barque of Dante* (cat. 5), which is remarkably adept. Cézanne's way of painting from the model in 1864 is securely documented by a dated *Portrait of a Woman*,[10] supposedly the future Mme Zola, in a confidently tonal style with affinities with Manet as well as with Courbet. There is a suggestion of contrapposto in the pose which links it with a more awkward and apparently earlier *Portrait of a Young Woman*.[11] This is carried out in long, curling and laboured strokes of paint and introduces us to the other aspect of Cézanne's style which alternates with the blocks of tone throughout the 1860s. The sharply contrasting directions are echoed in another portrait[12] also dominated by a blue shirt but in every way more assured which we must link with his increasing capability after 1864. The development of this strip-like style of brush-work was immediately affected by his study of Delacroix and Rubens in 1864–5. The most developed drawing after Rubens was made before 1865 (cat. 73) when it was given to Jacomin. The still life in Cincinatti, dated 1865 (cat. 7), depended on more recent models. The conception and vision as well as the rounded modelling are akin to painters in the wake of Courbet like Bonvin, while the strips of paint take on a stringy and tenacious rhythm which reflects admiration for the virility of Baroque-type styles. The culmination of this trend was the famous portrait of an old man (cat. 6), which came to the French National Collection from Vollard. It has been suggested that this might be the portrait of Père Rouvel, the father of Cézanne's landlady at Bennecourt, in the summer of 1866, which he described beginning in the open air in a letter to Zola on 30 June. This is improbable for two reasons; the *Old Man* was clearly painted in a habitual studio where abandoned

earlier canvases were to hand, and it shows no sign of the freshness with which Cézanne was likely, at any date, to respond to working outdoors. It seems that the unfinished Père Rouvel has been lost; there is no other candidate for the identification among the surviving pictures of the middle sixties. It is not impossible that the head of the old man was painted early in 1866; it surely dates from before the large group of palette-knife pictures on which he embarked in August. In this culmination of the style of 1865, the strips of colour on which it was based took on a snaking power, and an observant figurative reference which reappeared in the curling strip-like styles of the years to come. The head of the old man is unfinished and under it there are traces of a juvenile picture of hooded worshippers in a religious procession, which seems to reflect an interest in ceremonies of the pious cults of Aix like the Penitents Gris which may help us to understand at least one of the subjects that Cézanne was to paint in the latter part of the decade.

The characteristic achievement of the middle sixties, the palette-knife pictures, most of them portraits (cat. 15, 16, 18–24), were not at all baroque, neither linear nor in any way historicist except in the variety of costumes that his uncle Dominique was made to wear. The units of style were the tonal slabs out of which the images were built. The whole astonishing group of pictures, of which seven heads, including the first mature self-portrait in the pose which later became habitual and five half-length portraits as well as the full-length survive, would seem to have been painted between August 1866 and the following January. Cézanne is described as finishing each of the heads in an afternoon; it was extraordinary testimony to his abilities. Like the other large picture in this style, the portrait of Valabrègue which had been painted earlier in

the year (cat. 16), the lower parts of Louis-Auguste's portrait reverted to the more linear, rhythmical handling. On the wall behind him hung a still life of a blue mug, a sugar-bowl and three pears as an additional demonstration; the original is now deposited at the Musée Granet in Aix (cat. 14). In it the handling with the knife can be observed replacing the fat brushwork which preceded it.

The picture of the father described by Guillemet on 2 November 1866 is a demonstration piece. Louis-Auguste is reading the paper, *L'Evénement*, which had printed Zola's series of articles on the Salon in which he had attacked the Jury that had refused (among other things) the portrait of Valabrègue. This series of articles went on to develop Zola's theory of art and to review not so much the exhibition as the whole Parisian artistic scene. This was the view of art that Zola had propounded a few months earlier in an article on Proudhon and Courbet when he defined art as a corner of nature seen through a temperament. In the Salon reviews he pursued the idea: 'It is not the tree, the countenance, the scene offered to me in a picture that touches me; it is the man whom I find in the work, the powerful individual who has known how to create alongside God's world a personal world which my eyes will never forget and which they will recognise everywhere.' In other words, the point of Zola's definition lay in the second half of the proposition – the power of the temperament through which the corner of nature was to be seen. This identification with the personal force that an artist brings to art as the ultimate artistic value is the context of Cézanne's cultivation of a forceful application of paint to the canvas. The reading of *L'Evénement* was a popular subject for painters in 1866: in Renoir's *Cabaret de la Mère Antoine* Sisley has the paper open in front of him in the foreground of the picture.[13] In fact Louis-Auguste did not read *L'Evénement*. Guillemet describes him reading *Le Siècle*, a conservative paper which had always attacked Manet as vigorously as Zola defended him. Cézanne's picture is not, as is sometimes supposed, an image of the proud father reading his son's praises; in fact Cézanne was not mentioned and the prefatory letter to him, which further developed the theme of the dominating temperament, was only added when the series was re-published as a pamphlet later in the year. 'We told ourselves', Zola wrote in the preface, that outside a powerful individual personality there is nothing but deceit and stupidity.'

The palette-knife pictures were exceptional. Looking at them stacked against his studio wall thirty years afterwards, Cézanne called them *une couillarde* – and the coarse word for ostentatious virility suited the crudity of the attack with which the palette-knife expressed the indispensable force of temperament for a few months in 1866.

Only Pissarro understood what Cézanne had begun in this group of pictures. This phase was not only the invention of modern expressionism, although it was inci-

dentally that; the idea of art as emotional ejaculation made its first appearance at this moment. But beyond this Cézanne was the first man in the group, perhaps the first man in history, to realise the necessity for the manner in which paint is handled to build up a homogenous and consistent pictorial structure. This is the invention of *forme* in the French modernist sense – meaning the condition of paint that constitutes a pictorial structure. It is the discovery of an intrinsic structure inherent in the medium and the material. Unlike Monet, Renoir and Pissarro, who were adapting Courbet's method to sensuous or atmospheric purposes in the relatively polite kinds of picture that went with ultimately conformist intentions, Cézanne was intensifying Courbet's least acceptable peculiarity, making it obstrusive, systematic and obsessional.

Underneath the rudeness of Cézanne's way with paint in 1866 there was the idea of an order of structure that would be inherent in the paint-stuff. It was the expression of what he found lacking in Manet and had in mind when he said: '*Il crache le ton . . . oui, mais il manque d'harmonie et aussi de tempérament.*'[14] He lacked, that is to say, 'the initial force which alone can carry someone to the destination he must attain'.[15] The remark about Manet is our first glimpse of Cézanne's special vocabulary of pictorial definitions, which takes on such importance in his later years when it articulates and sustains a shift in the whole intention of art.

'Harmony' is evidently not merely the tonal accord which a painter like Manet might possess, but the structure of correspondences. 'Temperament' meant the compulsive force with which real painters had to deploy such structures.

1866 is the first of the dates that Cézanne offers us – there are several others later – which we may if we wish call the beginning of modern art. Cézanne's initial force and the innovation that it dictated were immediately understood by one man, Camille Pissarro. A still life dated 1867, now in Toledo, Ohio, was executed entirely with the knife in a passable (though relatively amenable) version of Cézanne's manner, and a picture like the *Square at Roche Guyon* (fig. 8) seems to show a knowledge of pictures like Cézanne's view of the *Rue des Saules* (cat. 29).[16]

One more picture can be documented to 1866, *Marion and Valabrègue setting out for the Motif* (cat. 25), a sketch from nature on the theme of friendship showing Valabrègue and Marion setting out to look for a landscape motif, the latter with an easel on his back – a picture which was to be painted outdoors. The months of intensive effort in the studio left Cézanne with the belief that pictures painted indoors would never be as good as those done in the open air; it was the nucleus of the convictions about painting from nature that he acted on five years later. To judge from the fat strips of paint that compose *Marion and Valabrègue*, the pictures that Cézanne produced on such

expeditions would have been like the *Clairière*[17] which recently appeared in the salerooms. We have no real conception of what the total achievment of 1866 would have been like. Thirty-three years later when the Jas de Bouffan was sold and the studio there cleared, Cézanne is said to have burned a number of large canvases which were figure compositions executed with the knife – pictures which, if they were correctly described, are quite hard to imagine, unless *Marion and Valabrègue* was among them.

But as soon as the structures of the palette-knife pictures had stabilised, Cézanne's style was on the move again. He spent the first half of 1867 in Paris and it must have been there that he painted the negro model Scipion, now at São Paulo (cat. 30).

The handling of the palette-knife pictures based on rigid blocks of tone, forming pictures that were solidly observed from life, which occupied Cézanne in the autumn and winter of 1866-7, was followed when he returned to Paris by a reaction towards the opposite element in his artistic constitution, the linear handling and rhythmical mobility which alternate with the principle of stability throughout his work, and which was applied in the later 1860s only to pictures that were uncharacteristically imaginative and fantastic.

The central picture of 1867, which bears a date, was *The Rape* (cat. 31), painted for Zola in his house in the rue La Condamine. The theme is the romantic one of erotic violence, akin to Zola's very earliest stories, before this theme was embedded in the industrial scene. Its rendering of passion is equally conventional; the bodies are bunched into a quivering muscular knot reminiscent of a drawing by Daumier known as *The Kiss*[18] which

Cézanne is unlikely to have seen. But he certainly knew Daumier's sources, the Romantic rapes extending back through Gèricault to Puget and Mannerism. *The Rape* remains reminiscent of Puget's *Andromeda* which Cézanne drew and Tintoretto's *Removal of the Body of St Mark*. It is the uncertainty whether Cézanne's victim will survive the rape which distinguishes his formulation from the Baroque rapture. Romantic passion has something deathly about it, and *The Rape* is akin to the climax of the poem *Une terrible histoire*. In his dream a woman, the most beautiful he has ever seen, calls the poet to her. Throwing himself before her he kisses with guilty lip her breast but in the instant the chill of death seizes him and the woman in his arms is changed into a corpse and then into a rattling skeleton. We feel the imagining and the image of *The Rape* to be the antithesis of the frame of mind of Cézanne's maturity. There is no doubt that his later engrossment in the actual held in check the very real burden of his fantasy. In old age Cézanne is said to have told Joachim Gasquet: 'My method if I have one is based on hatred of the imaginative.'[19] Many of the imaginings of the later 1860s might have incurred such a hatred. The counterbalance to it was the equally emotional attachment to the objective recreation, which was within the reach of painting controlled by the motif.

The imagining of the dark ravisher in *The Rape* may be connected with a picture that was studied from life, no doubt in the same year, of a model who was a favourite with the students at the Académie Suisse, the negro Scipion. It may be that the study was suggested by the composition rather than vice versa and the curling brush strokes attain more freedom as well as a richer substance than they are

Fig. 8 Camille Pissarro, *Square at La Roche-Guyon*, c.1867. National Gallery, Berlin.

allowed in *The Rape*. It is one of the pictures before Impressionism in which one is most aware of the necessity, indeed the imminence of Post-Impressionism. Monet who owned the picture and hung it in his bedroom with his favourite possessions, used to boast of *'ce nègre de Cézanne, . . . qui est un morceau de premier force'*. Van Gogh already existed *in peto*.

The passionate handling of the *Negro Scipion* links it with elements of the two parts of a picture which was an even more extreme result of the drive towards imagined (or at least borrowed) composition, the decoration correctly entitled *Christ in Limbo with the Magdalen* (cat. 32 and 33). This was painted for the Jas de Bouffan, offered by its owners to the French State in 1907, refused and then cut in two parts, of which one, the right hand part, has now reached the National Collection. The right hand part in particular is linked with the study of Scipion. The drawing of the hands also recalls the same detail in *The Rape*. The pendulous loops of drapery are not far from the looped folds of Scipion's trousers, and, given the fact that, whenever it was painted, the decoration represents the irruption of a mood near to hysteria, which is repeatedly noticed in the story of Cézanne's twenties, its positive affinities are with the pictures of 1867. The evidence held

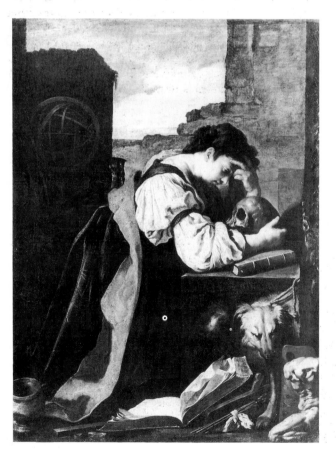

Fig. 9 Domenico Feti, *Melancholy*, 1867. Musée du Louvre, Paris.

to tell against this view has been misunderstood. It is well known that the two halves of the decoration were each suggested by earlier pictures representing the same subjects. The limbo design was taken from a picture in the Prado illustrated by Charles Blanc in the *Histoire des peintres de toutes écoles (École Espagnole)* while the Magdalen comes from a Magdalen picture by Domenico Feti in the Louvre where it is entitled *La Mélancolie* (fig. 9). Charles Blanc's work was published in 1869, and has been held to provide a *terminus ante quem* for the date of *Christ in Limbo*. However Blanc's work had previously been issued in periodical parts (to which the Library of Congress subscribed, recording at intervals the dates of receipt) and the traceable dates of the parts show the beginning of the Spanish School to have been available in 1867. Moreover the Navarrete, or rather Sebastiano, an otherwise little-known picture, was certainly available to the public in 1867 and was imitated by Daumier in a lithograph (directed against the exclusiveness of the Exposition Universelle) captioned 'You aren't in this show children' and published in the same year.

It is worth looking again at this curtailed masterpiece of Cézanne's painting in his twenties, if only in the hope that opinion will encourage its reconstitution. Some critics seem almost willing to consent to its dismemberment. So far from joining two subjects without logical connection, *Christ in Limbo with the Magdalen* was a perfectly orthodox and current Easter subject. It depicted an integral and moving part of the Christian legend on the eve of the Resurrection, and echoed a number of previous pictures as well as a devotional tradition (lately studied by Mary Lewis[20]). Without the flash of sky across the *Limbo* canvas, the bitter brilliance of the other picture hardly conveys the originality of the colour. The picture is only seen as a whole in illustrations[21] of the photograph taken before the decoration was cut (fig. 10) and these do not support the idea that the disproportion between the two parts, *Christ in Limbo* and *the Magdalen,* was injudicious or even unconventional. It may be that the effect of the Magdalen being placed as if on a rostrum higher and closer than the narrative scene to the left was as convincing and impressive as it appears in the illustration of sixty years ago. Certainly the discrepancy was no more disturbing to the unity than in many Mannerist compositions both from Italy and the North. It was quite similar in structure to Beccafumi's *Roman Tribune Cremating*, and far less discordant than Hans Bock's *Allegory of Day*. Cézanne's instinct for sixteenth-century conventions was in fact as remarkable here as it was in *The Rape* and *The Seasons*. Finally, Cézanne's borrowings from earlier pictures were supplemented on both sides with additions of his own invention which contributed to the serious meaning of the whole. The artist's sister Marie did duty for Eve, improving considerably on Sebastiano's type. On the other side Mrs Lewis has resourcefully discovered in pious French poetry the

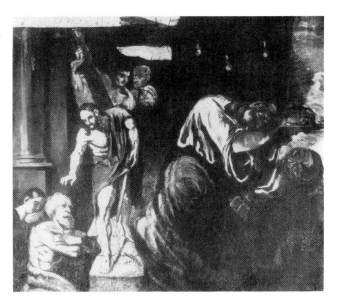

Fig. 10 *Christ in Limbo and the Magdalen*, *c*.1867 (V.84; V.86), before the picture was cut. Reproduced in Fritz Burger's *Cézanne and Hodler* (Munich, 1909).

innovative procedure remained dependent all his life. The pictures by or attributed to Ribera that were acquired by the Louvre in the 1860s were the major formative influence on the gaunt *Preparation for the Funeral* (cat. 35) but it cannot be said that the resemblances, even to the notably influential *Deposition*, passed to the Louvre by Napoleon III and exhibited from the beginning of 1869, were specific enough to fix a date for the picture. But the bearded, wrinkled head, which obstinately resists foreshortening, of the man in the *Preparation*, reminds one of the series of bald heads which fill the middle of Caravaggio's *Death of the Virgin*. The bowed head that defies conventional perspective reappears on the villainous woman who holds the victim still for stabbing in *The Murder* (cat. 34), now at Liverpool. The gale of violence that rushes through this picture blows all the drawing sideways, to its ultimate expressive benefit. Without straining the evidence we can imagine these related, violent pictures as representing the style of 1869. The retrospective style of the sixties is apparent in the picture of the studio stove,[22] which must have reminded Cézanne of Delacroix as much as it does us. A composition of four lumpish bathers by a river (see fig. 20), which exists both in a watercolour rehearsal and in an oil, possessed an implicit geometry as well as the authentic freedom from received formulations which were to characterise Cézanne's realisation of such subjects within a few years.

bright red tears, like Pentecostal flames, in which the Magdalen's grief materialises above her.

A number of Cézanne's pictures in the later sixties in fact took up traditions of sacred art and revived them in his own uncompromising terms. The museum drawings of around 1867 formed the habit on which Cézanne's

Cézanne's production mounted in a crescendo as the end of the decade approached. In April 1869 he painted a sombre watercolour of smoking factories to be mounted in the lid of Mme Zola's elegant work-box (fig. 11). One

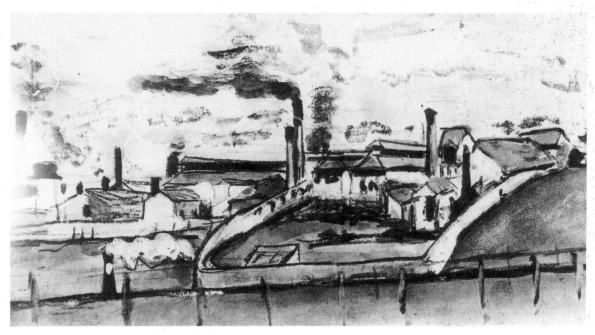

Fig. 11 *Factories at L'Estaque*, 1869 (RWC.24). Atelier Cézanne, Aix-en-Provence.

cannot imagine a more incongruous purpose for an image that gloried in industrial squalor.[23] This was the single moment at which Cézanne's brand of realism, with its gathering, brooding undertone, coincided with Zola's. Meanwhile, Cézanne had found (or invented) a smoking factory beside the Mont du Cengle, the flank of Mont Sainte Victoire, and painted a closely related oil (cat. 48) of that. In September 1869 Zola met Cézanne's friend Paul Alexis, who became his amanuensis, and the autumn is the earliest time at which Cézanne can have painted Alexis reading to the master (cat. 47), another strange transmutation of expectations and a remarkable icon of the Pasha of realism *en grand divan*, which the Zolas found entirely unacceptable and consigned to the attic where it was later discovered. Meanwhile Cézanne was probably finishing the picture of his younger sister Rose playing the *Overture to Tannhäuser* (cat. 44) on the Jas de Bouffan piano, the dominating achievement in this phase of domestic painting transcended. It had been started and 'half-built' in 1866, with Louis-Auguste looking out of the armchair on the model of Degas père in the *Bellelli Family* (Musée d'Orsay, Paris). It was repainted in 1867 in the lighter tonality that was developing, with Fortuné Marion in the armchair, and then painted over again, possibly on top of

the earlier versions though no traces remain, with the armchair empty and the domestic design resolved into its simplest, most absolute form, without doubt in 1869. The Baudelairean reading of Wagnerism, the faith that extremism would achieve the artistic greatness from which moderation was for ever debarred, reached its full expression at last. Several aspects of the extremism to come made their appearance all together. The colour had a barely credible heraldic simplicity. The lustre on the girl's hair and the light that modelled the mother's hands at her needlework were still quite gentle and Manet-like, but everywhere else the style was Manet gone barbaric. Fat black drawing passed ruthlessly *over* the Whistlerian greys of the girl's dress. The splendid arabesques of the wallpaper leave one wondering whether Fauvism is about to be prematurely born before one's eyes.

Some masterpieces seem to set the centuries at nought. Then we realise that a great painter has created the future single-handed.

It was in 1870 that Cézanne submitted to the Salon his full length portrait of *Achille Emperaire* (sitting in the same armchair that had figured in his father's portrait and in the *Overture*) (cat. 46) as well as a nude that is lost. During the submission he was interviewed by the corre-

Fig. 12 *Album Stock*. Caricature of Paul Cézanne with the two paintings rejected by the Salon Jury of 1870.

spondent of the *Album Stock*, which printed a caricature of him (fig. 12) and the following paragraph:

'The artists and critics who happened to be at the Palais de l'Industrie on March 20th, the last day for the submission of paintings, will remember the ovation given to two works of a new kind . . . Courbet, Manet, Monet, and all of you who paint with a knife, a brush, a broom or any other instrument, you are out-distanced! I have the honour to introduce you to your master: M. Cézannes (sic) . . . Cézannes hails from Aix-en-Provence. He is a realist painter and, what is more, a convinced one. Listen to him rather, telling me with a pronounced Provençal accent: "Yes, my dear Sir, I paint as I see, as I feel – and I have very strong sensations. The others, too, feel and see as I do, but they don't dare . . . they produce Salon pictures . . . I do dare, Sir, I do dare . . . I have the courage of my opinions – and he laughs best who laughs last!"' [24]

In this defiant mood there can be no doubt that Cézanne would have submitted recent works to the Salon jury. So the portrait of *Achille Emperaire* and the lost *nu à la puce* must be added to the pictures that were painted in 1869. It was painted after the portrait of *Louis-Auguste reading L'Evénement*. Cézanne has gone forward from proto-impressionist intimism toward a style that offers a timeless monumentality. Here and in the *Overture* an observed domestic subject, rather than merely portraiture, has been given an enduring form. The inscription on the Emperaire, 'ACHILLE EMPERAIRE PEINTRE', was no doubt suggested by the inscription that was then to be seen on Tintoretto's self-portrait, or by a Velázquez in the Louvre. It is significant, and not only because it was stencilled with ordinary packers' stencils across the canvas, yellow ochre on purple, suggestive of the future as this economy of effort is. The character of the stencil lettering, the exaggeration of the Bodoni-style thick and thin, reminds one that it was in these years and this group of pictures that the meaning of parallels in Cézanne's art first became clear. Parallel lines, parallel folds, pleats, crevices; parallel planes; the parallel partnership of forms; this systematic parallelism is the essence of Cézanne's design.

Comparison between the styles of the two full-length portraits shows that there were several years of development between them. The distinction between the tonal illusion of pattern on the loose cover as it was seen in the portrait of *Louis-Auguste* and the bold restatement of the rosebud motifs as such in the *Emperaire* shows what happened. In the new style nothing is a merely visual effect, everything is itself, intact and complete. Even a shadow is a thing in itself, never now an amorphous smear. Light comes transversely, left to right. Flat areas of cast shadow *on* the chair and *of* the chair give a strong sense of the volume contained. The head is almost twice life size yet its character is sombre and pathetic. The grey

tones as much as the colours are galvanised by this sense of scale.

The drawing is more powerful than ever before in Cézanne's painting. The substance of paint, thick all over, is encrusted more thickly still along the contours where the linear definition has been laboured to such effect. In preparation for this picture Cézanne had in fact aligned himself, as never before, with specifically graphic traditions. The two great studies for it (cat. 79; 80), are at first sight profoundly different from the picture and from one another; one is almost Baroque and the other indubitably classic, very much in the sense of the finished picture, resplendent in its breadth yet gentle and grand. One must compare the first drawing (cat. 80), now in the Louvre, with real Baroque, a portrait like Van Dyck's etching of Lucas Vorsterman, to see that the seventeenth century itself had no rhythms to show more powerful and penetrating than these. The consistency and coherence of the result was the theme of the second drawing at Basel (cat. 79). From 1870 onwards it was the recurrent object of his art to bring the two concerns together. He aligned himself all his life between the polarities that were established in his early work. Cézanne's apparent historicism, his brilliantly vivid revival of the Baroque, in fact served a distinct and opposite purpose. He was not studying the historic repertory, certainly not a flashing eye or curling lock. Any preconceived pattern would have been repugnant to him. Thirty years later, when he was still drawing Baroque busts in the Louvre to help him with the least Baroque of his pictures, the portrait of Vollard, it became clear that he was studying the nature of continuity itself; the rhythmic spring would fortify him, not only for serpentine line, but for any sequence that he required to hold in mind, chromatic as well as linear, as he explained. Cézanne loved Emperaire, one must imagine, with just the same admiration for the living impetus that he felt in front of the curly rhythms of Coysevox.

In the simple style of 1869 Cézanne pursued his intention to paint from nature outdoors and set about a second, more deliberate version of the railway cutting beyond the garden wall, the picture at Munich in which the formal strophe and antistrophe of modern painting established themselves for the first time (fig. 13). [25] A little later a similar pictorial system, generated of a ravine with a watermill (cat. 58).

War with Prussia was declared on 18 July 1870 and, anticipating the conscription, Cézanne withdrew to L'Estaque (fig. 14) with Hortense Fiquet who eighteen months later bore his child. He was virtually in hiding. The half-dozen L'Estaque landscapes dating from 1870 might appear sufficient output under the circumstances but, original though they were, the more unaccountable achievements were the fantastic scenes that were perhaps painted at Aix during the previous months. These oppressively emotional works centre on a picture, dated 1870 by

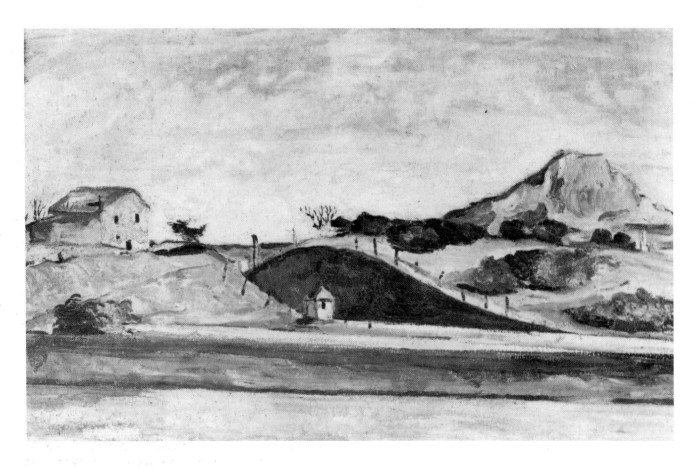

Fig. 13 *The Cutting*, c.1869–70. (V.50),
Bayerische Staatsgemäldesammlungen, Munich.

tradition and bearing an uncertain inscription, known as
Idyll, lately acquired for the Musée d'Orsay from the
Pellerin Collection (cat. 52). Naked personifications of
passion surround a bearded figure reasonably identified
as the artist, reclining in a riverside landscape furnished
with phallic vegetation. It is a sombre 'Temptation of
Cézanne' and another picture, not dissimilar in spirit,
depicts St Anthony in the same state (cat. 50), while a
third, an attempt at colour like Veronese which has long
been known as *The Orgy*, has lately been identified as the
Banquet of Nebuchadnezzar from Flaubert's book (cat.
39). A Flaubertian vein of fantastic sensuality in fact runs
through the whole group. There are also a *Déjeuner sur
l'herbe* (cat. 51) and a *Modern Olympia* (cat. 40), which have
neither of them anything to do with Manet, except in
their ironical correction of his standpoint, and *The Robbers
and the Ass* (cat. 41) in the manner of Daumier.

We have not been aware of Cézanne's pictures as
holding, or withholding, meaning except the formal
articulation that modernism accounted significant, and as
we come to look seriously at these figured landscapes,
quite clearly composed with more concentrated attention
than posterity has ever brought to them, we may be

surprised to find ourselves in need of more data about
their contexts and connotations than is easily come by.
More, it may be, than we have been aware of requiring
for any French picture of Cézanne's time.

Those who are ready to look and read closely will
therefore be grateful to Mary Louise Krumrine (q.v.) for
releasing some of the preliminary results of studying the
way towards Cézanne's later bather compositions that are
relevant to these landscapes-with-figures in which the
work of the 1860s culminated. It has always been evident
that the context included an artistic element (in particular
an attitude to the art and influence of Manet) and it
should have been plain that the relationship with Zola
(who had himself a very specific relation to Manet) was
only part of a deeply rooted and deeply sexual dilemma.
Together with all this we are now ready to recognise that
the attitude to art in general and to literature in particular
– to Baudelaire and to Wagner, whose importance to him
Cézanne openly advertised – was inseparable from the
nostalgia for natural beauty and for male companionship.
The development of a new genre of triumphant emotional
allegory at the very moment that Hortense Fiquet was
induced to enter his life is so comprehensible that we may
easily overlook that this was, certainly not by coincidence,
also the time in his life when the forms of his native
landscape came together for him in structures of such

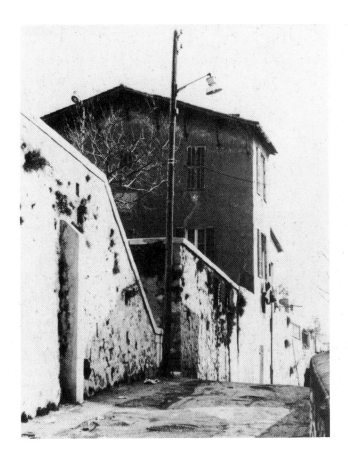

Fig. 14 Cézanne's house at L'Estaque (contemporary photograph).

seeming inevitability (and familiarity to us) that it is now difficult for us to recognise how unparalleled they were in sheer self-evident, axiomatic grandeur (aside from the invention of the fugue in music) in the whole art of the world.

The dramatic intensity of the allegorical illustrations of emotional states, if not of the actual events, as well as the frustrations of his erotic life, has escaped recent critical accounts of Cézanne's art. The present compiler, writing some months before anyone has ever seen as many of Cézanne's early works as this together in one place, is quite unable to foresee the effect of the experience on the unified estimate of the artist. As the work of the young Cézanne emerges in its full complexity, it becomes more and more difficult but more and more rewarding to understand that the later painter, the classic formalist, that veritable Johann Sebastian of painting, was the same man.

Perhaps not quite the same, but with some of the scholarly and highly literate emotionalism of the younger man shorn away? But no, it was still there; everything of the passionate, poetic youth was still there inside him all his life. For example: in these pages we are concerned with the young man to whom his unhappily parted intimate,

Zola, wrote: 'As you have translated Virgil's second Eclogue, why not send it to me? Thank God I am not a young girl and I shall not be shocked.' Twenty years later, asking the help of Zola himself in his passion for the maid Fanny with her 'body like a man', which swept him away, in a passion that in failure prompted the last degree of that sublimation which began just when this exhibition ends – Cézanne quoted from the very same Eclogue, '*Trahit sua quemque voluptas.*' Rediscovering the pastoral mood intact within the ageing painter, one finds oneself reflecting on the historical associations of that apparent suspension of the traditional purposes of description and illustration and their replacement by self-sufficient structures of alignment and the logic of colour which occupied Cézanne for the remaining thirty-four years of his life. As a figurative system the inherent harmonies of painting made a sudden appearance in Venice in the first years of the sixteenth century. The basic work of Cézanne's twenties, the build-up of emotional pressure aside, was the realisation that the best tribute to the past was the emulation of figurative integrity, as his friends in the Ile-de-France were emulating it. In Venetian painting the harmonies could be seen to spring, as they sprang in the nascent Impressionism, from observation and painterly purity of heart. Reassuring Emile Bernard in 1904, when he was in truth more inclined to convict him of historicism, Cézanne wrote: 'On the day when you find your own means of expression, be assured that you will rediscover without effort the means employed by the four or five great ones of Venice.' The indecision as to the number was perhaps that he did not know, any better than we know, whether to credit the *Concert champêtre* to one master or two.

As soon as the war was over and the restraint on his movements lifted, Cézanne seems to have begun a series of portraits of his friends which showed more social awareness than anything that he painted before or after. They must have been begun after his return from L'Estaque in March and they took up again the affinity with Manet of the pictures that he had been painting in 1870. The portraits gave his contemporaries a resolute bourgeois air, as if the new generation was required to assume a more serious responsibility in the wake of the defeat. His sitters included Boyer, an old school friend characterised as a valiant hunter in one of Cézanne's rhymes about the circle. He sat both with (cat. 57) and without his hat.[26] Cézanne was always sensitive to the connotations of headgear, as later self-portraits show. There was a second portrait of Valabrègue (cat. 56), to be followed by still another in the 1870s, in which the worldly stature of the man evaporated into a pattern of feckless charm. He painted Fortuné Marion, one of the Aix painters said to have been following Cézanne's use of the palette-knife (who signed the picture of St Jean de Malte which was once ascribed to Cézanne in the Fitzwilliam Museum,

Cambridge), with his head winningly and weakly inclined.

The symbolic overtones of some still lifes in 1866 do not recur and the anticipations of Expressionism that were felt in them are missing from the still lifes of after 1870. These show a confidence and an inherent grandeur that was essentially unprecedented even in Chardin. Before, it had nearly always been possible to regard still lifes as the outcome of real domestic life, well-disciplined and not essentially surprising. With Cézanne's *Black Clock* (cat. 49) and its successors (cat. 53, 54) there is no doubt that the group and its picture were incidents in an exceptional procedure ordained and enacted by the painter himself. Even if we had not been told by witnesses how solemnly and with what moving delicacy Cézanne, at any rate in later life, performed this ritual we could probably imagine it. These are pictures of a certain conception, possibly a conception of pictorial art, but we cannot be quite sure because we notice in other pictures that the objects depicted here belonged in fact in Zola's house and it may be that some tribute to Zola is celebrated in this embodiment of domestic grandeur. Further, the pink recess of the shell is more vivid than conchology usually supplies; is it possible that it carries associations of an intimacy between the friends? It is rather the gaunt impersonality that makes the *Black Clock* so great and grand. We realise that the absolute self-sufficiency of these rugged forms and surfaces was achieved without reduction in the emotional charge that painting carried, at that moment particularly for Zola. The momentum, the address were so powerful that the pictorial presence was transformed. One thinks of this as painting *to* Zola. This is a factor in Cézanne's art which we may have recognised without valuing it fully, emotionally enough. Without loss of original individuality, perhaps with a concentration of it, painting soon after becomes painting *to* Pissarro, then *to* Chocquet, *to* Renoir. A great moment in Cézanne's art in the eighties was a watercolour *to* Hortense with a hortensia beside her on the sheet.[27] Only the painting to Fanny was rather colourless.

Assembling the fruit, napkins, bottles and pitchers which became his subjects, Cézanne was meditating on the character of the private rite with which he was to replace domestic painting. The example now in the Musée d'Orsay (cat. 53) convinced Roger Fry of Cézanne's genius at a stroke and the *Black Clock* did somewhat the same for Rilke. The *Pots, Bottle, Cup and Fruit* (cat. 54), now in Berlin, remained in Cézanne's studio and twenty-five years later, as if to portray the kind of meditation that occupied him, he painted a smoker in melancholy reflection in front of the canvas.[28] There was never another picture like the *Black Clock*. It constitutes an unarguable presence with which no other picture or painter quite compares.

These pictures have been understood, so far as masterpieces of the highest order ever are, and assimilated to our view of the painter. The emotional allegories, or however we agree to describe the twilight picnics, have still to be incorporated in a conception of his genius that is hardly wide enough to take them. When he felt like hating the imaginative – and I do not believe that was one of Gasquet's literary interpolations – they must have been among his pictures that he liked least. In 1872 he turned to objectivity to sublimate both the love of violence and the violence of love, but he still faced issues of extreme personal difficulty all his life. It was the fact that he looked so directly at a private dilemma that made him, as he claimed, a realist. Cézanne is found continually to be more complex than we thought. Coming to worship at a classic shrine, we find that we are present at an apocalyptic culmination of Romanticism as well.

The inventive and controlled little landscape of the chestnut avenue must have been one of Cézanne's last pictures before he went north (cat. 60). The interplay of vertical trunks with diagonal planes of foliage discovered a scheme that was to last him as long as he painted at the house. The design and the fat touch resemble both the *Overture to Tannhaüser* (cat. 44) and the *Cutting* (see fig. 13), yet the picture has almost equally clear links with the next phase of his thought in Provence. The frontal design of the later pictures was waiting to be born.

By the end of the year Cézanne was living opposite to the Halle aux Vins. Emperaire reported that the noise was enough to waken the dead. In January there was a baby in the house. Cézanne borrowed the studio of Armand Guillaumin, in which to paint the vehement *Self-Portrait*, formerly in the Laroche collection and now at the Musée d'Orsay (cat. 63); it is the last we see of the furious passions that were forthwith to be sublimated into the harmonies of the art to come.

NOTES

1. Cézanne, *Correspondance*, 1978, pp. 48–50.
2. The first letter in the correspondence, containing 104 lines of verse and signed Paul Cézanne, Salve, carissime Zola, *Cézanne, Correspondance*, 1978, pp. 17–20.
3. Cézanne, *Correspondance*, 1978, pp. 33–5.
4. Quoted in full in the English edition, 1976, pp. 363–5.
5. Salvini, *Botticelli* (Milan, Rizzoli, 1965), vol. 4, pl. 137, 138.
6. Cézanne, *Correspondance*, 1978, pp. 66–9.
7. Cézanne, *Correspondance*, 1978, p. 87.
8. V. 24.
9. V. 19.
10. V. 22.
11. V. 95.
12. V. 109.
13. F. Daulte, *Auguste Renoir, I, Figures 1860–1890*, Lausanne, 1971, 20.
14. Vollard, 1919, p. 29 ff, recording information from Guillemet.
15. To Charles Camoin in a pregnant postscript, *Cézanne, Correspondance*, 1978, 22 January 1903, p. 293.
16. Venturi – Pissarro.
17. V. 43.
18. Musée du Louvre, Paris. K.E. Maison, *Honoré Daumier, Catalogue Raisonné of the Paintings, Watercolours and Drawings*, London, 1968, 810.
19. Gasquet, 1921, 1926, p. 94.

20. Mary Tompkins Lewis, 'Cézanne's "Harrowing of Hell and the Magdalen"', *Gazette des Beaux-Arts* (April 1981), pp. 175–8.
21. F. Burger, *Cézanne und Hodler: ein Einführung in die Probleme der Malerei der Gegenwart* (Munich, 1919), vol. 2, pl. 188.
22. V. 64.
23. *Usines à l'Estaque*, dated 1869 in an inscription by Madame Zola, Rewald, 1948, fig. 36; RWC. 24.
24. J. Rewald, 'Un article inédit sur Paul Cézanne en 1870', *Arts* (Paris), July 21–7, 1954; Rewald, 1973, pp. 246, 268; Rewald, 1986, pp. 84, 85. The caricature of the Emperaire portrait has been tinted in watercolour by someone familiar with the original picture. It may be that the copy which came to light in Aix was that transmitted by Cézanne's uncle to his friend Justin Gabet, a joiner in Aix, *Cézanne, Correspondance*, 1978, 7 June 1870, p. 135.
25. *La Tranchée, avec la montagne Sainte-Victoire*, Munich, Bayerische Staatsgemäldesammlungen, V. 50.
26. V. 130.
27. Adriani, 1981, no. 85. Rewald, 1983, no. 209.
28. V. 686, now in Leningrad.

Parisian Writers and the Early Work of Cézanne

MARY LOUISE KRUMRINE

In a short story written in the late 1860s, Edmund Duranty, art critic and novelist of the realist movement, told of an artist who was much discussed in Paris as being 'very odd'. From pure inquisitiveness, yet with some trepidation, the narrator of the story paid a visit to this painter's studio. 'Enter,' he heard, in a voice redolent of the south of France. What he saw there was the room of a rag picker, a *chiffonier*. Dust, garbage, old clothes and pieces of broken dishes were piled everywhere; a smell of mould permeated his nostrils. Then he saw the painter called Maillobert. He was bald with a great beard, and gave the impression of being both young and old at the same time, somehow personifying the symbolic divinity of his own studio – indescribable and sordid. He gave the visitor a grand salute accompanied by a smile that was indefinable; it might have been either bantering or idiotic. At that moment the narrator's eyes were assailed by enormous canvases hung in every direction, so horribly painted, so wildly coloured, that he stood petrified. 'Aah,' said Maillobert, with his slow, exaggerated Marseillaise accent, 'Monsieur is a lover of painting! Observe! These are merely the *small* scraps from my palette', and he pointed to the huge sketches thrown about the room.[1]

It was generally understood then, as it is now, that Duranty's somewhat harsh caricature represented Paul Cézanne.[2] Duranty met regularly with the circle of artists and writers known as 'Le Groupe des Batignolles', which included the painters Manet, Renoir, Fantin-Latour, Degas and Monet, and the writer Emile Zola, at the Café Guerbois in Paris. It was there that he was surely witness, as were the others, to the peculiar behaviour of the artist from Aix. It was true that people heard more about Cézanne than they saw, but much of the popular legend was accurate: he was at once violent and gentle, timid and proud; he did paint and exhibit 'odd' pictures; and, perhaps most significant for the artistic circle, he was the old boyhood friend of Emile Zola.

Cézanne, nearly thirty in 1867 – the time of Duranty's story – was of average height, thin and bearded. He had knotty joints and a powerful forehead. He wore a battered felt hat, an enormous overcoat which the rain had streaked green, and below his short trousers bright blue stockings could be seen protruding from huge laced boots. He had a nervous shudder that was to become habitual. When Cézanne did come to the Café Guérbois he seldom entered into conversation with the group. His first glance was usually mistrustful; then he would quickly shake hands all round. But in the presence of the urbane Manet, he would remove his hat, and apologise: 'I do not shake your hand, M. Manet. I have not washed for a week.' Taking himself off to a corner, he would show little concern with the conversation around him, but when he heard an opinion different from his own, he would stomp out of the café, not to be seen again for days.

Cézanne's ill-kempt exterior, crude language and

scowling face, although bold attempts to express his disdain for convention, were little more than a thin veil which covered great tenderness and insecurity. He had a keen intellect; he was a scholar who knew Lucretius, Cicero and Apuleius, and called Plato the 'supreme philosopher'. He wrote his own verse in Greek and Latin. Gauguin was to speak of him as 'a man of the south of France who passes entire days on the summit of the mountain, reading Virgil and looking at the sky.'[3] He avidly read the works of Victor Hugo, Alfred de Musset, Balzac, Stendahl, Gustave Flaubert and the brothers Goncourt. He was the first to whom Zola presented copies of his criticism and his novels. Baudelaire was his favourite poet. Cézanne's copy of Baudelaire's *Les Fleurs du mal* was worn to tatters, and from this volume he knew 'Une Charogne' from memory, never missing a word.[4] Of all composers, he particularly admired Beethoven and, like many artists in Paris, was enraptured by the music of Wagner, especially his opera, *Tannhäuser*.[5]

Cézanne's so-called 'black' pictures, those early works from the decade of the 1860s, were seldom appreciated and less understood, even by his friends and fellow artists. To shock and insult the august jury of the Salon, he submitted canvases for six consecutive years, 1864–9. Anticipating rejection, he was never disappointed. A portrait of his friend Valabrègue, entered in 1866 (cat. 16), was judged as having been painted not only with a knife but with a pistol as well. Other works elicited public jeers and laughter. Manet was said to find Cézanne's still lifes powerful, but later mitigated his remark by noting that Cézanne was not much more than an interesting colourist.[6] When he saw *Afternoon in Naples* (cat. 27), also submitted to the Salon that year, Manet's disdain was fully evident. He asked the painter Guillemet, one of Cézanne's staunch supporters, 'How can you abide such foul painting?'[7]

These paintings and drawings from the sixties are usually considered only as the outpourings of the youthful artist's dark moods and impetuous nature, but the interested observer is compelled to seek elsewhere the foundations of their eccentric and sensational subject matter. Among the most fertile sources for clues to these troubled works are Cézanne's letters and poems, written to Emile Zola when the future novelist left his boyhood home in Aix-en-Provence to live in Paris. In romantic effusions to his friend we find Cézanne's fond references to their youthful camaraderie, interspersed with descriptions of macabre dreams and fantasies – these centering, almost without exception, on his family and on women.

Cézanne's friendship with Zola began in 1852 when the two met at the Collège Bourbon in Aix. Strong and burly, Cézanne took the puny, slightly younger Zola under his protection. 'We were opposites by nature', Zola was to recall later, 'but we became united forever, attracted by secret affinities'.[8] When free from school, the boys roamed the countryside, hunting, fishing, swimming,

reading, and writing their own poetry. 'Victor Hugo's dramas haunted us, like magnificent visions. When we were dismissed from classes, our memories frozen from the classical tirades we had to learn by heart, we experienced an orgy replete with thrills and ecstasy, warmed by reciting scenes from *Hernani* and *Ruy Blas*. Victor Hugo reigned as monarch until one morning we discovered Alfred de Musset. Reading de Musset was for us the awakening of our own hearts.'

Each boy believed the other to have an extraordinary destiny, particularly concerning artistic questions. In 1860, Cézanne wrote to Zola that painting began to appeal to him more and more; Zola longed to write.[10] It was his idea for a great artistic collaboration:

'I had a dream the other day. I had written a beautiful book, a wonderful book, which you had illustrated with beautiful, wonderful pictures. Both our names shown in letters of gold on the first page, and, inseparable in this fraternity of genius, were passed on to posterity.'[11]

The group of young artists who rallied around Manet after the Salon des Refusés in 1863 found in Zola a champion who expressed his opinions in plain, sincere language. His publications on art gave him an important place with the Batignolles artists. In a series of articles published in the newspaper *L'Evénement*, he defended the painters as the official Salon rejected them. But it is curious that in all of Zola's reviews of his friends' rejected works – those of Pissarro, Monet, and especially Manet whom he particularly admired – he never once discussed any of Cézanne's canvases.[12] It was apparent that he could better appreciate Manet's more naturalistic approach than the romantic, seemingly crude and moody scenes that Cézanne was painting at the time. As such an outspoken proponent of this 'new art', Zola was severely criticised and was virtually forced to give up his contributions to the newspaper.

But in the Spring of 1866, he immediately reprinted his articles in a pamphlet entitled 'Mon Salon'. Its long dedication, to 'Mon Ami, Paul Cézanne', was a tribute to friendship, a public avowal of Zola's affection for the artist; it apparently was *never* an appreciation of the painter. These sentiments are clear from the beginning where Zola wrote:

'Happy are they who have memories! I envisage your rôle in my life as that of the pale young man of whom de Musset speaks. You are my whole youth; I find you mingled with all my joys; with all my sufferings. Our minds, in brotherhood, have developed side by side. We have faith in ourselves because we have penetrated each others hearts and flesh.'[13]

In poignant terms, Zola seemed to express a farewell to Cézanne, an end to an era of fond happiness never hinted at again.

Even if Zola could never appreciate Cézanne's painting,

it is apparent in his novels that he reveals a great deal about his friend as an individual and as an artist. From his many notes, beginning as early as 1868, for the construction of the monumental Rougon-Macquart cycle, it becomes clear that Zola had Cézanne in mind as the central character, Claude Lantier. And it is from these sketches that we learn of his conception of the 'intense psychological process of an artist's temperament and the terrible tragedy of an intelligence which consumes itself.'[14] His setting for the novels was Aix (which he called Plassans); the patriarch of the family was obviously based on Cézanne's father (mocking, bourgeois, cold, stingy). Thus from the memories of his youth, Zola made use of his friend, and in truth it is in this way that the two become inseparably linked.[15]

It is not surprising, then, that even in the works before the Rougon-Macquart series – particularly the novels *Thérèse Raquin* (1867) and *Madeleine Ferat* (1868) – allusions to Cézanne and to Zola himself cannot but be acknowledged. When the so-called triangles in these stories are analysed, it is clear that one of the young men is ineffectual, unattractive and effeminate. He lacks a parent, as did Zola, and is usually dependent on a stronger, more virile comrade who befriended him at a provincial school.[16] Zola persists with realism and autobiography in *Thérèse Raquin* – Thérèse, the desired object of both her lover and her husband.[17] She and the vigorous artist, Laurent, conspire to carry out the murder of the pale, weak-willed and mother-dominated Camille. The similarities between Laurent and Cézanne are too marked to be merely coincidental: both are from Provence, both painters, both impoverished by wealthy fathers who disapprove of their careers.

What was the nature of Cézanne's artistic production during those years? Several of his paintings from the mid-sixties were gifts to Zola: the bizarre *The Rape* (cat. 31), a scene of violation which appears to take place in the shadow of the Mont Sainte Victoire, near Aix; the enigmatic *Black Clock* (cat.49), where heavy geometric shapes contrast with sensuous, bright undulations. But several other of Cézanne's figure paintings and drawings reveal clear parallels to the violent themes which are explicit in Zola's novels. These portray physical struggles with a cast of characters that is nearly always constant. As in Zola's work, there is again a threesome. But for Cézanne this trio consists of an attacker, always a male; a victim, always a female; and an observer-accomplice who may be either male or female. Only the woman-victim's part varies. At first she appears as seductress, but later relinquishes this rôle as she becomes progressively terrorised, unconscious, and ultimately killed. Throughout this development, the fate of the beleaguered heroine is brutally evident. We wonder if she is meant to be getting her just desserts.

The three actors differ slightly in paintings where Cézanne dwells on death. The artist scarcely disguises his own presence in *Preparation for the Funeral* (cat. 35) where he is recognisable by his bald pate framed by hair that is particularly long at the back, and by his revolutionary beard.

It seems that in such representations of the watchers and the dead, Cézanne is never far from Zola's imagery. The artist, Laurent, in Zola's *Thérèse Raquin*, becomes almost an inhabitant of the morgue, examining bodies daily, searching for Camille's corpse not yet recovered from the river at the scene of the 'accident'. At last he found him.

'. . . He saw Camille, stretched on his back, head elevated, eyes half-open. Laurent, lost in unconscious contemplation, engraved on the depths of his memory all the horrible lines, the dirty colours of the picture which he had under his eyes.'[18]

The connections between painting and novel are even more fascinating when we recall how closely Laurent's characteristics were based on Cézanne.[19] It seems to me that similarities such as these not only indicate affinities in the psychological make-up of the two friends at this time, but an obvious relationship in their artistic production as well. Which came first – painting or novel, or why the artist played a pivotal role in either 'tableau' – can be only a matter of conjecture.[20]

In the most enigmatic of Cézanne's early, so-called 'romantic' pieces, *The Temptation of St Anthony* (cat. 50), the artist's overt participation is perhaps never questioned.[21] He is both actor, barely disguised as the bald saint at the left margin, and observer, joining our position as spectators of the scene. The theme of the painting seems to have a spiritual link with Flaubert's novel, *La Tentation de Saint Antoine*, and it appears that the 'subconscious and rebellious capacity for suffering' that Baudelaire sensed in Flaubert's work was to permeate Cézanne's painting as well.[22] Only excerpts from Flaubert's first version of *La Tentation* had appeared in *L'Artiste*,[23] a journal with which Cézanne was very familiar. A complete and revised version of the story was published in 1874, and Cézanne's return to the subject in the same year shows a more explicit depiction of the Saint beset by a seductive woman.[24]

The often-noted peculiarities of Cézanne's composition are clearly calculated. St Anthony, the subject of the painting, is relegated to the margin where he is confronted by his temptress. The three other starkly lit and isolated nudes are unbalanced in arrangement. If we follow the deliberate parallel vertical and diagonal directives, two emphases are apparent: the standing frontal figure with drapery and the opposing images of the Saint and the fire. Although opposites in position, colour and intensity of illumination, they are given equal space and like proportions, thereby suggesting their thematic importance

EMBLEMA XXXIII. *De ſecretis Naturæ.*
Hermaphroditus mortuo ſimilis,in tenebris jacens,igne indiget.

EPIGRAMMA XXXIII.

ILle biceps geminiſexus,en funeris inſtar
 Apparet,poſtquam eſt humiditatis inops:
Noĉte tenebroſa ſi conditur,indiget igne,
 Hunc illi præſtes,& modò vita redit.
Omnis in igne latet lapidis vis,omnis in auro
 Sulfuris,argento Mercurii vigor eſt.

Fig. 15 *Hermaphroditus mortuo . . .*, illustration from Michael Maier, *Atalanta Fugiens, hoc est, Emblemata Nova de secretis naturae chymica*, Oppenheim, 1618. (Facsimile ed., Kassel and Basel, 1964.)

in the composition. These too, the monk and the fire, are the components which separate the painting from representations of the Judgement of Paris where there are always three nudes and a melancholic contemplative figure.[25]

Unlike older representations of Saint Anthony's temptation, Cézanne's Saint is tempted not by demons *per se*, but by four robust nudes. The poses of three may be read as sensual and seductive, but the figure resting next to the fire is obviously melancholic and contemplative or saturnine.

The fire seems to allow further penetration into the meaning of the corner figure. Its androgynous features have led to many questions concerning its role in the *Temptation*. If it were indeed a 'tempting' female, it would serve as part of the Saint's hallucination. Yet in Cézanne's other works, this contemplative posture is usually linked with male figures. Were it not for this nude's bulbous breasts and rounded abdomen, those characteristics delineated by the fire, it too would seem to exhibit only masculine traits. Essentially, then, we may recognise here an hermaphrodite, a figure with male and female attributes, one often seen in ancient art although never in this posture (fig. 15).[26]

There is a clue which may disclose the identity or meaning of the figure: the remarkable similarity of the head with Cézanne's early portrait of Zola (fig. 16).[27] Both visages closely correspond to the description of a studio photograph taken when the writer was about twenty:

'Thick dark hair and what used to be called a Newgate frill – a fringe of beard running from ear to ear but scraped away from the cheeks and chin – encircle a sad little face, almost feminine in its wistfulness; the eyes gaze soulfully, the corners of the mouth are drawn down to give an expression not so much of grimness as of resigned melancholy.'[28]

As for the ambivalent physique, the brothers Goncourt, never noted for their flattery, described Zola at twenty-eight:

'[He had an] ambiguous, almost hermaphroditic appearance; at once burly and frail, he looked more youthful than he was, with the delicate moulding of fine porcelain in his features, in the arch of his eyebrows. Rather like the weak-willed, easily dominated heroes of some of his early novels, he seemed like an amalgam of male and female traits, with the latter dominant, . . .'[29]

Why would Cézanne introduce Zola into the picture?

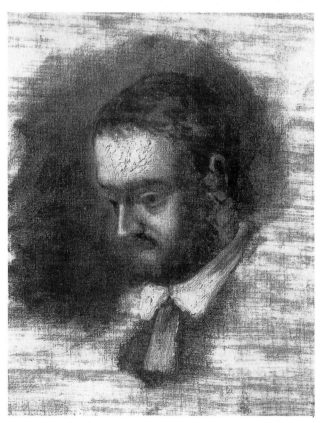

Fig. 16 *Portrait of Emile Zola, c.*1862–4 (V.19). Present location unknown.

Fig. 17 *Woman Bather drying herself*, and *Head of Mme Cézanne*, 1879–82;
1883–5 (Ch.520). Collection Mme A. Chappuis, Tresserve.

Or (as Schapiro has intimated) in the case of the novelist whose invented characters seemed to portray facets of both himself and Cézanne,[30] could the painter have transposed and/or merged the two identities into one image? Discussion of their intimate relationship is beyond the scope of this paper, but the consideration of Zola's sexual preferences and behaviour inevitably raises questions about the nature of their friendship.[31]

If we re-examine the painting in the light of Zola's 'portrait', we find a closer correspondence between Cézanne's St Anthony and Zola's Madeleine Férat. For if Cézanne/ Anthony appears to be afraid of the seductive female, the melancholy, androgynous nude/Zola maintains a passive role. Actually, the monk seems to turn his body, head and arm in order to shrink from even visual contact with his temptress.

In this scene, then, Cézanne may have separated two facets of one character – the fear and the *ennui* in response to female flesh – and portrayed each in two different characters. This may be the first occasion which alludes to the artist's dual personality, or alter ego, described in two forms: the hermit/monk and the hermaphrodite. At the outer limit of interpretation, we might suggest that Cézanne had injected his own feelings into the image of another person, in this case, Zola. Such an idea may be strengthened by Schapiro's observation of the conflated name of Sandoz in *L'Œuvre*, by Badt's comment on the men's 'inter independence', by Rewald who senses Zola's own blood flowing in the veins of Claude Lantier, and in Zola's own words, '. . . *nous avons pénétré nos coeurs et nos chairs.*'[32]

If each of the central nudes in Cézanne's *Temptation* represents – or prefigures – Zola's response to '*une belle dame sans merci*', their single effect on the two corner figures becomes apparent. One is intimidated, afraid; the other contemplative, unaroused. They manifest a complex personal, psychological presentation in the painting.

Cézanne seems to have summarised his own subconscious feelings toward women, finding in each one, as perhaps did Zola, a terrifying masculinity scarcely disguised in the voluptuous exterior of a courtesan or femme fatale. It is the reaction of painter and writer to the aggressor that is different.

The motivation for Cézanne to paint this particular scene of Temptation is usually, and no doubt correctly, attributed to his 'fear of women'. Nevertheless, an incident central to Cézanne's personal life took place concurrently with his work on this composition, and it may account in some ways for its puzzling imagery:

'Cézanne returned to Paris at the beginning of 1869. It is about this time that he met a young model, Hortense Fiquet, who was then nineteen . . . [She was] a tall and handsome brunette with large black eyes and sallow complexion. Cézanne, eleven years older than she, fell in love with her and persuaded her to live with him . . .'[33]

Curiously, the central nude, actually the primary emphasis of the composition, has great affinity with several portraits of Hortense Fiquet/Mme Cézanne in which her head is inclined toward the right and downward, and her hair pulled behind her ears to reveal a particular grace and elegance.[34]

I would suggest that the so-called *Temptation of St Anthony* – and the contemporary *Déjeuner sur l'herbe* (cat. 51) to be discussed below – are indeed manifestations of a remarkable emotional change which took place in Cézanne's life and his art. This was simply a physical attachment to a woman. His daydreams of beautiful women and of romantic encounters need not be reiterated here. Nevertheless, the impression which emerges from his erotic verbiage is one of chasteness, even virginity (fig. 17).

Even as late as 1886, in *L'Œuvre*, Zola was to recall Claude/Cézanne:

'This was his chaste passion for the flesh of a woman, a foolish love of nudity desired and never possessed, an impotence to satisfy himself, to create this flesh so much that he dreamed of holding it in his two bewildered arms. These women whom he drove away from his atelier, he adored in his paintings – there he caressed them and violated them, desperate that through his tears he would not have the power to make them as beautiful and vibrant as he desired.'[35]

The book was to end their friendship.

In fact, in *The Temptation*, Cézanne may have told us a great deal about the emotional and psychological conflict that his affair with Hortense brought him, the conflict which achieved sublimation in the years to come.

About 1869–70, at the same time that he conceived of *The Temptation*, Cézanne painted what is now called *Le Déjeuner sur l'herbe* (cat. 51). What at first glance appears to be a group of friends casually gathered around a white cloth for an afternoon's pleasure, upon closer scrutiny takes on a contrived, even sinister aspect. The food is sparse - three pieces of fruit; the libation discarded – a bottle lying on the grass; the postures and gestures of the figures calculated and emphasised – a pointing finger, a hand raised to the lips, arms folded to the breast.

That it was Cézanne's intention to recall older pastoral scenes is obvious. He sketched the *Concert champêtre* – then attributed to Giorgione, in the Louvre,[36] where he also no doubt encountered the amorous couplings and cosmic landscape of Watteau's *Embarquement pour l'Ile de Cythère*.[37] Cézanne's debt to Manet's 'scandalous' *Le Déjeuner sur l'herbe* has always been acknowledged: the group of four in a wooded setting, the still life, the shed clothing. Monet's life-sized 'picnic' (1862/3), and Bazille's *La Famille de l'artiste à Montpelier*, exhibited at the Salon of 1868, were undoubtedly familiar.[38] But Cézanne denies the lyricism and unity of the older works, isolating, even enclosing, each figure in its own space. The landscape is imagined or artificial, unlike Monet's sensitive rendering of the Forest of Fontainebleau. The fashionable display of elegantly dressed men and women in Monet's and Bazille's paintings seemed not to capture Cézanne's fancy. His women are clad in simple, unadorned dresses, the men in white shirts except for the self-portrayed artist who is clothed in a contemporary frock coat and light breeches (how different from the descriptions of his normal attire!).

Because of his sombre, contemplative presence, we sense a personal testimony to the weightiness of the subject, somehow substituting a part of his imagination for a piece of nature.[39] Comfortable in scale (and nearly identical in size to *The Temptation of St Anthony*, Cézanne's *Déjeuner* must be realised within this intimate framework, not as the monumental salon pieces of which Monet's and Bazille's works speak. Growing out of his own earlier

scenes of violent physical contact, lust and sensuality, this sedate, social occasion presents an abrupt change in mood but not, I believe, in the level of personal involvement.

Cézanne's first letters to Zola tell of his fondness for clever word games and charades. He begged his friend to rhyme everything, and he in turn would puzzle over Zola's riddles.[40] He would then reply with a rebus, which would require Zola to divine the mystery of its combination of letters (pronouns) and vignettes (portraits, a scythe, buildings, etc.)[41] It seems likely then, that *Le Déjeuner sur l'herbe* may be another of Cézanne's games of this sort wherein he has indicated his intention with disparate people and things, but without words. The persons and objects may all serve as keys to the contrived arrangement of the picture.

Two isolated pieces of fruit, illuminated and emphasised by the circular sweep of the white cloth, locate the exact left-right centre of the canvas. The relationship of the other parts is graphic. The actual convergence of the action is found at a point below the lower edge of the canvas from which radiating lines indicate a gesture or glance; i.e. Cézanne's pointing finger, the lighted face of the blond man and the standing woman's gaze. This construction sets up a 'tableau' which seems to involve the four (or five, if the observer in the rear is included) central characters in a primary story, and suggests that the departing couple may represent a subsequent action.[42]

If we have a two-part narrative, what has taken place in the first instance to warrant the second? In Cézanne's arrangement of the four principal figures, we seem to have a confrontation, a game as it were, in which the figures placed across from each other are in opposition: male *vs* male; female *vs* female.

Standing at the left and silhouetted against the dark forest, the blonde woman holds an apple; her face seems to express perplexity as if to determine whether to take a bite of the fruit or to offer it to the artist at whom she looks. If she were pondering either alternative, we could see her role as a temptress, even as an Eve. Cézanne has given her the air of an enticing female. She has strongly modelled breasts, a small waist, and an elongated form emphasized by serpentine curves which accent the folds and hem of her skirt. Her blonde hair is loose, unlike the more decorous chignons worn by women of the day (actually recalling the unbound tresses of the female victims discussed earlier, as well as three of the nudes in *The Temptation of St Anthony*). We are reminded of Zola's description of Thérèse Raquin, distraught by guilt and appearing as a degraded streetwalker:

'. . . she was clothed like a girl, in a long trailing dress; she strutted on the sidewalk in a provocative fashion, looking at the men; . . . she moved slowly, her head slightly turned, her hair hanging down her back.'[43]

An antithesis to the vertical figure is the crouching

woman whose neatly coiffed head is outlined against the blue sky. She raises her left hand to her lips as if to stifle a gasp or give a warning, possibly in response to her counterpart's gesture. Her position near the artist may give a clue to her identity. She does bear a striking resemblance to Cézanne's elder sister, Marie, whom he portrayed seated at the piano in *Overture to Tannhäuser*[44] (cat. 44). Cézanne lived with her and his mother even after his marriage.

The figure which must take precedence as the subject of the painting is, of course, that of the artist. Although his back is turned to the observer, he is impressive on several counts: his bulk near the centre of the canvas; the fact that he is framed by objects found on the grass; and the pointing gesture whose direction is reinforced by his bent leg.

Reclining with one knee drawn up toward his body, a young man faces the observer and the artist. Though no more handsome than the other figures, he seems, in comparison, to be idealised, even set apart from his companions because of his golden hair, luminous pink complexion, and air of femininity. He rests his chin on his right hand in the standard pose of the melancholic.

Who, then, is the young man directly aligned with the artist's left hand? Their opposing features are more distinctive than those of the two women. Cézanne is sombre, his hair is dark and sparse, his complexion sallow, his coat black. The other, his blond hair falling over his forehead, smiles faintly; his skin is fair, his shirt white. Why would this figure be a pendant to the artist? When Zola wrote about Cézanne in *Mon Salon* (1866), . . . '*Je te vois dans ma vie comme ce pâle jeune homme dont parle Musset*,' he left an indication of the source not only for the man's countenance and his posture, but for his melancholic pose as well.[45] The 'pale young man' of whom Zola writes comes from 'La Nuit de décembre' by Alfred de Musset, the poet who awakened the boys' heart, who became their 'religion'.

Does the painting show a bisecting, or separation, of de Musset's character: smiling, melancholy, patient as well as gloomy, sombre, dressed in black? If this is his mirror-image, as suggested in the poem, it must return his likeness in spirit rather than in reality.

To suppose that Cézanne painted his 'double' is further supported by another story written by Duranty about 1869, the date of our painting. *La Double Vue de Louis Séguin*[46] concerns a group of artists who gather at the Café Barboise (a thinly veiled reference to the artists' Café Guerbois) in Paris. In the manuscript of the story, the author forgetfully refers to his subject as *Paul* and *not* as the Louis Séguin of the title, a young artist who speaks of his concern about a rival for the favours of an attractive shopgirl. If this anecdote refers to Paul Cézanne (and the phonetic similarity of the family name, the author's slip as to the Christian name, and the turbulent personality of the protagonist leave little doubt that this is the case),[47] it

does so in a heightened expression of the artist's dual nature.

If we could presume, then, that the blond man is Cézanne's alter ego, how can we account for the remaining persons in the picture? Aside from his stoic posture, the man in the distance has only one attribute which lends him distinction: a clay pipe. Cézanne and Zola often mentioned smoking in their early letters; the latter was particularly fond of a pipe. For both young men it was a custom associated with relaxation and reverie.[48] The image of a figure smoking and withdrawn from his companions appears several times in other paintings contemporary with *Le Déjeuner sur l'herbe*.[49] Twenty years later, about 1890, the pipe-smoker is found in the series of *Joueurs de cartes*.

From none of these figures, whose pose or activity is their only common bond, could we identify the smoker in our picture. Like his role in some scenes of card-players, the man stands in the distance, clearly not a participant in the conflict, but one watching how the game is played. Kurt Badt has suggested that the contemplator in the *Card Players* is Zola,[50] and since we know him as Cézanne's confidant, his presence in *Le Déjeuner sur l'herbe* would not be unlikely.

Solitude, almost necessarily, became a way of life for Cézanne. If the smoking contemplator represents Zola, the concept of the artist's loneliness is reinforced by his friend's distance.

In his 'picnic' Cézanne placed several diverse objects close to where he is seated on the grass. Near his right hand are a top hat and folded parasol; both appear again at the far left of the canvas, the hat on the man's head, the parasol now open, carried by the woman. Lying near the artist's left foot is a chain, and on it a bottle whose neck points toward the departing couple; both seem bizarre accompaniments to a picnic. The thick black chain could hardly have a pleasant connotation; the bottle, lacking the graceful shape of a wine carafe, resembles a whisky flask or even a marked container of poison. Again we must seek a covert, personal meaning that these things could have had for Cézanne.[51]

The seated, fawn-coloured dog is different from those in Cézanne's other pictures – from the comical *petit chien* in *A Modern Olympia* (see fig. 18), the lunging black animal in *La Lutte d'amour* (see figs. 20, 28), and the one lying at the centre of the Barnes and London *Bathers*.[52] Cézanne himself explained the presence of the barking black dog in *The Apotheosis of Delacroix* as a *symbole de l'envie*,[53] but such an association seems at odds with his pleasant recollections '*d'être nous trois et le chien, là où à peine quelques années auparavant nous étions.*'[54] The dog in *Le Déjeuner* has no visual connection with the friends' 'Black', but it may stand for faithfulness, sitting obediently and observing cautiously. It bars the artist's path of exit, at the same time pointing its nose at the pale young man seated opposite.

Let us review our observations of this strange mélange of performers and attempt to propose the main scenario in which they act. The apples are both the subject, centrally placed, and the object awaiting action. Cézanne is the protagonist. The standing woman-temptress questions her own partaking, or proffering, of a piece of fruit. Cézanne's sister watches him, stiffling a sound of warning or surprise. The artist, who gestures toward his alter ego as if seeking guidance, receives only a patient smile (*Tu me souris sans partager ma joie, tu me plain sans me consoler!*), no admonition or amelioration for his difficult decision. Another figure, detached and calmly smoking, observes the scene from a distance.

But it is evident that the protagonist has made his own decision, as the secondary scene testifies. He has succumbed to the young woman's enticement, they have gathered their belongings and leave centre stage. Like the biblical Adam, Cézanne yields to temptation, and with his Eve leaves the lighted garden for the darkness of the unknown wood.

Because the organisation of figures in Cézanne's picnic reflects so closely its prototypes – Giorgione's *Concert champêtre* and Manet's *Le Déjeuner sur l'herbe* – we might presume that its symbolic intention is the same. Recent interpretations of the Venetian work indicate its representation of an allegorical choice between vice and the natural life of passion (depicted by the woman at the musician's left), and virtue and the control of reason (depicted by Temperance at his right).[55] A similar analogy follows in George Mauner's study of Manet's painting. By tracing the source of both the seated nymph and the bathing figure to images by Raphael, we see that they represent respectively the profane and sacred attributes of water. When the gesturing man directs the observer's attention to these two figures, he invites a moral choice between the flesh and the spirit, the passionate and the temperate.[56] In the progression of the three works, it becomes apparent that the human dilemma of choosing between evil and good exists on comparable levels of symbolic content.

Following the pattern of his own *Temptation of St Anthony*, many images converge in the 'picnic' to represent for the artist an intimate, secularised, and veiled analogy to the Garden of Eden. When taking into account the concurrent date of the two pictures, about 1869–70, the likelihood of their being a pendant for one another seems very strong. I must point out again their coincidence with the beginning of Cézanne's liaison with Hortense Fiquet. Although in the picnic the blonde woman bears no particular resemblance to Cézanne's mistress (and future wife), this is not the case in the scene of Saint Anthony's temptation, as we have observed it.[57] Could the blonde woman in *Le Dejeuner* symbolise Cézanne's momentous decision to take Hortense into his life as a sexual partner? He reinforces the difficulty of his choice by including his

'double' and his sister, a reminder of familial negative sentiment and judgement.[58] Where Cézanne first put his fantasies into his own poetry, they are now gathered and placed on canvas, becoming even more vivid reminders of guilt and indecision, or acting as a catharsis for them.

The philosophical examination of self, of the question '*tort ou raison*', seemed pervasive, even fashionable, in the mid-nineteenth century. Numerous novels told of the 'good country girl' *vs* the 'bad city girl' who were in conflict in a young man's life. The Judgement of Paris was the theme of many operas. A similar theme is explicit in Wagner's *Tannhäuser*, so beloved by Cézanne.[59] It was in this work, according to Baudelaire, that the hero must choose between Satan and God, 'a duality immediately indicated by the overture with incomparable skill'.[60]

Mauner believes that Manet's *Déjeuner sur l'herbe* was enigmatic for both his contemporaries and the public, and for this reason it is striking that Cézanne should emulate the older painter's subject as well as his composition. But for all of their similarities, there is one distinct difference: the singular gesture, the pointing hand. If Manet's Parisian dandy distinguishes the upward-downward and sacred-profane dichotomy,[61] Cézanne's own hand points toward the other part of himself, thereby stressing the personal aspect of his choice. We might reason that if Manet's painting presents an abstract, philosophical choice, Cézanne's intent and his images may not have been cultivated in the same intellectual vein. They were expressed rather as a natural part of his innermost sensibilities, as the feeling between painter and subject. By arranging a 'game of life' in *Le Déjeuner*, where the ubiquitous apple is a metaphor for choice or chance, by standing lover against sister and self against inner-self (vice against virtue, as it were, in each case), Cézanne actually sets forth in this picture of *c.*1869–70 his lifetime conflict. More than twenty years later, the same opposition or duality may be evoked in the monumental *Card Players* whose serious purpose likewise seems concealed by the apparently casual subject matter.[62]

In tracing the chronology of Cézanne's early paintings, two narrative threads emerge: the repeated self-portrait of the artist (or a motif or literary allusion to him) and an evolution of relationships between the sexes, but more explicitly, as the works develop, between Cézanne and 'woman'. The scenes move from those of violence to the point of bodily injury (*The Strangled Woman, The Murder* (cat.34)), to fear of eroticism (*The Temptation of St Anthony*), to suppressed feeling in the guise of meditation, and eventually submission to woman (*Le Déjeuner sur l'herbe*). In the last group of figure paintings before he begins the series of bather pictures (*c.* 1872 until his death in 1906), Cézanne removes himself from the primary narrative, maintaining his presence in the picture but acting as an

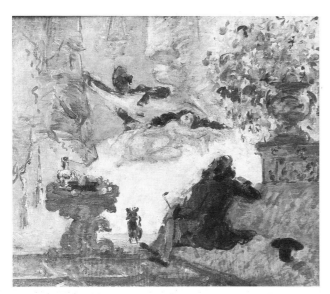

Fig. 18 *A Modern Olympia*, 1873–5 (V.225). Musée d'Orsay, Paris.

observer rather than a participant. The visible dread of the temptation scene is overcome or suppressed, and the self-contemplation of the 'picnic' is transferred to a nude woman on whom he looks with apparent detachment. She becomes an object seen intellectually and, seemingly, without lust. In her nudity, the woman might be a time-less or universal symbol. But at this point in his artistic development, Cézanne never fails to leave clues to the origins of her suggestive posture, allowing no doubt that an inner turmoil still haunts the outwardly detached artist.

Possibly the most familiar scenes of 'woman observed' are found in the two versions of *A Modern Olympia* (cat. 40 and fig. 18), the later one being shown at the first Impressionist exhibition in 1874.[63] Much has been said about this picture's relationship to Manet's *Olympia*, a work which greatly affected Cézanne when it was hung in the Salon of 1865. Their differences, I believe, are more impressive than their affinities. Cézanne's heroine-courtesan appears drowsy, melancholy and introverted, a sharp contrast to the tense, impertinent Olympia. Her patron, in this case the artist himself, is introduced rather than intimated as in Manet's picture. This visitor serves a double function. Because of his position in the pictorial scheme, he detains us, as viewers, from establishing a rapport with the woman, and yet because of his presence, affirms that we, with him a part of the outside world, can enter the habitat of the courtesan.

Manet's Olympia, the woman, astonished and shocked her audiences for many reasons, but most profoundly for the realism of her contemporaneity and nudity. If Cézanne had been creating a 'modern' parody of this prototype, he has led us into a more 'modern' painting by denying scale, perspective and objectivity. It is not his *thematic* interpretation that was new, but his artistic translation of

it. In this environment, the painting moves away from the 'real' toward the abstract. Several aspects of *A Modern Olympia* are remarkably similar to *Le Déjeuner sur l'herbe*. Cézanne's posture and his contemporary dress are the same; his black hat is in the same relative place behind him; he is confronting a tempting woman. The object-subject is centred and emphasised on white fabric. But the artist seems to take his Olympia beyond the everyday world into an imaginary, dream-like environment seen through his own eyes.

This dreamy unreality reminds us of the artist Frenhofer in Balzac's *Chef-d'oeuvre inconnu* who, at sea in creative agitation, searches for the unearthly, spiritual model for his imaginary work of art.[64] Emile Bernard's well-known anecdote tells of Cézanne's identification with Balzac's legendary artist:

'One night, when I spoke to him about the *Chef-d'œuvre inconnu* and of Frenhofer . . . he rose from the table, stood in front of me, and, hitting his head with his index finger, likened himself, without a word but with this repeated gesture, to the person in the story. He was so overwhelmed that tears filled his eyes.'[65]

If Cézanne was so moved to enter the role of Frenhofer, it may not be mere coincidence that *A Modern Olympia* is replete with the details of Frenhofer's own painting:

'One sees a woman lying under curtains, on a couch of velvet. Near her a three-footed stool of gold exudes perfume. You are tempted to pull the tassels on the cords which draw back the draperies, and it seems that you can see the breast of Catherine Lescault, a beautiful courtesan called Le Belle Noiseuse, move as she breathes.'[66]

Whereas the only recognisable part of Frenhofer's beautiful Catherine that escaped his progressive destruction was a nude foot that emerged from a chaos of colours and obliterating brush strokes, Cézanne leaves us the allegorical figure of a woman revealed, with the artist still searching for her true identity. The perfect woman existed in Frenhofer's mind, but he never found his spiritual ideal in his painting. In the end, the mad artist proclaimed that his painting was life itself. Does Cézanne ponder two such questions here: the real, his ability to paint, and the ideal, his ability to fathom the '*éternel féminin*'?

The formidable emasculating woman, portrayed in the early works of both Cézanne and Zola (and undoubtedly expressing their similar feelings toward her) may have been the catalyst that destroyed the men's long friendship. An artist's seemingly hopeless struggles with his career in painting, and his all-consuming attempts to represent his ideal woman on canvas, is the *dénouement* in Zola's novel, *L'Œuvre*.[67] In this story, the artist's passionate bouts with both woman and art – actually represented as one and the same – were fatal.

Of course, Cézanne never succumbed to the central

Fig. 19 *L'Eternel féminin, c.*1875–7 (V.247). The J. Paul Getty Museum, Malibu.

character's ultimate solution to his dual frustration – suicide. Instead, as his works progress, he side-steps further confrontation with 'woman,' becoming more objective, apparently immersing his feelings in more subtle story-telling, fewer autobiographical references. When the *Bather* compositions begin, some concurrent with *A Modern Olympia* and *L'Eternel féminin* (fig.19), and work their way to the monumental conclusions thirty years later, his femme fatal becomes an artistic form, one used to build a composition. But the inheritance is from the early works, from the temptress and the *éternel féminin*. The essence of her ungainly, unattractive form is repeated continuously in groups of *Baigneuses*.

When Cézanne chose structural blocks for the ultimate figural work, *The Great Bathers,*[68] the forms came from pieces of sculpture or from other paintings, thereby acquiring proportions of grace and nobility which were never found in the imaginary women. We may sense that the subjective and personal content of the first works, found mirrored in the literature with which he was so familiar, become almost completely subsumed in the last paintings. With his revolutionary manipulation of colour, volume and space, what Cézanne had experienced internally found its translation into painterly form.

NOTES

This paper was originally presented in the lecture series 'Paris: Center of Artistic Enlightenment', at the Pennsylvania State University in April 1986. It will be published in a longer version, in the collection of essays, *Papers in Art History from the Pennsylvania State University*, volume iv.

1. Edmund Duranty, 'Le Peintre Louis Martin', in *Pays des Arts*, Paris, 1881, pp.313–50 (published posthumously).
2. Excerpts from this story are found in Rewald, 1986, p. 140. Unless otherwise noted, the accounts of Cézanne's life are drawn from Professor Rewald's book as well as from the original publication of his thesis; Rewald, 1936. See also Mack, 1935, p. 133.
3. Paul Gauguin, *Letters de Gauguin, à sa femme et ses amis*, annot. Maurice Malingue (Paris, 1946) pp. 45–6; letter to Emile Schuffenecker, 14 January 1885.
4. Mack, 1935, p. 240.
5. See particularly Cézanne, *Correspondance*, 1978, p.130; letter to Heinrich Morstatt, 24 May 1868.
6. Rewald, 1986, pp. 56–7. The portrait of Valabrègue is V. 127, *c*. 1870. All of Cézanne's works cited here are identified by numbers (i.e. V. 127, RWC. 36, Ch. 1156) given in one of three publications: Lionello Venturi; John Rewald, 1983; and Adrien Chappuis, 1973.
7. Quoted in Vollard, 1914, p. 35.
8. Zola's recollection of their friendship is in *L'Œuvre*, 1927–1929, XV, p. 34.
9. Ibid., XLV, pp. 74–5.
10. Rewald, 1986, pp. 21–8.
11. Zola, *Correspondance*, 1978, vol. 1, p. 141; letter of 25 March 1860:

 'J'ai fait un rêve, l'autre jour. J'avais écrit un beau livre, un livre sublime que tu avais illustré de belles, de sublimes gravures. Nos deux noms en lettres d'or brillaient, unis sur le premier feuillet, et, dans cette fraternité du génie, passaient inséperables à postérité.'

12. It was not until 1880 that Zola again mentioned Cézanne in his critical writings; 1966, XII, p. 1018.
13. Ibid., p. 785:

 'Heureux ceux qui ont des souvenirs! Je te vois dans ma vie comme ce pâle jeune homme dont parle Musset. Tu es toute ma jeunesse; je te retrouve mêlé à chacune de mes joies, à chacune de mes souffrances. Nos esprits, dans leur fraternité, se sont développés côte à côte. Aujourd'hui, au jour du début, nous avons foi en nous, parce que nous avons pénétré nos coeurs et nos chairs.'

14. The quotation is from Zola's manuscripts for *La Fortune des Rougon*, cited by Rewald, 1936, p. 72, n.3.
15. The *ébauches* for *La Conquête de Plassans* seem to reveal very clearly that Cézanne's mother and father were the models for the Mouret parents; Zola, 1927–1929, V, pp. 372, 381.
16. A relationship plainly like that of Cézanne and Zola is told in *Madeleine Férat* (1927–1929, XXXIV, pp. 72–3) by Guillaume. '... de longues journées ensemble! Nous courions les champs, la main dans la main. Je me souviens d'un matin où nous pêchions des écrevisses sous les saules; il me disait: "Guillaume, il n'y a qu'une bonne chose ici-bas, l'amitié. Aimons-nous bien, cela nous consolera plus tard."' Compare, for example, with Cézanne, *Correspondance*, 1978, pp. 19, 31.
17. Zola, 1927–1929, XXXIV (*Thérèse Raquin*).
18. Zola, 1927–1929, XXXIV, pp. 85–6:

 '... en face de lui, sur une dalle, Camille le regardait, étendu sur le dos, la tête levée, les yeux entr'ouverts. ... Il resta immobile, pendant cinq grandes minutes, perdu dans une contemplation inconsciente, gravant malgré lui au fond de sa mémoire toutes les lignes horribles, toutes les couleurs sales du tableau qu'il avait sous les yeux.'

19. Of chief concern here is the link between *Thérèse Raquin* and *L'Œuvre*, as Laurent is the prototype for the artist, Claude Lantier, whom Zola considered 'plus près de Cézanne', Zola, 1927–1929, XV, p. 410. See John C. Lapp, *Zola before the Rougon Macquart* (Toronto, 1964), p. 101, for further insight into this relationship, and particularly into the similarities of males and females in Cézanne's portraits, a 'weakness' which also occurs in Laurent's paintings.
20. Rewald, 1936, pp. 1, 69, associated their actual artistic output only when he stated, about *Thérèse Raquin*, 'Cette lecture évoquera plutôt ces tableaux de Cézanne où des scènes étranges et érotiques sont rendues avec emphase.'
21. Consult Reff, 1962.

22. Charles Baudelaire, *Œuvres complètes*, ed. Claude Pichois (rev. ed., Paris, 1960), p. 657.

23. Gustave Flaubert, 'La Tentation de Saint Antoine' (1856), *L'Artiste* (1856–7).

24. Idem, *La Tentation de Saint Antoine* (1874), (Paris, Edition Garnier-Flammarion, 1967). See V. 240, 241, *c.* 1875.

25. Reff, 1962, pp. 117–19; and idem, 1966, pp. 40–1, discusses the relationship of all four nudes to earlier depictions of the Judgment of Paris. See also Lewis, q.v., Adriani, q.v.

26. Regarding the symbols of androgeny in philosophy and alchemy, consult Marie Delcourt, *Hermaphrodite, Myths and Rites of the Bisexual Figure* trans. J. Nicholson (London, 1961), pp. 67–84.

27. Reff, 1962, p. 117, n. 40. The painting is V. 19.

28. F.W.J. Hemmings, *The Life and Times of Emile Zola* (London, 1977), p. 108, and fig. 42.

29. Idem, pp. 87–8. Zola was thus portrayed in the Goncourts' notations of 14 December 1868; Edmond and Jules de Goncourt, *Journal*, vol. VIII (Paris, 1956), pp. 154–6. See also Lapp, 1964, for his discussion, especially pp. 138–46, of Zola's 'autobiographical' characters in his early novels – their ambivalent sexuality, their relationship to women.

30. Meyer Schapiro, 1968, p. 36, and n. 10. Lapp, 1964, pp. 139–41, refers to Zola's projection, into his novel *La Curée*, of his own early familiarity with sexual inversion. As an addendum to Schapiro's notion that Zola joined his name with his friend's in *L'Œuvre*, i.e. Sandoz, I would point out what may be a similar 'merger' on Cézanne's part. This occurs in *La Lecture chez Zola* (cat. 43, V. 118, *c.*1867–9) which supposedly portrays the writer Paul Alexis and Zola. It seems very clear to me that the man who faces us, although called Zola, may also be Cézanne. Although he obviously has Zola's nose, he is bearded, long haired, and has a high forehead which suggests the artist's premature balding. Fascinating to note as well is that the position of his hands, holding a book, so closely resembles *Les Joueurs de cartes*, particularly the preparatory sketch of a single figure (V. 568) who is frontally posed. Compare the similar composition (cat. 47, V. 117), where the rendering of Zola's head is completely different.

31. Lapp, 1964, p. 141, when speaking of letters Zola had received pertaining to the ambivalence of his characters, assesses the novelist's reaction: 'One reason why Zola may have been disturbed by the revelations in these letters is that they brought home to him the personal factor in his literary creations, revealing the close connection between the traditional "Byzantium" and the actual homosexual in a hostile world, a connection of which he may have been only subconsciously aware.'

32. See n. 13 above. In *Madeleine Férat*, 1927–1929, XXXIV, pp. 113–14, Zola repeats an exactly similar phrase in an overtly sexual connotation.

'La jeune femme l'avait absorbé; elle le portait en elle maintenant. Ainsi qu'il arrive dans toute union, l'être fort avait pris fatalement possession de l'être faible, et desormais Guillaume appartenait a celle qui le dominait. Il lui appartenait d'une facon étrange et profonde. Il en recevait une influence continuelle, ayant ses tristesses et ses joies, la suivant dans chaque changement de sa nature. Lui, disparaissait, il ne s'imposait jamais. Il aurait voulu se révolter qu'il se serait trouvé comme emporté dans la volonté de Madeleine. A l'avenir, sa tranquillité dépendait de cette femme, dont l'existence devait forcement devenir la sienne. Si elle gardait sa paix, il vivrait paisiblement de son côté; si elle s'affolait, il se sentirait fou comme elle. C'était une pénétration complète de chair et de coeur.'

Consult also n. 30 above and Rewald, 1936, p. 163. Badt, pp. 108–9, proposes that Cézanne's compositions in *Mardi Gras* (V. 552) and *Les Joueurs de cartes* (V. 559, 560) metaphorically fuse two figures into one person.

33. Rewald, 1986, pp. 78, 164.

34. I think particularly of V. 527 and also of V. 569. See Rewald, 1986, p. 136 concerning the painting of a young woman (Hortense?) whose figure becomes part of the compositions of the *Bathers*.

35. Zola, 1927–29, XV, p. 50:

'. . . c'était sa passion de chaste pour la chair de la femme, un amour fou des nudités desirées et jamais possédées, une impuissance à se satisfaire, à créer de cette chair autant qu'il rêvait d'en éteindre, dans ses deux bras éperdus. Ces filles qu'il chassait de son atelier, il les adorait dans ses tableaux, il les caressait et les violentait, désespéré jusqu'aux lames de ne pouvoir les faire assez belles, assez vivantes.'

Concerning the identity of Zola's Claude Lantier, see Robert J. Niess, *Zola, Cézanne and Monet* (Ann Arbor, 1968), especially chapters IV and V.

36. Rewald, 1983, no. 65, *c.* 1878.

37. Hélène Adhémar, *Embarkation for Cythera* (London, 1947).

38. Joel Isaacson, *Monet: Le Déjeuner sur l'herbe* (New York, 1972), pls. 2–5, 33. Rewald, 1973, p. 177; and Ibid., p. 595, documents Cézanne's visit in 1865 to the studio Bazille shared with Monet.

39. Expressed by Badt, 1965, p. 256.

40. Cézanne, *Correspondance*, 1978, pp. 27, 29. Letters are of 29 . . . 1858 and 9 July 1858. The charade was in a letter of 29 December 1859. Ibid., p. 61.

41. Ibid., pp. 21–2, Fig. 3; letter of 3 May 1858.

42. Suggested by Schapiro, 1952, p. 34.

43. Zola, 1927–29, XXXIV, pp. 217–18:

'. . . elle s'habillait comme une fille, avec sa robe a longue trâine: elle se dandinait sur le trottoir d'une façon provocante, regardant les hommes . . . la jeune femme marchait lentement, la tête un peu renversée, les cheveux dans le dos.'

44. V. 90, 1866–7; the likeness of the woman to Marie is also observed by Rewald, 1986, p. 63. About the identity of the figures and the date of this version of *Overture to Tannhäuser*, see Mack, 1935, p. 22, and Alfred Barr, Jr. and M. Scolari, 'Cézanne in the Letters of Marion to Morstatt, 1865–1868', *Magazine of Art* (May 1938), pp. 289–91. It is thought that Marie had considerable dominance over the artist. She was a spinster and, like her mother, was known for her nearly fanatical piety.

45. Zola, 1966, XII, p. 785. In Zola's youth, his admiration for de Musset was exceeded only by the influence the poet had on him. Observe his frequent references to, and adaptations of, de Musset's work in his *Correspondance*, passim. The feeling of 'les plus chers souvenirs de ma jeunesse' permeates Zola's commemorative essay on the poet (Idem, pp. 327–51). In 'Les Cimetières – La Tombe de Musset', one of *Les Nouveaux Contes à Ninon*, Zola weighed the strange power on his generation that came from de Musset:

'Il est peu de jeunes hommes qui, après l'avoir lu, n'ait gardé au coeur une douceur éternelle. Et pourtant Musset ne nous a appris ni à vivre ni à mourir; il est tombé à chaque pas; il n'a pu, dans son agonie, que se relever sur les genoux, pour pleurer comme un enfant. N'importe, nous l'aimions; nous l'aimions d'amour, ainsi qu'une maitresse qui nous feconderait le coeur en le meurtrissant. C'est qu'il a jeté le cri de désespérance du siècle; c'est qu'il a été le plus jeune et le plus saignant de nous.'[84]

According to Reff ('Cézanne's "Dream of Hannibal"', *Art Bulletin*, XLV (1963), pp. 148–52), some of Cézanne's own verses reveal the moods of de Musset's 'Rolla' and 'Les Contes d'Espagne et d'Italie'. He finds thematic, even personal, links with 'Le Songe d'Annibal', written in 1858. The progression of Cézanne's images – from fantasy, to verse, to painting – when in a period of ten years 'Le Songe' moved toward *The Orgy*, have been noted. There are good reasons to believe, then, that *Le Déjeuner*, nearly

contemporary with both *The Orgy* and Zola's 'Les Cimetières' (published in 1868), also bears the mark of the romantic poet. To Lois Boe Hyslop I owe thanks for many conversations about Zola and Baudelaire. It was also she who knew of the Doppelgänger in de Musset's poetry.

46. Petrone, pp.235–9. The author suggests that the character may be Manet or Degas; but the personality of Séguin, as Duranty describes it, would seem to rule this out. On the other hand, since Manet was a member of the Guerbois circle, it seems likely that he, as Duranty, was fascinated by the notion of the homo-duplex, a concept that he dealt with in his own art. See Mauner, 1975, particularly pp. 15–18.

47. Rewald, 1986, p. 142 and n. 12, refers to Duranty's frequent play on names.

48. See the friends' letters: Zola, *Correspondance*, 1978, vol. 1, p. 126, letter of 5 January 1860; Ibid., p. 142, letter of 25 March 1860. Cézanne would compliment his friend on his gift of cigars: 'Par ma foi, mon vieux, tes cigares sont excellents, j'en fume un en t'écrivant; . . . grâce à ton cigare voilà mon esprit qui se raffermit, . . .' *Correspondance,* 1978, p. 49.

49. *Pastoral* (cat. 52) and *The Robbers and the Ass* (cat. 41), V. 108.

50. Badt, 1965, p. 113.

51. Cézanne, in his early letters and notably in his poem 'Le Songe d'Annibal', often alludes to drinking in excess. In Flaubert's *Salammbô* (well-known to the artist), the broken chain is associated with lost virginity.

52. V. 380, 1875–7; V. 720, 721, 1895–1906.

53. V. 245. The quotation is from Emile Bernard, *Souvenirs sur Paul Cézanne* (Paris, 1925), p. 55.

54. Cézanne, *Correspondance*, 1978, p. 131. Letter to Numa Coste, *c.* beginning of July 1868. The three were Cézanne, Baille and Zola. Cézanne does call the dog 'Black'. Ibid., p. 109; letter to Coste, 5 January 1863.

55. Schapiro, 1968, p. 38. See also Eugenio Battisti, article in press.

56. Mauner, 1975, pp. 74–5, develops this argument.

57. I think particularly of V. 527, and also V. 569. See Rewald, 1986, p. 136, concerning the painting of a young woman (Hortense?) whose figure becomes part of the compositions of *Baigneuses*.

58. Theodore Reff, 'Cézanne: the severed head and the skull', *Arts Magazine,* LVII (1983), pp. 84–100, elaborates on Cézanne guilts and fears that are so closely associated with his family. A little

known picture, V. 87, painted about 1864–6 and remaining in the Jas de Bouffan until 1936, shows a double image of a man and woman, he closely resembling Cézanne with dark hair and bushy beard, she with light skin and shown in profile. Entitled *Contrasts* (cat. 42), we would wonder if they could be Paul and Marie Cézanne.

59. Barr, *Magazine of Art* (May, 1938) (cited in note 44 above) pp. 288–91. This popular theme was discussed by George Mauner in his lecture, 'Manet and the Playing Card Principle', given at The National Gallery of Art, 4 March 1983.

60. Baudelaire, *Œuvres complètes*, p. 1223.

61. See Mauner, 1975, Fig. 7.

62. Schapiro, 1952, p. 88, notes that the two players in the later versions are opposite types – left dark, right light; hat down, hat up; face in shadow, face in light. Could both of these represent Cézanne, alluding again to the homo-duplex?

63. V. 225, 1872–3; cat. 40, V. 106 is a similar composition, usually dated *c.* 1870.

64. See Dore Ashton, *A Fable of Modern Art* (London, 1980), pp. 30–47, concerning Cézanne's association with Frenhofer.

65. Bernard, 1921, p. 44:

'Un soir que je lui parlais du *Chef-d'oeuvre inconnu* et de Frenhofer, . . . il se leva de table, se dressa devant moi, et, frappant sa poitrine avec son index, il s'accusa sans un mot, mais par ce geste multiplié, le personnage même du roman. Il en était si ému que des larmes emplissaient ses yeux.'

66. Honoré de Balzac, *Œuvres complètes*, XIV (Paris, 1845), facsimile ed. 1967), pp. 301–2:

'Qui le verrait, croirait apercevoir une femme couchée sur un lit de velours, sous des courtines. Près d'elle un trepied d'or exhale des parfums. Tu serais tenté de prendre le gland des cordons qui retiennent les rideaux, et il te semblerait voir le sein de Catherine Lescault, une belle courtisane appelée la Belle-Noiseuse, rendre le mouvement de sa respiration.'

67. Zola, 1927–29, XV, pp. 380, 391. Concerning Zola's projecting himself into this conflict of passion and art, see Niess, 1968, Chapter VII, especially pp. 159–69. Rewald, 1986, pp. 171–84, discusses the break with Zola.

68. V. 719, 1900–06.

Literature, Music and Cézanne's early subjects

MARY TOMPKINS LEWIS

Several of Cézanne's early subject pictures betray an unrestrained Romanticism that seems inexplicable when placed within the context of his total œuvre. This is notable in the case of four fantasy paintings dating from *c*.1870: *The Feast (The Orgy)* (cat. 39), the *Temptation of St Anthony* (cat. 50), a small *Bathers* (fig. 20), and the *Pastoral (Idyll)* (cat. 52). In each, Cézanne's provocative figures, distortions of space, imaginative palettes and visionary settings suggest an emphasis upon subject matter that is unique to his early art. When seen as a group, an understanding of their elusive content reveals the deep significance he placed upon literary themes in particular. Moreover, the specific subjects of his fantasy paintings show not only the breadth of Cézanne's sources, but his repeated attempts to capture in his early art the most *au courant* themes of his day. Far more than private fantasies, Cézanne's four canvases of *c*.1870 attest to his ability to transform contemporary literary subjects into Romantic vehicles of his own. Coming as they do at the end of his first decade of painting, they are characteristic of both an artistic era and a working method the artist would soon leave behind.

Framed by columns on the left and a vaporous canopy above, Cézanne's raucous scene of revellers at a banquet table in the *Orgy* places him squarely within the Parisian art world of his time. Along with so many of his contemporaries, Cézanne here took a traditional theme and reworked it in modern terms. Updated from Renaissance bacchanals, Baroque love feasts and Rococo *soupers*, the popular orgy theme was being revived on a grand scale in nineteenth-century France.[1] Even without the pretext of classical mythology or a moralising genre, the theme demanded the presence of sensual nudes, elaborate still lifes of food and drink, and as often as not, exotic or historical settings. It thus held an obvious appeal for Salon painters and popular artists who catered to a pleasure-seeking public.

Descriptions of orgies, with strong undertones of escapism and a libertine atmosphere of excess, figured frequently in nineteenth-century literature as well. So familiar, in fact, was the terrain among writers, that Gautier had one of the protagonists in a tale from his satire, *Les Jeunes France* (1833), proclaim solemnly: 'There is nothing so up to date as an orgy. Every new novel that comes out has an orgy; let us likewise have ours.'[2] Orgies were appearing in the theatre as well. The success of Offenbach's *Orphée aux Enfers* (1858), with its bacchanalic finale, extended the subject to the popular Paris stage where it would evolve in countless forms.[3] Thus, the orgy theme, so boldly transformed in Cézanne's painting, had long since captured the imagination of his generation.

In his own work, Cézanne would conjure up the popular theme of orgies in several variations. It is reflected in the scenes of debauchery in some of his early erotic verses.[4] It would appear to be suggested, as well, by such

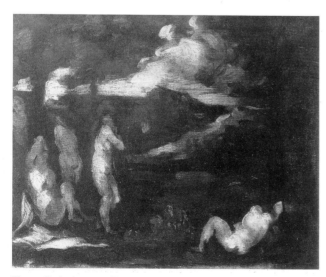

Fig. 20 *Bathers*, *c*.1870 (Non-V.). Private collection.

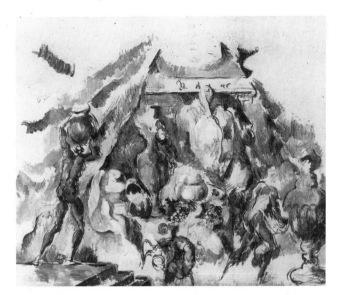

Fig. 21 *Preparation for a Banquet, c.*1890, 45.7 × 55.3 cm (18 × 22¾ in) (V.586). Acquavella Galleries, Inc., New York.

Fig. 23 Two sketches; *Women, c.*1883–6 (Ch.639). Private Collection.

Fig. 22 Thomas Couture, *Romans of the Decadence,* 1847. Musée d'Orsay, Paris.

Fig. 24 Veronese, *Wedding Feast at Cana.* Musée du Louvre, Paris.

intimate compositions as his *c.*1866 watercolour *The Rum Punch* (cat. 67) and by the series of paintings and drawings entitled *Afternoon in Naples* from *c.*1870–5 (see cat. 27). The theme is even strangely recalled in a later fantasy, Cézanne's *Preparation for a Banquet* of *c.*1890⁵ (fig. 21), in so many ways reminiscent of the earlier *Orgy.* Cézanne's fascination with the orgy subject thus extends far beyond his Romantic first decade.

Certainly the grandest restatement of the orgy theme in the nineteenth century, and a major reason for its currency in Cézanne's time, was Couture's *Romans of the Decadence* (1847; Musée d'Orsay, Paris) (fig. 22). A massive scene of Roman debauchery in a shallow Corinthian vestibule, Couture's erotically suggestive painting received more public attention when it was unveiled at the Salon of 1847 than any other painting of the decade.⁶ Its eclectic forms, rich palette, and Romantic theme of decadence brought it almost as much notice when it was re-exhibited

at the 1855 World's Fair. Later, Cézanne was one of countless admirers to copy a figure from the canvas (fig. 23); he also kept a photograph of it in his studio.⁷ Thus, Couture's monumental *Romans* not only gave the subject of the orgy additional prominence but provided a standard of opulence against which all later artists would judge their treatment of the theme.

For his composition, Couture had turned to a vast array of pictorial sources, but perhaps most notably to Veronese's *Wedding Feast at Cana* in the Louvre (fig. 24).⁸ While Couture achieved a mood quite different from that of Veronese, he borrowed from the Venetian's work the architectural setting of columns, the distant blue sky, and most of all, the shallow horizontalism of the table that, in his own painting, was replaced by the low couch on which the Romans reclined. Although most orgy scenes up to this time had been presented in a similar horizontal fashion – perhaps the very nature of the subject encouraged it –

Fig. 25 Eugène Delacroix, *Heliodoros driven from the Temple*, 1862. St-Sulpice, Paris.

Couture's version made it the prevailing standard. Moreover, the shallow, stage-like quality of his *Romans*, as well as its dramatically posed and outward-looking figures, suggests the influence on Couture of nineteenth-century theatrical productions, in which the subject of orgies was becoming standard fare.[9] This horizontal, stage-like setting is an important point of departure for discussing Cézanne's *Orgy*. Although Cézanne would revive much of the imagery that had become the rule in such scenes – the drunken revellers, wanton women, the exquisite still lifes and the table – his curiously deep perspective is quite foreign to the subject's standard depiction.

Scholars have long searched for possible visual sources for Cézanne's unique perspective in the *Orgy* and also for its brilliant colour. Sara Lichtenstein has suggested that Cézanne based both composition and colouring on Delacroix's fresco at St Sulpice, *Heliodorus driven from the Temple* (fig. 25), of which the artist owned an etching.[10] The *Orgy* does date from a period when Cézanne was immersed in the study of Delacroix. A comparison of the painting and fresco reveals some pictorial elements in

common – most notably the diagonals of the central shadows in the Delacroix which are echoed in Cézanne's table. There are also the columns of colossal scale and lustrous, flowing draperies in each. Yet on its own the Delacroix mural does not explain the unique composition and elusive imagery of Cézanne's painting.

Like Couture, Cézanne had also looked to Veronese's *Wedding Feast at Cana*. Cézanne deeply admired the Venetian work, which Gautier had called a 'most radiant' masterpiece, and which Delacroix, Fantin-Latour and others would copy endlessly.[11] Cézanne himself had copied details from the painting in the 1860s, and as late as the 1890s still spoke reverently of its composition and colour.[12] An unusually complete study for the *Orgy*, dated *c*.1867 and only discovered by John Rewald in 1978 (cat. 65), establishes Cézanne's debt to the Venetian painting; yet, as his final version of the *Orgy* took shape, that relationship subtly changed. Rewald has noted that the study exhibits a number of elements that do not figure in the later painting, or else appear quite differently on canvas.[13] For example, in the background of the study, vertical columns and amphora bearers create an architectural screen that functions like the horizontal balustrade in the *Wedding Feast*; this background screen is totally absent from Cézanne's subsequent version in oil. By contrast, the sombre tones of the study, executed in pastel and gouache, are replaced with a much brighter palette in the later painting. Its coloration is now closer to the *Wedding Feast*. What cannot be explained, however, by Veronese's work or any other pictorial source are Cézanne's fantastic imagery and dream-like space. Only an understanding of the *Orgy*'s subject matter can account for its unprecedented pictorial form.

Cézanne's *Orgy* has also been called *The Feast*, and was originally exhibited in 1895 under the title *Le Festin*.[14] Little wonder, then, that its specific subject matter has remained problematic. Certainly, as Theodore Reff has pointed out, the wild and erotic feeling of the *Orgy* makes it consistent with Cézanne's other romantic statements both in paint and in poetry.[15] And Reff is correct to look in literature as well as in painting for the source of Cézanne's fantastic scene. The numerous precedents in nineteenth-century writing for Cézanne's subject provided a strong literary context for his image; the work of de Musset, Hugo, Gautier and, more locally, the Provençal poet, Frederic Mistral, who describes a 'Sardanapalen feast' in his epic of 1866, the *Calendau*, were perhaps the most accessible to Cézanne.[16] Yet Reff's contention that Cézanne is illustrating one of his own youthful poems, the *Songe d'Annibal*, is not convincing in light of a much closer literary source, a scene from Flaubert's *Temptation of St Anthony*. An elaborate description of the exotic orgy at the Banquet of Nebuchadnezzar, in which the hermit St Anthony is tempted by visions of luxury and wealth, could hardly have failed to attract the romantic young

Cézanne. Flaubert's passage, in fact, explains in detail Cézanne's transformation of the orgy motif:

'Ranked columns half lost in the shadows, so great is their height, stand beside tables which stretch to the horizon – where in a luminous vapour appear super-imposed flights of steps. . . . Fellow diners crowned with violets rest their elbows on very low couches. Wine is dispensed from tilting amphorae. . . . Running slaves carry dishes. Women come around with drinks. . . . So fearful is the uproar that it might be a storm, and a cloud floats above the feast, what with all the meats and steamy breath.'[17]

Cézanne's painting quite clearly denotes the Flaubert passage. In the upper-left portion of the canvas, two towering columns disappear, as Flaubert described, into a shadowed mist. The distorted perspective of the composition is heightened by the dramatically foreshortened table, which stretches into a central and distant space. Above the lavish banquet hovers the luminous vapour, an element so critical to Flaubert's scene that when it was adapted for a shadow play at a Parisian cabaret, great effort was expended, as Reff notes, to recreate this particular effect.[18] Above the vapour, Cézanne superimposes a small flight of steps, a literal detail from Flaubert and, without benefit of the literary source, the most inexplicable element in the painting. The tilting amphorae, running slaves, and women bearing drinks have all been included by the artist. Even 'a cloud floats about the feast', as described by Flaubert.

In his efforts to visualise his subject, Flaubert had been inspired by the descriptions in the *Book of Daniel* of the epic towers and palaces of Babylon, built during Nebuchadnezzar's reign in the sixth and seventh centuries BC.[19] Both Flaubert and Cézanne could have been aware of the account in *Daniel* of another exotic feast, that of Belshazzar. The latter was a popular subject among Baroque artists, had been revived by Romantic painters, and may have had some influence on Cézanne's overall scheme.[20] However, the exactitude with which Cézanne rendered the Flaubert passage, with such additional details as the broken and scattered crockery on the banquet table, which refer to a subsequent line from the text ('The king eats from sacred vessels, then breaks them'), clearly establishes Cézanne's primary debt to his literary contemporary.

Also like Flaubert, Cézanne seems to have deliberately emphasised the theme of temptation in his *Orgy* scene. In Flaubert's story, so enticing was the vision of Nebuchadnezzar's copious wealth that the envious saint took on the persona of the King, only to become 'instantly sick' and seized with a craving to 'wallow in filth'. Finally, in Flaubert's version, the saint warded off the temptation with a brutal, self-inflicted lashing. Cézanne augments the theme of temptation in his painting of the *Orgy* by manifesting Nebuchadnezzar's riches with frequent touches of gold and by adding a sinister, undulating serpent in the lower right corner. The serpent serves as a telling footnote and ominous mirror to the curves of the tempting female forms above.

After numerous emendations, the third and definitive version of Flaubert's *Temptation of St Anthony* was published in 1874. As such, it helped create Cézanne's painting of the *Temptation* of c.1874–5, now in the collection of the Musée d'Orsay (fig. 26), a watercolour of St Anthony

Fig. 26 *The Temptation of St Anthony, c.1873–7* (V.241).
Musée d'Orsay, Paris.

of c.1877 and numerous related studies.[21] But three major fragments from Flaubert's second version of *St Anthony*, a longer and more emotional text, had appeared serially in the popular journal *L'Artiste* between 1856 and 1857.[22] These excerpts described the monk's temptation by the Queen of Sheba, the visit of the heretic, Appolonious, and, most notably, the extravagant feast of Nebuchadnezzar. Giula Ballas has recently documented that during the first two decades of his career, Cézanne frequently turned to the engraved reproductions of paintings published in *L'Artiste* as sources of his art.[23] Ballas notes that it is highly likely that all of Cézanne's borrowings came from back issues of the journal, dating from 1838 to 1858. His painting of the *Orgy* is proof that Cézanne found inspiration not just in the engraved reproductions, but in the literary extracts which the journal published during these years as well.[24]

The *Orgy*'s abundance of tempting allurements makes it a rich companion piece to Cézanne's more austere but equally fantastic painting of c.1870, the *Temptation of St Anthony* (cat. 50). While less indebted, as Reff believes, to Flaubert's serialised text, Cézanne's *Temptation* also transforms an iconographic image that had long captured the Romantic imagination.[25] With the revival of religious art in the mid-nineteenth century and the continuing Romantic interest in sensual and exotic themes, the enduring story of the Egyptian hermit had again become fashionable. In the second half of the century, there was even new academic interest in the life of the fifth-century saint, and many artists besides Cézanne, such as Fantin-Latour and Isabey, took up the subject again.[26] Yet in many Romantic versions, and in Cézanne's in particular, the saint's temptations are more sexual than physically torturous. Nude temptresses replace the monsters who tormented the saint in earlier representations. Cézanne even painted additional nudes who confront the cowering monk and fill his gloomy landscape with their truly frightening forms. By comparison with his Flaubert-inspired *Orgy*, Cézanne's c.1870 *Temptation of St Anthony* gives more explicit and freer form to the artist's Romantic longings.

Flaubert's involvement in his own temptation imagery was no less acute. Even from reading the published fragments, Baudelaire concluded that Flaubert's *Temptation of St Anthony* 'unveiled the author's secret chamber'.[27] Flaubert himself saw the capacity for self-revelation, writing in a letter, 'In *St Anthony*, I was myself the saint'.[28] Likewise, Cézanne would see himself in the fantastic imagery of c.1870 and emphasise above all the theme of sensual temptation.

———

Closely related to Cézanne's *Orgy* and *Temptation of St Anthony* are two other paintings of c.1870 of an equally fantastic nature, a small *Bathers* (see fig. 20) and the *Idyll* (cat. 52). With its sombre palette, impassioned style and strangely specific landscape, this *Bathers* painting (unknown to Venturi) demands a thematic as well as a formal reading. Similarly, the problematic subject of Cézanne's gloomy *Idyll*, which has long confounded scholars, merits further thematic attention.[29]

The visionary imagery of these two works again suggests a literary source. The emphasis in both paintings upon voluptuous nudes in dark, restless settings lends them an aura of troubled Romantic sensuality so like Cézanne's *Orgy* and *Temptation of St Anthony*. It was, in fact, the story of another medieval hero, reborn in the Romantic era, who inspired Cézanne's problematic *Bathers* and *Idyll*. This legendary hero, who struggles between the conflicting realms of the senses and of the spirit, was *Tannhäuser* as he was portrayed by Wagner at the Paris Opéra in 1861.

The production of *Tannhäuser* at the Opéra in the spring of 1861 set off a controversy in Parisian circles that needs only brief summary here.[30] In an attempt to court Austria's favour and to woo liberal support at home, Napoleon III had issued an order to the Imperial Opéra in 1860 to perform the radical work. Many of Wagner's supporters were outraged by an alliance they regarded as a betrayal. The conservative upper classes and opera-goers, in particular members of the élite Jockey Club, were equally incensed, though hardly for political reasons. When they learned of the composer's plans to present a long, arduous production without the traditional 'grand ballet for the second act', they indignantly demanded one.[31] Wagner finally relented, after nearly a year of pressure, but only by agreeing to expand the existing ballet in the first act's realm of Venus which he felt had been rather flat in an earlier production in Dresden.[32] His concession, unfortunately, pleased no one. After the first three performances had been disrupted by members of the Jockey Club, some even blowing dog whistles at the stage, Wagner withdrew his score. A storm arose on all sides; aided by Baudelaire's eloquent defence of Wagner, *Tannhäuser* quickly achieved the mythic status it has retained in operatic circles.[33]

Baudelaire had called for 'well-bred, open-minded *littérateurs*, artists, and even *gens du monde*' to encourage Wagner 'to persist in his destiny'.[34] Prominent among those answering the call were the painters of the Café Guerbois group who would come to be known as the Impressionists. Renoir, who would later paint a pair of overdoor panels inspired by Wagner, recalled going with Bazille to hear Wagner's music at the *Concerts Populaires* in the 1860s.[35] An accomplished pianist as well as a painter, Bazille liked to play Wagner with his friend and fellow musician, Edmond Maître.[36] Manet's wife, who was also a pianist, played Wagner's music for her husband and their guests at home, and even for Baudelaire shortly before his death in 1867.[37] And Cézanne, who with Zola would join the Wagner society in Marseille, mentions in a

Fig. 27 H. Fantin-Latour, *Tannhäuser: Venusberg*, 1864. Los Angeles
County Museum of Art, donation of Mr and Mrs Charles Boyer.

letter of 1865 'the noble tones' of Wagner's music he had enjoyed in a concert.[38] At the same time, he was working on one of several versions of his Realist paintings of a young woman at a piano, which would become a tribute to the composer's controversial opera by virtue of its title, *Overture to Tannhäuser* (cat. 44). Thus, the Wagnerist movement in Paris, which would grow in strength until the outbreak of the Franco-Prussian war, became a true bond for the group of young painters later called the Impressionists, Cézanne among them. Looking back at the 1860s in *L'Œuvre*, Zola would aptly describe Wagner's music of that decade as having sounded the 'sublime hallelujah of the new century'.[39]

Perhaps the most ardent *Wagnériste* among the Café Guerbois painters was Fantin-Latour, whose tickets for the cancelled fourth performance of the Paris *Tannhäuser* went unused. Fantin-Latour has drawn lasting attention to the opera's Romantic theme in three major works which are taken from the first act: a lithograph of 1862, a large oil painting which was shown at the Salon of 1864 (fig. 27), and a transfer lithograph of 1876. Set in the Venusberg, the opera's first act featured the elaborate bacchic ballet Wagner sketched especially for the Parisian production. With lovers both embracing and fleeing in the foreground, 'satyrs and fauns appearing from the cliffs' and forcing themselves upon the revellers, and through-out, 'a general frenzy' that 'gives way to maenadic fury', Wagner had envisioned an allegory in dance of rampant sexuality.[40] After the bacchanal, Tannhäuser awakens from

a reverie at Venus's side, and suddenly longs to leave her sensual realm for that of harsh reality. In his three depic-tions, Fantin-Latour treats the dilemma of the suffering Tannhäuser and contrasts his dark melancholy with the idyllic pleasures of his surroundings.

Douglas Druick has noted how meaningful the Tannhäuser struggle was for Fantin-Latour. He had dreamt of being a great artist but saw himself caught, like Wagner's hero, 'in the agitations and follies of this era . . . in the struggle between life and art'.[41] The sensual side of this dramatic context, or, in Baudelaire's words, Tann-häuser's 'psychic duality', had been intensified in the revised Parisian opera with the enlargement of the danced bacchanal. Like Flaubert's *St Anthony*, Tannhäuser be-came, in Wagner's hands, a typically Romantic hero. Torn by inner conflicts and tortured by pangs of love, he remained medieval enough to be burdened by feelings of guilt and to desire pain as well as pleasure.[42] The theme would hold an obvious and familiar appeal for Cézanne as well.

Fantin-Latour's Venusberg scenes had depended for authenticity upon descriptions of the opera's elaborate staging in Paris.[43] A small gouache attributed to Delacroix of Act I, Scene 2, follows the scenography even more closely and confirms the accessibility of written, if not also illustrated descriptions.[44] These were available in the widely read prose translations of the composer's operas, *Quatre poèmes d'opéras*, and in the French libretto, both published in 1861.[45] In addition, fragmentary accounts of

eye-witnesses and enthusiasts kept Wagner's extravagant vision before the public eye. Despite minor disagreements among translations and some last-minute emendations by the composer, a basic pictorial scheme of *Tannhäuser* can be derived that holds true even for later productions.

For his realm of Venus, Wagner had envisioned a dark subterranean grotto, representing the interior of the Venusberg. A wide, shadowy cavern at the front edge of the Opéra stage looked back onto a deep landscape with a blue lake and dramatic waterfall in the distance. The entire scene was 'framed by irregular rocky peaks' and the foreground lit by a 'bewitching roseate light from below'.[46] As the curtain rose, and thus before the ballet began, Venus was seen reclining in the foreground with the three graces at her feet.[47] The Wagnerian staging must have been known to Cézanne, as it is closely recalled in the imagery of his elusive *Bathers*.

Although Cézanne may not have known the gouache attributed to Delacroix, he would have seen Fantin-Latour's *Tannhäuser: Venusberg* at the Salon of 1864 and doubtless been attracted to it. Yet his *Bathers* suggests a familiarity on his part with the published descriptions as well. The mysteriously black setting of his *Bathers*, so alien to even his earliest depictions of the *Bathers* theme, and here so ill-attuned to his sensuous figures, is, in fact, the underground grotto where Venus dwells.[48] Strong black verticals on the left side of his landscape denote the stalactite formations that figure in the Delacroix gouache and became standard to *Tannhäuser* stage sets.[49] The dim area of blue in the centre of Cézanne's painting is the lake, while shimmering strokes of blue, which plunge on a sharp diagonal in the background, set forth the necessary waterfall. A mountainous horizon and rocky terrain complete the Wagnerian landscape. In the foreground, the goddess reclines as Wagner pictured her, with the three graces at her feet. Vibrant pink tones, which help to model the thickly painted nudes, allude to the first act's 'bewitching roseate light'. Even the composition of the *Bathers*, with its figures carefully stretched across a shallow foreground plane, suggests a frieze-like, staged tableau.

The mood and imagery of Cézanne's small *Bathers* is closely related to his other fantasy paintings of c.1870. It shares with his *Temptation of St Anthony*, especially, its dark Romantic mood, as well as a number of expressive forms. The standing nude at the centre of his *St Anthony* closely recalls a figure in a similar position in the *Bathers*. The nude with upraised arm, who aggressively confronts the frightened monk, has turned in the *Bathers* to face the viewer. Most striking, however, is the figure set at the far left edge of the *Bathers*. Like the terrified St Anthony, this mysterious figure peers out onto a scene of voluptuous temptation. As much as Cézanne's swirling, impassioned strokes, this figure embodies the unrestrained Romanticism the artist reveals in so many of his early fantasy images.

Finally, Cézanne's painting, *Idyll*, of c.1870 was in-spired, at least in part, by Wagner's staging and story of Tannhäuser. More so than the small *Bathers*, however, Cézanne seems to have intended in the *Idyll* much more than a gloomy Wagnerian vision. Coming at the end of his Romantic first decade, the *Idyll* presents a poignant image of both the artist and the fantasies and fears of his youth in a Romantic genre Cézanne would soon abandon.

As Fantin-Latour had done in all three of his *Tannhäuser* depictions, Cézanne omits the dark grotto in his *Idyll* in favour of a more traditional open landscape. The troubled hero Tannhäuser, in whom Cézanne saw himself, lies in melancholic repose as both Wagner and Fantin-Latour pictured him, just after the uproarious bacchanal. The sensual reclining Venus is in the foreground. Between these two figures passes the 'struggle between the flesh and the spirit' which forms the dramatic core of the opera.[50] At the left, two nudes flaunt their charms with pictorially familiar gestures: the pose of the standing nude recalls one of Fantin's dancing graces of 1864, while the seated nude with upraised arm is found in the same position in Cézanne's related *Bathers*.

More closely than had Fantin-Latour, Cézanne responded in his *Idyll* to Wagner's elaborate vision for the *Tannhäuser* stage. The tumultuous atmosphere of the realm of Venus is captured in the *Idyll*'s turbulent skies and restless landscape, while the carnal pleasures of the goddess's realm explain what Schapiro has described as the 'eroticised thrust of the trees and clouds' and 'the suggestive coupling of a bottle and glass' in the foreground.[51] Although Cézanne would add two male figures in contemporary clothes, who have been identified as his childhood friends Baille and Zola, his *Idyll* is saved from becoming a Manet-like *Déjeuner sur l'herbe* by its dark mood and strikingly imaginative palette.[52] Despite the gloom created by its dark setting and troubled hero, the *Idyll* is warmed by the intense blues of the requisite lake and, above all, by the sensual pink tones of the nudes and skies. This could only be the 'bewitching roseate light' which the libretto prescribes; as Tannhäuser confronts Venus in the second scene, this becomes an 'even denser rosy mist' that 'veils the whole background'.[53] So essential was this warmly coloured atmosphere to Wagner's vision that for the elaborate Parisian production he ordered rose-toned curtains of gauze to be lowered over the entire stage as the dialogue between Tannhäuser and Venus begins.[54] In his painting, Cézanne confronts his own sensual fantasies in the same heated environment.

Cézanne's *Idyll* goes beyond a simple reading of the *Tannhäuser* text to become a poignant self-portrait of the artist's youth that was inspired by Wagner's Romantic vision. Like Flaubert, Cézanne transformed a literary image into a uniquely personal vehicle and himself became the tormented hero. Emile Bernard, Cézanne's disciple, may have recognised the Wagnerian imagery of the *Idyll* when he saw it in the collection of Dr Gachet in Auvers years

later. Bernard would likewise give a melancholic *Tannhäuser* his own features in a fantasy of Wagner's opera that echoes Cézanne's *Idyll*.[55] And when, in a letter of 1904, the aged Cézanne warned Bernard about 'the literary spirit which so often causes the painter to deviate from his true path – the concrete study of nature', he must have seen in the younger artist's work the same propensity for Romantic excess that characterised his own early efforts.[56]

A closer reading of the *Idyll*, and of Cézanne's other three fantasy paintings of *c*.1870, reveals much more than the artist's youthful longings. At the same time that Flaubert and Wagner gave form to the private passions of his youth, they also provided Cézanne with avant-garde subjects for compositions in which he could rival the painting of the old masters. Like them, Cézanne transformed earlier themes by giving them a new Romantic context. But he stubbornly clung to a traditional notion of the role of subject matter in his early art. Thus, the sensual nudes, imaginary landscapes, rich palettes and narrative gestures in his four pictures of *c*.1870 link them more closely to the traditional pastoral than to the paintings of his contemporaries, and tell us more about the artist than do all of his self-tormented images of sensuality. The raw intensity of his fantasy paintings, which lurks so powerfully beneath their elusive forms, reveals above all the passionate determination of Cézanne to become part of a tradition he would soon after transform.

NOTES

I delivered a short version of this essay as a paper at the annual College Art Association Conference in Philadelphia, February 1983. A slightly revised version of this essay comprises one chapter in my forthcoming book, *Cézanne's Early Imagery*.

1. For the fullest discussion of the theme's revival, see A. Boime, *Thomas Couture and the Eclectic Vision* (New Haven, 1980), pp.143–52; 165–8.
2. Théophile Gautier, 'Bowl of Punch', *The Works of Théophile Gautier*, trs. and ed. F.C. de Sumichrast (New York, 1902), vol. 22, p. 326.
3. Gustave Doré, who designed the costumes for Offenbach's *Orphée aux Enfers*, later recorded the final orgy on canvas. See Alexander Faris, *Jacques Offenbach* (London and Boston, 1980), p. 65, fig. 6 for an engraving after Doré's painting. For a discussion of the operetta's orgy and its popular success, see pp. 63–72.
4. For example, Cézanne's *Songe d'Annibal*, published in Cézanne, *Correspondance*, 1976, p. 351–3. For the best discussion of Cézanne's *The Rum Punch* and related works, see Rewald, 1983, pp. 90–1.
5. V. 586.
6. Boime, p. 131.
7. See Wayne Andersen, 'A Cézanne Drawing after Couture', *Master Drawings*, I, no. 4 (Winter, 1963), pp. 44–6.
8. On Couture's numerous pictorial sources for his *Romans*, see Boime, pp. 152–60.
9. Boime, p. 139.
10. Sara Lichtenstein, 'Cézanne and Delacroix', *Art Bulletin* (March, 1964), pp. 57–8.
11. Théophile Gautier, 'Les *Noces de Cana* de Paul Veronese', 1852, *Souvenirs de théâtre, d'art et de critique* (Paris 1883), pp. 205–14. On Delacroix's lost copies after details in Veronese's painting, see Lee

Johnson, *The Paintings of Eugène Delacroix* (Oxford, 1981), vol. 1, p. 180. For Fantin-Latour's copies, see Douglas Druick and Michel Hoog, *Fantin-Latour* (Ottawa, National Gallery of Canada, 1983), pp. 164–6.
12. Gasquet, 1926, pp. 163, 166ff.
13. Rewald, 1983, no. 23, pp. 87–8. Rewald also notes that two pieces of paper, at the bottom centre and a strip along the top, were pasted on to the original sheet to afford revisions. This would also suggest the artist gradually altered his scheme to depict a specific setting.
14. Vollard, 1914, pp. 31, 58.
15. Theodore Reff, 'Cézanne's *Dream of Hannibal*', first published in *Art Bulletin*, XLV (1963), pp. 148–52; revised for *Cézanne in Perspective*, ed. Judith Wechsler (Englewood Cliffs, 1975), pp. 148–59.
16. See, for example, de Musset's *Rolla* (1833) or *La Nuit de décembre* (1843), Hugo's 'Noces et festins' from *Les Chants du crépuscule* (1835), cited by Boime, p. 166, or Gautier's *Les Jeunes-France* (1838), discussed above. On the orgy in Mistral's *Calendau*, see R. Lyle, *Mistral* (New Haven, 1953), p. 26.
17. Gustave Flaubert, *The Temptation of St Anthony*, trans. Kitty Mrosovsky (Ithaca, 1981), pp. 81–2.
18. On the shadow plays produced by Henri Rivière at the Chat Noir, see William Ritter, 'Henri Rivière', *Die graphischen Künste*, XXII (1899), pp. 112–16; cited by Theodore Reff, 'Cézanne, Flaubert, St Anthony and the Queen of Sheba', *Art Bulletin* XLIV (1962), n. 97.
19. Mrosovsky, 'Notes to the Translation', Flaubert, *Temptation*, pp. 248–52.
20. For example, John Martin's *Feast of Belshazzar*, illus. in William Feaver, *The Art of John Martin* (London, 1975), pl. III. See also A. Pigler, *Barockthemen* (Budapest, 1956), I, pp. 213–16.
21. For the fullest discussion of Flaubert's role in Cézanne's later *Temptation of St Anthony* paintings, see Reff, 'Cézanne, Flaubert', p. 119ff.
22. Through his friend, Théophile Gautier. The entire second version was published in 1908 by Louis Bertrand under the title *La Première Tentation de Sainte Antoine*. On the three versions, see Mrosovsky, introduction to Flaubert, *Temptation*, pp. 12–18.
23. Giula Ballas, 'Paul Cézanne et la Revue *l'Artiste*', *Gazette des Beaux-Arts*, Ser. 6, vol. 98 (December, 1981), pp. 223–32.
24. p. 224.
25. See Jean Seznec, 'The *Temptation of Saint Anthony* in Art', *Magazine of Art*, XL (1947), pp. 86–93.
26. Mrosovsky, p. 5. On Fantin-Latour's interest in the theme, which began in the 1860s and continued throughout his life, see Druick, p. 353. For Isabey's painting at the Salon of 1869, see sale catalogue, Hôtel Drouot, Paris, 21 May 1909, no. 26, ills.; cited in Reff, *Cézanne, Flaubert*, n. 104.
27. *Œuvres complètes*, ed. Y.G. Le Dantec and Claude Pichois (Gallimand, 1961), p. 657.
28. *Correspondance*, vol. II, p. 462, letter to Louise Colet, 6 July, 1852.
29. See especially Sylvie Gache-Patin, 'Douze œuvres de Cézanne de l'ancienne collection Pellerin', *La Revue du Louvre et des Musées de France*, no. 2 (1984), pp. 130–3.
30. For the best study of Wagner's *Tannhäuser* in Paris, see Carolyn Abbate, *The Parisian Tannhäuser* (Ph.D. dissertation, Princeton University, 1984). For a broader study of Wagner's reception in France, see Gerald Turbow, 'Art and Politics: Wagnerism in France', *Wagnerism in European Culture and Politics*, eds David Large and William Weber (Ithaca and London, 1984), pp. 134–66.
31. Abbate, pp. 269–70. The ballet was desired in the second act to ensure that it would be performed only after everyone had arrived at the Opéra. The custom had evolved in deference to Jockey Club members, who, after a leisurely dinner, expected to be entertained with dance upon their arrival. For Wagner's account, see his letter

to Liszt, 29 March 1860 in *Briefwechsel zwischen Wagner und Liszt*, ed. Erich Kloss (Leipzig, 1910), vol. 2, p. 279.

32. See Wagner's letter to Mathilde Wesendonck, Paris, 10 April 1860, published in Herbert Barth, *et al.*, *Wagner, A Documentary Study* (New York, 1975), pp. 193–4.

33. Charles Baudelaire, 'Richard Wagner et *Tannhäuser* à Paris', in *Œuvres complètes de Charles Baudelaire*, 15 vols., Jacques Crepet, ed. (Paris 1923–48), vol. 2: *L'art romantique* (1925); first published May, 1861.

34. pp. 251–2.

35. Barbara E. White, *Renoir* (New York, 1984), pp. 94–6; Jean Renoir, *Renoir: My Father*, trans. Rudolph and Dorothy Weaver (London, 1962), pp. 169–70.

36. See François Daultre, *Frederic Bazille et son temps* (Geneva, 1952), pp. 47, 78, 94–5; John Rewald, *The History of Impressionism* (New York, 1976), p. 116.

37. Manet's painting, *Mme Manet at the Piano* of 1867–8, is in the collection of the Musée d'Orsay. On her admiration of Wagner's music, see Françoise Cachin and Charles Moffett, *Manet* (New York, 1983), pp. 286–7.

38. On the Wagner society in Marseille, see O.G. Bauer, *Richard Wagner, The Stage Designs and Productions from the Premières to the Present* (New York, 1982), p. 147. *Correspondance*, 23 December, 1865; cited by Rewald, *History of Impressionism*, p. 116. On Cézanne's appreciation of Wagner, see Alfred H. Barr, Jr., 'Cézanne: In the Letters of Marion to Morstatt, 1865–1868: Chapter III, Cézanne and Wagner', trans. Margaret Scolari, *Magazine of Art*, 31 (1938), pp. 288–91.

39. *L'Œuvre* (Paris, 1928), p. 218.

40. Quoted in Bauer, *Wagner, The Stage Designs*, p. 79–80.

41. *Fantin-Latour*, p. 152.

42. Wagner's opera made the legend very popular and it became the subject of countless lyric poems, verse epics, short stories, novels and drama. On Tannhäuser's transformation by Wagner into a popular nineteenth-century hero, see S.W. Thomas, *Tannhäuser: Poet and Legend* (Chapel Hill, 1974), p. 83 ff.

43. *Fantin-Latour*, pp. 152–3.

44. Herbert Barth *et al.*, *Wagner, A Documentary Study*, fig. 128. The gouache, which is signed 'Eug. Delacroix', is in the collection of W. Coninx, Zürich.

45. *Fantin-Latour*, pp. 152–3.

46. R. Wagner, *Tannhäuser and the Minstrels*, trs. Mrs John P. Morgan (Berlin, 1891), pp. 5–6. See also Antonio Livio, Richard Wagner, *L'Œuvre Lyrique* (Paris, 1983), pp. 268–9, and for a discussion of the first act, pp. 263–5. The *Tannhäuser's* frenetic bacchanale, which is choreographed on the banks of a lake, provides a fascinating analogy to Cézanne's later scenes of riotous love in his *La Lutte d'Amour* paintings of *c*.1880.

47. In some versions, Tannhäuser is asleep at the side or knees of Venus throughout the first scene of the bacchanal; in others, he arrives only after the more raucous sections of the ballet, which this setting precedes. See Abbate, pp. 280, 291.

48. The subject of *Bathers* had held only a minor place in his œuvre up to this date, but Cézanne's dark palette here separates this painting from such works as V. 113 (cat. 38).

49. See, for example, Michael Echter's illustration of the bacchanal setting from the Munich production of 1867 (Bauer, p. 68), which also had pink and blue lighting.

50. Baudelaire, *The Painter of Modern Life*, ed. J. Mayne (London, 1970), p. 126; cited in Druick, p. 152. The pose of Cézanne's central figure, who bears his own likeness, may have also been inspired by Delacroix's meditative hero in his *Death of Sardanapalus* (Salon of 1827). The Assyrian king is likewise surrounded by voluptuous nudes and confronted with his own gloomy fate.

51. Meyer Schapiro, 'The Apples of Cézanne: An Essay on the Meaning of Still Life', *Modern Art, 19th and 20th Centuries* (New York, 1978), p. 8, first published in *Art News Annual*, XXXIV (1968), pp. 34–53.

52. So identified by Guy Cogeval, *From Courbet to Cézanne, A New 19th Century* (Paris, 1986), p. 45.

53. Wagner, *Tannhäuser*, p. 6.

54. Noted in 13th episode of Wagner's plan for the Opéra scenario. See Abbate, *The Parisian Tannhäuser*, p. 291.

55. For Bernard's painting (1906), see Jean-Jacques Luthi, *Emile Bernard, catalogue raisonné* (Paris, 1982), p. 104 and fig. 700; coll. Mme L. Horowitz, Paris.

56. *Correspondance*, to Emile Bernard, 26 May, 1904; p. 303.

'La lutte d'amour'

Notes on Cézanne's early figure scenes

GÖTZ ADRIANI

When the twenty-one-year-old Paul Cézanne arrived in Paris in the spring of 1861, he felt that he had achieved everything he desired. His father's autocratic domination seemed to have been broken and the way was clear for the realisation of all the strokes of genius that he had planned for years with Emile Zola, the closest friend from his childhood and youth in Aix-en-Provence. In the conviction that 'there will never be any dreams or any philosophy comparable with ours',[1] the two young heroes resolved to put the world, that is to say Paris, in its place. Yet neither the emancipation from paternal authority,[2] nor the hoped for career as a celebrated artist was to be fulfilled. Father's domination proved too strong and the hopes invested in the metropolis too unrealistic. Both these factors, however, stimulated the development of an artistic consciousness and a body of works that won recognition against all expectations, and against the mechanisms that would normally have brought success.

No detailed account has survived of how the inexperienced provincial from Provence responded to the fashionable exhibitions of Parisian life.[3] There are, however, paintings which reveal the assertive, profoundly existential reaction of a young man in revolt against the dictatorial taste of this gilded age, who was searching for a provocative response to the glib illusionism that then prevailed in painting.

Cézanne's early figure scenes, whose originality and fascinating powers of suggestion have been unjustifiably overshadowed by the later work, bear witness to a personality that was described by a friend in 1858 as 'poetic, fantastic, jovial, erotic, antique, physical, geometrical'; as Zola commented in 1861: 'To prove something to Cézanne would be like trying to persuade the towers of Notre-Dame to dance a quadrille. . . . He is made of one single piece, obstinate and hard in the hand; nothing can bend him, nothing can wring a concession from him. . . . So he

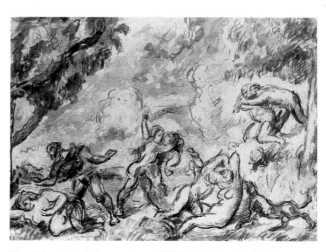

Fig. 28 *La Lutte d'Amour*, 1875–6 (RWC.60). Private Collection.

Fig. 29 Page from an unpublished sketchbook (*recto*), *Scene from the Tannhäuser Saga*, 1858–9, 12.3 × 20.9 cm. Kunsthalle, Hamburg.

Fig. 30 Page from an unpublished sketchbook (*verso*), *Scene of Rape, Study of a Hand*, 1866–8, 12.3 × 30.9 cm. Kunsthalle, Hamburg.

has been thrown into life with definite ideas, unwilling to change them except when following his own judgement.'[4]

In contrast to Cézanne's later practice, the first figure compositions often depict thrilling, climactic action, with reckless clashes of form and colour. They can be subsumed under the following, admittedly rather schematic theme: the antipodal relationship of man and woman, and the diverse forms of their confrontation. This theme, which can be sharpened into a *Lutte d'amour* (fig. 28), has archetypal qualities. It can portray the coquette as an all-dominating female power, courted by male society (fig. 29); the penitent Mary Magdalen (cat. 33); or the temptress, the incarnation of evil, avenging herself for past humiliations (fig. 30). The theme extends from apparently insignificant dialogues in the open air (cat. 26), via orgiastic festivities (cat. 39) to scenes of abduction (cat. 31), rape and murder (cat. 34). Between these poles moves the thematic material, some of which occupied Cézanne into the 1870s, in which sexuality and death appear directly related.

Such projections reflect with absolute clarity the personality, the sensibility and the compulsive entangle-

ments of a man, entirely isolated as an artist, who was never to escape from the control of his family, and even as an old man in his native Aix-en-Provence suffered under the bigotted benevolence of his sister.[5] In Cézanne's early work it is particularly clear that the choice and transformation of the subject was related directly to his personality and its attendant problems. For in the alienation of the sexes is revealed nothing less than Cézanne's own lack of human relationships. His tumultuous compositions derived their authenticity from an expressive volition born of torment and repression. They reveal very strikingly the profusion of emotions that provoked their creation. At this point the artist had not yet acquired the patience necessary for the careful study of nature; he also used portraits, still lifes and landscapes as vehicles for the dramatic struggle for self-expression.

Two main reasons can be given for this most private iconography and its vehement implementation. First, it offered the young painter an expressive plane appropriate to a repressed emotional life, which had been thrust into the subconscious by paternal authoritarianism and provincial conventions. Even the schoolboy letters and poetic outpourings of the young Cézanne treat themes that would today be categorised as sublimation. In them, the mood of the author swings constantly between apathetic dejection and youthful exuberance, between facetious sarcasm and an existential fear and despair, 'suffused with melancholy sadness'. Perplexity over the opposite sex is a recurring theme in the ironic and macabre dream visions addressed to Zola. The nineteen-year-old Cézanne feared that his 'smitten sighs' might 'betray themselves outwardly', and hoped that the 'inner sadness' and a 'certain ennui' might be redressed through drink. 'Vaporous elegies' swirled around the yearned-for loved one, who sometimes appeared within grasp, only to turn into a vision of deathly coldness, into 'a pale, angular corpse with rattling bones and empty eyes'.[6] Decades later, in the preparatory notes to the novel *L'Œuvre*, Zola wrote of Cézanne: 'He mistrusted women. . . . He never brought women to his room; he always treated them like a youth who ignored them in an agony of shyness, hidden under brutal boastfulness. . . . "I don't need women", he said, "it would be too much of a nuisance. I don't even know what their use is; I've always been afraid to find out".' Underlined in the margin beside this comment are the words 'very important'. The novel itself, whose publication in 1886 led to a rupture between the two friends,[7] contains the following remark about sensual desire lurking behind a mask of contempt: 'It was a chaste man's passion for the flesh of women, a mad love of nudity desired and never possessed, an impossibility of satisfying himself, of creating as much of this flesh as he dreamed to hold in his frantic arms. Those girls whom he chased out of his studio he adored in his paintings; he caressed or attacked them, in tears of despair at not being able to

make them sufficiently beautiful, sufficiently alive.'[8] No wonder that the suppressed desires of a personality characterised in these terms should have poured out in pictures portraying both the merciless violation and the sarcastic deification of womanhood.

The second impulse behind these works was Cézanne's search for a provocative answer to the aesthetic irrelevance of the manner of painting that was the dominant force at the time in the Salon in Paris, where he lived more or less constantly after 1861. Established on an annual basis in 1863, the Salon exhibition, housed in the Palais de l'Industrie, represented an incontestible authority, established to pass rigorous judgement on the artistic success or failure of the débutantes. Only those who submitted to the academic demands of the Salon jury could hope to join the circle of successful new arrivals. Cézanne's initial hopes of exhibiting regularly in the Salon were thwarted in 1863, when his still life was consigned to the Salon des Refusés. The following year he was disappointed again, and in March 1865 wrote to Pissarro of his intention to submit pictures that year, in front of which, in his own words, 'the Institute will blush with rage and despair'. In 1861 the newly-arrived Cézanne still found the salon worthwhile: 'I have also seen the Salon. For a young heart, for a child borne for art, who says what he thinks, I believe that is what is really best, because all tastes, all styles meet there and clash there.' Five years later, in 1866, he demanded a jury-free exhibition. This hardening of attitudes reflected the decisive process of self-realisation that had been accomplished over this period. This process reached a culmination in the sentence: 'I wish to appeal to the public and to be exhibited at all costs.'[9] Cézanne's claim to be following in the footsteps of Courbet – who had finally isolated the avant-garde by questioning the absolute authority of the Salon – cannot disguise the fact, however, that right into his old age, and with the same vigour with which he attacked the trite conventions of the Salon, he sought the approval of just those Salon painters who operated successfully within these conventions.[10] For the role of the déclassé, operating on the fringes of society and trusting only in his own authority was not one particularly well suited to an excessively vulnerable provincial like Cézanne. He had neither the robust constitution of Courbet, who even Baudelaire had praised as an murderous iconoclast, nor the temperament of Manet, applauded by Zola for 'shattering the dreadful mediocrities that surround him.'[11]

Cézanne, in fact, would have felt most at home in the beautific womb of the Salon. But as this was denied him, he saw an attack on the officially endorsed cultural dictatorship as the only opportunity of asserting his originality and of generating the publicity that might even persuade his father in distant Aix of the significance of his work. The 'artistic' overpainting of reality by the Salon painter was to be countered by 'artless' expressiveness. Cézanne set about the revaluation of current aesthetic and moral standards with great vigour, intentionally rejecting the received notions of painterly deftness and formal perfection. Disfiguring dissonances were left untouched; diversities in form and colour were openly displayed. The self-confident artistic expectations of the bourgeoisie, gratified by prettiness and technical finesse, were questioned by the accord that Cézanne achieved between object and execution, between offensive content, improper form and suggestive coloration. Breaking free from the academic tradition, he pursued a personal vision, recklessly employing his own methods and techniques. By coarsening form to the point of disintegration, Cézanne ventured to challenge taboos on subject matter. The genre themes and quasi-religious allegories favoured by the Salon painters were ruthlessly taken apart. A deeply felt discord between his personal volition and an externally imposed sense of what was expected drove Cézanne – who still regarded scandal as a measure of success – to give free rein to his neurosis-laden fantasies as a protest against the hated art world of the *grande bourgeoisie*.

Zola, who had become editor of the Parisian daily paper *L'Evénement* in the spring of 1866, supported his friend in this truly anti-authoritarian position. Their discussions on this theme were soon put onto paper in Zola's stinging review of the Salon, which appeared in seven articles published between 27 April and 20 May 1865. In these pieces Zola savaged the 'little tricks of the hand', 'theatrical effects' and 'perfumed dreams' favoured by the jurors, who, according to their own judgement, had mixed together 'a sort of mush of consensus', and were responsible for the 'long, cold, bloodless halls', in which 'are spread out every sort of timid mediocrity, every sort of stolen celebrity'. His demand for the artist to be the creator of individual values was published on 4 May: 'I want people to be alive, I want them to create something new, free of everything else, following the individual eye and the individual temperament.'[12] Without Cézanne's prompting, Zola would not have supported so uncompromisingly Manet's 'simple, honest talent,' which 'takes hold of nature directly . . . and tries to create directly from nature, without concealing anything of the artist's own character'.[13] As Manet's masterpiece, Zola hailed the *Déjeuner sur l'herbe* of 1863 (fig. 31), described by the Emperor as obscene, and the *Olympia* from the same year (fig. 32). Whereas the *Déjeuner sur l'herbe* was shown in the Salon des Refusés, where it was thoroughly discussed by Cézanne and Zola, the *Olympia* managed, against all expectations, to satisfy the selection criteria of the Salon jury in 1865. Zola overstepped the limits of public tolerance when he attacked the hypocrites who had mocked the two paintings, or professed themselves shocked by the naked *Olympia*. According to Zola, she had simply 'made the grave mistake of looking like many other women' that one knew, and was accompanied by a

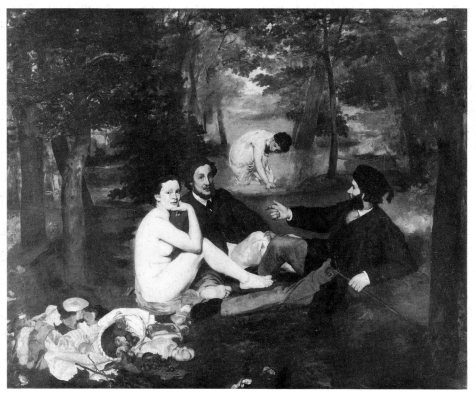

Fig. 31 Edouard Manet, *Déjeuner sur l'herbe,* 1862. Musée d'Orsay, Paris.

black cat, which had provoked frivolous thoughts among 'simple-minded people'.[14] The editor's office was inundated with letters of protest. They reviled Manet as a 'vulgar and grotesque' dauber, and demanded that Zola should be censured for his 'spiritual shamelessness, for his lack of faith and atheism.' The subject of the criticism, whose support for Courbet and Manet carried an implicit attack on imperial taste, drew the consequences and brought the series of articles to a premature close. The final promise, that he would 'always stand on the side of the underdog' was broken over thirty years later when Zola bravely stood up for Captain Dreyfus, but not for his friend Cézanne.

Zola's only comprehensive, if generalised judgement on the work of Cézanne appeared in 1867. In spite of, or perhaps directly because of, Zola's devastating critique of 1866, the unyielding position of the Salon jury remained unchanged in 1867. A certain Arnold Mortier found the ritual of the annual rejection of Cézanne's work worthy of a sarcastic comment in the magazine *L'Europe*, extracts of which were subsequently printed in *Le Figaro*:

'I have heard of two rejected paintings done by Monsieur Sésame [sic] (nothing to do with the *Arabian Nights*), the same man who, in 1863, caused general mirth in the Salon des Refusés – always! – by a canvas depicting two pig's feet in the form of a cross. This time Monsieur

Sésame has sent to the exhibition two compositions that, though less queer, are nevertheless just as worthy of exclusion from the Salon. These compositions are entitled: *The Rum Punch*. One of them depicts a man to whom a very dressed-up woman has just brought a rum punch; the other portrays a nude woman and a man dressed up as a lazzarone: in this one the punch is spilt.'

Zola, who was never able to appreciate the full significance of his friend's work, did, nevertheless, point out the inadequacy of this account. On 12 April 1867 he wrote in *Le Figaro*:

'My dear colleague, be good enough, I beg you, to insert these few lines of correction. They concern one of my childhood friends, a young painter whose strong and individual talent I respect extremely. You reprinted a clipping from *L'Europe* dealing with a Monsieur Sésame who was supposed to have exhibited at the Salon des Refusés in 1863 'two pig's feet in the form of a cross' and who, this year, had another canvas rejected, entitled *The Rum Punch*, I must say that I had some difficulty recognising under the mask stuck to his face one of my former schoolmates Paul Césanne [sic], who has not the slightest pig's foot in his artistic equipment, at least not so far. I make this reservation because I do not see why one should not paint pig's feet just the same as one paints melons and carrots. Monsieur Paul Césanne, in excellent

Fig. 32 Edouard Manet, *Olympia*, 1863. Musée d'Orsay, Paris.

and numerous company, has indeed had two canvases rejected this year: *The Rum Punch* and *Drunkenness*. Monsieur Arnold Mortier has seen fit to be amused by these pictures and to describe them with flights of the imagination that do him great credit. I know all that is just a pleasant joke, which one must not worry about. But I have never been able to understand this particular kind of criticism, which consists of ridiculing and condemning what one has not even seen. I insist at least on saying that Monsieur Arnold Mortier's descriptions are inaccurate.'[15]

The grounds for this public dispute were two paintings, since lost, whose theme reappears in a gouache with the title *The Rum Punch* (cat. 67). This composition, which convinces through the intensity of its colour and the power of its forms, is a surviving example of a series of sketches, watercolours and paintings of the same or similar themes, which played an important part in Cézanne's early work.[16] Even under the title *Afternoon in Naples* (cat. 27), they were all inspired by Manet's *Olympia*, commended by Zola as 'the painter's real flesh and blood', and damned by the critics as a portrait of a courtesan – as an entirely scandalous picture.[17] To take a strong stance in support of the much abused Manet and his provocative work meant taking on public ignorance. Both Cézanne and Zola did this in their own ways, and the gifted writer

soon attracted the desired publicity. Cézanne worked on the assumption that he could only achieve a comparable *succès de scandale* by developing Manet's technical and iconographical innovations even more uncompromisingly, creating examples of even more banal sensuality with which to confront the public. And what better to build on than *Olympia*, that Salon outrage, which upset the public and the press as no painting had done before. It was obviously not too difficult for Cézanne to surpass Manet's scandalous triumverate of nude, servant and cat, and in *The Rum Punch* he achieved this both in his expressive intensity and in the unmistakable directness of the message. The notion of the female nude as an image of ideal beauty, on whose well-attested coquetry the Salon lions had banked for years with their armies of Venuses and Odalisques, was suddenly twisted into a grotesque caricature. *Olympia*'s lack of naturalness and the angular exaggerations of the form support Baudelaire's thesis on the indecency of thin, ungainly female nudes.[18] In addition to exposing a female body that is undressed rather than nude – in a pose reminiscent of contemporary erotic daguerreotypes – the attitude of *Olympia* creates a sense of distance. This is achieved almost in spite of the painting's intentionally vulgar aspects, the inexact proportions and the planar composition, which suggest a mocking comparison with *Images d'Epinal* (broadsheets from Epinal). What Manet had devalued into the profane pose of an

intentionally provincial beauty was completely trivialised by Cézanne through the introduction of a man into the figure group taken over from *Olympia*. Manet's figure was the last branch of a genealogy of female nudes that ran from Titian's celebrated *Venus of Urbino* (*c.*1538; Florence, Uffizi), via Goya's *Naked Maja* (1802/1803; Madrid, Prado) and the odalisques of Ingres and Delacroix, in which the partner of the reclining beauty remains undisclosed. In these cases, the partner is assumed to be the viewer, on whose arrival the reclining beauty is obviously waiting. Suddenly Cézanne introduced a lover into this scene, comfortably settled on the divan that had previously been reserved for the female nude. The tryst of the naked couple, intentionally conceived as an outrage to polite morality, left no doubt over the profession of the hostess or the intentions of the guest – over the relationship between consumer and commodity.[19] Neither the bustling activity of the procuress, a figure that had already appeared as a ministering spirit in Baroque iconography, nor the indiscretion of the viewer disturbs the suggestive repose of the protagonists. An essential inclusion in this glimpse behind the scenes of philistine respectability is the black cat with its tail held erect,[20] an incarnation of the devil and of sexual aggression since time immemorial. The symbol had gained in potency around the mid-nineteenth century, when E.T.A. Hoffmann's *Lebensansichten des Katers Murr* and Edgar Allan Poe's *The Black Cat* were essential reading for Parisian aesthetes. Champfleury's cultural history of the cat, with illustrations by Manet, and Zola's novel *Thérèse Raquin* (1867) further served to reinforce the demonic image of the cat as the embodiment of both evil and sensuality; and Charles Baudelaire, who was much admired by Cézanne, actually identified the cat with the ruinous woman in his poem *Le chat*.

In Manet's *Olympia* Cézanne sought out much deeper layers of meaning than did his friend Zola, who stressed the painterly qualities of the work and even claimed that the painting was conceived quite simply as 'a pretext for analysis'. Anyone, he felt, who looked in *Olympia* for 'a philosophical meaning', or who was inclined 'to discover obscene intentions in it' would be disappointed.[21] In the case of Cézanne's *Rum Punch*, Zola also warned the viewer against looking for 'philosophical ideas', since his friend belonged to that group of 'analytical painters' who 'are satisfied with the great realities of nature.'[22] Such a one-sided approach is especially surprising from Zola, since he knew these painters well, and could hardly have been unaware of the deeper significance of their work. He had also employed similarly risqué themes himself in his early novels and short stories. An example is his very first publication, *La Confession de Claude* (1865). This is an account of a relationship set up by an aged procuress, involving the hero, Claude, and a prostitute named Bertha. Bertha was an alias for Laurence, a girl who Zola had sheltered during the winter of 1860–1 in seedy lodgings

in the former Rue Soufflot. This happy arrangement was shortlived, however, and Zola wrote to Cézanne in Aix in early February 1861 that he had just been through the hard lessons of true love, with all its 'painful and sweet sensation', adding that with this experience behind him, he now knew how to guide his friend wisely in Paris.[23] This autobiographical novel, whose supposed immorality attracted the attention of the State Prosecutor, is dedicated to Cézanne and Baille, the friends of Zola's youth, in the following words:

'Brothers, can you remember the days when life was a dream for me? We were friends, we dreamed of love and fame. . . . But Provence is no more, my fears and joy, my dreams and hopes. What has taken its place? Paris, the dirt, the room, Laurence, the shame of my tenderness for this woman. . . . I live in ecstasy, screaming with pain, stammering with rapture, in heaven and in the sewer, more devastated after each new advance, more radiant after each new reverse.'[24]

Zola's second novel, *Thérèse Raquin*, was completed in December 1867 and is concerned with the murder of a husband by an adulterous couple. It provoked the wrath of Louis Ulbach, who described the book in *Le Figaro* as 'a pool of blood and dirt'. Among the painters, Cézanne alone took up the garish themes of this shady, dubious milieu – the world of brothels, rapes, abduction and murder. Perhaps Zola had Cézanne's work in mind when he referred in *Thérèse Raquin* to an artist whose studies:

'were painted with real energy, thick and solid in appearance, each part standing out in magnificent strokes. . . . Of course they had a strangeness and character so powerful that they proclaimed a highly developed artistic sense. It might be called painting that had been lived.'[25]

Years before Manet's infamous *Nana* (1877; Kunsthalle, Hamburg) and the related innovations of Degas, Cézanne had unashamedly introduced in the various versions of *The Rum Punch* the rude directness of the professional prostitute.[26] Abandoning the romantically-tinted, literary tradition of the elegant, bohemian courtesan, Cézanne offered not erotic dreams, but sarcastically distorted sexual fantasies. The lack of any hint of visual prettiness removes any possibility of escape from Cézanne's scenario into the realm of moralising allegory. Any hint of polite compromise was rejected. The pharisees in the temple of art could and would not allow fantasies like these, which offended all prevailing moral and aesthetic standards, to have their claims to the status of art endorsed by consecration in the Salon. The jury, on principle, continued to reject Cézanne's submissions.

It was inevitable that the creator of such provocative outrages, which were clad neither in historical nor in religious disguise, should become the target of the Parisian caricaturists, who had previously revelled in the nudes of

Courbet and Manet. In the spring of 1870, Cézanne had the seal of disapproval hung around his neck in the form of a disgusting drawing of a reclining nude by a cartoonist called Stock (fig. 12).[27] The drawing, which was used as the cover illustration for a weekly magazine edited by Stock, referred to two paintings that had just been rejected by the Salon, and presented Cézanne to the public as the archetypal *refusé*, as a risible revolutionary. Armed with shield and broken-off lance in place of palette and maulstick, the champion of his art presents the laws of 'naturalistic' painting, with the bony nude hanging from his ear and the monumental portrait of his friend, the crippled painter Achille Emperaire, in his hand.

In the early 1870s Cézanne created a very singular double-portrait by confronting his own image with that of a 'modern' *Olympia* (cat. 40). The bald head with the dark surround of hair, the full beard, the generous planes of the face and the striking profile of the nose all lead one to conclude that this painting combines a self-portrait of the artist and the object of his desire. It is the work of a painter-voyeur, whose relationship with the opposite sex was made up of both fascination and animosity – the work of a painter-habitué, who claimed to frequent the dazzling, voluptuous boudoirs of Parisian high life.[28] Symbolising the artist's alienation, the two pictorial zones are demonstratively separated from each other. The first contains the essential props and the elegantly clad guest, with his top hat laid explicitly to one side. Facing this scene, and bathed in a radiant light is the goddess of love, whose rosy flesh tones are emphasised by the brown of her hair, the dark skin of her servant, and by the white of her couch. The divide is unbridgeable, the two areas precisely defined. Only the inevitable lap-dog moves in the no-man's-land between the two protagonists. The exact spatial disposition, however, remains unclear. One might almost think that the artist, dressed as a salon lion, is looking at an enormous *tableau vivant* or at an imaginary stage, on which he discovers the femme fatale. Through the use of specific props and repoussoirs, Cézanne exactly recreates the particular atmosphere of dignified ostentation of a Second Empire boudoir, the golden age of the demi-mondaine, supported by a parvenu nobility.

Although Cézanne presents himself here as an habitué in this world of grand sensuality, we can assume that this type of salon too, in which the most celebrated courtesans received their patrons, remained an unattainable object of his desires. The only link between the avant-garde and the great courtesans, who were dubbed *La Garde*, was created by the bourgeois role hierarchy, which consigned to both the bohemian and the prostitute a very similar status as outsiders, with a certain potential for advancement as an artist-prince or *grande horizontale* respectively. Paraphrasing the old motif of artist and model, Cézanne was the first to portray this community of outsiders.

Besides developing the *Rum Punch* theme, Cézanne's

reason for producing this painting may have been his desire to push beyond Manet's compositional techniques. This would also explain the title of the painting, *A Modern Olympia*, which was unveiled at the first group exhibition of the Impressionists, as they called themselves, held in the spring of 1874 in the studios of the photographer Nadar. In spite of its small format, Cézanne's painting more than any other attracted the mockery and derision of the critics and exhibition visitors. In *Le Charivari* of 25 April, Louis Leroy jibed:

'Alas, go and look at it! A woman folded in two, from whom a negro girl is removing the last veil in order to offer her in all her ugliness to the charmed gaze of a brown puppet. Do you remember the *Olympia* of M. Manet? Well, that was a masterpiece of drawing, accuracy, finish, compared to the one by M. Cézanne.'[29]

In a similar vein, Marc de Montifaut reported in the May 1874 edition of *L'Artiste*:

'This apparition of rather rosy, naked flesh, which swells up in front of him out of a celestial cloud – a sort of demon or incubus, like a voluptuous dream, this phony corner of paradise has silenced even the bravest, and Monsieur Cézanne seems no more than a madman, driven to painting by delirium tremens.'

Even the worthy Castagnary could not conceal his incomprehension when he protested in *Le Siècle* on 29 April against the unrestrained subjectivism proposed by the painter:

'Cézanne offers a cautionary example of the fate awaiting those who do not ponder and learn, but merely exaggerate the external impressions. After an idealistic beginning they will lapse into an unbridled romanticism, in which nature is only the pretext for daydreams; and power of imagination will no longer be able to express anything other than personal, subjective fantasies with no relation to general truths, since they are removed from all controls or comparisons with reality.'[30]

Yet it was exactly this much-maligned subjectivism that underpinned Cézanne's generally overlooked contributions to the portrayal of conflict and to questions of discord and alienation. Even today, when judged according to a more tolerant definition of art, his work still retains certain questionable and offensive qualities. At the time, the subjectivity of Cézanne's visions must have been highly suspect. They could not be classified either formally or generically, and corresponded neither to the fatuous platitudes of the Salon nor to the new tenets of Impressionism.

By reviving Manet's provocative title a decade later, and brazenly giving it a new actuality through the attribute 'modern', Cézanne, on his first public appearance, actively aligned himself with Courbet and Manet in the ranks of

the provocateurs. This was emphasised by the picture itself, in which he did not recoil from equating himself with the coquette, and employed almost satirical coarseness to distance his work as much as possible from the contemporary norms. Nevertheless, it is still surprising that the combination of exposed woman and male observer, however profane, should have so incensed the public, since comparable themes are to be found in French graphic art – if not 'high' art – from the seventeenth century on. An example is an amorous scene from 1686 (fig. 33), which, right down to the details of the lighting, the cast-aside hat, the theatrical draperies and the formality of the servant, already illustrates a disrobing ritual involving the drawing back of the curtains and the inviting ribbons of the corset.

In addition to *Olympia*, Cézanne was drawn to Manet's monumental *Déjeuner sur l'herbe* as an inspiration for his own, highly original variations on the *Déjeuner* theme.[31] Cézanne's first painted version (cat. 51), however, does not adopt Manet's provocative mixture of a naked woman accompanied by fully-dressed men. Furthermore, the composition lacks all those qualities that both Manet and Monet, who took up the theme in 1865–6, brought to their rustic idylls in terms of pastorale atmosphere, naturalness and joie de vivre. These can all be found in Monet's

large scale design, which transforms Manet's *Déjeuner* into a picnic (two surviving fragments are to be found in the Musée d'Orsay, Paris).

Both Manet and Monet, however, were bound to a perception of modern life and manners which Cézanne firmly rejected. He left the observer unclear as to what was actually taking place. The significance of this strange, festive meeting of seven people cannot be explained with certainty, especially as there is no trace of the usual eating utensils. The scenery, unlike Manet's, is not distinguished by a mythological precedent, and gives barely a hint of the jolly, carefree occasions celebrated by the Impressionists. Without atmosphere, and therefore more tensely, large areas of form, with dark and light colours contrasted in the early Baroque manner, define a composition that is strikingly disjointed. Although the rather grave protagonists wear modern dress, there is nothing contemporary about them. They appear to take no part in the elegant conventions of the social occasion. Are they talking, or concentrating on a game, in which the centrally placed fruit has some significance? A dialogue, indicated by restrained gestures, is conducted along a receding diagonal. Only the two main figures take part – the bending girl meaningfully holding a piece of fruit in her hand, and the seated figure in the foreground, whose features point to

Fig. 33 Jean de Dieu called Saint Jean, *Amorous Scene*, 1686.

Fig. 34 *L'Eternel féminin*, 1875–7, watercolour (RWC.57). Private Collection

another self-portrait of Cézanne, who had lost his hair at an early age. The couple disappearing into the darkness on the left-hand side might also give some indication of the idea behind the meeting, and the ultimate desire to make a discrete exit *à deux*. This is surely a secularised image of temptation, in which a victorious Venus-Eve figure offers the forbidden fruit to her chosen partner as a pledge of her talents as seductress and lover.

Such an interpretation is supported by a roughly contemporaneous composition, *The Temptation of St Anthony* (cat. 50). This subject, which was often exploited in the nineteenth century as an excuse for religiously-tinged pornography,[32] offered Cézanne, too, an outlet for his sexual obsessions and for his resulting awkwardness with all things feminine. He was not alone, as Flaubert also identified with the hallucinations of the Saint in his own version of *La Tentation de Saint Antoine*. For the young painter whose ascetic existence closely paralleled that of the reclusive St Anthony, the erotic aspects of the scene were of paramount importance. This explains the careful modelling of the naked bodies, as they swell palely out of the darkness. The compositional emphases are unusual, however, with the Saint forced into an insignificant position at the left-hand edge of the painting. There is no indication that St Anthony will rebuff the temptress, as he did in later versions of the subject.[33] While the main character is displaced from the central focus, the three figures facing each other in a foreground group are strongly accentuated.

In them one might recognise echoes of the Judgement of Paris, the mythological correlation to the Temptation.[34] The combination of religious and mythological themes is also touched on in the three principal female figures, who embody the classical triad of contemplative, active and sensuous existence. The monstrous ugliness of the Megaera on the right-hand side creates a counterbalance to the Saint and to the graceful activities of her younger colleagues. The Megaera herself abstains rather apathetically from any hint of suggestiveness.

Cézanne ultimately extended the realm of the temptress in a savage allegory of homage, apotheosising *L'Eternel féminin* (fig. 34),[35] in which the male world worships the 'eternal feminine'. The unnamed representatives of the sacred and secular world pay tribute to the fair sex. Above the parody of a devotional parade, the triumphant female power is elevated to a cult object, set on a mountainous bed. There she receives the ovations of those who submit to her caprice. Focused on the reality of collective desire, the travesty is given brilliance and splendour by a regal canopy and by the pompous colour harmonies of blue, scarlet and gold.[36] As the focus of the unflinching gaze of the surrounding males, the abused and therefore despised woman encourages the *Grand Corrupteurs*, who exploit her and the social class to which she belongs. By idolising and damning the woman in her reversible role as exploiter and exploited, Cézanne mirrored his own problematic response to women, which vacillated

between fascination and animosity. It was not by chance that he portrayed the image of the woman with the power to enrapture men as an unholy idol. The panorama of male society, linked by a mutual purpose, is ordered according to class and occupation. The key figure linking the divergent social groupings – the artists on the right and the established professions on the left – is a figure towards the bottom of the canvas, set on the same vertical axis as the female nude, with his back to the viewer. The powerful, partly bald skull, framed by dark hair and a full beard, suggests that this, yet again, is a self-portrait. Around this central personage are assembled the permanent representatives of male society. From the top right, they are led by a painter, brush and palette in hand, standing in front of his easel. He is joined by a group of musicians blowing a fanfare. A gourmand, carrying a tray laden with drink and golden-yellow fruit, caters for the woman's physical well-being. Simply through their actions, the members of this group – the heirs of the *artes libérales* – pay tribute through their various arts to the ample, egalitarian figure of the woman. Opposing this group, however, stands the camp of the bourgeoisie, led by a bishop in magnificent vestments. Apparently unconcerned for her spiritual well-being, he thrusts his mitre and staff, the symbols of his power, towards the lost sheep reclining on her bed. The semi-circle of adorants is completed by the secular dignitaries, the representatives of legal, military and financial power. They are personified by the devoted civil servant in his grey frock-coat, by a helmeted officer, and by the indispensible financier, complete with his money-bags. Cézanne himself, who had once been forced to choose between the advocate's chambers and the artist's studio, between security and risk,[37] appears in the painting as a passive observer, keeping his distance from the surrounding melée. He identifies with neither side, but has come to terms with the fact that he, in contrast to all those with more to offer, is destined for a role as a spectator on the fringes of society. The world of the conquering courtesan is out of his reach, and there is no hope of bridging the divide. Like the courtesan, the artist only appears to be at the centre of society. In reality, however, both the artist and the courtesan, as 'homme' and 'femme fatale', are kept outside society, as social dynamite. In its transcience, the cult of the artist-prince is similar to that of the *grande courtesane*, for both can only function in their respective occupations as long as they are willing to satisfy the demands of their rich patrons.

This many-layered exposition of the man-woman dialectic considers not only the direct relationship of the two sexes, but also such questions as the position of the artist within the wider society, the conflicting demands of state control and artistic freedom and the role of the boudoir as a meeting point for the otherwise divorced realms of power and creativity. An insight into this complex enquiry can be gained from some notes made by Zola at roughly this time, while working on the novel *Nana*, published in 1879–80. 'Nana', Zola wrote,

'will be an elemental force, a ferment of destruction. Without wishing it, she will destroy everything that comes near her through her sexuality and her female aroma . . . The derrière in all its power. The backside on the altar, before which everyone makes sacrifice. The book must be a poem to the posterior, and the moral will be the posterior, which lets everyone dance around it. . . . This is the philosophical theme: a complete society throws itself at the posterior. A mob after a bitch that isn't on heat, and makes fun of the dogs that follow her. A poem of male carnality, the great lever that sets the world in motion. There are only buttocks and religion. I must, therefore, exhibit Nana: the focus of interest like the idol, at whose feet all men fling themselves, for various reasons and with differing attitudes. . . . I shall assemble a multitude of men, embodying all of society.'[38]

Among the precedents for the painterly reproach is an etching by an Antwerp Mannerist (fig. 35), who depicts his artists as clowns, and has them dance around womankind, replete with all the requisites of *vanitas*. Other in-

Fig. 35 After Pieter Baltens, *Dance of Lady World*. Engraving, *c*.1600

fluences on Cézanne's composition include the popular nineteenth-century French illustrations, which often differentiated between an overscale individual and the swarming masses. This technique served, for example, to glorify the République française in the naïve pictorial language of political agitation, or, in caricature, to stress ironically the omnipotence of the journalist.[39] One further source for Cézanne's formal and iconographic innovations must be added – the epochal allegory of the *Atelier* by Gustave Courbet (1854–5; Musée d'Orsay, Paris). This *'allégorie réelle'* combines a self-portrait and a female nude in the midst of a figure group, which is split into two

camps – an anticipation of Cézanne's composition. Courbet's cosmos, in his own words, has 'on the right-hand side the friends, collaborators and lovers of art', while the left-hand side is given over to 'the everyday world, the people, the misery, the poverty, the wealth, the exploited, the exploiter, the people who live off death.'[40]

Around the mid-1870s, Cézanne pushed the theme of opposing sexes even further with his *Lutte d'amour* (fig. 28), set in an arcadian landscape.[41] What is striking here is the effort that Cézanne made to achieve the assimilation of man and nature.[42] The powerful interplay of the figures is located on a river bank, flanked by high trees, which falls steeply from the right towards the centre of the picture. The intensity of the action is softened by the loose distribution of the groups. The short, mainly diagonal brush strokes running from top right to bottom left, which are typical of this period, produce a scintillating harmony that gains expansiveness from the atmospheric sky blue. Both the interlocking of the ecstatically agitated bodies and the cloud formations, with contrasting areas of white and colour, are carefully thought out. Reinforced by his great admiration for Titian, the painter was clearly aiming in a smaller format to capture the mythical spirit of joy and exaltation that the masters of the Venetian High Renaissance were so skilled at portraying.

The specific inconography of the early figure scenes, which were repeatedly set in interior spaces, was finally superseded in the mid-1870s by a theme that occupied Cézanne right up to his death in 1906: male and female bathers. The conflict and confrontation of the earlier works were resolved in these later compositions, and the alienation of man and woman formalised, in the literal sense of the word. In accord with the intention to neutralise subjectivism in favour of formal analysis, the dissonant elements in the means of representation were abandoned. In their incontrovertible existences, the male and female bathers, freed from complex interrelationships, express exactly a desire for objectification and a release from emotionalism. The formally conceived and executed figures of the bathers allow one to forget the provocative gestures with which the painter had previously confronted the problems of his age. Although not yearning for the past in a romantic sense, Cézanne nevertheless sought to re-establish contact with the mainstream historical tradition. His vehicle was the bathers, who were based on a very heterogeneous repertoire of figures, developed from graphic rather than painterly premises. Cézanne was intensely aware of the conflict between his fascination with tradition on the one hand, and his urge to break with tradition on the other. He saw tradition as a responsibility, as something that had to be re-animated through the act of creative appropriation. By incorporating traditional forms and motifs into completely new configurations, and by investing them with new meanings, Cézanne restored a validity that had been thought lost.

A presupposition for these images of the unity of man and nature was the neutralisation of all conflict in both subject matter and form. The move from the sexual confrontation and sensationalist iconography of the early period to the sexually isolated, formally disciplined bathers of the later years is one of fundamental importance. By definitively separating the male and female figures, the artist resolved his own, very problematic perception of the polarisation of the sexes. In the paintings of male and female *Bathers*, conflict-laden situations are transformed into hermetically conceived images of an introspective, unquestioning sensuality, following the precedents established by Giorgione, Titian, Poussin and Rubens. Removed from the hierarchies and conflicts of real life, the bathers offer the visionary construction of a classless, totally anonymous existence. The naked figures become part of the natural environment, freed from all spatial or temporal connection with the present, be it clothing, objects or location. The rhythm of these archetypal communities, in their uniquely unselfconscious grace and beauty, is one of timeless permanence. While the critically dissonant early works documented Cézanne's break-out from the safe confines of his childhood and youth, the self-sufficient forms of the bathers in his later works reveal a longing for the protection of a community demonstratively bound together by nature. Their existence represents neither a contemporary bathing scene, nor an escape into the fondly-nurtured image of a lost idyll. Although he dedicated himself to landscape painting, especially in the first and last decades of his creative life, Cézanne sought to define his idyll not, significantly, in terms of landscape, but through his figure compositions. As a social outsider, he gave form to the hopes of his century for reconciliation. In the male and female bather compositions he succeeded, as the Renaissance masters had done before him, in giving convincing form to the primeval desire for the fusion of the real and the ideal, of man and nature.

In contrast to his motif-orientated landscapes, still lifes and portraits, the conflict-laden figure scenes of Cézanne's early years and the bathers of the late period were based on perceptions and convictions that existed exclusively in the artist's imagination. Courbet, Daumier and Manet, Baudelaire, Flaubert and Zola had all taught the young Cézanne to regard man as the product of his surroundings. In his later years he rejected this position and sought to reassert, through the metaphysical vitality of his bathers, the self-evident unity of idea, scenery and purpose, of experienced reality and pictorial conception – the historical components of monumental figure composition. Employing the same radical fervour with which he had initially sought to master his age through an entirely subjective, self-referential definition of art, Cézanne later came to resist the implications of his age. The vehicles for this resistance were the figure groups, set in an ageless, primeval landscape. They bear witness to the gradual

development of self-awareness in a man with little comprehension of the banal certainties of self-assurance.

Translated from the German by Iain Boyd Whyte.
This text is based, in a slightly modified form, on the following publications: Götz Adriani, *Paul Cézanne 'Der Liebeskampf'*, Munich, 1980, Götz Adriani, *Paul Cézanne, Aquarelle*, Cologne, 1981. *Paul Cézanne, Watercolours*, New York, 1983.

NOTES

1 *Cézanne, Correspondance*, 1976, p. 54. This comment by Cézanne was quoted by Zola in a letter to Baptistin Baille, dated 17 March 1860. Eight days later Zola wrote to Cézanne: 'I had a dream the other day. I had written a beautiful book, a magnificent book for which you had done beautiful, magnificent illustrations. Our two names shone together in gold letters on the title page and, in this brotherhood of genius, went inseparably on to posterity. Unfortunately, this is as yet only a dream.' (Ibid., p. 55).

2. On the difficult relationship between father and son, see: Kurt Badt, *Die Kunst Cézannes* (Munich, 1956), pp. 72 ff.; Theodore Reff, 'Cézanne's Dream of Hannibal', *The Art Bulletin*, 45 (2 June 1963), pp. 148 ff.; and John Rewald, 'Cézanne and his Father', *National Gallery of Art, Washington, Studies in the History of Art*, 1971/1972, pp. 38 ff.

3. As Cézanne reported despondently to a friend in Aix: 'I thought that when I left Aix I should leave behind the boredom that pursues me. I have only changed place and the boredom has followed me. I have left my parents, my friends, some of my habits, that's all. Yet I admit that I roam about aimlessly nearly all day. I have seen, naïve thing to say, the Louvre and the Luxembourg and Versailles. You know them, the pot-boilers (*tartines*) which these admirable monuments enclose, it is stunning, shocking, knocks you over. Do you not think that I am becoming Parisian.' *Cézanne, Correspondance*, 1976, p. 85.

4. Ibid., pp. 29, 87–8.

5. In 1866 Cézanne wrote to Pissarro: 'Here I am with my family, with the most disgusting people in the world, those who compose my family stinking more than any.' Ibid., p. 114. In a letter to Zola of 1868, Cézanne's friend Fortuné Marion added: 'What a generation of suffering, Zola, my dear friend. We two and so many others. Among us sufferers are some with fewer worries who are just as unhappy as we are. Cézanne, for example, with his secure existence and his dark attacks of spiritual despair.' Extracts from Marion's letters to Heinrich Morstatt, who belonged briefly to the circle of friends in Aix, were published by Alfred Barr in: 'Cézanne d'après les lettres de Marion à Morstatt', *Gazette des Beaux-Arts*, 17, no. 79 (1937), pp. 37–58. (The surviving 35 letters, which are in a private collection in Stuttgart, are quoted here from the originals, paying attention to previously unpublished passages.) See also, *Cézanne, Correspondance*, 1976, pp. 138, 157–8, 161–2, 163–5, 167–8, 172. A letter written to Zola in 1885 noted: '. . . besides, for me, there is complete isolation. The brothel in town, or something like that, but nothing more. I pay, the word is dirty, but I need rest, and at that price I ought to get it.' Ibid, p. 221.

6. Ibid., pp. 21, 34–6, 57, 365.

7. The friendship between Cézanne and Zola was based on a mutual affection as friends, rather than a mutual respect as artists, and each saw the incarnation of his own youth in the other. Although alienated by success or the lack of it, and by the conviction that the other was unable to fulfil the ideals of their youth, they were bound throughout their lives by their shared memories. The decisive factor in the formal split between the two may have been the unique position of Cézanne, which enabled him more than any other to recognise in Zola's novel details and episodes from the youthful years that the two had shared. When the novel appeared, hardly anybody in Paris could remember the Provençal painter who had attempted to provoke the art world a few years earlier, and hardly anyone knew of the shared past of the best-selling author and the unsuccessful painter, who had disappeared from the memory of a fickle public. See: Götz Adriani, *Paul Cézanne: Zeichnungen* (Cologne, 1978), pp. 65 ff.

8. Rewald, 1986, p. 78.

9. *Cézanne, Correspondance*, 1976, pp. 102, 84–6, 103–4. According to Zola, Cézanne 'now maintained that one should always present something to the jury, if only to put it in the wrong; moreover, he recognised the usefulness of the Salon, the only battlefield on which an artist could reveal himself at one stroke.' Quoted: Rewald, 1986, p. 56. As Marion noted in 1866: 'Cézanne hopes to be turned down by the exhibition, and the painters in his circle are already preparing an ovation. Guillemet is playing the hunting horn.' Marion assessed the situation realistically when he wrote to Morstatt in the same year: 'Cézanne will not, for a long time, be able to take part in the exhibition of officially approved and patronised works. His name is already too well known and too many artistically revolutionary ideas are linked to him for the painters who make up the jury to weaken for a moment. And I admire the persistence and sang-froid with which Paul writes to me: "Well! They will be offered something like this with even greater persistence for all eternity".'. Marion, *op. cit.*, pp. 45, 48.

10. Cf. *Cézanne, Correspondance*, 1979, pp. 126–7, 144–5, 160–1, 174–5, 178–9, 211–12, 315.

11. Emile Zola, *Malerei* (Berlin, 1903), p. 69.

12. Ibid., pp. 33 ff., 49 ff. Zola wrote the essay to prevent 'the artists who will be the masters of tomorrow' from being 'the persecuted of today'.

13. Ibid., pp. 64, 61.

14. Ibid., pp. 65 ff.

15. Rewald, 1986, p. 69. Zola continued: 'Even you, my dear colleague, add your opinion: you are 'convinced that the artist may have put a philosophical idea into his paintings'. That is an inappropriate conviction. If you want to find philosophical artists, look for them among the Germans, or even among our pretty French dreamers; but know that analytical painters, the young school whose cause I have the honour to defend, are satisfied with the great realities of nature.'

16. See, for example, the following works: V. 112, 223, 224; RWC. 35, 135, 137; Ch. 86, 180, 236, 275–80, 283–6, 291, 460, 461.

17. See Jules Clarétie, 'Deux heures au Salon', *L'Artiste* (15 May 1869), p. 226; Theodore Reff, *Manet: Olympia* (London, 1976), pp. 111 ff.; and George Mauner, *Manet: Peintre-Philosophe* (Pennsylvania and London, 1975), pp. 79 ff.

18. Reff, 1976, p. 57.

19. The pairing is reminiscent of the central group in Thomas Couture's *Romans of the Decadence* (1874; Musée d'Orsay, Paris), and also of Courbet's *Les Demoiselles des bords de la Seine* (1856/1857; Musée du Petit Palais, Paris), which, when exhibited at the 1857 Salon, had provoked the headline 'Odalisques in the shape of shop-girls'. The picture was exhibited again in 1867.

20. See Reff, 1976, pp. 96 ff.; and Mauner, 1975, pp. 94 ff.

21. Zola, 1903, p. 139.

22. See above, note 15.

23. *Cézanne, Correspondance*, 1979, pp. 78–81.

24. Karl Korn, *Zola in seiner Zeit* (Frankfurt, 1980), p. 42.

25. Rewald, 1986, p. 78. Cézanne's efforts to transform subjective confessions into subjective perceptions were noted by Marion in the spring and autumn of 1868: 'He has now achieved a truly remarkable degree of insight. All the excessive wildness has been calmed down, and I believe that the time has come when the means and the opportunity will offer themselves for a rich creativity. . . . Cézanne is striving with all his strength to learn

how to control his temperament and to impose on it the discipline of an exact science. When he achieves this goal, we shall have powerful and accomplished works to admire.' See above, note 5, pp. 48, 57.

26. See also his painting *Les courtisanes*, V. 122.

27. The caricature was accompanied by the following, ironic text: 'Incident of 20 March in the Palais de l'Industrie, or success in vestibule prior to the opening of the Salon: Before we begin our tour through this year's Salon, we wish to show the public two paintings – the forbidden fruit, as it were – belonging to the rejected category. The artists and critics who assembled at the Palais de l'Industrie on 20 March, the last day for submitting paintings, will remember the sensation caused by two paintings of a new genre. As we believe our readers will approve, we have taken the necessary steps to secure the first accurate reproductions of these canvases, as well as a portrait of the painter. *Lumen lucet* – the light illuminates; Courbet, Manet, Monet and all of you painters with the scraper, toothbrush, broom and other utensils, you've all been outdone. I have the honour of presenting to you your master: Monsieur Cézannes [sic]. Cézannes! Who? What?? Who's that??? Monsieur Cézannes comes from Aix-en-Provence, and is a realistic painter, and, what is more, a painter of conviction. Listen to what he has said, in his marked southern accent: 'Indeed, my dear Monsieur Stock, I paint as I see and as I feel . . . my feelings are very strong. The others, Courbet, Manet, Monet and so on also feel and see as I do, but have no courage. They do paintings for the Salon. In contrast, Monsieur Stock, I dare, I take the risk. I have the courage of my convictions, and who laughs last laughs best.' Quoted: John Rewald, 'Un article inédit sur Paul Cézanne en 1870', *Arts*, 473, no. 21 (July 1954).

28. On the theme of self-representation in the early works, see Adriani 1981, pp. 50 ff.

29. John Rewald, *The History of Impressionism* (4th ed., London, 1973), p. 324.

30. Ibid., p. 330.

31. See also the compositions on the same or similar subjects: V. 232, 234, 238, 377; Rewald, 1983, nos 45, 46, 47, 56; Chappuis, 1973, nos 235–50, 256, 318.

32. In the France of Napoleon III, the fashionably romantic *Temptations*

by painters like Tassaert, Delaroche, Rops and many others belonged to the standard repertoire of themes that successfully combined demonic and satirical elements, and prospered not only in painting, but also in graphic art, folk-songs and street ballads. See: Claude Roger-Marx, 'Les tentations de Saint Antoine', *La Renaissance* (January/February 1936), pp. 3 ff.; Theodore Reff, 'Cézanne, Flaubert, St Anthony, and the Queen of Sheba', *The Art Bulletin*, 44 (June 1962), pp. 113 ff.

33. See V. 240, 241; RWC. 40, 41: Rewald illustrates as no. 61 the unpublished *verso* side, but does not recognise it as a figure study for the upper half of the painting *The Temptation of St Anthony* (cat. 50); Ch. 444–53.

34. Cézanne also treated the mythological theme, see: V. 16, 537; Ch. 658, 659.

35. See the painting V. 247, and also the other versions, RWC. 139, 385, and Ch. 257, 258.

36. Cézanne repeated the compositional structure shortly afterwards on another level of meaning in his *Apotheosis of Delacroix*, V. 245, and Rewald, 1983, no. 68.

37. As a young man, Cézanne had occupied himself with the Hercules theme, see: *Cézanne, Correspondance*, 1976, pp. 32–4, 72–5, 76, and Theodore Reff, 'Cézanne and Hercules', *The Art Bulletin*, 48 (1 March 1966), pp. 35 ff.

38. Werner Hofmann, *Nana, Mythos und Wirklichkeit* (Cologne, 1973), p. 58.

39. See Adriani, 1981, pp. 262 ff.

40. Klaus Herding, *Realismus als Widerspruch: Die Wirklichkeit in Courbets Malerei* (Frankfurt, 1978), p. 24.

41. See also the painted versions, V. 379, 380.

42. When, in 1878, Zola sent Cézanne a copy of his latest novel *Une page d'amour*, complete with a dedication, Cézanne replied that he found that the developing passions of the two main characters had been very finely graded. He added: 'Another observation that seems to me just, is that the places, through their descriptions, are impregnated with the passion that moves the characters, and through this, form more of a unity with the actors and are less dissociated from the whole. They seem to become animated, to participate as it were in the sufferings of the living beings.' See: *Cézanne, Correspondance*, 1979, p. 157.

The Collectors of Cézanne's Early Works

SYLVIE PATIN

I am beginning to think myself abler than those around me . . . I must work all the time . . . And believe me, there always comes the moment when one makes one's mark, and one has admirers who are far more fervent, more convinced, than those who take pleasure merely in vain appearances.

Cézanne, letter to his mother,
Paris, 26 September 1874.[1]

To investigate the provenance of the paintings of Cézanne's early period is to discover the names, which are often famous ones, of the owners who form successive links in the chain of 'fervent admirers' of these often rather unapproachable compositions. Valued from the outset by a prescient few, these are the works of a genius who was simultaneously a lover of tradition and a herald of twentieth-century modernism.

It is only fair to pay tribute to the intelligence shown by these people in acquiring the paintings; after all, it is thanks to them – the artist's friends, together with a few dedicated collectors and some perceptive dealers – and to their descendants that these works have survived to be assembled in this exhibition. Some of the works have come down to us positively enriched by the personalities of their owners: think of the great *Portrait of Achille Emperaire* (cat. 46), rejected at the 1870 Salon, which was bought from the Impressionists' colourman, Père Tanguy, by the painter Emile Schuffenecker, who passed it on to another painter, Eugène Boch, before it entered the collection of Auguste Pellerin and passed to the French nation in 1964; it is now in the Musée d'Orsay, Paris.

To trace the ownership of these first paintings is also to follow the course of Cézanne's artistic career. Successively, we encounter the names of those who crossed his path: the friends of his youth in Aix; his new Parisian friends, the future Impressionists and their first champions; his dealers and his collectors. Finally, in the years that immediately preceded the artist's death, the record shows something of the ways in which his work was received, both in France and elsewhere.

I shall restrict this enquiry to the 132 paintings listed by the Italian art historian Lionello Venturi at the beginning of his 1936 book *Cézanne, son art, son œuvre* (Paris, 2 vols), under the heading 'Academic and Romantic Period (1858–71)'. These are the works, painted before Cézanne's move to the area round Pontoise and Auvers-sur-Oise, that form the subject of this exhibition. I shall trace the record of their ownership beyond the artist's death in 1906; but I have come up against insuperable difficulties in pinning down all the changes of location and the date and manner of every successive change of ownership. In addition, a number of early works have disappeared, either destroyed by the artist or simply lost (such as *Nu à la puce* submitted to the Salon in 1870; see fig. 12). This study is therefore not an exhaustive one.

Close Relatives

In his youth Cézanne painted a number of pictures[2] to decorate the family house, the Jas de Bouffan, near his native city of Aix-en-Provence. These included four panels of *The Seasons* (cat. 1a–d); the *Portrait of Louis-Auguste Cézanne, Father of the Artist* (cat. 4); the *Christ in Limbo* (cat. 32); and *Sorrow or Mary Magdalen* (cat. 33). They remained in the large drawing-room at the Jas de Bouffan when the estate was sold in 1899, some years after the death of Cézanne's father (23 October 1886). After the painter's death they were taken off the walls and sold to the dealer Jos Hessel (see below, p.61).

About twenty other works[3] are said by Venturi to have first belonged to Paul Cézanne *fils*, the artist's son by Hortense Fiquet (with whom he lived, and who became his wife in 1886). These were probably given by the artist as presents to his own mother or to his son (born 4 January 1872), or else found by the son in his father's studio. They include a number of works of deep emotional significance, including portraits of members of the family (the artist's sisters), and the first two self-portraits. Unlike M. Cézanne *père*, the artist's mother always believed in her son's vocation and held high hopes for his future as a painter. According to the dealer Ambroise Vollard:

'Elisabeth Aubert, Cézanne's mother, born in Aix of a family with remote Creole ancestry, was lively and romantically inclined, quick and spontaneous but with an uneasy, irascible temperament. It was from her that Paul derived his imagination and his vision of life.'[4]

At the end of his life, Cézanne once more turned for support and comfort to a relative: this was his son, to whom he had always been close. A month before he died, he wrote:

'My dear Paul . . . All I see is gloom, and so I must lean more and more on you, and find my sunrise in you . . . I am so slow to achieve anything that it makes me very sad. Only you can console me in my melancholy state.'[5]

Classmates and Friends from Aix

The most famous of Cézanne's school friends at the Collège Bourbon in Aix-en-Provence, Emile Zola, moved to Paris and persuaded Cézanne to join him. He wrote of their friendship in the dedication, 'To My Friend Paul Cézanne', with which he prefaced his book *Mon Salon*, published in 1866:

'It is a profound joy to me, my dear Cézanne, when we talk alone. . . . We have been discussing art and literature for ten years now. . . . You are all my youth; you are involved in each and every one of my joys and my sorrows. Our minds, in their brotherly closeness, have developed side by side.'[6]

John Rewald has traced the relationship between the painter and the writer in detail, up to the moment when they parted company after the publication of Zola's *L'Œuvre* in 1886. Cézanne, who felt that he recognised himself in the character of the failed painter created by Zola, never visited the writer's house in Médan again.

Nevertheless, to the end of his days Zola owned a number of works painted by his friend before 1871,[7] and most of them were in the posthumous sale of his collection (9–13 March 1903). Those sold then were *The Rape* (cat. 31),[8] which was painted in Zola's apartment in the rue de la Condamine and given to him by the artist in 1867; a *Study of a Woman*;[9] a landscape painted at L'Estaque, near where Cézanne and Hortense Fiquet had taken refuge in 1870, entitled *The Fishing Village*;[10] an interior, *The Stove in the Studio*;[11] the very fine *Black Clock* (cat. 49),[12] painted in Zola's dining-room; a *Portrait* (of Cézanne himself?);[13] and finally *Paul Alexis reading to Emile Zola* (cat. 47),[14] showing Paul Alexis, in which the same black clock is just visible in the background (it is still in Zola's house at Médan).

The Zola sale gave rise to a vicious article by Henri Rochefort, in *L'Intransigeant* of 9 March 1903, in which, under the title of 'The Love of Ugliness', the journalist gave free rein to his loathing of both the painter and the writer:

'. . . the modern paintings that [Zola] had lumped in with these lumber-room scourings [previously described] stirred the crowd to unalloyed mirth. There are ten or so works, landscapes and portraits, that bear the signature of an ultra-Impressionist by the name of Cézanne. . . .

Pissarro, Claude Monet and the most eccentric of the other painters of *le plein-air* and *le pointillé* are mere academics by comparison with this extraordinary Cézanne, whose productions Zola was at such pains to garner. Even the experts in charge of the sale were embarrassed by having to catalogue these fantastic objects and accompanied each one with a meaningful little note: "A very early work".

If M. Cézanne was still with his wetnurse when he perpetrated these daubs, then we have no cause for complaint. . . .'

This article was the signal for a virulent anti-Cézanne campaign, only three years before his death.

It was another of Cézanne's boyhood friends, slightly younger than himself, Antoine-Fortuné Marion (1844–1900), who introduced him to a German musician, Heinrich Morstatt (1844–1925). In a letter of 23 December 1865, Cézanne wrote to Morstatt: 'I beg you to accept Fortuné's invitation; you shall set our acoustic nerves atingle with the noble strains of Richard Wagner.'[15] Morstatt owned two Cézannes painted in 1865–7: *Still Life: Skull and Candlestick* (cat. 12) and *Portrait of Uncle Dominique as a Monk* (see p.104).[16]

It was probably through the young poet Joachim Gasquet – whose father Henri had been at school with Cézanne at the Pensionnat Saint-Joseph in Aix – that Cézanne met the Marseille lawyer Xavier de Magallon[17] (born 1866). Magallon, an old boy of the Collège Bourbon in Aix, owned Cézanne's copy of Delacroix's *The Barque of Dante* (cat. 5); he was among the artist's last admirers.

Painters in Paris, and the First Defenders of Impressionism

Cézanne's first stay in Paris (April to September 1861), and his move to Paris in November 1862, gave the young artist the opportunity to exchange ideas with a number of his painter contemporaries, some of whom were to become friends.

At the 'free studio' of the Académie Suisse, Cézanne met Antoine Guillemet, Francisco Oller and above all Armand Guillaumin, who became a particular friend. Guillaumin owned just one early Cézanne: *The Rue des Saules, Montmartre* (cat. 29).

Guillaumin is said to have introduced Pissarro (fig. 36) to Cézanne. The understanding between the two men was to be a deep and lasting one, and the influence was to be mutual. In 1874 Cézanne wrote to his mother: 'Pissarro

Fig. 36 *Portrait of Camille Pissarro, c.*1873 (Ch.298). Cabinet des Dessins, Musée du Louvre, Paris.

. . . has a high opinion of me, and I have a high opinion of myself.'[18] In 1902 he reportedly acknowledged his debt to 'humble, colossal Pissarro' in the following terms: 'As for old Pissarro, he was a father to me. He was a man to turn to, something like God Himself.'[19]

The collaboration between the two artists at Pontoise and Auvers-sur-Oise in 1872–4 is well known, but Pissarro took an interest in Cézanne's work long before 1870, and said of himself in 1896: 'I who have been defending him for thirty years with such force and such conviction. . . .'[20] He had underlined the disconcerting character of Cézanne's early work when he replied to Théodore Duret's wish in 1872 to see some original works from that period: 'the moment that you start looking for five-legged sheep, Cézanne will be able to oblige, since he has some extraordinarily strange pieces seen in a unique way'.[21] Pissarro told his son in a letter in 1884: 'As for Cézanne, I have treated myself to four highly curious studies of his' – probably at Père Tanguy's shop, according to John Rewald.[22]

It is no surprise, therefore, to find Pissarro listed as the owner of three works painted by Cézanne before 1871, namely the very Parisian view of the *Paris: Quai de Bercy* (cat. 62) (which recalls Pissarro's own fascination, at the end of his life, with the 'urban landscape'), *Women Dressing* (cat. 28)[23] and *The Angler*.[24]

Cézanne often met Guillaumin and Pissarro at the house of Dr Paul Gachet (1828–1909) (fig. 37), whose face is familiar to us from his portrait by Van Gogh. A good friend to many painters,[25] he welcomed them to his house at Auvers-sur-Oise, and its walls were hung with their works. Dr Gachet's magnificent collection thus came to include four works of Cézanne's youth: the *Pastoral (Idyll)* (cat. 52), now in the Musée d'Orsay in Paris, and three still lifes,[26] two of which, *Green Apples* and *The Artist's Accessories*, are also in the Musée d'Orsay as part of the collection donated to the French national museums by Dr Gachet's son.

Another owner of a still-life painted by Cézanne in 1864–6 was Dr Gachet's friend Eugène Meunier, known as Murer[27] (1846–1906), an amateur painter who ran a restaurant in Paris – and later in Rouen – where Cézanne and other artists used to congregate. Murer often gave them meals in exchange for works, and consequently built up a sizeable collection.

In Paris in the 1860s, Cézanne made friends with a number of other painters besides those who were working at the Académie Suisse; and these were to be among those who joined with him in the first Impressionist exhibitions. In them he found not only friendship and encouragement but a sense of respect for his art. In 1895 Cézanne wrote to Monet: '. . . I'll tell you how glad I have been of the moral support I have received from you, and which acts on me as a stimulus to paint.'[28] Monet owned two early works by his friend,[29] one of which was the oil painting *The Negro Scipion* (cat. 30), a study of one of the models at

Fig. 37 *Portrait of Dr Gachet*, 1872–4 (Ch. 295). Cabinet des Dessins. Musée du Louvre, Paris.

the Académie Suisse. In November 1894 Monet expressed his admiration for Cézanne: 'How sad that this man has not found more support in his life! He is a true artist, who has been brought to the point where he doubts himself too much. He needs cheering up. . . .'[30] Monet was writing to Gustave Geffroy to ask him to come and be introduced to Cézanne over a meal at Giverny attended by Monet, Cézanne, Geffroy, Auguste Rodin and the writer Octave Mirbeau.

Mirbeau (1848–1917) was a close friend of Zola and an old acquaintance of Cézanne, several of whose works he owned. One work painted by Cézanne prior to 1870, *The Angler*[31] (which had previously belonged to Pissarro), was in the sale of Mirbeau's collection on 24 February 1919.

On the occasion of the Cézanne exhibition mounted by Ambroise Vollard in 1895, Pissarro's letters to his son reveal how Cézanne was seen by his friends:

'. . . while I was engaged in admiring that curious, disconcerting side of Cézanne that I have been aware of

for a good many years, in comes Renoir. But my enthusiasm is a mere John the Baptist by comparison with Renoir's. Degas himself, who is under the spell of this sophisticated savage, and Monet, and all of us – are we all wrong? I don't think so. The only people immune to the spell are precisely those artists, or collectors, who make it clear to us by their errors that they have a sense missing somewhere. . . . Degas and Monet bought some stunning things [by Cézanne]. . . . You'd never credit how hard a time I have in getting certain collectors, otherwise well-disposed to the Impressionists, to understand what great and rare qualities there are in Cézanne. . . . Degas and Renoir are enthusiastic about Cézanne's work. . . . Degas so wild about Cézanne's sketches, what do you think of that? Wasn't I right in 1861, when Oller and I went to see this curious Provençal at the Atelier Suisse, where Cézanne was doing academic life drawing and being hooted at by all the incompetents in the school. . . . It's a funny business, reliving long-past battles like this!'[32]

In the Degas sale of 26–7 March 1918 there was one youthful work by Cézanne, *Venus and Cupid*.[33] At the sale of the Henri Rouart collection on 9–11 December 1912 there was a small early canvas, the *Woman at a Mirror*[34] (now in the Musée Granet, Aix-en-Provence). Like his friend Degas, Henri Rouart (1833–1912) took part in the 1874 Impressionist exhibition, and helped to organise the exhibitions that followed. Both possessed a number of paintings by Cézanne.

As for Renoir, his Cézannes were all later works. The same was true of the collector Victor Chocquet, a senior customs official, whom Renoir introduced to Cézanne. Chocquet seems to have bought his first Cézanne in 1875, when Renoir took him to Père Tanguy's shop.

Julien Tanguy (1825–94), known familiarly as Père Tanguy, was the Impressionists' colourman, and because he put their works on show in his shop in the rue Clauzel he became, for several of them (including Cézanne), their first 'dealer'. It was from Tanguy's shop that the painters Emile Schuffenecker (1851–1934) and Eugène Boch (1855–1941) bought the great *Portrait of Achille Emperaire* (cat. 46). Boch, incidentally, was a friend of Van Gogh, who painted his portrait (Musée d'Orsay, Paris) as well as three portraits of Tanguy (one of which is in the Musée Rodin, Paris). Emperaire himself (1829–98) was a painter from Aix-en-Provence who also made use of the colourman's good offices in selling his works. Cézanne mentions 'the good Tanguy' several times in his letters; he wrote to Zola on 28 August 1877: 'Yesterday evening, walking into my colourman's shop in the rue Clauzel, I came across dear old Emperaire.'[35]

The young Cézanne was also championed by a number of art critics: Théodore Duret (1838–1927), a close friend of Zola, who was to devote a chapter of his *Histoire des peintres impressionnistes* (1906) to Cézanne; Adolphe

Tavernier, who possessed a still life of Cézanne's first period;[36] and Georges Rivière (1855–1943), who dared to say as early as 1877, on the occasion of the third Impressionist exhibition, the last in which Cézanne took part:

'The artist who has been most attacked, most abused by the press and by the public for fifteen years past, is M. Cézanne ... M. Cézanne is a painter, a great painter. Those who have never held a brush or a pencil have said that he does not know how to draw and have blamed him for alleged imperfections which are in fact no more than the subtlety that springs from immense skill.'[37]

And in 1894, a few months before he first met Cézanne at Monet's house, Gustave Geffroy took the occasion of the posthumous sale of Père Tanguy's collection to devote an article to Cézanne in which he emphasised 'the rarity of one's encounters with Cézanne's paintings':

'Paul Cézanne's fate as an artist has long been a curious one. He might be defined as a figure who is both unknown and famous: rarely in contact with the public and yet cherished as an influence by all the restless, questing spirits of painting; known only to a few; living in obstinate seclusion; abruptly reappearing and disappearing from the ken of those closest to him. From the obscurity of his life-story, from the almost secret nature of his work, from the rarity of his paintings, which seemed to have been shielded from publicity in all its accepted forms, he derived a remote, bizarre sort of fame; a mystery came to enshroud him and his work. Those who hankered after all that was new and unheard-of, those who liked to unearth things never seen before, used to speak of Cézanne's paintings with a knowing air, dropping hints as if they were passwords. Those who had the curiosity and the enthusiasm to set out upon the untrodden ways of modern art ... used to ask their elders about this shadowy Cézanne, who lived thus on the fringes of life, taking no thought for his role or for self-presentation. What did his paintings look like? Where could they be seen? The answer came that there was one portrait at Emile Zola's house, two trees at Théodore Duret's and four apples at Paul Alexis'; or perhaps that a picture had been seen the week before at Père Tanguy's, the colourman's shop in the rue Clauzel, but that one had to look sharp if one wanted to see it, because there were always collectors quick to pounce on so rare a treasure as a Cézanne painting. There was talk, too, of extensive collections, containing a considerable quantity and variety of paintings, which could be seen only by gaining access to the house of M. Cho[c]quet in Paris, or that of M. Murer in Rouen, or that of Dr Gachet at Auvers, near Pontoise.'[38]

Painters, and the first champions of Impressionism, formed the daily milieu in which the young Cézanne lived. Some works of his first period did find their way into the possession of famous collectors; but Cézanne was never as close to them as to the group of friends who had shared with him the adventure of the birth of Impressionism.

The First Collectors

Georges Charpentier (1846–1905),[39] who was a close friend of a number of leading writers, including Zola, Gustave Flaubert, Alphonse Daudet and J.-K. Huysmans, offered his support to the Impressionists immediately after the first Impressionist exhibition in 1874. His name is most often mentioned in connection with Renoir and Monet, to whom he devoted one-man exhibitions in the gallery that he ran in conjunction with his artistic periodical *La Vie moderne*, founded in 1879. But he also took an interest in Degas, Boudin, Sisley, Pissarro and Cézanne. When his collection was disposed of on 11 April 1907, one of the paintings on sale was *Marion and Valabrègue setting out for the Motif* (cat. 25),[40] depicting Cézanne's boyhood friends from Aix.

A *Portrait of Valabrègue* (cat. 56) was in the collection of Count Doria (1824–96) at the Château d'Orrouy. 'Count Doria was one of the first collectors to appreciate [Cézanne]', wrote Théodore Duret in 1906.[41] Doria's claim to fame is that he acquired, very early on, *The House of the Hanged Man*,[42] exhibited in 1874; this is the work that opens the section entitled 'Impressionist Period' in Venturi's catalogue. It also introduces the names of two great collectors of Cézanne's works, neither of whom ever owned an early one: Victor Chocquet and Count Isaac de Camondo.

Another *Portrait of Valabrègue* (cat. 16) belonged to Baron Denys Cochin[43] (1851–1922), who had a particular appreciation of Cézanne; he is said to have met the painter when he was working at Montgeroult in 1898.

A curious painting, *L'Estaque, Evening Effect*,[44] which has been variously dated 1870 and much later, was first owned by the collector Maurice Leclanché[45] (who died in 1921); then it went to Eugène Blot,[46] a collector and dealer who was a friend of Guillaumin. It appeared in the Blot sale on 2 June 1933. In 1900, in his preface to the catalogue of the Blot collection, Georges Lecomte recalled, as Geffroy had done, the long interval during which Cézanne's works remained unseen by the public:

'Until 1894 it was only by chance, and in the houses of a very few friends, that one could still see paintings by Cézanne. ... A landscape by him was known to be in M. Zola's house, a fruit piece at M. Paul Alexis', a study at M. Duret's and another at M. Huysmans'. It was said that once in a very long while a painting passed through the good Père Tanguy's shop.'[47]

Over Thirty Early Works in the Collection of Auguste Pellerin

Pride of place among all the collectors of Cézanne's early works must surely go to Auguste Pellerin (1852–1929).[48] Paris-born, Pellerin was a major industrialist who built factories in France and elsewhere, notably in Scandinavia; from 1906 to 1929 he was Norwegian consul-general in Paris. He was remembered as a man with a passion for art who began his collection of paintings and *objets d'art* long before 1900. He was clear-sighted and intuitive enough, very early on, to sell his collection of works by Vollon, Henner and even Corot and buy the works of Manet and the Impressionists (Cézanne, Renoir, Monet, Pissarro, Sisley, Degas and Berthe Morisot). Later, he bought such 'modern' artists as Edouard Vuillard, Maurice Denis, Charles Camoin, André Derain and Henri Matisse. In 1916 Matisse accepted a commission to paint Pellerin's portrait, at a time when he was painting major portraits of his wife and of collectors such as Michael and Sarah Stein. The two versions of Matisse's *Portrait of Auguste Pellerin* are juxtaposed here: one is an official, commissioned work (fig. 38) and the other offers a more personal interpretation of the sitter based on the artist's spontaneous vision (fig. 39).

Fig. 38 Henri Matisse, *Portrait of Auguste Pellerin*, 1916. Private Collection.

Fig. 39 Henri Matisse, *Portrait of Auguste Pellerin*, 1916. Centre National d'Art et de Culture Georges Pompidou, Musée National d'Art Moderne, Paris.

Pellerin took a particular interest in Manet, and above all in Cézanne, over ninety of whose paintings he owned.[49] A number of authors have followed Emile Bernard and Roger Fry[50] in emphasising the importance of the Pellerin collection for the study of the successive phases of the evolution of Cézanne's art. In its richness and diversity, the extraordinary group of masterpieces assembled by this great collector in his passion for Cézanne's art aroused the admiration of contemporary connoisseurs when it was placed on public view in 1907, the year after the artist's death. Twenty-five paintings, catalogued under the heading of 'The Collection of M. Pellerin', appeared in the Cézanne retrospective of that year at the Salon d'Automne. When Pellerin died (on 18 October 1929, at Neuilly), he left three of Cézanne's finest still lifes to the Louvre;[51] they are now in the Musée d'Orsay. Pellerin's

collection was then split between his daughter Juliette and his son Jean-Victor, a playwright. Over the years that followed several more works from the collection found their way into museums in France[52] and abroad,[53] where they continue to evoke the memory of one of the finest private collections ever assembled.

Of the ninety-odd paintings by Cézanne that Pellerin owned, about a third (32) belonged to the artist's first period, Venturi's 'Academic and Romantic Period (1858–71)', which itself covers 132 paintings in all. These 32 paintings[54] collected by one man thus represent a quarter of the artist's entire surviving youthful output – an indication in itself of Pellerin's particular love for Cézanne's early work.

It is also worth stressing the harmonious way in which Pellerin built up his collection, not only as a whole but in the balance between the painter's various themes: eleven portraits, thirteen miscellaneous figure compositions, five landscapes, one still life, one interior. Among the portraits were two *Portraits of the Artist*, a *Portrait of Louis-Auguste Cézanne, Father of the Artist reading 'l'Evénement'* (cat. 21), four *Portraits of Uncle Dominique* including cat. 20 and 23,[55] and finally the celebrated *Achille Emperaire* (cat. 46) which was rejected at the 1870 Salon. Among the figure compositions were the *Christ in Limbo* (cat. 32) from the drawing-room at Jas de Bouffan, *The Preparation for the Funeral* (cat. 35), *A Modern Olympia* (cat. 40), *The Orgy* (cat. 39) *Le Déjeuner sur l'herbe* (cat. 51), *Marion and Valabrègue setting out for the Motif* (cat. 25), *The Walk* (cat. 26), *Paul Alexis reading at Zola's House* (cat. 43) and the lovely *Pastoral (Idyll)* (cat. 52). Among the landscapes were *The Fishing Village at L'Estaque, Melting Snow at L'Estaque*[56] and *Paris: Quai de Bercy* (cat. 62). The still life was *Sugarpot, Pears and Blue Cup* (cat. 14).

The provenance of these thirty-two paintings, up to the point where they entered the Pellerin collection, makes an interesting study. For sixteen of them, the first owner listed by Venturi is Pellerin himself, implying that he acquired them direct from the painter;[57] another, one of the two *Portraits of the Artist* (cat. 2), had apparently belonged to Cézanne's son. Four works had been in Zola's collection and had been sold off in March 1903: *The Fishing Village at L'Estaque, The Stove in the Studio*, the other *Portrait of the Artist* and *Paul Alexis reading at Zola's House* (which had then passed through the hands of the dealer Hessel, as had *Christ in Limbo*). The *Paris: Quai de Bercy* had belonged to Pissarro, the *Portrait of Achille Emperaire* to Eugène Boch at Monthyon, and the *Woman at a Mirror* to Henri Rouart, the *Pastoral* to Dr Gachet at Auvers-sur-Oise. *Marion and Valabrègue setting out for the Motif* had been in the Georges Charpentier sale of 11 April 1907 and had then passed to Eugène Druet before coming to Pellerin.

Finally, one of the two *Portraits of Valabrègue* had belonged to Baron Denys Cochin and the other to Count Doria. *A Modern Olympia* seems to have been acquired through the Bernheim-Jeune gallery.

Of these thirty-two early paintings by Cézanne, five are now in French museums. The *Portrait of Achille Emperaire* and the *Pastoral (Idyll)* are in the Musée d'Orsay in Paris; *The Poet's Dream, Still life: Sugarpot, Pears and Blue Cup* and *Woman at a Mirror* are on permanent loan to the Musée Granet in Aix-en-Provence.

On the occasion of this exhibition devoted to Cézanne's early period, it seems entirely opportune to pay tribute, once more, to the memory of Auguste Pellerin, who was so quick to take the full measure of Cézanne's genius and to include in his choice these complex, difficult and even forbidding early works. The dealer Ambroise Vollard recalled that Pellerin was the first collector who ever bought a Cézanne nude from him. This was during the painter's lifetime, at the exhibition Vollard held at his gallery in 1895:

'Several people who were among those most interested in the exhibition had urged me to take the nudes out of the window, telling me that the public was not yet ready. . . . I gave in eventually, rather against my will, and turned the nudes to face the wall; but one visitor, turning the paintings round, discovered the *Leda and the Swan* and bought it on the spot. And so the first nude painting to be sold during the exhibition was acquired by M. Auguste Pellerin.'[58]

The Paris Dealers

Ambroise Vollard (1868–1939) is said to have seen his first Cézannes at Père Tanguy's. When Tanguy died in 1894, Vollard persuaded the painter to let him be his dealer. The exhibition he organised in his gallery in the rue Laffitte in 1895 enabled the younger generation of painters to discover Cézanne's work, and it was Vollard's gallery that Maurice Denis chose as the setting for his *Homage to Cézanne*, painted in 1900 (Centre national d'Art et de Culture Georges Pompidou, Musée national d'Art moderne, Paris). Vollard also wrote a monograph on Cézanne, published in 1914, and a number of subsequent books.

As early as 1894, Pissarro sensed Vollard's future importance. He wrote to his son:

'A young man . . . has set up shop in the rue Laffitte. He has nothing but pictures by young painters. . . . When you have something, you must send it to him. I think this little dealer will be just what is needed; he likes only the things of our school, or those that approach it by virtue of the artist's talent. He is full of enthusiasm, and he knows what he is doing. He already has a few collectors interested, and they are starting to ferret around.'[59]

Cézanne too, in his letters, is full of praise for him:

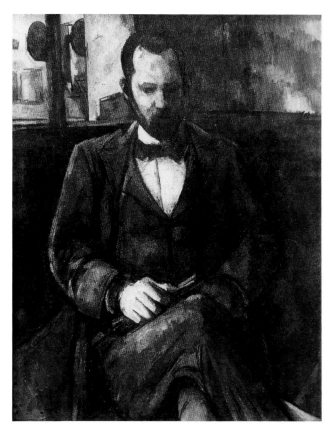

Fig. 40 *Portrait of Ambroise Vollard,* 1899 (V.696). Musée du Petit Palais, Paris.

'. . . Vollard, who is a sincere man and serious too, . . . I have no doubt, will continue to be the intermediary between myself and the public. He is a man of great flair, well-mannered, who knows how to behave.'[60]

In 1903 Cézanne wrote to Vollard from Aix: 'I regret the distance that comes between us; more than once I would have turned to you for a little moral support.'[61]

In 1906 Théodore Duret mentioned Vollard in the chapter of his *Histoire des peintres impressionnistes* devoted to Cézanne:

'Cézanne, the most despised of all, lagged behind the others in public favour. He still perceived himself as ignored by an uncomprehending public, and yet he did have a growing nucleus of admirers, made up of artists, connoisseurs and collectors. . . . It was now possible to find buyers for his works, and a man had appeared, in the person of Vollard, who was to undertake their sale and make a success of it.'[62]

Vollard, who had commissioned Cézanne to paint his portrait in 1899 (fig. 40), was a collector in his own right, and it is hard, as so often with dealers, to distinguish between his private collection and the works that passed

through his hands before being sold on. In all, Vollard had in his possession, at one time or another, twenty-four of the works of Cézanne's first period:[63] these included the *Head of an Old Man* (Musée d'Orsay, Paris) (cat. 6), the *Boy Leaning on his Elbows* (Private Collection, Switzerland),[64] and *Afternoon in Naples* or *The Rum Punch* (cat. 27).

Vollard conducted some business with Paul Rosenberg, who is listed as having owned ten early Cézannes.[65] Three of these came to him direct from Vollard: *The Man with the Cotton Cap* (otherwise known as *Uncle Dominique*) (cat. 22), *The Courtesans*[66] and *The Strangled Woman* (Paris, Musée d'Orsay).[67]

The dealer Etienne Bignou (1891–1950) owned three early works[68] which had previously passed through Vollard's hands: *The Two Children*, a *Portrait of Marie Cézanne, Sister of the Artist* (cat. 24a) and *The Rape* (cat. 31), once in Zola's collection.

The family firm of Bernheim, and in particular the two sons of Alexandre Bernheim-Jeune, Joseph (known as Josse, 1870–1941) and Gaston (the painter Gaston Bernheim de Villers, 1870–1953), had in their hands eight early Cézannes in all.[69] The artist wrote to Gaston Bernheim de Villers in 1904: 'I am deeply touched by the marks of esteem and the words of praise contained in your letter.'[70]

A relative of the Bernheims', Joseph (Jos or Josse) Hessel (died 1941), who worked as director of the Galerie Bernheim-Jeune before setting up in business on his own, is listed as the owner of ten or so early period paintings.[71] It was he who bought the wall paintings from the Jas de Bouffan. Cézanne had sold the house to one Louis Granel in 1899; and Granel's son-in-law, Dr Corsy, retained three other youthful works by Cézanne that were still *in situ*.[72]

Eugène Druet, who ran a gallery in the rue Royale, is listed as having owned two paintings.[73]

Finally, the name of the Impressionists' great dealer and friend, Paul Durand-Ruel (1831–1922), appears only once in this connection, as the possessor of *The Rape* (cat.31) after it was owned by Zola and Vollard, and before it went to the United States, where the role played by dealers in artistic life was to become such a vital one.

Foreign Collectors

'The number of studies of mine to which you have extended your hospitality is confirmation in itself of the great feeling for my art which you are kind enough to express', wrote Cézanne on 31 May 1899 to an Italian collector living in Florence, Egisto Paolo Fabbri[74] (1866–1933), who had written him a letter of praise three days previously:

'I am the fortunate possessor of sixteen of your works. I know them in all their austere, aristocratic beauty – to me they are all that is noblest in modern art. And often, looking at them, I have wanted to tell you in person of

the emotion that I feel. . . . Please accept this expression of my profound admiration.'[75]

The Stove in the Studio which had belonged to Auguste Pellerin and before that to Zola, was one of the four early works by Cézanne that Fabbri owned.

Other lovers of Cézanne's early works included a number of dealers and collectors outside France whose names are familiar to historians of modern art: they include Paul Cassirer (1871–1926) in Berlin[76] and the Thannhauser family in Germany and Switzerland.

It was thanks to the efforts of Mary Cassatt, of Durand-Ruel, and later of Bignou and other dealers, that the works of the Impressionists came to be shown in the United States; and the provenance of a number of early works by Cézanne includes the names of some famous transatlantic collectors. Mary Cassatt's faithful friend Louisine Waldron-Elder (1855–1929) and her husband Henry O. Havemeyer[77] (1847–1907) owned two major works of Cézanne's first period: *The Rape* (cat.31), once in Zola's collection, and *The Man with the Straw Hat – Gustave Boyer* (cat.57), which entered the Metropolitan Museum of Art in New York as part of the important bequest passed on by the widow after Havemeyer's death. The collection of Lillie P. Bliss (died 1931), another New Yorker, went to The Museum of Modern Art; it included a landscape by the young Cézanne.[78] John Quinn acquired the *Portrait of Louis-Auguste Cézanne, Father of the Artist* (cat.4), which had formerly adorned the drawing-room of the Jas de Bouffan; on his death in 1925 it was sold to Raymond Pitcairn of Bryn Athyn. Two celebrated New York collections, those of Harry Bakwin and Adolph Lewisohn, each possessed a *Portrait of Uncle Dominique* (see cat.19).[79] The Van Horn collection in Montreal included one youthful Provençal landscape by Cézanne (cat.36).[80]

Finally, the great Russian collections of Sergei Shchukin[81] (1854–1936) and the brothers Ivan (1871–1921) and Mikhail (1870–1904) Morozov[82] were rich in works by Cézanne, including early ones: the *Black and White Still life* belonged to Shchukin, and two early works – one of which is *The Overture to Tannhäuser* (cat. 44) – were in the Morozov collection before being placed in museums in Moscow and Leningrad.[83]

Some Great Twentieth-Century Collectors

The history of the ownership of the works of Cézanne's early period reveals the names of five individuals born between 1870 and 1890 who became known for a highly personal style of collecting.

Related on his father's side to a family of notable collectors, Alphonse Kann (1868–1948),[84] who was of British nationality although he spent almost all his life in France, had four early Cézannes[85] in the collection he assembled in his house at Saint-Germain-en-Laye: the

Bather and Rocks and *Sorrow, or Mary Magdalen* (cat.33) (which were among the decorative paintings bought from the Jas de Bouffan by Hessel), the artist's first *Temptation of St Anthony* (cat. 50) and *Afternoon in Naples* or *The Rum Punch* (cat. 27).

Jacques Laroche acquired *The Angler*, which had belonged to Pissarro before passing to Octave Mirbeau and being included in the sale of his collection on 24 February 1919. In 1947 Laroche gave a group of Impressionist paintings to the French national museums, subject to a lifetime retention in favour of his son, who handed the works over in 1969. It was thus that the Jeu de Paume came to house the fine *Self-Portrait*, painted by Cézanne in 1872 and now in the Musée d'Orsay (cat.63).

Victor Lyon[86] (1878–1963) presented the major part of his collection to the Louvre in 1961, again with a lifetime retention for himself and his son. Since the death of Edouard Lyon in 1977, and in accordance with the donor's wishes, two rooms of the Louvre are set aside for the Hélène and Victor Lyon Donation; this includes the painting *L'Estaque, Evening Effect*, which had previously belonged to Maurice Leclanché and then to Eugène Blot.

Georges Renand (1879–1968), who was successively secretary-general of the Crédit Lyonnais and co-director of the Samaritaine store group, was a client of the dealers

Fig. 41 *Max Kaganovitch in his Parisian apartment.*

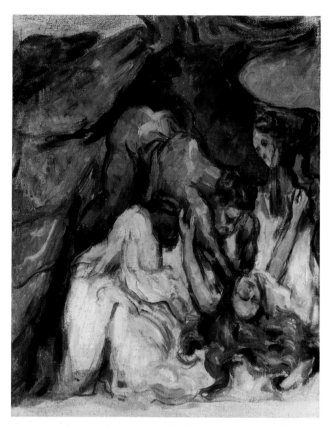

Fig. 42 *The Strangled Woman, c.*1870–72. Musée d'Orsay, Paris (Donation M. and R. Kaganovitch, 1973).

Vollard, Rosenberg and Hessel; he acquired from the last-named the Paris view, painted by Cézanne before 1870 and first owned by Guillaumin, which shows the Rue des Saules in Montmartre (cat.29). After Renand's death, his important collection of old masters, Impressionists and moderns remained in his apartment until his widow died. *The Rue des Saules, Montmartre* was in the recent sale of part of the Georges Renand collection on 20 November 1987.[87]

Max Kaganovitch (1891–1978)[88] who was Ukrainian by origin, left Russia about 1920 and settled in Paris for good a few years later (fig.41). There this former sculptor mounted numerous exhibitions, mostly at the Galerie Le Portique (99, boulevard Raspail), where he started trading in 1934. In 1938, for the first time, he showed works from his own personal collection. In 1973, thanks to Max Kaganovitch's generosity, twenty or so works entered the Musée du Jeu de Paume, where, in accordance with this great benefactor's wishes, a room was set aside for the Max and Rosy Kaganovitch Donation (he had added the name of his wife, who died in 1961). Since the Musée d'Orsay opened in December 1986, Max Kaganovitch's wish has continued to be respected.

In the room devoted to his collection there is a work by Cézanne, painted in 1870–2, which passed through the hands of Vollard and Rosenberg, and which was in a sale at the Galerie Charpentier on 23 February 1954: *The Strangled Woman* (fig.42).[89] In 1973, Hélène Adhémar, then Chief Curator of the Museum of Impressionism at the Jeu de Paume, was particularly anxious to have this small work for her museum, which had not previously held any of the dramatic compositions that are so numerous in Cézanne's early work.

The paintings of the artist's first period have thus always had a place in the affections of his collectors. Not always as attractive to look at as those painted at Auvers-sur-Oise or – in the last years of the artist's life – around Aix-en-Provence, they show the artist torn between the art of the past and the artistic upheavals of the present, but already conveying his own vision of the world.

Maurice Denis emphasised this dual nature of Cézanne's inspiration:

'By instinct, by virtue of an underlying Latin culture and a classical temperament, he unites in his work the chromaticism of the moderns and the robustness of the old masters.

The conflict, the drama, the mystery of Cézanne reside in just this half-deliberate, half-spontaneous combination of a style and a sensibility; utterly characteristic of his genius, this was his torment and his greatness. What others have sought in the imitation of the artists of the past, he ultimately found within himself.'[90]

The interest of the early works lies in the way in which they help us to appreciate all that Cézanne's painting tells us of the man himself, his profound nature, the complexity of his character. His collectors seem to have been able to discern this unique dimension within these youthful works. Picasso made the point with typical sensitivity: 'Cézanne would never have interested me if he had lived and thought like Jacques-Emile Blanche. . . . What interests us is the unease of Cézanne . . . that is to say the drama of the man.'[91]

Translated from the French by David Britt

NOTES

1. *Cézanne, Correspondance*, 1937, pp. 122–3.
2. V. 4, 5, 6, 7, 25, 84, 86; the *Bather with Rock* (V. 83) also has as its first entry under 'provenance' the Jas de Bouffan. See also Rewald, 1986, p. 46: photograph of the drawing-room at the Jas de Bouffan, c.1900.
3. V. 1, 2, 3, 8, 9, 13, 15, 16, 18, 21, 26, 27, 29, 30, 31, 32, 35, 36, 42, 98, 119; V. 28 gives 'P. Cézanne *fils*' as the second owner, after Ambroise Vollard.
4. Vollard, 1924, p. 9.
5. *Cézanne, Correspondance*, 1937, pp. 292, 294–5, letters of 22 and 28 September 1906.

6. Emile Zola, *Mon Salon, Manet, Ecrits sur l'art*, with preface by A. Ehrard (Paris, 1970), p. 45; also quoted by John Rewald in Rewald, 1936, pp. 35–6.

7. V. 22, 55, 64, 69, 81, 101, 118. V. 117 was not in the Zola sale of 9–13 March 1903; it was found at Médan later.

8. Zola sale, 9–13 March 1903, No. 115.

9. V. 22, Zola sale, 9–13 March 1903, No. 117; in Venturi's entry the date of the sale is wrongly given as May.

10. V. 55; Zola sale, 9–13 March 1903, No. 111.

11. V. 64; Zola sale, 9–13 March 1903, No. 112.

12. Zola sale, 9–13 March 1903, No. 114.

13. Zola sale, 9–13 March 1903, No. 116.

14. Zola sale, 9–13 March 1903, No. 113; for the Zola sale see Rewald, 1937, pp. 161–2, with prices and the Rochefort article. The catalogue of the sale itself includes nine works by Cézanne (Nos 110–18): the seven listed by Venturi with a mention of the sale, plus *Nereids and Tritons* (sale No. 110) and *Still Life* (sale No. 118).

15. *Cézanne, Correspondance*, 1937, pp. 92–3, and p. 105, letter of 24 May 1868.

16. V. 72.

17. Xavier de Magallon is quoted by Rewald in *Cézanne, Correspondance*, 1937, p. 270 n. 1, and in *Rewald*, 1986, p. 219. I am grateful to Bruno Ely, assistant curator at the Musée Granet, Aix-en-Provence, for supplying accurate information on the family of Xavier de Magallon.

18. *Cézanne, Correspondance*, 1937, p. 122, letter of 26 September 1874.

19. Jules Borély, 'Cézanne à Aix', *L'Art Vivant*, No. 2 (1926), pp. 491–3, reprinted in *Conversations avec Cézanne*, ed. P.M. Doran (Paris, 1978), p. 21.

20. Pissarro, *Letters to his Son Lucien*, ed. J. Rewald (New York, 1943).

21. Rewald, 1936, p. 82, letter of 8 December 1872 (dated 1873, presumably by mistake), now in the Musée du Louvre, Département des Arts graphiques.

22. Pissarro, 1943, letter of March 1884.

23. V. 93 (Camille Pissarro sale, 3 December 1928, No. 14).

24. V. 115.

25. Sophie Monneret, *L'Impressionnisme et son époque, Dictionnaire international illustré* (Paris, 1978–80), vol. 1, pp. 219–20, and Michel Laclotte, ed., *Le Petit Larousse de la peinture* (Paris, Larousse, 1979), vol. 1, p. 674, article by Marie-Thérèse de Forges; Van Gogh, *Portrait of Dr Gachet*, 1890 (Paris, Musée d'Orsay, RF 1954–15).

26. V. 63; V. 66 (Paris, Musée d'Orsay, RF 1954–6), 67 (Paris, Musée d'Orsay, RF 1954–7); the two last-named still lifes are listed by Venturi among the works of Cézanne's first period (which is why they are mentioned here), but they are generally considered to date from 1872–3.

27. Monneret, 1978–80, vol. 2, pp. 96–8; *Petit Larousse*, vol. 2, p. 1251, article by Anne Distel. See also Pissarro, 1943, letter of 13 October 1887; Anne Distel, 'Les Amateurs de Renoir', exhibition catalogue *Renoir* (London, Paris and Boston 1985–6), p. 34.

28. *Cézanne, Correspondance*, 1937, p. 220, letter of 6 July 1895.

29. V. 100 (*The Negro Scipion*) and 102 (*Portrait of a Man*).

30. Daniel Wildenstein, *Claude Monet, biographie et catalogue raisonné* (Lausanne and Paris, 1979), vol. 3, p. 278, letter 1256 of 23 November 1894.

31. V. 115; Octave Mirbeau sale, 24 February 1919, No. 3. On the links between Cézanne and Mirbeau, see *Cézanne, Correspondance*, 1937, pp. 270–1, where Rewald recalls that Mirbeau had tried, unsuccessfully, to get the *Légion d'Honneur* for Cézanne.

32. Pissarro, 1943, letters of 21 November and 4 December 1895.

33. V. 124; Degas sale, Galerie Georges Petit, 26–7 March 1918, No. 9.

34. V. 111; Henri Rouart sale, Paris, Galerie Manzi-Joyant, 9–11 December 1912, No. 95 (*Nude Study*). Rivière (1923, p. 250)

35. and Venturi refer wrongly to No. 94 in the sale, which is a *Still Life*; for Rouart, see also Distel, in *Renoir*, 1985–6, p. 30.

35. *Cézanne, Correspondance*, 1937, p. 157, letter to Chocquet of 28 January 1879; p. 132, letter to Zola of 28 August 1877, and n. 1, reference to the article by Emile Bernard in *Le Mercure de France*, 26 December 1908. See also Pissarro, 1943, p. 339 n. 1: 'After the death of Père Tanguy [1894], his collection was auctioned off. The bidding was very low. The paintings by Cézanne fetched between 45 and 215 francs.' See also Monneret, 1978–80, vol. 2, pp. 291–3, and *Le Petit Larousse*, 1979, vol. 2, p. 1790.

36. V. 12 (*Peaches in a Dish*).

37. Georges Rivière, 'L'Exposition des Impressionnistes', *L'Impressionniste, Journal d'Art*, 14 April 1877, pp. 2–3.

38. Gustave Geffroy, 'Paul Cézanne', *Le Journal*, 25 March 1894, reprinted and expanded in *La Vie Artistique* (3rd series, Paris, 1894), pp. 249–60 (pp. 249–51 quoted here).

39. Monneret, 1978–80, vol. 1, pp. 130–1, and *Le Petit Larousse*, 1979, vol. 1, p. 321, article by P.Th. Madroux-Franca; on Charpentier, see also Distel, in *Renoir*, 1985–6, pp. 31, 33–4.

40. Georges Charpentier sale, 11 April 1907, No. 3.

41. Théodore Duret, *Histoire des peintres impressionnistes* (Paris, 1906), p. 186; see also Monneret, 1978–80, vol. 1, p. 182, and Distel, *Renoir*, 1985–6, p. 33.

42. V. 133; Chocquet sale, 1899.

43. Monneret, 1978–80, vol. 1, p. 141. See also *Cézanne, Correspondance*, 1937, p. 234 n. 2.

44. V. 57; Eugène Blot sale, 2 June 1933, No. 44. See Hoog, in exhibition catalogue *Cézanne dans les musées nationaux* (Paris, Orangerie des Tuileries, 1974), No. 20.

45. Monneret, 1978–80, vol. 1, p. 323.

46. Monneret, 1978–80, vol. 1, p. 78.

47. Rewald, 1937, p. 157; reprint of the preface written by Lecomte for the catalogue of the Blot collection (Paris, H. Drouot, 1900, p. 26).

48. Monneret, 1978–80, vol. 2, pp. 114, and *Le Petit Larousse*, 1979, vol. 1, pp. 1403–4, article by Anne Distel. A *Portrait of Auguste Pellerin* by Matisse is in the Centre national d'Art et de Culture Georges Pompidou (AM 1982–97P). A crayon drawing on paper (560 × 375mm) by Matisse, representing Pellerin, was acquired by the Centre Pompidou in 1984 (AM 1984–47D). The first version of Matisse's *Portrait of Auguste Pellerin* (100 × 75cm, Private Collection) was in the centenary exhibition *Henri Matisse*, Paris, Grand Palais, 1970, No. 131.

49. Venturi, vol. 1, index of places, pp. 397 (Lecomte Collection), 398 (J.-V. Pellerin Collection).

50. Emile Bernard, 'La Technique de Paul Cézanne', *L'Amour de l'Art* (December 1920), p. 278 n. 1, on Cézanne's artistic career: 'The Pélerin [*sic*] collection currently gives a comprehensive notion of it. There it is possible to follow all the phases of a tireless quest.' Fry, 1927, 'Preface to First Edition': 'M. Pellerin's collection is so much the most representative of all the various phases of Cézanne's art in existence, that a study of it is essential to understanding his development. . . .'

51. These were *Still Life with Soup Tureen*, c.1877, V. 494, *Still Life with Basket*, c.1888–90, V. 594 and *Still Life with Onions*, c.1895, V. 730 (Paris, Musée d'Orsay, RF 2818, RF 2819 and RF 2817, respectively). See Georges Pascal, 'Les Cézannes de la collection Pellerin', *Beaux-Arts* (20 November 1929), p. 5, and Georges Rey, 'Trois tableaux de Cézanne', *Bulletin des musées de France* (December 1929), No. 12, pp. 272–5.

52. To mark the fiftieth anniversary of Cézanne's death, in 1956, M and Mme Jean-Victor Pellerin generously agreed to donate to the Musée du Louvre the famous figure painting *Woman with a Coffee Pot* (c.1890–5; Paris, Musée d'Orsay, RF 1956–13; see Germain Bazin, 'La Femme à la cafetière' de Cézanne entre au Louvre', *Arts*, 26 December 1956–1 January 1957). In 1964,

thanks to a donor who has chosen to remain anonymous, another painting from Pellerin's collection found its way to the Louvre. This was the amazing *Portrait of Achille Emperaire*, rejected at the 1870 Salon (Paris, Musée d'Orsay, RF 1964–38). Then, in 1969, an anonymous donation subject to a life interest added two more magnificent paintings which had belonged to Auguste Pellerin, and which will one day hang in the Musée d'Orsay: *Mont Sainte Victoire* (c.1890, RF 1969–30) and the *Portrait of Gustave Geffroy* (1895, RF 1969–29); see the exhibition catalogue *Cézanne dans les musées nationaux*, 1974, Nos. 37 and 45, articles by Michel Hoog. Finally, in 1982, twelve more of Pellerin's Cézannes reached the Musée d'Orsay collection after being left to the State in lieu of death duties (RF 1982–38 to RF 1982–49); see Sylvie Gache-Patin, 'Douze œuvres de Cézanne de l'ancienne collection Pellerin', *La Revue du Louvre et des Musées de France* (April 1984), No. 2, pp. 128–46. Some of these works have been placed on loan at the Musée Granet in the painter's birthplace, Aix-en-Provence.

53. Among these are the *Portrait of Cézanne's Father Reading 'L'Evénement'* (Washington, National Gallery of Art), *Mme Cézanne in a Yellow Armchair* (New York, The Metropolitan Museum of Art), *The Large Bathers* (Philadelphia, Museum of Art) and *Bathers* (London, National Gallery).

54. V. 11, 18, 51, 54, 55, 56, 58, 62, 64, 74, 75, 79, 81, 82, 84, 88, 91, 92, 95, 96, 99, 104, 105, 106, 107, 111, 114, 116, 118, 126, 127, 130.

55. V. 74, 75, 79, 82.

56. V. 55, 51.

57. V. 11, 51, 54, 62, 74, 75, 79, 82, 91, 92, 95, 99, 105, 107, 114, 116.

58. Vollard, 1924, p. 89; this episode is retold in the same author's *En écoutant Cézanne, Degas, Renoir* (Paris, Grasset, 1938), p. 44 (Cézanne, pp. 7–95).

59. Pissarro, 1943, letter of 21 January 1894; see also Monneret, 1978–80, vol. 3, pp. 56–9, and *Le Petit Larousse*, 1979, vol. 2, pp. 1950–1, article by Anne Distel.

60. *Cézanne, Correspondance*, 1937, pp. 246–7, letters to Camoin of 3 February and 11 March 1902.

61. *Cézanne, Correspondance*, 1937, p. 252, letter to Vollard of 9 January 1903.

62. Duret, 1906, p. 190.

63. V. 4, 5, 6, 7, 10, 17, 19, 24, 28, 33, 34, 37, 38, 46, 49, 73, 89, 101, 109, 112, 113, 122, 123, 132.

64. V. 109.

65. V. 20, 39, 40, 64, 69, 73, 117, 122, 123, 124; see also *Le Petit Larousse*, 1979, vol. 2, p. 1613, article by A. Angliviel de La Baumelle.

66. V. 122.

67. V. 123.

68. V. 10, 89, 101; see also *Le Petit Larousse*, 1979, vol. 1, p. 177, article by Anne Distel.

69. V. 23, 47, 50, 60, 70, 83, 106, 120; see Monneret, 1978–80, vol. 1, pp. 73–4, and *Le Petit Larousse*, 1979, vol. 1, pp. 170; also *Renoir*, 1985–6, p. 43.

70. *Cézanne, Correspondance*, 1937, p. 266, letter of 11 October 1904.

71. V. 4, 5, 6, 7, 45, 73, 83, 84, 86, 118, 120 and probably 25; see also Monneret, 1978–80, vol. 1, pp. 277–8.

72. V. 14, 85, 87. I am grateful to Bruno Ely for having elucidated for me the exact relationships between the Granel and Corsy families.

73. V. 12, 96.

74. Monneret, 1978–80, vol. 1, p. 203, and *Le Petit Larousse*, 1979, vol. 1, p. 565.

75. *Cézanne, Correspondance*, 1937, pp. 237–8, letter of 31 May 1899 and letter from Egisto Fabbri of 28 May 1899; see also p. 306, bibliographical reference to A. Germain, *In memoriam E.P. Fabbri*, Florence 1934. Fabbri owned *The Stove in the Studio* (V. 64), and three other early paintings, V. 39, 40, 94.

76. V. 108, 110, 121; see Monneret, 1978–80, vol. 1, p. 114, and *Le Petit Larousse*, 1979, vol. 1, pp. 291–5.

77. Monneret, 1978–80, vol. 1, pp. 268–9, and *Le Petit Larousse*, 1979, vol. 1, pp. 799–800, article by G. Barnaud.

78. V. 52; subsequently de-accessioned (see cat.61).

79. V. 77.

80. V. 53; see *Renoir*, 1985–6, p. 37.

81. Monneret, 1978–80, vol. 2, p. 278, and *Le Petit Larousse*, 1979, vol. 1, p. 340, article by G. Barnaud.

82. Monneret, 1978–80, vol. 2, pp. 92–3, and *Le Petit Larousse*, 1979, vol. 2, p. 1236, article by G. Barnaud.

83. The other painting V. 24 is in the Pushkin Museum of Western Art, Moscow.

84. *Le Petit Larousse*, 1979, vol. 1, p. 934.

85. V. 83, 86, 103, 112.

86. Isabelle Compin and Anne Distel, 'Acquisitions: la donation Hélène et Victor Lyon', *La Revue du Louvre et des Musées de France*, 1978, Nos. 5 and 6, pp. 380–406 and particularly 398–9.

87. Catalogue of Georges Renand sale, Paris, Drouot-Montaigne, 20 November 1987, No. 4, colour reproduction.

88. See Raymond Cogniat, 'M. Max Kaganovitch: "La peinture que j'ai acheté à Paris"', *Connaissance des Arts*, No. 211 (September 1969), pp. 44–51; 'Ce Monsieur Kaganovitch qui nous donne une fortune', *Paris-Match* (1973); *Le Monde* (8 April 1978).

89. V. 123; sale at Galerie Charpentier, 23 February 1954, No. 54 (Maître Buffetaud's research suggests that Max Kaganovitch acquired the work at this sale through the intermediary of another gallery).

90. Maurice Denis, 'L'influence de Cézanne', *L'Amour de l'Art* (December 1920), p. 283.

91. Transcription by Christian Zervos of an interview with Picasso: 'Conversation avec Picasso', *Cahiers d'Art*, X (1935), p. 178.

The Catalogue

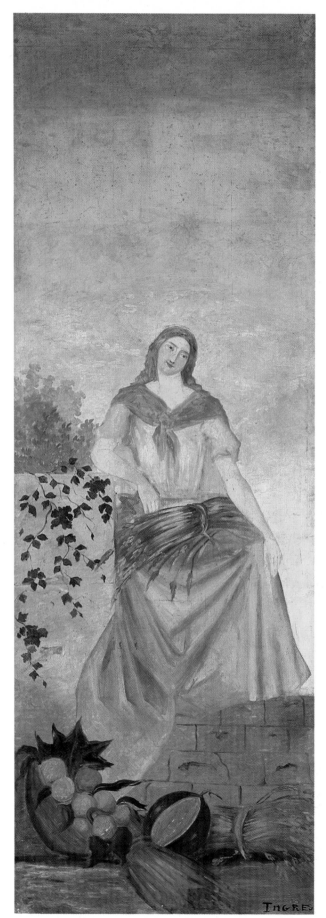

1c

1a

1b 1d

1 The Four Seasons

(Les Quatres Saisons)

Cézanne's father, Louis-Auguste, bought the country mansion of the Jas de Bouffan a short distance to the west of Aix in 1859 and was at first in no hurry to redecorate the grand salon of the house. His son, however, had plans for it almost from the first. On 13 June 1860 his schoolfellow, Emile Zola, who had moved to Paris, wrote to tell Cézanne that during a country walk he had come on a café in the village of Vitry decorated with large and striking panels 'such as you want to do at home'. On 21 September of the same year another of Zola's circular letters to his old friends in Aix mentioned that during a coming holiday in Aix he had much to see, including 'Paul's panels and Baille's moustache'. It would seem that after six months there was at least enough painting by Paul to take note of in the salon but that it was no more seriously regarded than a new moustache. It seems likely that by September 1862 when Paul, with his father's agreement, went to study in Paris, the chief decorations in the salon were at least sufficiently impressive to weigh against parental opposition.

The *Seasons* filled an alcove at one end of the salon but the calendar order of the arrangement was disturbed by the fact that in the series from left to right *Winter*, the fourth subject, preceded *Autumn,* the third. This evidently reflected two successive phases in the work of painting. It would seem that the scheme, which was painted on the wall and could not be rearranged, began by way of experiment with the paintings of *Summer* and *Winter* to left and right of the alcove. This experiment must have been regarded as successful, as it was soon extended by the addition of *Spring* and *Autumn* on the adjoining walls to left and right. To judge by the first reference in Zola's letter to Paul's wishes, this intention was already formed by the June in which Cézanne was twenty-one. By the time he went to study in Paris at twenty-three, he had probably painted – on the other walls of the salon and elsewhere – pictures comparatively so self-reliant as to make the *Seasons* seem naïve. We may therefore suppose that these juvenilia, as enterprising though not as assured as any painter of the time has left us, were carried out in the later months of 1860, possibly through 1861.

There are ironical inscriptions on these pictures, which yield surprising information about the mood in which Cézanne was painting. *Winter* is inscribed 'Ingres 1811'. This is an echo of the inscription by Ingres himself on his *Jupiter and Thetis*, the largest and most famous picture in the Aix Museum, which Ingres signed and dated from Rome in that year. Cézanne never cared for Ingres and a highly Romantic youthful commitment developing under the dominance of an antipathetic masterpiece was cause enough for his antagonism. It may even be that Cézanne's mocking inscription was intended in 1861 specifically to pillory the half-centenary of Ingres.

Several of Cézanne's subsequent pictures in the 1860s contributed to the continuing decoration of the salon at the Jas de Bouffan, early among them perhaps his first portrait of his father which was added between the *Seasons,* where it centralised their symmetry (cat. 4). On the long left wall of the room there was a decoration showing the back of a male bather in a landscape (fig. 3), which was coarsely adapted from the *Baigneuse* by Courbet that Napoleon III had struck at with his whip in 1853. The figure that Cézanne inserted in his decoration was later cut out and removed. It now hangs in the Chrysler Museum at Norfolk, Virginia. If this or another such borrowing from Courbet was painted as early as 1860 it may have accounted for Cézanne's claim to realism in a letter now lost and his boast that he painted only subjects that were devoid of poetry, which Zola answered on 25 March 1860. No other surviving picture fills the bill. Zola, however, took Cézanne's claim to imply (according to the popular meaning of 'realism') that he chose for preference to paint sordid subjects and warned him astutely that the choice to paint a dung heap reflected associations that were in their own way no less aesthetic than the choice to paint a flower. Neither a dung hill nor a flower is in evidence among Cézanne's early pictures.

On the right, opposite the bather, a diffuse and detailed sunset view over a flooded river towards distant towers and spires was later discovered under wallpaper and was for a time known as *Landscape with a Fisherman* (fig. 2), until it was removed, dismembered, and sold in numerous fragments. A copy of Lancret, possibly suggested by Zola's description of the village fêtes in the café at Vitry, was also originally in the salon. A subject now entitled *Contrasts* (cat. 42), the heads of a young woman and an old man, is included in the present exhibition. The later additions to the decoration of the salon were in character miscellaneous; those that figure here are discussed in cat. 4 and cat. 42.

a) Summer
(Eté)

*c.*1860–62
314 × 109 cm 124 × 43 in
Inscribed lower right: INGRES
V.5
Musée de la Ville de Paris, Petit Palais

PROVENANCE Jas de Bouffan, Aix-en-Provence; Louis Granel,
Aix-en-Provence; Jos. Hessel, Paris; Ambroise Vollard, Paris.

EXHIBITION Paris, Petit Palais, 1953, *Une Siècle d'Art Français*, no. 441, pl. 37.

BIBLIOGRAPHY Mack, 1936, fig. 12; Mack, Paris, 1938, ill. opp. p. 129;
Dorival, 1948, pl. 2; Ikegami, Tokyo, 1969, fig. 2; N. Ponente, *Paul
Cézanne*, Bologna, 1980, p. 14, ill.; D. Coutagne, *Cézanne au Musée d'Aix,*
Aix-en-Provence, 1984, p. 175, ill.

b) Winter
(Hiver)

*c.*1860–62
314 × 104 cm 124 × 41 in
Inscribed and dated lower left: INGRES *1811*
V. 7
Musée de la Ville de Paris, Petit Palais

PROVENANCE Jas de Bouffan, Aix-en-Provence; Louis Granel,
Aix-en-Provence; Jos. Hessel, Paris; Ambroise Vollard, Paris.

EXHIBITION Paris, Petit Palais, 1953, *Une Siècle d'Art Français*, no. 443, pl. 37.

BIBLIOGRAPHY F. Burger, *Cézanne und Hodler* (fifth edition), Munich, 1923,
pl. 188; A. Zeisho, *Paul Cézanne*, Tokyo, 1921, fig. 34; Rivière, 1933, p. 3,
ill.; Mack, 1936, fig. 12; Mack, Paris, 1938, ill. opp. p. 129; Cogniat, 1939,
pl. 1; Rivière, Paris, 1942, p. 5, ill.; Dorival, 1948, pl. 3; Schapiro, 1973,
p. 55, ill.; Ikegami, Tokyo, 1969, fig. 3; Venturi, 1978, ill. p. 4; N. Ponente,
Paul Cezanne, Bologna, 1980, p.15, ill.; D. Coutagne, *Cézanne au Musée
d'Aix,* Aix-en-Provence, 1984, p. 175, ill.

c) Spring
(Printemps)

*c.*1860–62
314 × 97 cm 124 × 38 in
Inscribed lower right: INGRES
V.4
Musée de la Ville de Paris, Petit Palais

PROVENANCE Jas de Bouffan, Aix-en-Provence; Louis Granel,
Aix-en-Provence; Jos. Hessel, Paris; Ambroise Vollard, Paris.

EXHIBITION Paris, Petit Palais, 1953, *Une Siècle d'Art Français*, no. 440, pl. 37.
Turin, Galleria Civica d'Arte Moderna, 1971, Il Cavallero Azzuro, n.n.

BIBLIOGRAPHY A. Pératé, 'Le Salon d'Automne', *Gazette des Beaux-Arts*,
1907, p. 388; F. Burger, *Cézanne und Hodler* (fourth edition), Munich, 1920,
pls. 187 and 188; *Cézanne und Hodler* (fifth edition), Munich, 1923, pl. 187;
Vollard, 1915, p. 18; Coquiot, 1919, p. 41; Gasquet, 1921, ill. opp. p. 44;
A. Zeisho, *Paul Cézanne*, Tokyo, 1921, fig. 36; Rivière, 1923, p. 196, listed,
ill. p. 8; R. Fry, *Samleren*, 1929, p. 100, ill.; Ors, 1930, pl. 25; Rivière, 1933,
p. 3, ill.; Ors, 1936, pl. 38; Mack, 1936, pp. 145–7, pl. 12; Raynal, 1936, pls. II
and III; Rewald, 1936, fig. 13; Novotny, 1937, p. 20; di San Lazzaro, 1938,
fig. 38; Mack, Paris, 1938, ill. opp. p. 129; Rivière, 1942, p. 5, ill.; Dorival,
1948, pl. 2; W. Sargent, *Life,* 25 Feb. 1952, p. 78, ill.; D. Cooper, 'Au Jas de
Bouffan', *Œil,* 15 Feb. 1955, p. 16; I. Elles, *Das Stilleben in der französischen
Malerei des 19. Jahrhunderts,* Zurich, 1958; Ikegami, Tokyo, 1969, fig. 1;
Schapiro, 1973, p. 54, ill.; Elgar, 1975, fig. 4; N. Ponente, *Paul Cézanne,*
Bologna, 1980, p.10, ill.; D. Coutagne, *Cézanne au Musée d'Aix,* Aix-en-
Provence, 1984, p. 175, ill.; B. Bernard, *The Impressionist Revolution,* London,
1986, p. 112, ill.

d) Autumn
(Automne)

*c.*1860–62
314 × 104 cm 124 × 41 in
Inscribed lower right: INGRES
V.6
Musée de la Ville de Paris, Petit Palais

PROVENANCE Jas de Bouffan, Aix-en-Provence; Louis Granel,
Aix-en-Provence; Jos. Hessel, Paris; Ambroise Vollard, Paris.

EXHIBITION Paris, Petit Palais, 1953, *Un Siècle d'Art Français,* no.442,
pl. 37.

BIBLIOGRAPHY Mack, New York, 1936, fig. 12; Mack, 1938, ill. opp. p. 129;
Dorival, 1948, pl. 3; Ikegami, Tokyo, 1969, fig. 4; Elgar, 1975, fig. 3;
N. Ponente, *Paul Cézanne*, Bologna, 1980, p. 15, ill.; D. Coutagne, *Cézanne
au Musée d'Aix,* Aix-en-Provence, 1984, p. 175, ill.

2 Self-Portrait

(Portrait de l'artiste)

c.1861–2
44 × 37 cm $17\frac{3}{8}$ × $14\frac{1}{2}$ in
V.18
Private Collection

A photograph of Cézanne said to have been taken in 1861 when he was twenty-two was the source of the first self-portrait of which we know. The intensity of gaze and the dour, grey modelling, flecked with accents of blood-red at emotionally crucial points, lead one to suspect a critical moment in the young man's fortunes, perhaps a crisis in the plans of the artist-to-be or the emergence of a private determination in the face of his father's opposition. He never, that we know of, painted in such a manner or under such pressure again.

PROVENANCE Paul Cézanne fils, Paris; Auguste Pellerin, Paris; René Lecomte, Paris.

EXHIBITIONS Lyon, Palais Saint-Pierre, 1939, no. 1, pl. 1; Paris, Bibliothèque Nationale, 1952, *Emile Zola*, no. 39; Paris, Orangerie, 1954, no. 1.

BIBLIOGRAPHY H. von Wedderkop, 'Paul Cézanne', *Cicerone*, 16 Aug. 1922, p. 683, ill.; H. von Wedderkop, *Paul Cézanne*, Leipzig, 1922, pl. I; Rivière, 1923, p. 196, listed; Rewald, 1936, fig. 4; Rewald, 1939, fig. 10; G. Bazin, *L'Epoque impressionniste*, Paris, 1947, pl. 18; Dorival, 1948, pl. 1; K. Leonhard, *Paul Cézanne in Selbstzeugnissen und Bilddokumenten*, Rheinbek bei Hamburg, 1966, p. 78, ill.; P. Pool, *Impressionism*, New York, 1967, pl. 7; Schapiro, 1973, p. 56, ill.; Elgar, 1975, pl. 6.

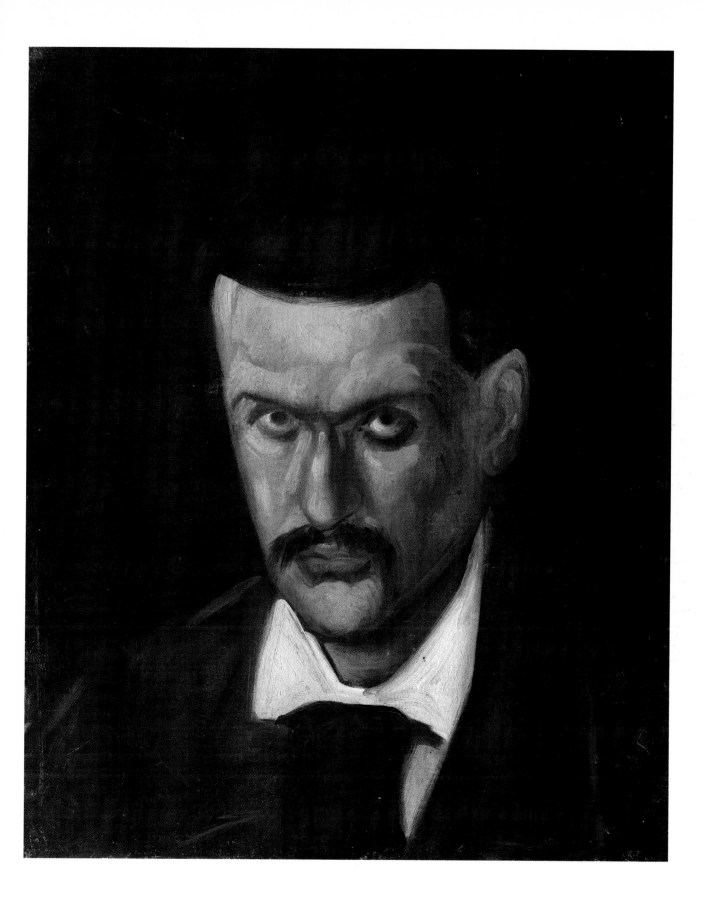

3 Lot and his Daughters

(Lot et ses filles)

*c.*1861
23.6 × 28.7 cm 9¼ × 11⅜ in
non-V.
Private Collection

The unbridled fancy of Cézanne's letters at nineteen and the erotic poems that often accompanied them, as well as the fertility of the scribble in his earliest sketchbooks, have previously seemed to leave surprisingly little mark on the circumspect restraint of his first paintings. Some of these were derived from conventional pictures loved by his sisters, for whom Paul's versions are said to have been made. Pictures like his copy of Frillié's *Rêve du poète* (1857, V.11; Musée Granet, Aix-en-Provence) were in fact very unlike Paul's own dreams as he confessed them to his friends. But recently this picture has come to light and it is quite different from the polite subjects for family consumption, although it is evidently by the same hand. The roundness with which the figures of Lot's daughters separate themselves from the Venetian shadow around them suggests a more developed capacity than most of Cézanne's pictures from before 1865, but a similar painterly direction. His illustration of the subject, though quite small, is far more gross than the versions of it that he saw in the Louvre.

The newly revealed picture descends from a former resident of Aix, who came by original material in the city. In present conditions the fantasy seems less disgraceful than formerly and more significant. In 1860 it would have been on the edge of pornography and was in spirit perhaps not far removed from it.

PROVENANCE Private Collection, Aix-en-Provence.

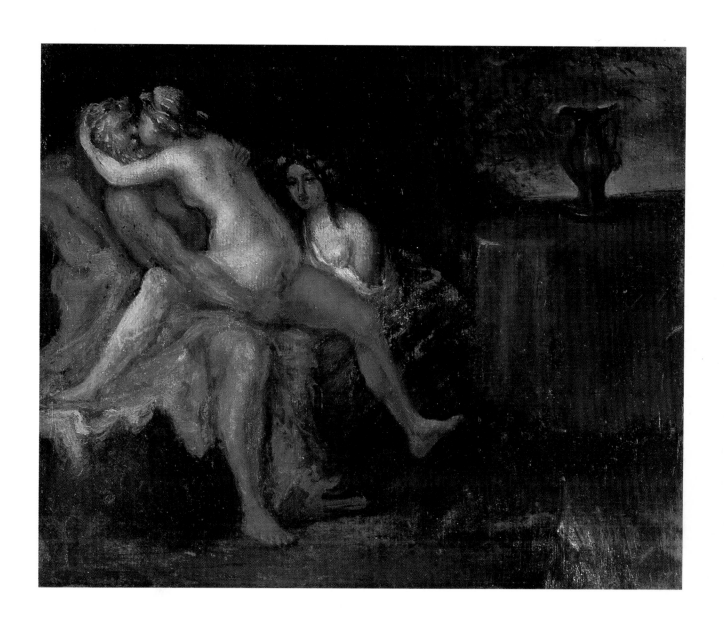

4 Portrait of Louis-Auguste Cézanne, Father of the Artist

(Portrait de Louis-Auguste Cézanne, père de l'artiste)

*c.*1862
On thin plaster on canvas; 168 × 114 cm 66 × 45 in
V. 25
The Trustees of the National Gallery

The portrait of the formidable master of the house was placed between *Summer* and *Winter* in the alcove of the salon in the Jas de Bouffan, one can only suppose to his gratification. The portrait had no relation to the style of the *Seasons* (cat. 1) beside it. The *Seasons* raise the at present unanswerable question of how much, and how, Cézanne knew about Renaissance painting at twenty-one; the portrait of Louis-Auguste inspires admiration for the originality and the force of the painter's adaptation of the realism of his own time. The red tiled floor may remind one of the colour on which Titian painted Charles V (in a portrait which Cézanne could not have known) but the bulging vigour of the formulation has no similarity to any existing style except the rotund modelling current among the Espagnolist painters working in the wake of Courbet. It is significant that in one of Cézanne's earliest pictures his formulation of solidity should already have been an essentially original, invented one.

PROVENANCE Jas de Bouffan, Aix-en-Provence; Louis Granel, Aix-en-Provence; Jos. Hessel, Paris; Georges Bernheim, Paris; John Quinn, New York; Raymond Pitcairn, Bryn Athyn, Pa (on extended loan to the Philadelphia Museum of Art); Sale, Parke-Bernet, New York, 26 Oct., 1967, no. 31, ill., bought-in.

EXHIBITIONS New York, Art Center, 1926, *Memorial Exhibition – John Quinn Collection*, no. 37, ill.; Philadelphia, Pennsylvania Museum of Art, 1934, no. 1, ill.; San Francisco, San Francisco Museum of Art, 1937, no. 1; Chicago, Art Institute, 1952, No. 1, ill. —New York, Metropolitan Museum, 1952, no. 1, ill.; New York, Wildenstein Galleries, 1959, no. 1, ill.; Vienna, Belvedere, 1961, no. 1 —Aix-en-Provence, Pavillon de Vendôme, 1961, no. 1; Liège, Musée Saint-Georges, 1982, no. 1 —Aix-en-Provence, Musée Granet, 1982, no. 1.

BIBLIOGRAPHY Meier-Graefe, Munich, 1910, p. 13, ill.; Vollard, 1914, p.31; Gasquet, 1921, ill. opp. p. 10; Meier-Graefe, 1922, ill. p. 89; Meier-Graefe, Munich, 1923, p. 13, ill.; T. Klingsor, *Cézanne*, Paris, 1923, p. 13; Rivière, 1923, p. 203, listed; *The John Quinn Collection of Paintings, Watercolours, Drawings, and Sculpture*, New York, 1926, p. 7, ill. p. 37; Gasquet, 1926, ill.; Pfister, 1927, fig. 14 (dated 1863); Ors, 1930, p. 29, ill.; Mack, 1936, fig. 12; Raynal, 1936, pl. II; Rewald, 1936, fig. 13; Mack, Paris, 1938, ill. opp. p. 129; R. Goldwater, 'Cézanne in America', *Art News*, 26 March, 1938, p. 139, ill.; E. Jewell, *Paul Cézanne*, New York, 1944, p. 48, ill.; G. Schildt, *Cézanne*, Stockholm, 1946, fig. 2; Dorival, 1948, pl. 4; Schapiro, 1952, p. 25, ill.; D. Cooper, 'Au Jas de Bouffan', *Œil*, 15 Feb., 1955, pp. 26–7; 'Chronique des Arts', *Gazette des Beaux-Arts*, Feb. 1969, p. 98, fig. 402; M. Davies, and C. Gould, *National Gallery Catalogues, French School, Early 19th Century. Impressionists, Post-Impressionists*, London, 1970, pp. 24–6, no. 6385; J. Rewald, 'Cézanne and His Father', *Studies in the History of Art*, 1971, pp. 45ff., fig. 1; Venturi, 1978, ill. p. 10; J. Zilczer, *'The Noble Buyer': John Quinn, Patron of the Avant-Garde*, Washington, D.C., 1978, Appendix I, p. 153; T. Reff, 'Cézanne: The Severed Head and the Skull', *Arts*, Oct. 1983, p. 88, fig. 5; J. Rewald, *Studies in Impressionism*, London, 1985, pp. 76, 78, fig. 38; B. Bernard, *The Impressionist Revolution*, London, 1986, p. 235, ill.

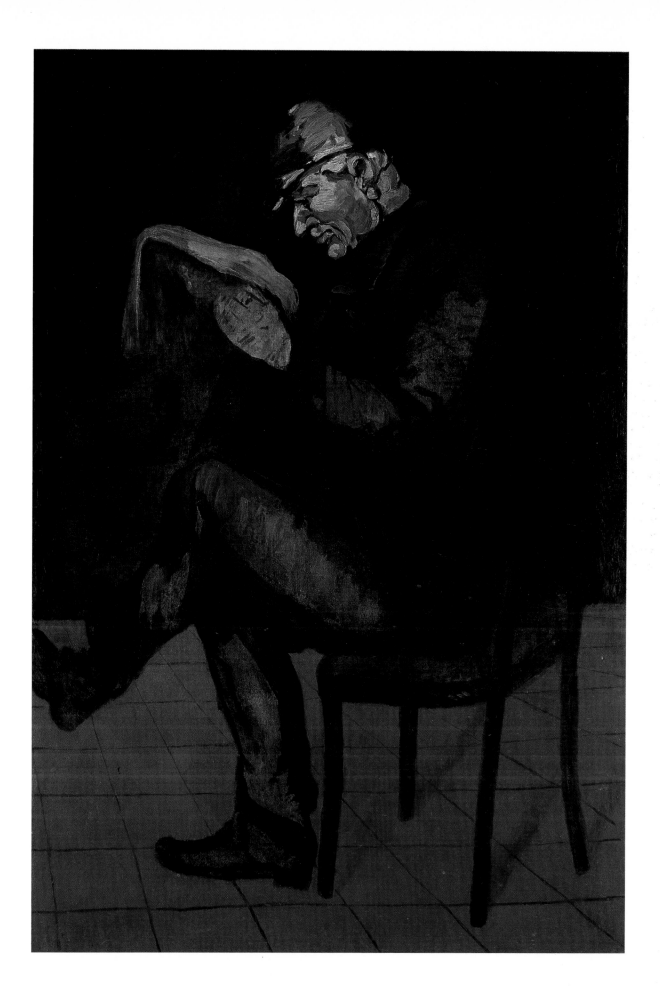

5 'The Barque of Dante', after Delacroix

('La Barque de Dante', d'après Delacroix)

c.1864
22.5 × 33 cm 8⅞ × 13 in
V.125
Private Collection, Cambridge, Mass.

Between 1822, when it was purchased by the state and hung in the Luxembourg, and 1874, when it passed to the Louvre, Delacroix's early masterpiece was copied by numerous painters, including Manet in 1854. Cézanne obtained a pass to copy in the Louvre on 20 November 1863 and in February 1864 he wrote to his friend Numa Coste that he 'had not touched his . . . after Delacroix for more than two months.' Unfortunately, the missing word is illegible, but the animation of the brush here as well as the strength of colour seem not unlike pictures that may have been painted before 1866. If Cézanne's work disabuses us of the former idea that his painting was ever in these years incompetent in the usual sense, 1864 may be regarded as a possible date for the execution of this copy. Cézanne's copies very rarely followed an original as closely as this. Indeed, the only copies that he ever painted as faithfully as this, a watercolour version of *Medea* (RWC.145), an oil of the *Bouquet* which Vollard gave him in 1900 (V.754), a picture of *Hamlet and Horatio* (non-V.) and this, were all after originals by Delacroix.

PROVENANCE Joachim Gasquet, Aix-en-Provence; Xavier de Magallon, Aix-en-Provence (friend of Gasquet's); Alfred Gold, Berlin; Eugène Blot, Paris; Sale, Blot Collection, Hôtel Drouot, Paris, 23 April, 1937, no. 52, pl. III; Storran Gallery, London; Kenneth Clark; Lady Clark, London; E.V. Thaw, New York.

EXHIBITIONS London, Storran Gallery, 1939, *Paraphrases*, n.n.; Edinburgh, Royal Scottish Academy, 1954, no. 1 — London, Tate Gallery, 1954, no. 1; London, Tate Gallery, 1959, *The Romantic Movement*, no. 51.

BIBLIOGRAPHY Gasquet, 1921, ill. opp. p. 96; Meier-Graefe, 1922, ill. p. 93; Rivière, 1923, p. 198, listed; Iavorskaia, 1935, pl. 5; Barnes and de Mazia, 1939, no. 29 (listed); E. Loran, 'The Formal Sources of Delacroix's "Barque de Dante"', *The Burlington Magazine*, 1948, p. 231, note 12; W. Andersen, 'Cézanne Self-Portrait Drawing Re-identified', *The Burlington Magazine*, June 1964, p. 285, note 4; S. Lichtenstein, 'Cézanne and Delacroix', *The Art Bulletin*, March 1964, p. 55, note 5; S. Lichtenstein, 'Cézanne's copies and variants after Delacroix', *Apollo*, Feb. 1975, fig. 1; L. Johnson, *Eugène Delacroix – A Critical Catalogue 1816–1831*, Oxford, 1981, no. 100, pp. 73–4.

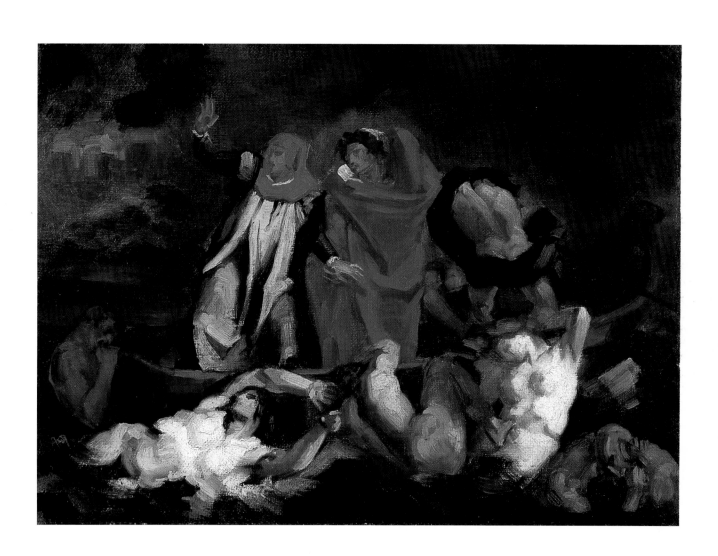

6 Head of an old Man

(Tête de vieillard)

c.1865
51 × 48 cm 20 × 18⅞ in
V. 17
Musée d'Orsay, Paris

It has been suggested that this might be a portrait of Père Rouvel, the father of Cézanne's hostess at Bennecourt (see cat. 17), whom he painted during the summer of 1866. This is, however, a smaller picture which could hardly have been painted in the open air without showing more signs of the freshness of natural light. Moreover, this was certainly painted in Cézanne's habitual studio, where abandoned canvases were to hand, as for this portrait, where he used the canvas of an unfinished picture. This represented a procession of penitents which can still be seen in the bottom right-hand corner of the painting. Cézanne was evidently interested in the pious processions that were a feature of Aix life, as Zola asked to be 'told a bit about the processions' on 13 June 1860; the skulls which featured in these cults became a lasting part of Cézanne's later subject matter (see cat. 12, 45). The procession of flagellants that was not quite deleted from the portrait of the old man was not entirely incongruous. It possibly accounts for something wryly sardonic in the characterisation. Cézanne's drawings of the time show that he was far from unaware of the attractions of the violence that he fantasised continually. For him there is an almost aggressive energy in rhythm itself.

The dense, curving brush strokes in the part of the *Head of an old Man* that was finished have no resemblance to the palette-knife handling which was habitual in 1866, but they are somewhat like the solid, curving handling adopted in a dated still life in 1865 (cat. 7) and in the dated *Rape* (cat. 31) in 1867. This is an example of the handling which was habitual both before and after the massive virility which replaced it in 1866. It is hardly possible to be sure if the head of the old man was painted on the way into the palette-knife style or out of it; it might have been executed at any point at the beginning or the end of a period extending from 1865 to 1867. The curving brush strokes were the handling most natural to Cézanne throughout the 1860s, except during the inspired interruption of the slab-like style of 1866.

PROVENANCE Ambroise Vollard, Paris; Musée du Louvre, Paris.

EXHIBITIONS Paris, Galerie Vollard, 1899, no. 30; Paris, Petit Palais, 1904, *Salon d'Automne*, no. 4; Paris, Orangerie, 1936, no. 5; Lyon, Palais Saint-Pierre, 1939, no. 3; London, Wildenstein Galleries, 1939, no. 5; Paris, Indépendants, 1939, no. 23; Paris, Orangerie, 1953, *Baroque provençal*, no. 1; Paris, Orangerie, 1954, no. 9; Paris, Orangerie, 1974, no. 2.

BIBLIOGRAPHY G. Lecomte, 'Paul Cézanne', *Revue de l'Art,* Dec. 1899, p. 84, ill.; Vollard, 1914, pl. 44; E. Faure, *P. Cézanne,* Paris, 1926, pl. 2; E. Faure, *Cézanne,* Paris, 1936, pl. 16; R. Huyghe, *Cézanne,* Paris, 1936, pl. 18; Raynal, 1936, pl. LXV; Cézanne, *Correspondance,* 1937, p. 96, note 2; Cogniat, 1939, pl. 3; L. Guerry, *Cézanne et l'expression de l'espace,* Paris, 1950, p.28; H. Adhémar, *Catalogue des Peintures, Pastels, Sculptures Impressionnistes du Musée du Louvre,* Paris, 1958, p. 16, no. 30; G. Bazin, *L'Impressionnisme au Louvre,* Paris, 1958, p. 274; C. Sterling, and H. Adhémar, *La Peinture au Musée du Louvre,* Paris, 1958, fig. 247; R. Walter, 'Cézanne à Bennecourt en 1866', *Gazette des Beaux-Arts,* Feb. 1962; Elgar, 1975, fig. 118.

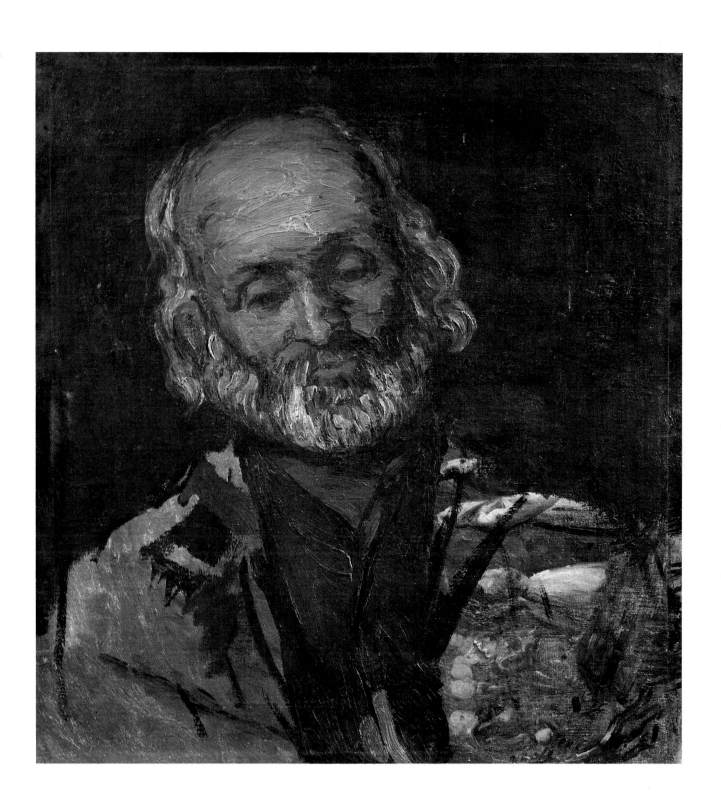

7 Still life: Bread and Eggs

(Nature morte: pain et œufs)

1865
59 × 76 cm 23¼ × 29⅞ in
Signed and dated lower left in red-brown: *P. Cézanne 1865*
V.59
Cincinnati Art Museum, Cincinnati, Ohio

Courbet was always important to Cézanne and his few references to him were admiring. The style which he took up in this picture was nearest to the realism of painters like Ribot and Bonvin, who were touched by Courbet's influence, as well as the still life tradition of Spain. There is no sign of Manet, whose studio Cézanne had lately visited, except in the relative clarity of colour. The picture was signed and dated, probably with a view to submission to the Salon with the portrait of Valabrègue (cat. 16) in 1866.

PROVENANCE Ambroise Vollard, Paris and Bernheim-Jeune, Paris; Ambroise Vollard, Paris; Paul Cassirer, Berlin; (?) W. Levinstein; Paul Cassirer, Berlin; Hugo Cassirer, Berlin; Mme Cassirer-Furstenberg, Berlin (on deposit for several years at the Gemeente Museum, The Hague); J.K. Thannhauser, New York.

EXHIBITIONS Prague, Pavillon Manes, 1907, *Tableaux Modernes,* n.n; Berlin, Paul Cassirer, 1909 (*Group exhibition*), no. 19; Berlin, Paul Cassirer, 1921, no. 4; Berlin, Paul Cassirer, 1925, *Impressionisten,* no. 1; Buenos Aires, Museo Nacional de Bellas Artes, 1939, *La Pintura Francesa de David a neustros dias,* no. 5; New York, Wildenstein Galleries, 1959, no. 2, ill.; Bordeaux, Musée des Beaux-Arts, 1966, *La Peinture française – Collections américaines,* no. 53, pl. 39; Washington D.C., Phillips Collection, 1971, no. 1 — Chicago, Art Institute, 1971, no. 1 — Boston, Museum of Fine Arts, 1971, no. 1.

BIBLIOGRAPHY T. Duret, 'Paul Cézanne', *Kunst und Kunstler,* 1907, p. 93, ill.; Vollard, 1914, pp. 19, 23; Meier-Graefe, 1918, ill. p. 88; Meier-Graefe, 1920, ill. p. 88; A. Zeisho, *Paul Cézanne,* Tokyo, 1921, fig. 22; Meier-Graefe, 1922, ill. p. 87; Rivière, 1923, p. 197, listed; E. Bernard, *Sur Paul Cézanne,* Paris, 1925, p. 60, ill.; Iavorskaia, 1935, pl. 7; R. Rilke, *Briefe über Cézanne,* Wiesbaden, 1952 (letter to Clara Rilke, Prague, 4 Nov., 1907); P. Adams, *Cincinnati Art Museum Bulletin,* March 1956, pp. 17–18, ill. (vol. IV, no. 2); I. Elles, *Das Stilleben in der französischen Malerei des 19. Jahrhunderts,* Zurich, 1958, p. 99; M. Schapiro, 'The Apples of Cézanne: An Essay on the Meaning of Still-Life', *Art News Annual,* 1968, p. 40; A. d'Harnoncourt, 'The Necessary Cézanne', *The Art Gallery,* April 1971, p. 35, ill.'; V. Bettendorf, 'Cézanne's Early Realism: "Still Life with Bread and Eggs" re-examined', *Arts Magazine,* 19 Jan., 1982, pp. 138–41, fig. 2; Rewald, 1986, p. 80, ill.

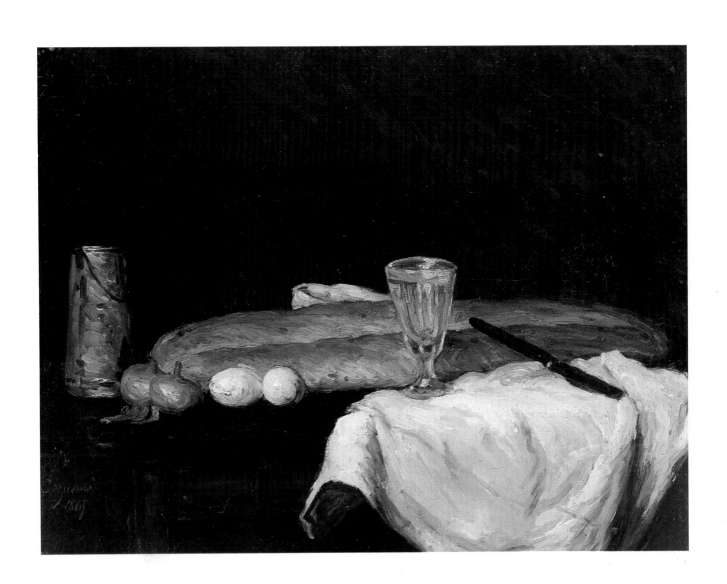

8 Landscape

(Paysage)

c.1865
26.7 × 35 cm 10½ × 13¾ in
V.37
Vassar College Art Gallery, Poughkeepsie, N.Y., USA (61.7)

The forms of landscape, starting from the shapes of the objects described – it might be leaves or rocks – were soon inherent in the style itself, the short emphatic brush strokes or the buttery facets spread by the knife.

PROVENANCE Ambroise Vollard, Paris; Mme Paul Delacroix, Morocco; Wildenstein Galleries, New York; Miss Loula D. Lasker, New York.

EXHIBITION Poughkeepsie, Vassar College Art Gallery, 1967, ill. p. 145; New Paltz, New York, Art Gallery, State University Collection at New Paltz, 1970, *Portraits and Self-Portraits*, n.n.

BIBLIOGRAPHY Vassar College Art Gallery, *Vassar College Art Gallery: Paintings 1300–1900*, Poughkeepsie, 1983, p. 129.

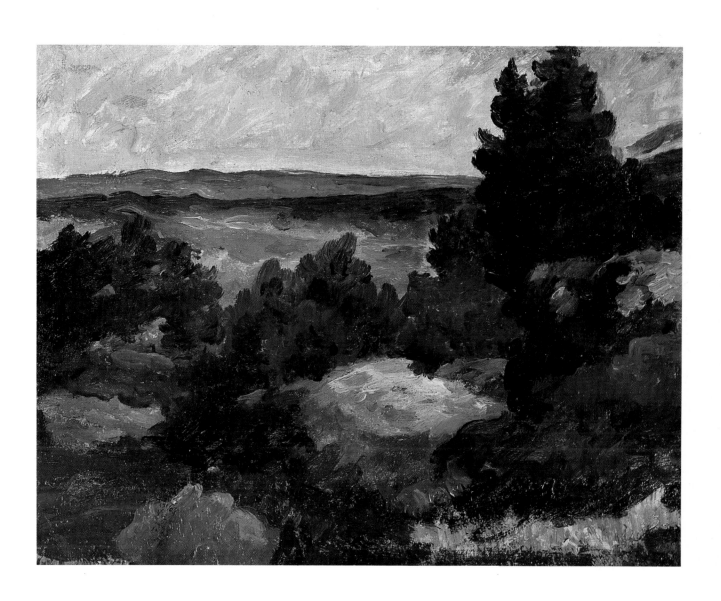

9 Landscape by a River

(Coin de rivière)

*c.*1865
29 × 42 cm 11½ × 16½ in
non-V.

The Sam Spiegel Collection

See cat. 8.

PROVENANCE G. Urion, Paris; Sale, Urion Collection, Galerie G. Petit, Paris, 30 May, 1927, no. 20, ill.; Galerie Marcel Bernheim, Paris; Sale, Parke-Bernet, New York, 22 Nov., 1944, no. 50, ill.; Walter P. Chrysler, Jr., New York; Sale, Chrysler Collection, Sotheby's, London, 1 July, 1959, no. 15, ill.; Sam Spiegel, New York.

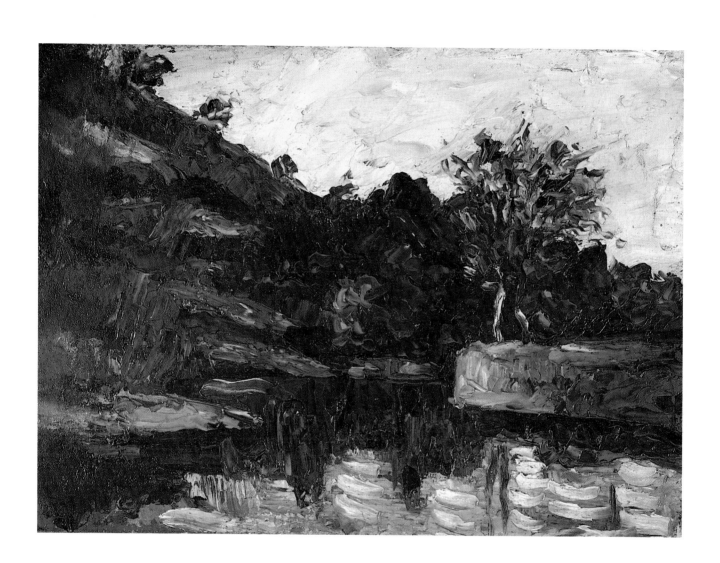

10 Landscape – Mt St Victoire

(Paysage – Montagne Ste-Victoire)

*c.*1865
22 × 28 cm 8$\frac{3}{8}$ × 11 in
V.1510
Private Collection

The landscape style that was common to several painters
*c.*1865, Pissarro and Cézanne among them, owed much
both to Corot and the Barbizon School. It encouraged
broad masses summarily stated in deep tones. The profile
of foliage was laid in boldly against the sky with a loaded
brush. In the foreground of this sketch the dragged brush
strokes of colour were flattened into long streaks with
the tip of the spatula, in a manner which was very close
to knife-painting.

PROVENANCE Ambroise Vollard, Paris; Sale, Hôtel Drouot, Paris, 1951;
Private Collection, France; Fine Arts Associates (Otto Gerson), New York;
E.V. Thaw, New York; (?) Schoenberg, St Louis; Schoenberg Foundation;
Sale, Parke-Bernet, New York, 16 May, 1979, no. 205, ill.; Private
Collection; Sale, Parke-Bernet, New York, 18 Feb., 1982, no. 11, ill.;
Private Collection; Sale, Sotheby's, London, 4 Dec., 1985, no. 106, ill;
Pascal de Sarthe Gallery, San Francisco.

EXHIBITIONS Cambridge, Mass., Fogg Art Museum, 1957, n.n; San Francisco,
Pascal de Sarthe Gallery, 1986, *XIX Century Works of Art,* no. 6, ill.

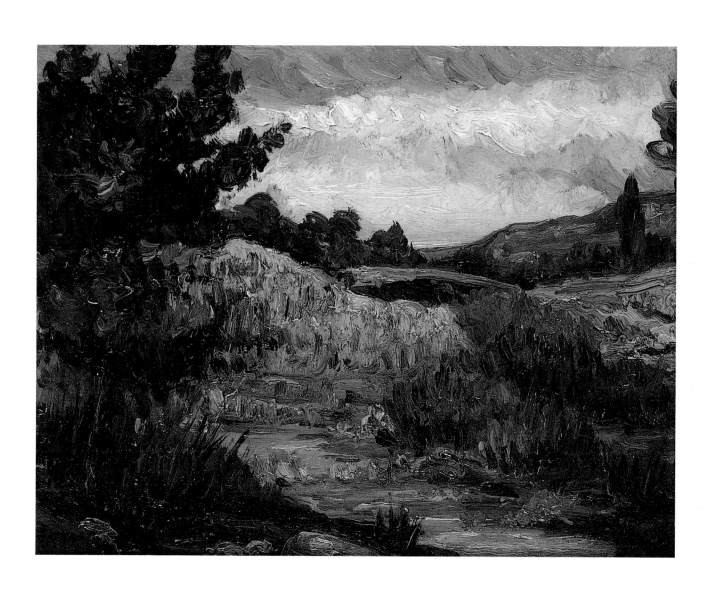

11 Landscape near Aix-en-Provence

(Paysage aux environs d'Aix-en-Provence)

*c.*1865
40.5 × 59.5 cm 16 × 23⅜ in
non-V.
Insel Hombroich

See cat. 10.

PROVENANCE: Maxime Conil, Montbriand (the artist's brother-in-law);
Henri Boissin, Aix-en-Provence; Madame Marquetty (Boissin's daughter);
Private Collection; Sale, Sotheby's, London, 1 Dec., 1982, no. 8.

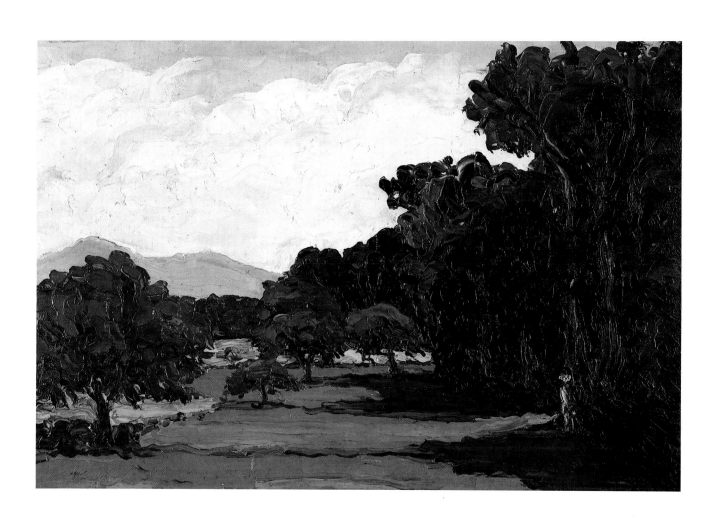

12 Still life: Skull and Candlestick

(Nature morte: crâne et chandelier)

*c.*1866
47.5 × 62.5 cm 18¾ × 24½ in
V.61
Private Collection, on loan to the Kunsthaus, Zurich

Admiration for Courbet led Cézanne naturally to the application of paint with a knife, which was characteristic of him. Cézanne, however, reflected the frame of mind of another generation. In the later 1860s young painters had an instinct for objectivity but little taste for detailed description. The style was to be comparatively impersonal, reducing the subject to a statement of tones and above all it was to be consistent. The chosen means, however extreme, was to be followed uniformly throughout a picture. The painters of his generation had this creed in common, and it made Salon painting and naturalism equally obsolete.

The new painting was not in essence illustrative, but on this aspect the young painters were less clearly agreed. Cézanne's palette-knife pictures retained subjects with an undeniable illustrative content. There were even relics of symbolism to recall the emblem still lifes of tradition. The models for his palette-knife portraits (cat. 16, 18–24) were eventually allotted historicist roles, as monks, advocates or artisans. *Skull and Candlestick,* the still life which combined the symbols of enlightenment with the reminder of mortality and the pietism of Aix, would have seemed antiquated to the painters who were now committed to a purely visual content. It was painted for Morstatt, the German musician who introduced the Aix circle to the new music, which blended rapturous tonal substance with the richest sentiment. Soon, as Cézanne himself put it, urging Morstatt to come to Aix in 1865, their acoustic nerves were vibrating to the noble accents of Richard Wagner.

Cézanne can hardly have painted the still life of the *Leg of Lamb* (cat. 13), with its subtle discord of style and theme, of delicacy and brutality, without the historicist tradition of still life painting in mind. The joint of meat was modelled like sculpture with a solidity that in portraiture took on eloquent, human meaning and an assurance that was altogether new to him. He drew this assurance from the example of Courbet, and with the palette-knife

pictures his art became mature as it had never been before.

We have a few clues to the order in which the palette-knife pictures were painted, one of them being the fact that *Sugar Pot, Pears and Blue Cup* (cat. 14) is to be seen hanging on the wall behind his father's armchair in the largest, but not the most consistent, of the pictures, the portrait of Louis-Auguste Cézanne now in Washington (cat. 21). The still life had already been framed and assimilated into the decoration of the room which was presumably the salon of the Jas de Bouffan, unless the armchair with the flowered slip-cover was removed to another room in the house for the use of his models. The pears, cup and sugar pot were already modelled in variations of colour with an impetus and a completeness that were hardly surpassed in the 1860s. Three pictures are at least by inference datable. The *Skull and Candlestick* was ready to be dispatched to Morstatt in July 1868, the *Portrait of Valabrègue* (cat. 16) was submitted to the Salon in the early summer of 1866, and the *Portrait of Louis-Auguste* (cat. 21) was described to Zola by Guillemet on 2 November 1866. The assurance that characterised these pictures and the force with which they were executed was perhaps entirely intended, yet a little surprising even to the artist himself. Looking at them again late in life, he remarked how *couillarde* the handling was, a coarse word for a specifically sexual virility.

PROVENANCE Heinrich Morstatt, Stuttgart; Moderne Galerie (Heinrich Thannhauser), Munich; Galerie Thannhauser, Lucerne; Bernhard Mayer, Zurich.

EXHIBITIONS Berlin, Galerie Thannhauser, 1927, *Erste Sonderausstellung,* no. 10, ill.; Basel, Kunsthalle, 1936, no. 3; Paris, Orangerie, 1953, *Baroque provençal,* no. 3; Zurich, Kunsthaus, 1956, no. 1, pl. 3; Schaffhausen, Museum zu Allerheiligen, 1963, *Die Welt des Impressionismus,* no. 3; Lausanne, Palais de Beaulieu, 1964, *Chefs-d'œuvre des collections suisses, de Manet à Picasso,* no. 84, ill.; Basel, Galerie Beyeler, 1983, no. 3.

BIBLIOGRAPHY Meier-Graefe, London, 1927, pl. III; J. Meier-Graefe, 'Die Franzosen in Berlin', *Der Cicerone,* Jan., 1927, p. 48; Pfister, 1927, fig. 18; M. Scolari, and A. Barr, 'Cézanne après les lettres de Marion à Morstatt', *Gazette des Beaux-Arts,* Jan. 1937, p. 42, fig.6; M. Scolari and A. Barr, 'Cézanne in the Letters of Marion to Morstatt, 1865–68', *Magazine of Art,* Feb., April, May 1938, fig. 5; I. Elles, *Das Stilleben in der französischen Malerei des 19. Jahrhunderts,* Zurich, 1958, p. 106; M. Schapiro, 'The Apples of Cézanne: An Essay on the Meaning of Still-life', *Art News Annual,* 1968, p. 40; Schapiro, 1973, p. 6, ill.; T. Reff, 'Painting and Theory in the Final Decade' in *Cézanne: The Late Work,* New York, 1977, p. 33, ill.; Venturi, 1978, ill. p. 9; T. Reff, 'Cézanne: The Severed Head and the Skull', *Arts,* Oct. 1983, p. 91, fig. 7.

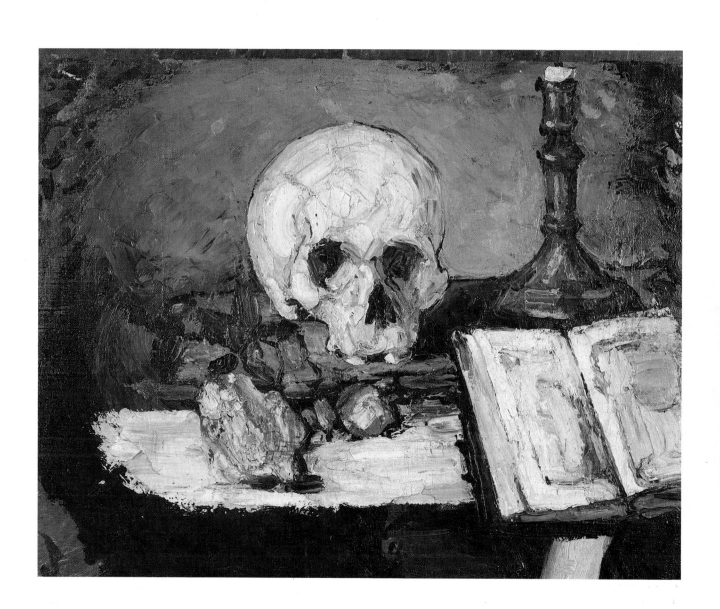

13 Still life:
Bread and Leg of Lamb

(Nature morte: pain et gigot d'agneau)

*c.*1866
27 × 35 cm 10½ × 13¾ in
V.65
Kunsthaus, Zurich

It was Cézanne's purpose, as it is the intention of this exhibition, to unmask the essential brutality and coarseness of painting as if with a murderous weapon or drawing as if with a writhing lash. The subject here and the unremitting style were equally foreign to French painting. The Goya *Still Life with a Sheep's Head*, which identified butchery as savage decapitation, entered the Louvre thirty-one years after Cézanne's death. It was Cézanne as much as Goya who decided that the art of the frightful age to come should not shrink from the violence inseparable from the propensities and the imaginings of mankind. In Cézanne's maturity the grievous dilemma was made good.

PROVENANCE Galerie Neupert, Zurich.

EXHIBITIONS Lyon, Palais Saint-Pierre, 1939, no. 5; London, Wildenstein Galleries, 1939, no. 4; Paris, Indépendants, 1939, no. 2; Zurich, Kunsthaus, 1943, *Ausländische Kunst in Zürich*, no. 543; Paris, Orangerie, 1953, *Baroque provençal*, no. 5, pl. XXVI; Zurich, Kunsthaus, 1956, no. 2—Cologne, Wallraf-Richartz Museum, 1956–57, no. 1, ill.; Vienna, Belvedere, 1961, no. 3, pl. 1—Aix-en-Provence, Pavillon de Vendôme, 1961, no. 3, pl. 1.

BIBLIOGRAPHY I. Elles, *Das Stilleben in der französischen Malerei des 19. Jahrhunderts*, Zurich, 1958, pp. 99–100; B.Chaet, *An Artist's Notebook, Techniques and Materials*, New York, 1979, p. 156, ill. p. 146.

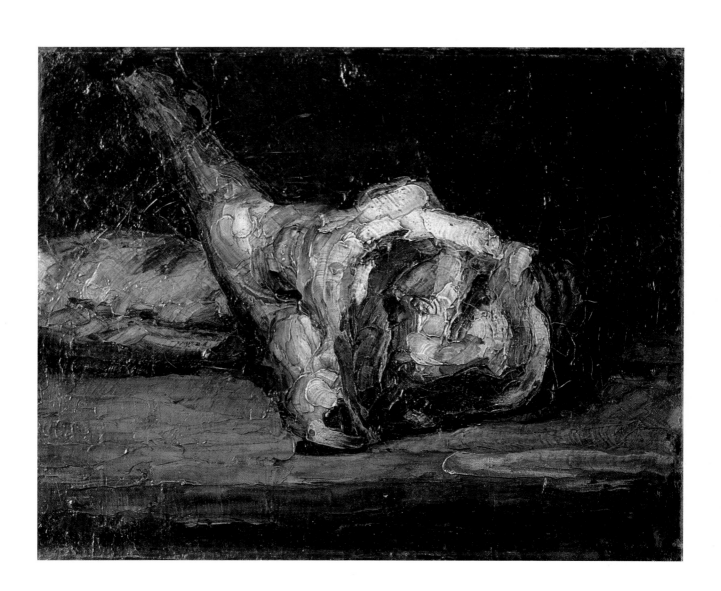

14 Still life: Sugar Pot, Pears and Blue Cup

(Nature morte: sucrier, poires et tasse bleue)

*c.*1866
30 × 41 cm 11$\frac{3}{4}$ × 16$\frac{1}{8}$ in
V.62
Musée d'Orsay, Paris, on deposit with the Musée Granet,
Aix

This is the still life which appears like a manifesto of the new style already framed and hanging on the wall in the background of Cézanne's portrait of his father reading *L'Evénement* (cat. 21). It demonstrated that the force of handling involved a freedom, indeed violence, of colour modulation more extreme than Cézanne or anyone else had conceived hitherto.

PROVENANCE Auguste Pellerin, Paris; Jean-Victor Pellerin, Paris.

EXHIBITIONS Paris, Orangerie, 1953, *Baroque provençal,* no. 4, pl. XXV; Madrid, Museo Espanol de Arte Contemporaneo, 1984, no. 1, ill.

BIBLIOGRAPHY Riviére, 1923, p. 201; Raynal, 1936, pl. LXXX; L. Guerry, *Cézanne et l'expression de l'espace*, Paris, 1950, p. 34; L. Guerry, *Cézanne et l'expression de l'espace* (2nd edition), Paris, 1966, p. 47; T. Reff, 'The Pictures within Cézanne's pictures', *Arts Magazine*, June 1979, fig. 5; S. Gache-Patin, 'Douze œuvres de Cézanne de l'ancienne collection Pellerin', *La Revue du Louvre et des Musées de France*, 2, 1984, p. 130, no. 2; D. Coutagne, *Cézanne au Musée d'Aix*, Aix-en-Provence, 1984, p. 212, ill.; *Anciens et nouveaux, choix d'œuvres acquises par l'Etat ou avec sa participation de 1981 à 1985*, 1985, p. 323, ill.; Rewald, 1986, p. 22, ill.

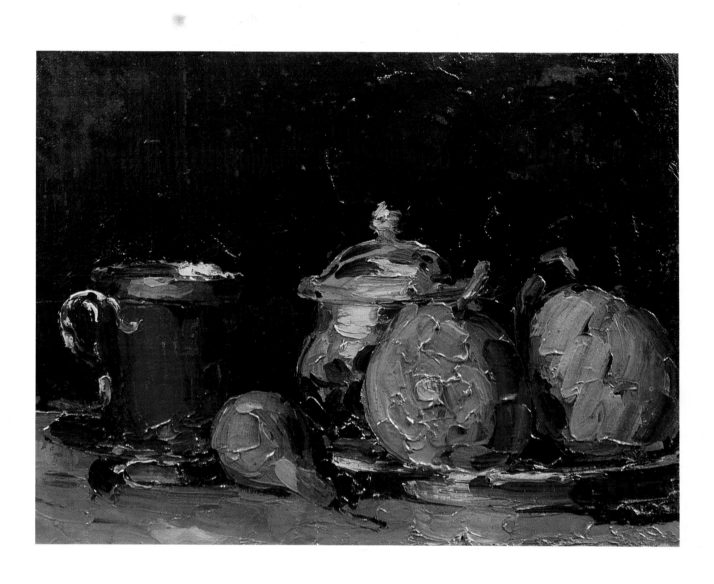

15 Self-Portrait

(Portrait de l'artiste)

*c.*1866
45 × 41 cm $17\frac{1}{2}$ × $16\frac{1}{4}$ in
Signed lower right in red capital letters: P. CEZANNE
V.81
Private Collection

An early achievement of the new assurance with the palette-knife was a portrait of himself quite unrecognisable as the same man who painted from his own photograph five years before (cat. 2). The self-image must have been deliberately styled as a token of creative independence. Marion described it to Morstatt in August 1866: 'Paul is superb this year with his fine hair immensely long and his revolutionary beard.' The expression is, as Roger Fry observed, quite truculent with little of the perceptiveness that he later brought to his own likeness but with a ferocity that speaks of refusal to brook the slightest opposition.

PROVENANCE Emile Zola, Médan; Sale, Zola Collection, Hôtel Drouot, Paris, 9–13 March, 1903, no. 116; Auguste Pellerin, Paris; René Lecomte, Paris.

EXHIBITIONS Paris, Orangerie, 1936, no. 2; Paris, Orangerie, 1954, no. 4.

BIBLIOGRAPHY Vollard, 1914, pl. 3; F. Gregg, *Vanity Fair*, Dec. 1915, p. 58, ill.; J. Meier-Graefe, *Entwicklungsgeschichte der modernen Kunst*, Munich, 1915, pl. 486; P. Westheim, *Die Welt als Vorstellung,* Potsdam, 1918, p. 119, ill.; F. Burger, *Cézanne und Hodler* (fourth edition), Munich, 1920, pl. 67; Meier-Graefe, 1922, ill. p. 82; F. Burger, *Cézanne und Hodler* (fifth edition), Munich, 1923, pl. 66; Rivière, 1923, pp. 196, 198, listed; O. Benesch, 'Rembrandt's Vermachtnis', *Belvedere,* 1924, pp. 172–3, ill.; F. Ruckstull, *Great Works of Art and What Makes Them Great,* New York, 1925, pp. 23–5, fig. 14; I. Arishima, *Cézanne,* Tokyo, 1926, pl. 6; Fry, Dec. 1926, p. 393, ill.; Fry, 1927, pl. I, fig. 6; Pfister, 1927, fig. 16; Iavorskaia, 1935, pl. 1; Rewald, 1936, fig. 5; Rewald, 1939, fig. 11; Barnes and de Mazia, 1939, no. 6, ill. p. 149; Rewald, New York, 1948, fig. 18; G. Schildt, *Cézanne,* Stockholm, 1946, fig. 20; J. Rewald, *The History of Impressionism,* New York, 1946, p. 125, ill.; J. Rewald, *The History of Impressionism* (second edition), New York, 1946, ill. p. 125; Dorival, 1948, pl. 6; G. Jedlicka, *Cézanne,* Berne, 1948, fig. 1; *The History of Impressionism,* New York, 1961, p. 145, ill.; K. Leonhard, *Paul Cézanne in Selbstzeugnissen und Bilddokumenten,* Rheinbek bei Hamburg, 1966, p. 101, ill.; D. Gordon, 'The Expressionist Cézanne', *Art Forum,* March 1978, p. 37, ill.; Rewald, 1986, p. 56, ill.

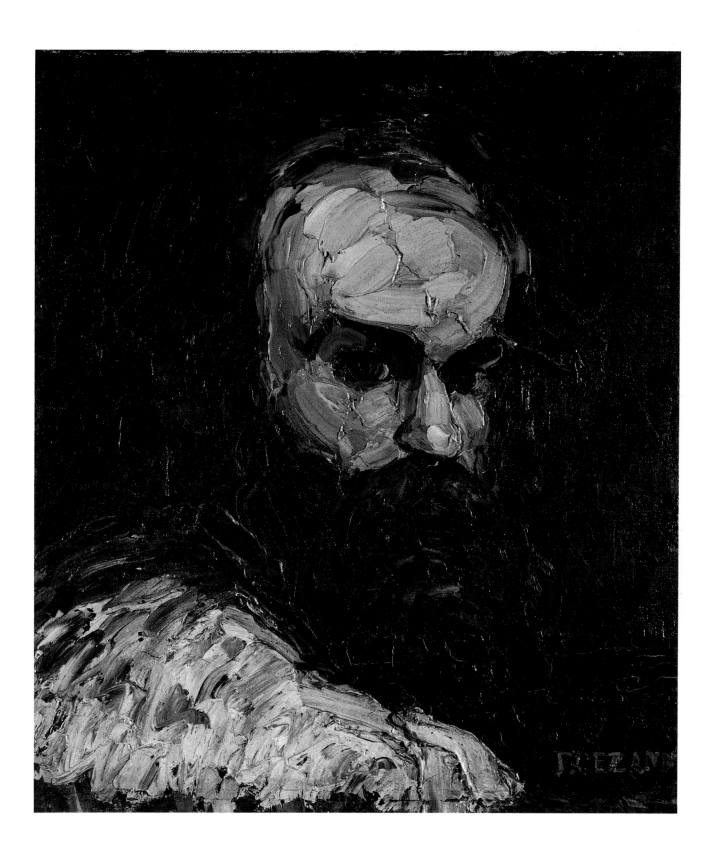

16 Portrait of Antony Valabrègue

(*Portrait d'Antony Valabrègue*)

1866
116 × 98 cm 45⅝ × 38⅝ in
Signed lower right (close to edge): *P. Cézanne*
V.126
National Gallery of Art, Washington, Collection of Mr and
Mrs Paul Mellon (1970.35.1)

This was the first of Cézanne's three portraits of the writer
who was his friend in early life (see cat. 25, 56). It was
submitted to the Salon in 1866 as an act of defiance rather
than with any serious expectation of acceptance. It shows
an early stage in the development of Cézanne's use of the
palette-knife which became a regular feature of his style
in 1866. Where the knife was not used, as in the hands,
it gave place to forceful, superimposed brushwork and
positive colour – 'worked up,' as Rilke wrote, 'almost to
orange'. Cézanne seems already to have been attracting
support, and in the anticipated event of his rejection,
there were plans among the painters who were his friends
for a public demonstration on his behalf. The palette-
knife became a favourite tool, especially for Cézanne's
smaller portraits of 1866 (cat. 16, 18–20, 22–4), and later
uses of it were more consistent; it evidently asserted both
the personal force of a sitter and the unity of a picture.
The technique was adopted by the young painters of Aix,
among them Marion, who signed a *View of Aix* (*c*.1866;
Fitzwilliam Museum, Cambridge) painted in tolerable
imitation of it.

The portrait of Valabrègue, tentative in some ways
though it is, clearly broke new ground for the painter, and
its sequels – the consistent and stable palette-knife pictures
that followed – changed the whole direction of Cézanne's
work. His best sitter was his mother's brother, the bailiff
Dominique Aubert, whose devoted service to his nephew
has left him an unshakable position in modern painting.
Valabrègue recounted the course of events to Zola in
November 1866: 'luckily I had to pose for only one day,
but the uncle serves as a model more often. Every after-
noon another portrait of him appears, while Guillemet
overwhelms him with atrocious jokes.' Regularly to have
painted such pictures in half a day each is convincing
proof of the painterly capacity that Cézanne commanded
(see cat. 18–20, 22, 23).

PROVENANCE Ambroise Vollard, Paris; Bernheim-Jeune, Paris; Auguste
Pellerin, Paris; Jean-Victor Pellerin, Paris; Wildenstein Galleries, Paris,
London and New York; Private Collection, Switzerland; Mr and Mrs Paul
Mellon, Upperville, Va.

EXHIBITIONS Berlin, Paul Cassirer, 1909 (*Group exhibition*), no. 9(?); Brighton,
Public Art Galleries, 1910, *Modern French Artists,* no. 184; Amsterdam,
Stedelijk Museum, 1938, *Honderd Jaar Fransche Kunst,* no. 3; Lyon, Musée
des Beaux-Arts, 1939, no. 7; London, Wildenstein Galleries, 1939, no. 6;
New York, Wildenstein Galleries, 1947, no. 2; Chicago, Art Institute, 1952,
no. 7 – New York, Metropolitan Museum, 1952, no. 7; Lausanne, Palais de
Beaulieu, 1964, *Chefs-d'œuvre des collections suisses, de Manet à Picasso,* no. 85;
Madrid, Museo Espanol de Arte Contemporaneo, 1984, no. 3, ill.;
Washington, D.C., National Gallery of Art, 1986, *Gifts to the Nation: Selected
Acquisitions from the Collections of Mr and Mrs Paul Mellon,* n.n.

BIBLIOGRAPHY Rivière, 1923, p. 199, listed; Barnes and de Mazia, 1939,
no. 10, ill. p. 152 (analysis pp. 311–12); Cogniat, 1939, pl. 9; Rewald, New
York, 1939, fig. 22; J. Rewald, *The History of Impressionism,* New York,
1948, ill. p. 120; Dorival, 1948, pl. 22; C. Ramuz, *Cézanne Formes,* Lausanne,
1968, fig. 4; W. Andersen, *Cézanne's Portrait Drawings,* Cambridge, Mass.
and London, 1970, fig. 5; Elgar, 1975, fig. 22; Venturi, 1978, ill. p. 12;
J. Rewald, 'Paintings by Paul Cézanne in the Mellon Collection', in *Essays
in Honor of Paul Mellon, Collector and Benefactor,* Washington, D.C., 1986,
pp. 290–94, fig. 1.

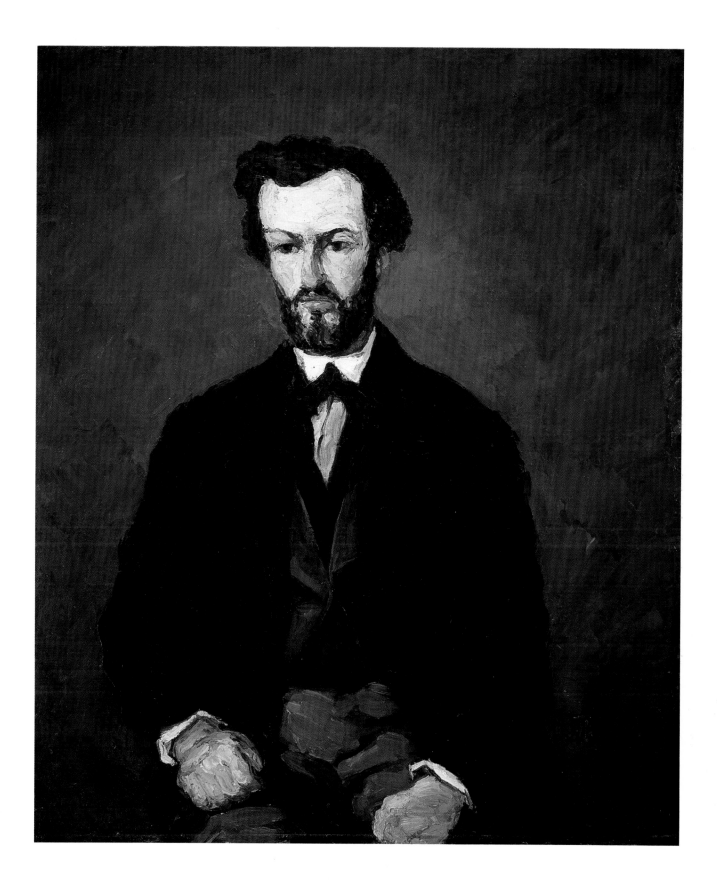

17 View of Bonnières

(Vue de Bonnières)

1866
38 × 61 cm 15 × 24 in
non-V.
Musée Faure, Aix-les-Bains

Cézanne went to spend the summer of 1866 at Bennecourt on the Seine near Mantes, across the river from Bonnières, in the company of Zola, Valabrègue and Guillemet, the painter who suggested the place. It was at Bennecourt that Cézanne arrived at a consistent palette-knife style for landscape. Zola wrote on 26 July: 'Paul is working. He is more and more confirmed in the original course on which his nature impels him.'

The view across the river to Bonnières on the opposite bank, which he painted that summer, was among the first of his landscapes to show the objective visual balance of the Impressionism to come, a quality that it shared with the family portraits of the following months (see cat. 18–24). It suggests that if the *Portrait of Père Rouvel* (see cat. 6), which Cézanne reported to Zola that he was painting at Bennecourt, had survived it would have resembled the Uncle Dominique pictures (cat. 18–20, 22, 23) rather than the *Head of an Old Man* (cat. 6).

PROVENANCE Emile Zola, Médan(?); Leon Orosdi, Paris(?); André Schoeller, Paris; Dr Faure, Aix-en-Bains.

BIBLIOGRAPHY J. J. Vergnet-Ruiz and M. Laclotte, *Petits et grands musées de France*, Paris, 1962. p. 189; R. Walter, 'Un vrai Cézanne: "La Vue de Bonnières"', *Gazette des Beaux-Arts*, May 1963, ill. pp. 359–66.

18 Portrait of Uncle Dominique (profile)

(Portrait de l'Oncle Dominique de profil)

1866
39.5 × 30.5 cm 15½ × 12 in
V.80
The Provost and Fellows of King's College,
Cambridge (Keynes Collection), on loan to the
Fitzwilliam Museum, Cambridge

The impetus with which, as Valabrègue described (see cat. 16), Cézanne set about the portraits of his uncle Dominique produced lasting results. The extent of his output in itself was astonishing and the assurance with which he accomplished it was quite new in his work. The technical means became the basis for a unity of pictorial ends. The consistency with which the paint was handled made it a foundation stone, which its material character rather resembled. In this it was analogous to the part that paint-handling was playing in the style of his contemporaries with whom he was to exhibit eight years later. In every other way Cézanne's *couillarde* style was the antithesis of Impressionism. It was as unified as Impressionism was fragmentary. At first the little palette-knife portraits were on the edge of naïveté, but as they developed they became monumental.

PROVENANCE J. Maynard Keynes, London; Lady Keynes, London.

EXHIBITIONS London, Goupil Gallery, 1924 (*Group exhibition*), n.n.; Edinburgh, Royal Scottish Academy, 1954, no. 2 — London, Tate Gallery, 1954, no. 2.

BIBLIOGRAPHY Coquiot, Paris, 1919, ill. opp. p. 216; R. Fry, 'Cézanne at the Goupil Gallery', *The Burlington Magazine*, Dec. 1924, pp. 311, 313, ill.; Iavorskaia, 1935, pl. 3.

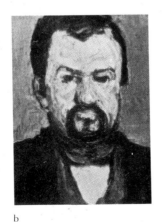
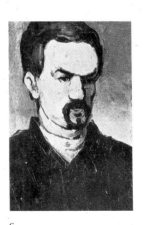
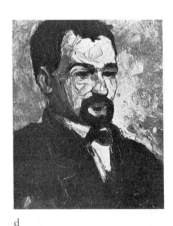

a b c d

a) Portrait of a Monk (Uncle Dominique) (*Portrait de moine*), *c*.1866, V.72. Haupt Collection, Palm Springs.

b) Uncle Dominique (*L'Oncle Dominique*), *c*.1866, V.77. Lewisohn Collection, New York.

c) Uncle Dominique (*L'Oncle Dominique*), *c*.1866, V.75. Ex-Pellerin Collection, Paris.

d) Uncle Dominique (*L'Oncle Dominique*), *c*.1866, V.79. Ex-Pellerin Collection, Paris.

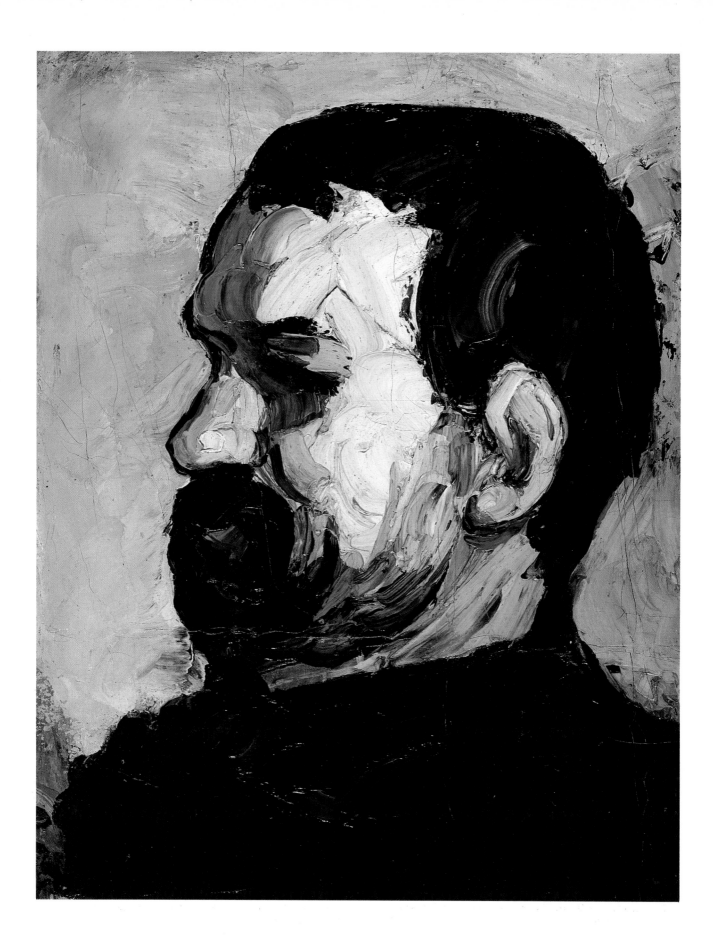

W

19 Portrait of Uncle Dominique

(*Portrait de l'Oncle Dominique*)

1866
41 × 33 cm 16¼ × 13 in
V.76
The Bakwin Collection

See cat. 18.

PROVENANCE Ambroise Vollard, Paris; Auguste Pellerin, Paris; Hugo Perls, Berlin; Dr and Mrs Harry Bakwin, New York.

EXHIBITIONS London, Goupil Gallery, 1924 (*Group exhibition*), n.n; Philadelphia, Pennsylvania Museum of Art, 1934, no. 3; San Francisco, San Francisco Museum of Art, 1937, no. 2; New York, Wildenstein Galleries, 1959, no. 3, ill.; New York, Solomon R. Guggenheim Museum, 1963, n.n; New York, Wildenstein Galleries, 1967, *The Bakwin Collection*, no. 3, ill.

BIBLIOGRAPHY Rivière, 1923, p. 115, ill.; R. Fry, 'Cézanne at the Goupil Gallery', *The Burlington Magazine*, Dec. 1924, p. 311, pl. Ic; J. Goulinat, 'Technique Picturale: L'Evolution du Métier de Cézanne', *Art Vivant*, March 1925, p. 23, ill.; J. Borely, 'Cézanne à Aix', *Art Vivant*, 1 July, 1926, p. 496, ill.; G. Charensol, 'Les Détracteurs de Cézanne', *Art Vivant*, 1926, p. 496, ill.; Rivière, 1933, p. 15, ill.; L. Venturi, 'Paul Cézanne', *L'Arte*, July and Sept. 1935, pl. 4; E. Loran, 'San Francisco's first Cézanne Show', *Magazine of Art*, Sept. 1937, p. 54, ill.; Rivière, 1942, p. 15, ill.; Badt, 1956, p. 279.

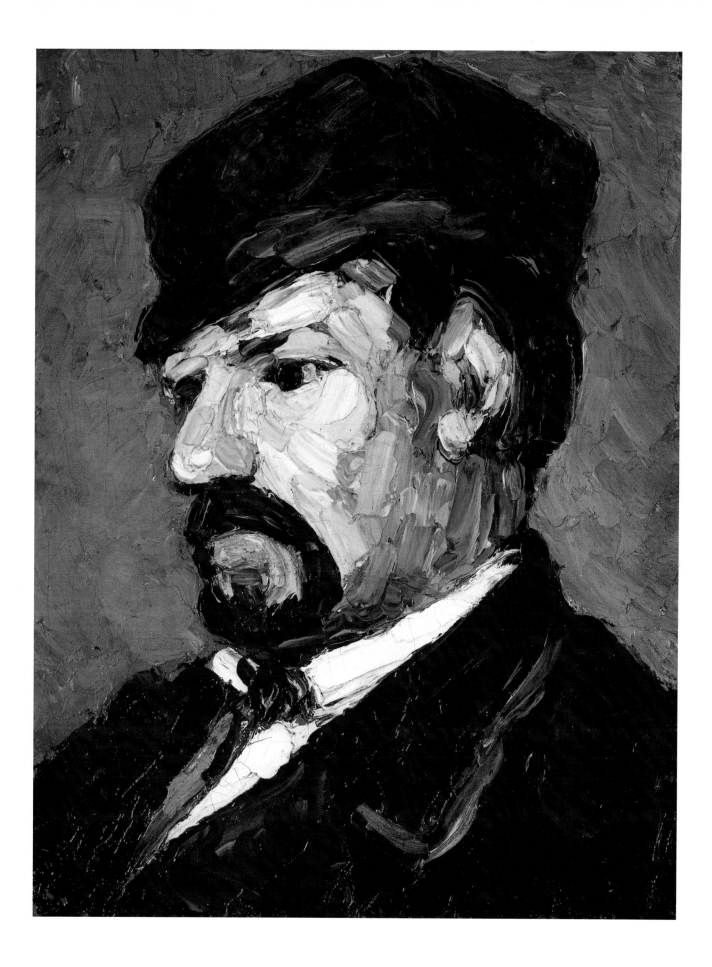

20 Portrait of Uncle Dominique (in a turban)

(Portrait de l'Oncle Dominique coiffé d'un turban)

1866
44 × 37 cm $17\frac{3}{8} \times 14\frac{5}{8}$ in
V.82
Private Collection

See cat. 18

PROVENANCE Ambroise Vollard, Paris; Auguste Pellerin, Paris; René Lecomte, Paris.

EXHIBITION Paris, Orangerie, 1954, no. 7.

BIBLIOGRAPHY Rivière, 1923, p. 202, listed.

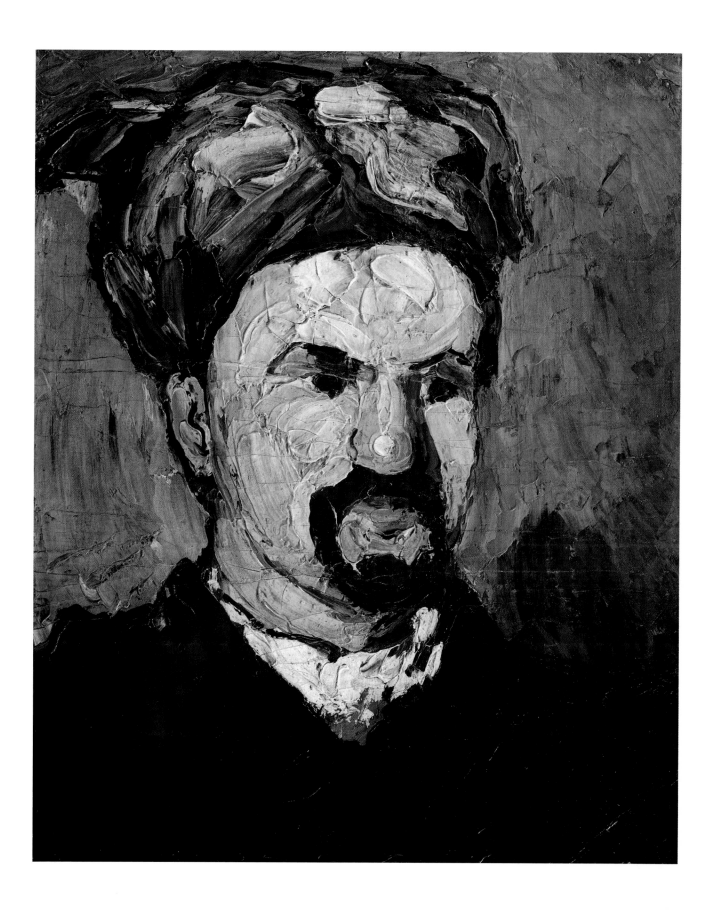

21 Portrait of Louis-Auguste Cézanne, Father of the Artist, reading *l'Evénement*

(Portrait de Louis-Auguste Cézanne, père de l'artiste, lisant l'Evénement)

1866
200 × 120 cm 78¾ × 47¼ in
V.91
National Gallery of Art, Washington, Collection of Mr and Mrs Paul Mellon (1970.5.1)

This is the major work among the palette-knife pictures and shows Cézanne's father sitting in the flowered arm-chair reading the newspaper called *l'Evénement*. Cézanne had chosen this newspaper to take the place of the republican one which his father normally read because *l'Evénement* had published articles by Zola. At this stage these had made no reference to Cézanne, but when they were republished the following year in a book, the latter was prefaced with a tribute to his old friend. The still life which is shown framed and hanging, as if already part of the decoration of the household, is exhibited and discussed as cat. 14. The banner heading of the newspaper is an integral part of the design of the picture. The thick and thin of the Bodoni-type lettering establishes the authority of reader and writer. In shape, the type descended from the capitals of Cézanne's first assertive signatures (see cat. 15) and it led the way to the emphatic verticals of the stencil lettering which announced the authority of *Achille Emperaire* (cat. 46) and placed his picture in the great portrait tradition. Otherwise there was a profound difference between the two works. The portrait of Louis-Auguste was the virtual invention of Impressionist intimism. The atmospheric notation of the pattern on the armchair and the counterpoint of angles in the pose were all at opposite extremes to the pattern and the form which were asserted and outlined for their own sake with an almost Byzantine rigidity in the portrayal of the afflicted cripple whom Cézanne admired. In the 1870s on his visits to Aix Cézanne went on drawing his father in this pose and costume, and in this armchair. Perhaps he felt, as we now feel, that the *Louis-Auguste* was the less successful of the two pictures and looked forward to painting the subject again.

PROVENANCE Auguste Pellerin, Paris; René Lecomte, Paris.

EXHIBITIONS Paris, Salon des Artistes français, 1882, no 502 ('Portrait de M.L.A....'); Paris, Orangerie, 1936, no. 3; Paris, Orangerie, 1954, no. 8,

pl. 4; Washington, D.C., National Gallery of Art, 1986, *Gifts to the Nation: Selected Acquisitions from the Collections of Mr and Mrs Paul Mellon*, n.n.

BIBLIOGRAPHY F. Lawton, 'Paul Cézanne', *The Art Journal*, 1911, p. 60, ill.; Meier-Graefe, 1913, p. 56, ill.; F. Lawton, 'A Private Collection in Germany that Contains Fourteen Examples of the Art of Cézanne . . . Darmstadt', *New York Times*, 1913, p. 15, mentioned; C. Borgmeyer, *The Master Impressionists,* Chicago, 1913, p. 271, ill.; A. Dreyfus, 'Paul Cézanne', *Zeitschrift für bildende Kunst,* June 1913, p. 200, ill.; Meier Graefe, 1918, ill. p. 83; Meier-Graefe, 1920, ill. p. 83; Gasquet, 1921, ill. opp. p. 12; Meier-Graefe, 1922, ill. p. 88; A. Burroughs, 'Ambroise Vollard, Sensible Biographer', *The Arts,* Sept. 1923, p. 170, ill.; T. Klingsor, *Cézanne,* Paris, 1923, p. 13, pl. 3; Rivière, 1923, p. 198, listed; E. Bernard, *Sur Paul Cézanne,* Paris, 1925, p. 117, ill.; I. Arishima, *Cézanne,* Tokyo, 1926, pl. 3; Gasquet, 1926, ill.; Fry, 1927, pl. IV, fig. 4; Iavorskaia, 1935, pl. 2; Mack, 1936, fig. 1; R. Huyghe, 'Cézanne et son oeuvre', *Amour de l'Art,* May 1936, fig. 37; Raynal, 1936, pl. LVI; Rewald, 1936, fig. 12; Novotny, 1937, pl. 7; Barnes and de Mazia, 1939, no. 7, ill. p. 151; Rewald, 1939, fig. 18; Rewald, New York, 1939, fig. 26; J. Rewald, *The History of Impressionism,* New York, 1946, p. 127, ill.; J. Vaudoyer, *Les peintres provençaux,* Paris, 1947, p. 83, ill.; Dorival, 1948, pl. 20; J. Rewald, *The History of Impressionism* (second edition), New York, 1955, ill. p. 127; D. Cooper, 'Au Jas de Bouffan', *Oeil,* 15 Feb., 1955, p. 16; Badt, 1956, pp. 117, 142, pl. 33; I. Elles, *Das Stilleben in der französischen Malerei des 19. Jahrhunderts,* Zurich, 1958, p. 107; J. Rewald, *The History of Impressionism,* New York, 1961, p. 146, ill. p. 147; P. Feist, *Paul Cézanne,* Leipzig, 1963, pp. 9, 21, pl. 3; K. Leonhard, *Paul Cézanne in Selbstzeugnissen und Bilddokumenten,* Rheinbek bei Hamburg, 1966, p. 119, ill.; M. Butor, *Les mots dans la peinture,* Geneva, 1969, p. 153, ill.; W. Andersen, *Cézanne's Portrait Drawings,* Cambridge, Mass. and London, 1970, fig. 4; National Gallery of Art, *Annual Report,* Washington, D.C., 1970, p. 26, ill. p. 6; M. Hours, 'Cézanne's Portrait of His Father' in *Studies in the History of Art,* National Gallery of Art, 1971, pp. 63–88, figs 1–11; J. Rewald, 'Cézanne and His Father', *Studies in the History of Art,* 1971, pp. 47–50, fig. 2; J. Rewald, *The History of Impressionism* (fourth edition), New York, 1973, p. 146, ill. p. 147; A. Barskaya, *Paul Cézanne,* Leningrad, 1975, p. 13, ill.; Elgar, 1975, fig. 13; National Gallery of Art, *European Paintings: Summary Catalogue,* Washington, D.C., 1975, no. 2369, ill. p. 63; Wadley, 1975, pl. 5; S. Monneret, *Cézanne, Zola . . . La Fraternité du génie,* Paris, 1978, ill. p. 11; Venturi, 1978, ill. p. 10; T. Reff, 'The Pictures within Cézanne's pictures', *Arts Magazine,* June 1979, fig. 4; S. Geist, 'Cézanne: Metamorphosis of the Self', *Artscribe,* Dec. 1980, fig. 10; D. Kelder, *The Great Book of French Impressionism,* New York, 1980, p. 397, ill.; J. Arrouye, *La Provence de Cézanne,* Aix-en-Provence, 1982, p. 25; S. Gache-Patin, 'Douze oeuvres de Cézanne de l'ancienne collection Pellerin', *La Revue du Louvre et des Musées de France,* 2, 1984, p. 130, no. 3; D. Coutagne, *Cézanne au Musée d'Aix,* Aix-en-Provence, 1984, p. 213, ill.; J. Rewald, 'Cézanne and his father', in *Studies in Impressionism,* London, 1985, pp. 78ff, pl. VII; M. Bessonova, and W. Williams, *Impressionism and Post-Impressionism. The Hermitage, Leningrad. The Pushkin Museum of Fine Arts, Moscow,* New York and Leningrad, 1986, p. 151, ill.; J. Rewald, 'Paintings by Paul Cézanne in the Mellon Collection', in *Essays in Honor of Paul Mellon, Collector and Benefactor,* Washington, D.C., 1986, pp. 294–7, fig. 4; Rewald, 1986, p. 23, ill.; R. Kirsch, 'Paul Cézanne: 'Jeune Fille au Piano' and some Portraits of his Wife: An Investigation of his Painting', *Gazette des Beaux-Arts,* July-Aug. 1987, p. 22.

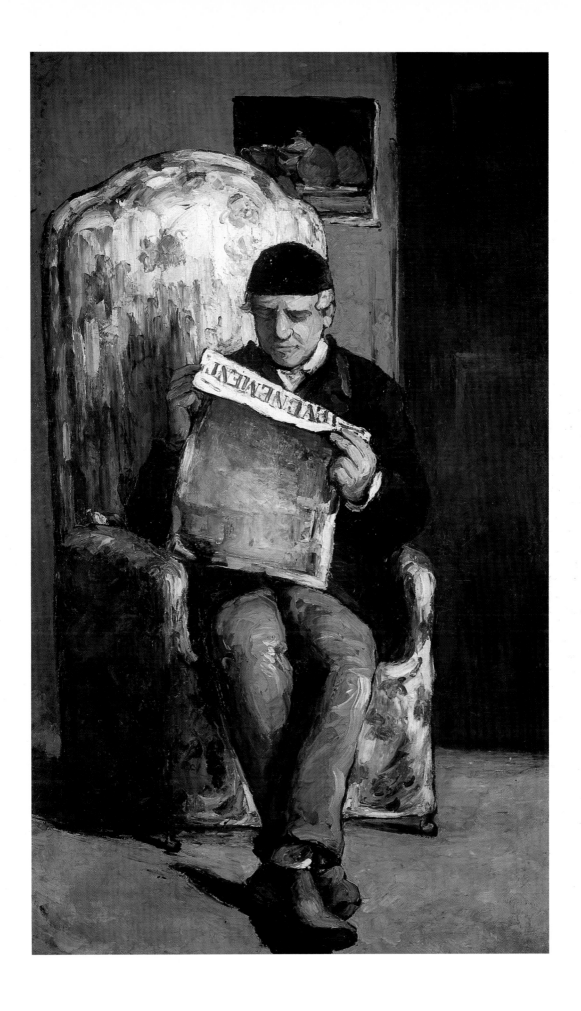

22 The Man with the cotton Cap (Uncle Dominique)

(L'Homme au bonnet de coton [L'Oncle Dominique])

*c.*1866
79.7 × 64.1 cm 31¼ × 25¼ in
V. 73
Lent by The Metropolitan Museum of Art; Wolfe Fund, 1951, from the Museum of Modern Art, Lillie P. Bliss Collection

In one picture (cat. 23), Uncle Dominique is posed in the position of a lawyer pleading on the lines of a figure from Daumier. In the other (cat. 22) he is an artisan and a man of the people, still catching our eyes with the same deep look. Both pictures are built up throughout from the flat lozenges of paint, rarely blending into one another, but placed precisely to model form where it presses against the wedges of black contour. It is the admixture of black that decides the tones in the Spanish manner of the 1850s. In both pictures the mood is solemn. Another of Dominique's disguises, perhaps the first, which may have suggested the later series in various costumes, was as a Dominican Friar (V.72; Haupt Coll., Palm Springs) with arms crossed on his chest and a conspicuous crucifix. These personifications for the uncle continued the habit of style-inducing fantasy which had been a feature of the historicist painting out of which impressionist figure-painting sprang. Dominique wore his costumes with somewhat the air that Manet's model in *Le Bon Bock* (1873; Philadelphia Museum of Art) was dressed as a Dutch beer-drinker for portrayal *à premier coup* in the style of Frans Hals.

These fantasy personifications for the uncle seem nevertheless to be later than the smaller pictures of the single heads (see cat. 18–20), which have occasionally a slight look of facetiousness. But it was in the smaller heads that the massiveness and consistency of the palette-knife style were evolved. Body and background, light and dark alike are all trowelled out of the same substance.

PROVENANCE Ambroise Vollard, Paris; Alexandre Rosenberg, Paris; Auguste Pellerin, Paris; Jos. Hessel, Paris; Marius de Zayas, New York; Lillie P. Bliss, New York; Museum of Modern Art, New York (Lillie P. Bliss Bequest).

EXHIBITIONS New York, Metropolitan Museum, 1921, *Impressionist and Post-Impressionist Paintings,* no. 4, ill.; New York, Modern Gallery (de Zayas) (*Group exhibition*), n.n; New York, Museum of Modern Art, 1929, *Cézanne, Gauguin, Seurat, van Gogh,* no. 1, ill.; New York, Museum of Modern Art, 1931 (*Bliss Collection*), no. 1; Andover, Mass., Addison Gallery of American Art, 1931, no. 1(n); Indianapolis, John Herron Art Institute, 1932, no. 1, ill.; New York, Museum of Modern Art, 1934–5, *Fifth Anniversary Exhibition,* no. 1; New York, Museum of Modern Art, 1939, *Tenth Anniversary Exhibition,* no. 56, ill.; Chicago, Art Institute, 1952, no. 5, ill.—New York, Metropolitan Museum, 1952, no. 5, ill.

BIBLIOGRAPHY Rivière, 1923, p. 204, listed, ill. opp. p. 10; R. Fry, *New York Times Magazine,* 1 May 1927, p. 6, ill.; Pfister, 1927, fig. 33; A. Bertram, *Cézanne,* London, 1929, pl. 2; R. Wilenski, *French Painting,* Boston, 1931, p. 309, ill.; Rivière, 1933, p. 21, ill.; R. Huyghe, *Cézanne,* Paris, 1936, pl. 11, pp. 29–32; Vollard, 1937, pl. 25; R. Wilenski, *Modern French Painters,* New York, n.d. (1941), fig. 3; R. Wilenski, *Painting and Sculpture in the Museum of Modern Art,* New York, 1942, no. 83, ill.; Rivière, *Cézanne,* Paris, 1942, p. 23, ill.; Rewald, 1948, fig. 17; J. Rewald, *The History of Impressionism,* New York, 1946, ill. p. 40; J. Rewald, *The History of Impressionism,* New York, 1961, p. 117, ill.; Ikegami, Tokyo, 1969, pl. 1; Schapiro, 1973, pl. 1; Wadley, 1975, pl. 11; R. Shiff, 'Seeing Cézanne', *Critical Inquiry,* Summer 1978, fig. 10; Venturi, 1978, ill. p. 53; K. Baetjer, *European Paintings in the Metropolitan Museum of Art,* 1980, p. 26, ill. p. 614; H. Hibbard, *The Metropolitan Museum of Art,* New York, 1980, fig. 788; N. Ponente, *Paul Cézanne,* Bologna, 1980, pl. 1; R. Shiff, *Cézanne and the End of Impressionism,* Chicago, 1984, fig. 45; C. Moffett, *Impressionist and Post-Impressionist Paintings in the Metropolitan Museum of Art,* New York, 1985, pp. 176–7, ill.

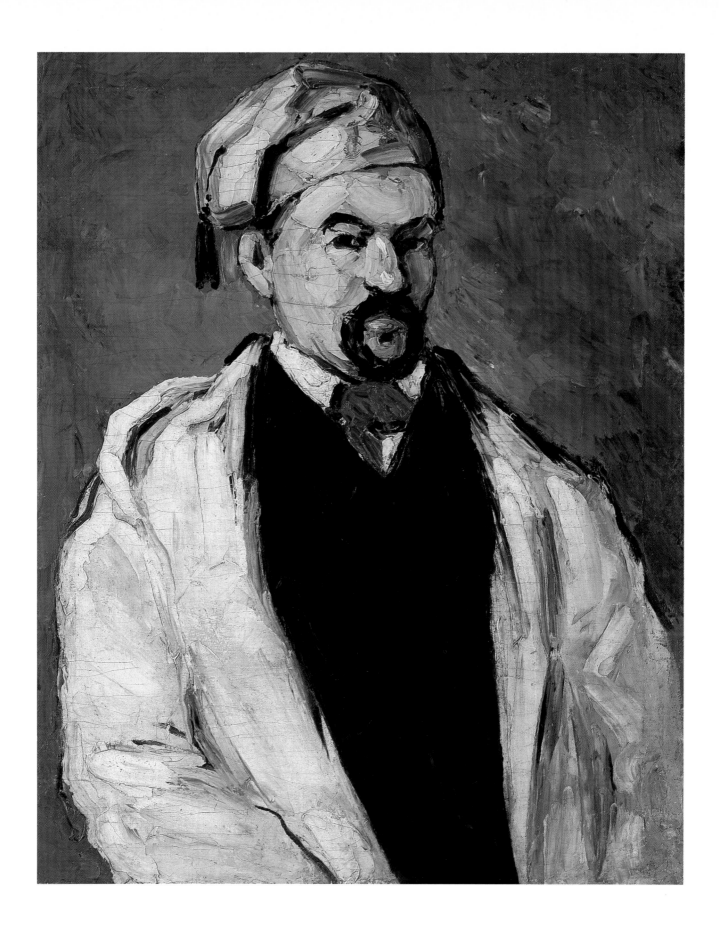

23 The Lawyer (Uncle Dominique)

(L'Avocat [L'Oncle Dominique])

*c.*1866
62 × 52 cm $24\frac{1}{4} \times 20\frac{1}{2}$ in
V.74
Private Collection

See cat. 22.

PROVENANCE Ambroise Vollard, Paris; Auguste Pellerin, Paris; René Lecomte, Paris.

EXHIBITIONS Paris, Grand Palais, 1907, *Salon d'Automne,* no. 1; Paris, Orangerie, 1954, no. 5, pl. 3.

BIBLIOGRAPHY E. Faure, 'Toujours Cézanne', *Amour de l'Art,* Dec. 1920, p. 270, ill.; Rivière, 1923, p. 202, listed; Fry, Dec. 1926, p. 394, ill.; Fry, 1927, pl. V, fig. 7; Raynal, 1936, pl. LIX; Rosenberg, *On Quality in Art,* Princeton, 1967, pl. 61; Schapiro, 1973, pl. 1.

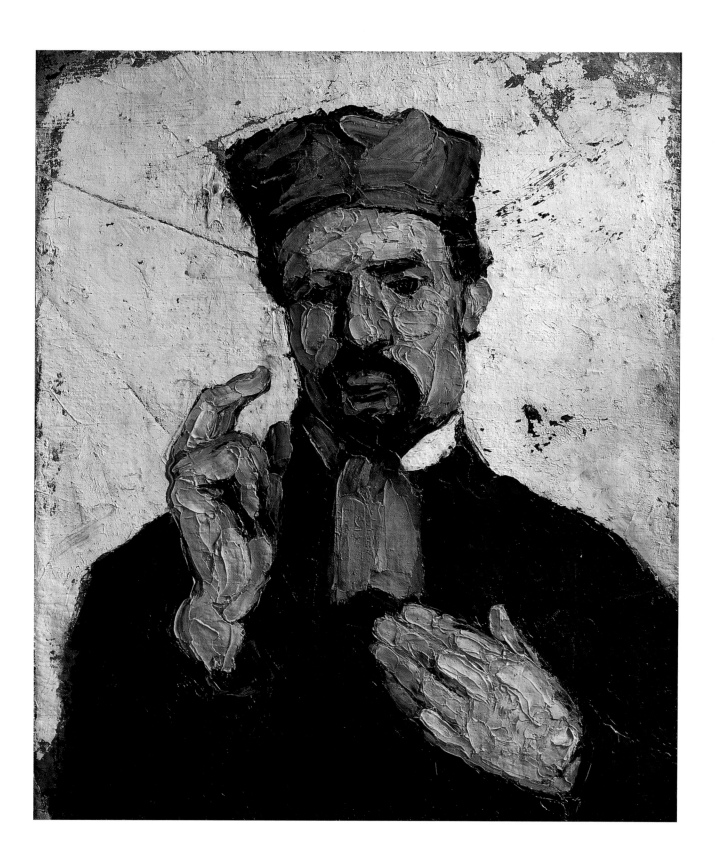

24 Portrait of Marie Cézanne, Sister of the Artist

(Portrait de Marie Cézanne, soeur de l'artiste)

*c.*1866–7
53.5 × 37 cm 21 × 13½ in
V.89
The Saint Louis Art Museum, Purchase

This delicate and sympathetic portrait of Marie was largely modelled in paint applied flatly as with a knife. Across the background and shoulders pass linear strips of colour as if in haste or at random, seeming in part to correct it and in part to delete. It is therefore possible that this state shows what is left of a *couillarde* portrait, rejected and half repainted, which was altered in keeping with the more fluent linear handling of 1867, before Cézanne left Provence for Paris and set about pictures like the *Negro Scipion* (cat. 30) in the rhythmical style that followed. After the picture was acquired for St Louis it was noticed that the *verso* of the supposed 1866 *recto* had been covered in unknown circumstances with a coat of black paint which on removal disclosed the head of a woman in a rather later style. Rivière had recorded a portrait of Cézanne's mother with a portrait of his sister on the other side, then regarded as the *verso*. This record may thus have described the state to which the canvas is now restored. The likeliest explanation is that at some stage, when the 'Marie' side appeared more attractive because more sketchy and Impressionistic, the canvas was reversed and the picture of the older woman concealed. A photograph of the older woman on the other side had in the meantime been illustrated by Venturi as a separate picture in a German collection.

PROVENANCE Ambroise Vollard, Paris; Galerie E. Bignou, Paris and New York.

EXHIBITIONS Paris, Galerie Pigalle, 1929, no. 39, ill.; New York, Knoedler Galleries, 1933, *Paintings from the Vollard Collection,* no. 4, ill.; Brussels, Palais des Beaux-Arts, 1953, *La Femme dans l'Art Français,* no. 16, pl. 38; New York, Wildenstein Galleries, 1958, *Fifty Masterworks from the City Art Museum of St Louis,* no. 45, ill. p. 63; Vienna, Belvedere, 1961, no. 2—Aix-en-Provence, Pavillon de Vendôme, 1961, no. 2; Tokyo, National Museum of Western Art, 1974, no. 1; Tokyo, Isetan Museum of Art, 1986, *Cézanne,* no. 4, ill.

BIBLIOGRAPHY Rivière, 1923, p. 196, listed; Iavorskaia, 1935, pl. 2; Rewald, 1936, fig. 9; Rewald, 1939, fig. 13; Barnes and de Mazia, 1939, no. 3, ill. p. 148; Rewald, New York, 1948, fig. 15; E. Jewell, *Paul Cézanne,* New York, 1944, p. 16, ill.; *Handbook,* City Art Museum, St Louis, 1953, p. 139; K. Leonhard, *Paul Cézanne in Selbstzeugnissen und Bilddokumenten,* Rheinbek bei Hamburg, 1966, p. 12, ill.; Wadley, 1975, pl. 12.

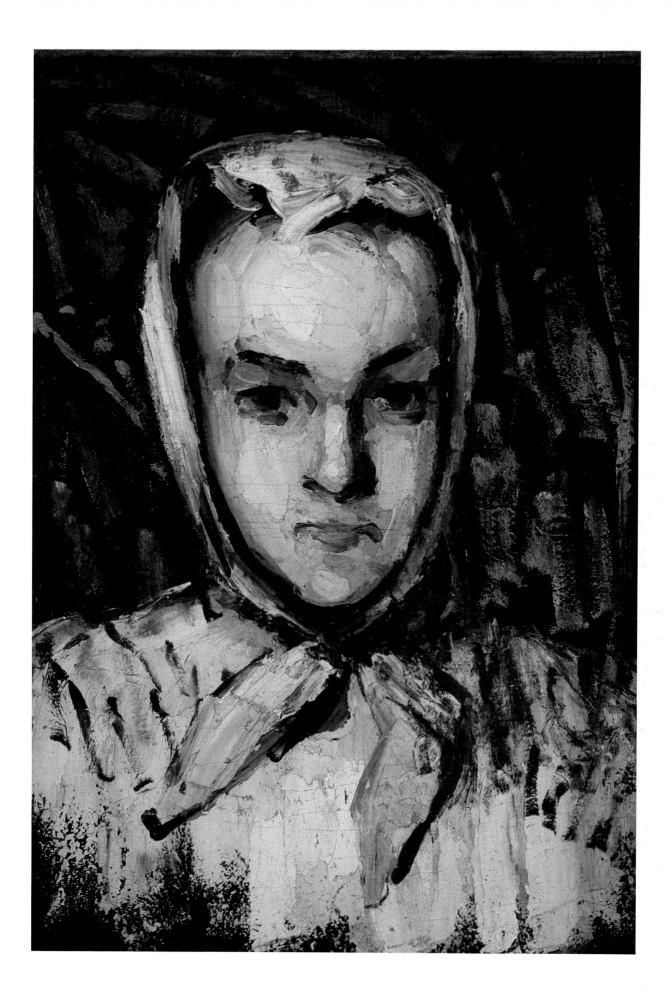

b) VERSO

24 Portrait of the Artist's Mother(?)

(Portrait de la mère de l'artiste[?])

c.1866–7
53.5 × 37 cm 21 × 14½ in
V.78
The Saint Louis Art Museum, Purchase

See cat. 24 (a).

PROVENANCE Ambroise Vollard, Paris; Galerie E. Bignou, Paris and New York.

BIBLIOGRAPHY Rivière, 1923, pp. 196, 197, listed; A. Vollard, 'Souvenirs sur Cézanne', *Cahiers d'Art*, 1931, p. 392, ill.; 'La Chronique des Arts', *Gazette des Beaux-Arts*, Feb. 1963, p. 45, fig. 165.

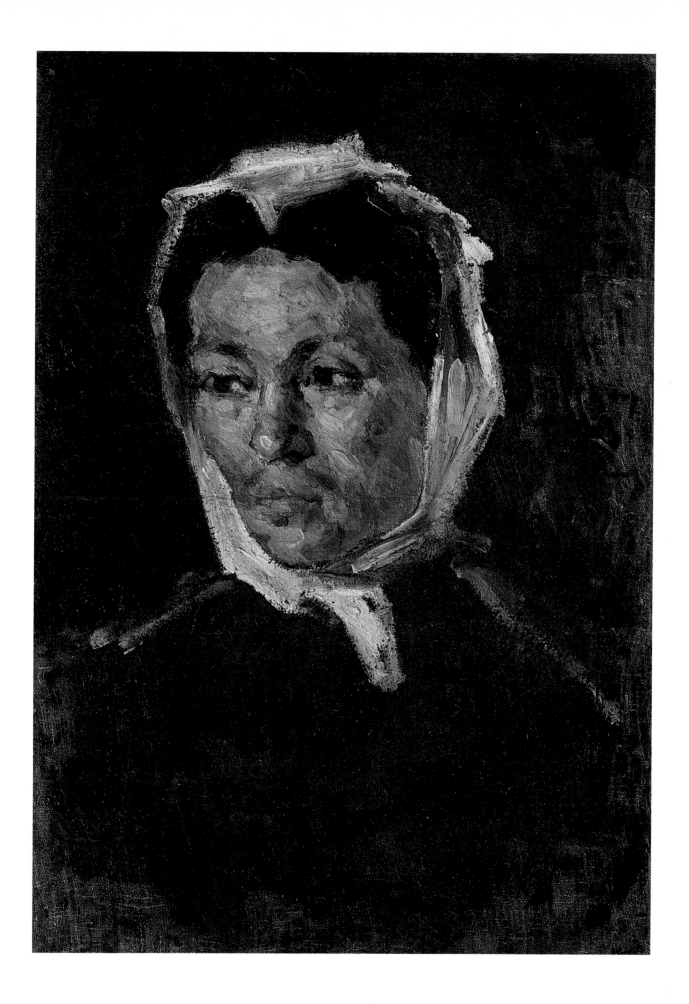

25 Marion and Valabrègue setting out for the Motif

(Marion et Valabrègue partant pour le motif)

1866
39 × 31 cm 15¼ × 12¼ in
V.96
Private Collection

After the period spent painting indoors in 1866 Cézanne wrote on 19 October to communicate to Zola his discovery that nothing done in the studio would ever equal what was done outdoors. Contrasts of figures with open air settings were astonishing, he wrote, and the effect of the landscape was magnificent. He was pleased with a large picture that he planned and sketched in the margin of his letter, showing Marion and Valabrègue 'setting out to look for a motif (a landscape motif of course)' for which he had already painted an oil sketch: 'the sketch, which Guillemet considers good and which I did after nature, makes everything else collapse and appear bad.'

Marion, who was to become a scientist and later directed the Natural History Museum at Marseilles, did in fact paint as a hobby. He is shown in this oil study for Cézanne's large picture with a Barbizon hat and a painter's pack, carrying a sketching easel. Valabrègue was a writer, who became a critic and historian and lost touch with Cézanne altogether. During 1866, when he wore a top hat, he was producing a poem a day with surprising fertility, as Guillemet told Zola. The pair were in fact accoutred and posed as open-air painters in illustration of Cézanne's new-found faith in *plein-airisme* and Valabrègue complained to Zola of the poses that they were made to assume in the midst of Paul's orgies of colour. In the event Cézanne's manifesto on behalf of *plein-airisme* seems, not surprisingly, to have missed its mark and on 2 November he had to inform Zola that his large canvas had been a failure. It was seven or eight years before he was able in his own work to justify his belief in painting from nature.

PROVENANCE G. Charpentier, Paris; Sale, Charpentier Collection, Hôtel Drouot, Paris, 11 April 1907, no. 3; Aubry; Galerie E. Druet, Paris; Auguste Pellerin, Paris; René Lecomte, Paris.

EXHIBITIONS Paris, Grand Palais, 1907, *Salon d'Automne*, no. 46; Paris, Orangerie, 1954, no. 10.

BIBLIOGRAPHY Meier-Graefe, 1918, ill. p. 89; Meier-Graefe, 1920, ill. p. 89; Meier-Graefe, 1922, ill. p. 101; Rivière, 1923, p. 198, listed; Fry, Dec. 1926, p. 400, ill.; Fry, 1927, pl. XXXVII, fig. 13; Fry, *Samleren*, 1929, p. 118, ill.; Cézanne, *Correspondance*, 1937, p. 99; Rewald, New York, 1939, p. 16, ill.; A. Chappuis, *Les Dessins de P. Cézanne au Cabinet des estampes du Musée des Beaux-Arts de Bâle*, Olten and Lausanne, 1962, fig. 1; W. Andersen, *Cézanne's Portrait Drawings*, Cambridge, Mass. and London, 1970, p. 218, fig. 241a; Rewald, 1986, p. 55, ill.

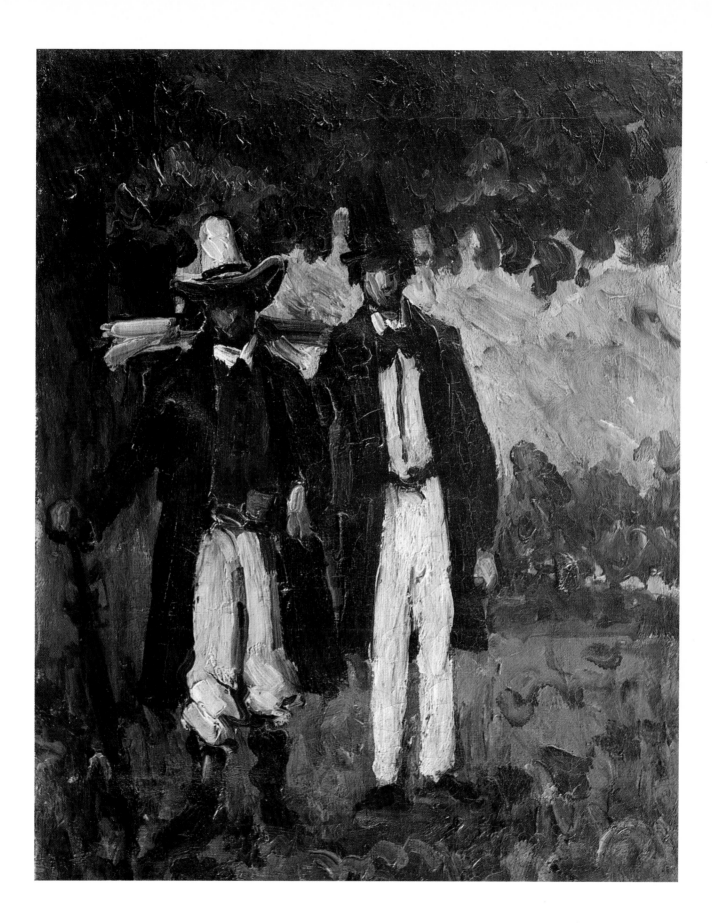

26 The Walk

(La Promenade)

*c.*1866
28 × 36 cm 11 × 14 in
V.116
Private Collection

Cézanne's desire for an open-air conversation-piece seems to have led him to adapt figures from a fashion plate. If he was concerned with the notation of light, he was at this stage apparently without any of the interest that he later took in the style of the fashion-plate itself (see cat. 55).

PROVENANCE Auguste Pellerin, Paris; René Lecomte, Paris.

EXHIBITION Paris, Orangerie, 1954, no. 16, pl. 6.

BIBLIOGRAPHY Rivière, 1923, p. 201; Rivière, 1933, p. 108; Ors, 1936, pl. 43; E. Faure, *Cézanne*, Paris, 1936, pl. 2; Raynal, 1936, pl. IX; di San Lazzaro, 1938, fig. 43; Barnes and de Mazia, 1939, no. 25, ill. p.164; Cogniat, 1939, pl. 4; Dorival, 1948, pl. 24; Schapiro, 1973, p. 56, ill.

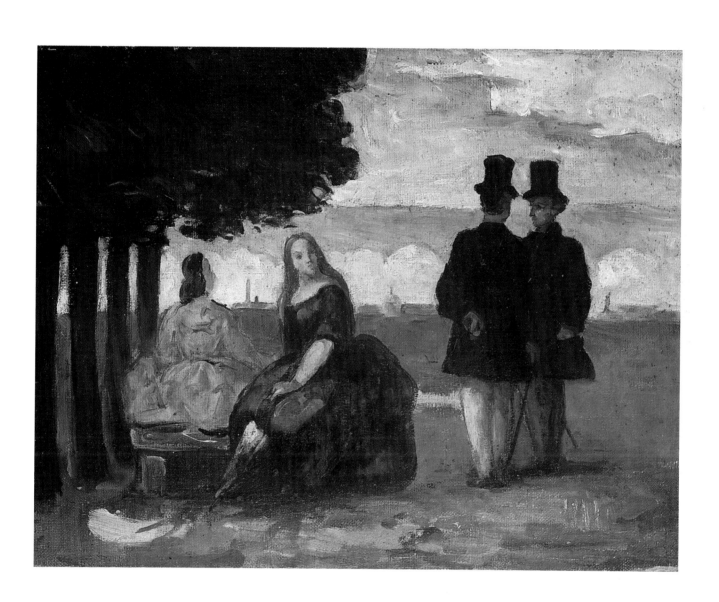

LP

27 Afternoon in Naples (with a negro servant)

(L'Après-midi à Naples [avec servante noire])

*c.*1866–77
37 × 45 cm 14⅝ × 17¾ in
V.224
Australian National Gallery, Canberra

This may be one of the two grotesque works on the theme of drunkenness which were rejected by the Salon in 1867 or one of the developments from them which were painted in the years that followed. The facetious title was invented by Guillaumin. The painter's ribald delight in scabrous, sprawling indulgence is a reminder, which may surprise us at a time when the art of a great painter is understood invariably to be in the best possible taste, that conventional delicacy or indeed restraint never figure in Cézanne's equipment.

PROVENANCE Ambroise Vollard, Paris; Bernheim-Jeune, Paris; Auguste Pellerin, Paris; Jean-Victor Pellerin, Paris; Wildenstein Galleries, New York.

BIBLIOGRAPHY Ors, 1936, pl. 42; Raynal, 1936, pl. XVIII; J. Laver, *French Painting & the Nineteenth Century*, London, 1937, pl. 113; di San Lazzaro, 1938, fig. 42; Cogniat, 1939, pl. 30; Rewald, 1939, fig. 42; Dorival, 1948, pl. 49 (commentaries, p. 151); Badt, 1956, pp. 226–7, 240; A. Chappuis, *Les Dessins de P. Cézanne au Cabinet des estampes du Musée des Beaux-Arts de Bâle*, Olten and Lausanne, 1962, fig. 28; S. Lichtenstein, 'Cézanne and Delacroix', *The Art Bulletin*, March 1964, fig. 11; Elgar, 1975, fig. 21; Rewald, 1986, p. 68, ill.

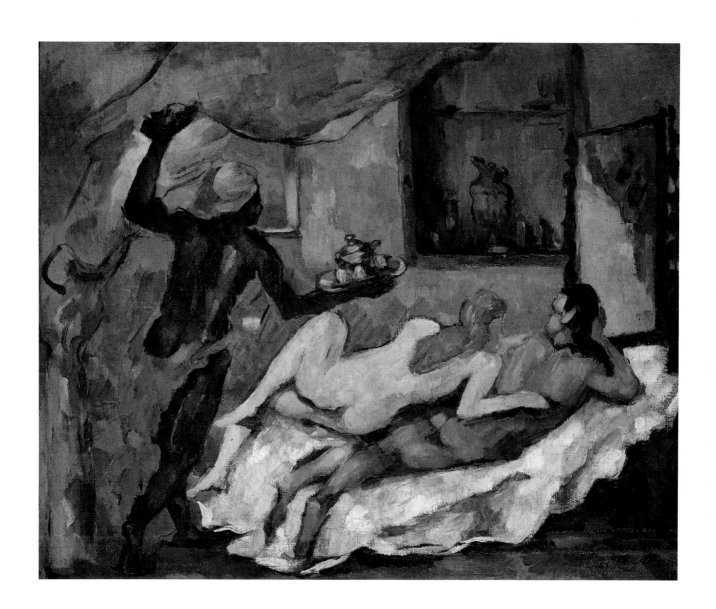

28 Women dressing

(Femmes s'habillant)

c.1867
22 × 33 cm 8½ × 13 in
V.93
Insel Hombroich

This composition, somewhat in the vein of the idyllic figure pictures of J.-F. Millet, was given to Camille Pissarro, who met Cézanne at the Académie Suisse and also owned four of the life drawings on which it was based (Ch. 201–204). It represents the first appearance in Cézanne's art of the vivid and imaginative colouring which matured in *The Rape* (cat. 31).

PROVENANCE Camille Pissarro, Paris; Sale, Pissarro Collection, Galerie G. Petit, Paris, 3 Dec. 1928, no. 28, ill. (as 'Trois Baigneuses'); Bernheim-Jeune, Paris; L'Art Moderne, Lucerne; Sale, 'L'Art Moderne' Collection, Hôtel Drouot, Paris, 20 June 1935, no. 22, ill. (as 'La Toilette'); Galerie Beyeler, Basel; Private Collection, Switzerland; Sale, Galerie Fischer, Lucerne, Nov. 1977, no. 1768, ill., bought-in; Sale, Galerie Lempertz, Cologne, 6 May 1978, no. 95, ill.; Private Collection, Paris; Sale, Sotheby's, London, 2 Dec. 1982, no. 407, ill.

EXHIBITIONS Venice, Biennale, 1920, no. 1; (?) Paris, Galerie Bernheim-Jeune, 1934 (no catalogue); Basel, Galerie Beyeler, 1967, *Impressionnistes*, no. 1; Basel, Galerie Beyeler, 1967–8, *Petits formats*, no. 17, ill.

BIBLIOGRAPHY Rivière, 1923, p. 197, listed; Raynal, 1936, pl. XX; J. Rewald, 'Sources d'inspiration de Cézanne', *Amour de l'Art,* May 1936, fig. 100.

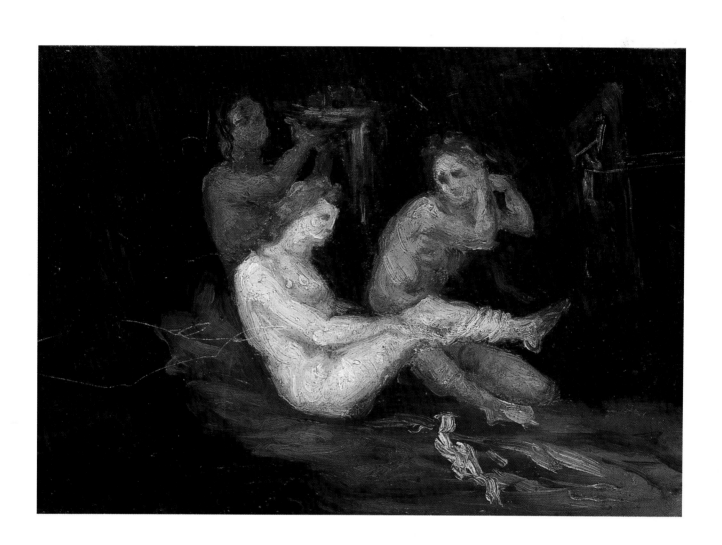

29 The Rue des Saules, Montmartre

(La rue des Saules à Montmartre)

c.1867
31.5 × 39.5 cm 12¼ × 15½ in
V.45
Private Collection

The stabbing strokes of the brush which succeeded the palette-knife facture and were employed on *Marion and Valabrègue* (cat. 25) were well suited to landscape and enabled Cézanne to paint a street in Montmartre, which was hardly within the range of the curling brush strokes that he was to use for the figure pictures of 1867 (see cat. 30, 31). This is one of the most impulsive and expressive of all Cézanne's pictures and, like the palette-knife still lifes (cat. 12–14), enables one to foresee Expressionism.

PROVENANCE Armand Guillaumin, Paris; Jos. Hessel, Paris; Georges Renand, Paris; Estate of Georges Renand; Sale, Hôtel Drouot, Paris, 20 Nov., 1987, no. 4, ill.

EXHIBITIONS Paris, Galerie Bernheim-Jeune, 1926, no. 27; Paris, Galerie Pigalle, 1929, no. 23; Paris, Indépendants, 1939, no. 4; Paris, Orangerie, 1953, *Baroque provençal*, no. 9.

BIBLIOGRAPHY C. Borgmeyer, *The Master Impressionists,* Chicago, 1913, p. 136, ill; A. Zeisho, *Paul Cézanne,* Tokyo, 1921, fig. 36; A. Warnod, *Les Peintres de Montmartre,* Paris, 1928, p. 138, ill. opp. p. 144; A. Bertram, *Cézanne,* London, 1929, pl. 13; Rewald, 1936, fig. 25; J. Rewald, 'Paysages de Paris, de Corot à Utrillo', *La Renaissance,* Jan.-Feb. 1937, ill; F. Novotny, *Cézanne und das Ende der wissenschaftlichen Perspektive,* Vienna, 1938, p. 206, no. 114; Dorival, 1948, pl. 9; S. Uchida, *Cézanne,* Tokyo, 1960, p. 17, ill.; R. Walter, 'Un vrai Cézanne: "La Vue de Bonnières"', *Gazette des Beaux-Arts,* May-June 1963, p. 363; L. Reidemeister, 'L'Ile de France et ses peintres', *Oeil,* 1965, p. 20, ill.; Rewald, 1986, p. 57, ill.

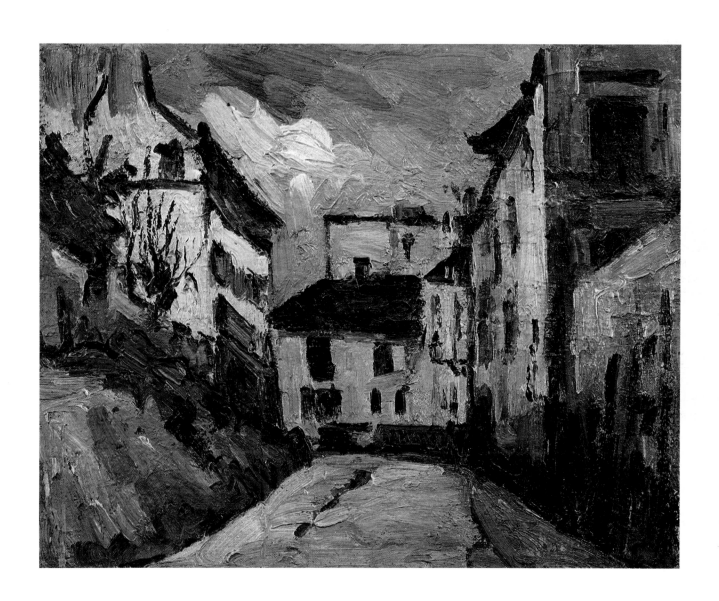

30 The Negro Scipion

(Le Nègre Scipion)

c.1867
107 × 83 cm 42⅛ × 32⅝ in
V.100
Museo de Arte, São Paulo

Scipion was a model at the Académie Suisse in Paris where Cézanne often went to draw from 1862 onwards; he must have posed in Cézanne's own studio for this picture. There is a pronounced resemblance to the dusky seducer in *The Rape* (cat. 31), both in the type of model and in the style, in which long brush strokes snaking energetically upwards alternate with strips of colour that curl downward where the form is inert. A similar range is seen in *Sorrow, or Mary Magdalen* (cat. 33) and in *Christ in Limbo* (cat. 32) from which it has been severed. Although the style of the pictures, both of them paraphrases of old masters, is considerably different from this more systematic painting from nature, there are good reasons for dating these works together and *The Rape* (cat. 31) is one of Cézanne's few pictures that bear a date. The probability is therefore that Scipion was painted from life in Paris in 1867. The picture was the high point of a rhythmical handling of paint which reversed the slab-like solidity of 1866 and re-established the opposite principle in Cézanne's art. The picture belonged to Monet, who hung it in his bedroom with the other favourites from his collection and delighted to point it out as '*un morceau de première force*'.

PROVENANCE Ambroise Vollard, Paris; Claude Monet, Giverny; Michel Monet, Giverny; Paul Rosenberg, Paris; Wildenstein Galleries, Paris, London and New York.

EXHIBITIONS Paris, *Exposition Coloniale Internationale de Paris,* 1931, n.n., ill.; Basel, Kunsthalle, 1936, no. 2; Paris, Paul Rosenberg, 1939, no. 1, ill.; London, Rosenberg & Helft, 1939, no. 1, ill.; Brussels, Palais des Beaux-Arts, 1947–8, *De David à Cézanne,* no. 137; Chicago, Art Institute, 1952, no. 4, ill.—New York, Metropolitan Museum, 1952, no. 4, ill.; Paris, Orangerie, 1953–4, *Chefs-d'oeuvre du Musée d'Art de Sao Paulo,* no. 2, ill.; London, Tate Gallery, 1954, *Masterpieces from the Sao Paulo Museum of Art,* no. 44; Milan, Palazzo Reale, 1954–5, *Masterpieces from the Sao Paulo Museum of Art,* no. 63, ill.; New York, Metropolitan Museum, 1957, *Paintings from the Sao Paulo Museum,* no. 43, ill.; Munich, Haus der Kunst, 1964–5, *Französische Malerei des 19. Jahrhunderts, von David bis Cézanne,* no. 18, ill.; Tokyo, National Museum of Western Art, 1974, no. 3; Madrid, Museo Espanol de Arte Contemporaneo, 1984, no. 2, ill.; Tokyo, Isetan Museum of Art, 1986, no. 3, ill.

BIBLIOGRAPHY L. Vauxcelles, 'Une après-midi chez Claude Monet', *Art et les artistes,* 1905, p. 89; Bernheim-Jeune (ed.), *Cézanne* (with contributions by O. Mirbeau, Th. Duret, L. Werth etc), Paris, 1914, pl. XII; Vollard, 1914, pl. 4; Meier-Graefe, 1922, ill. p. 86; H. von Wedderkop, *Paul Cézanne,* Leipzig, 1922 (pl. II), ill.; T. Klingsor, *Cézanne,* Paris, 1923, p. 11; Rivière, 1923, p. 197, listed; M. Elder, *Chez Claude Monet à Giverny,* Paris, 1924, p. 49; Gasquet, 1926, p. 47; Pfister, 1927, fig. 17; Iavorskaia, 1935, pl. 6; Ors, 1936, pl. 1; Raynal, 1936, pl. VII; di San Lazzaro, 1938, fig. 1; Barnes and de Mazia, 1939, no. 24 listed; J. Rewald, *The History of Impressionism,* New York, 1946, p. 141, ill.; J. Rewald, *The History of Impressionism* (second edition), New York, 1955, ill. p. 141; P. Bardi, *The Arts in Brazil,* Milan, 1956, pl. 367; Dorival, 1948, pl. 8; J. Rewald, *The History of Impressionism,* New York, 1961, p. 158, ill.; L. Guerry, *Cézanne et l'expression de l'espace* (2nd edition), Paris, 1966, pl. 5; R. Gimpel, *Journal d'un collectionneur marchand de tableaux,* Paris, 1963, p. 155; Ikegami, Tokyo, 1969, pl. 2; Schapiro, 1973, p. 56, ill.; Elgar, 1975, fig. 18; N. Ponente, *Paul Cézanne,* Bologna, 1980, p. 25, ill.; D. Coutagne, *Cézanne au Musée d'Aix,* Aix-en-Provence, 1984, p. 183, ill.; B. Bernard, *The Impressionist Revolution,* London, 1986, p. 113, ill.; Rewald, 1986, p. 48, ill.

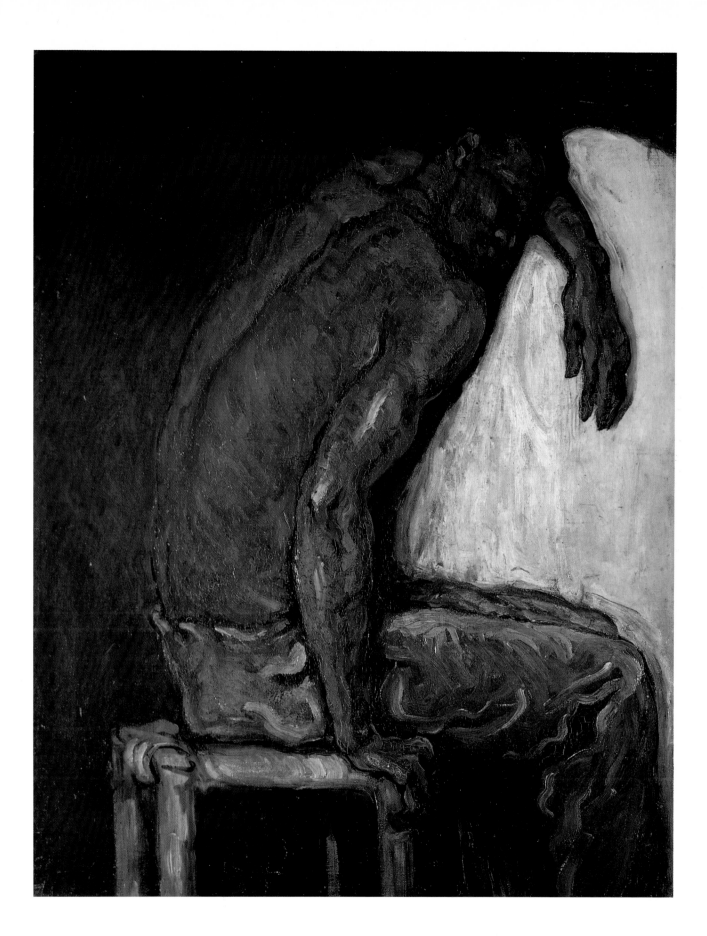

31 The Rape

(L'Enlèvement)

c.1867
90.5 × 117 cm 35½ × 46 in
Signed and dated: 67 Cézanne
V.101
The Provost and Fellows of King's College,
Cambridge (Keynes Collection), on loan to the
Fitzwilliam Museum, Cambridge

This most traditional of Cézanne's compositions was painted for Zola, it is said in his house in rue La Condamine. Some have thought to connect the subject with the writer's Romantic early stories, but Mary Lewis has now recognised that the girdle in the hands of one of the victim's companions establishes her as Persephone abducted by Pluto to his nether kingdom. The shaded vale and the elements of the drama are in fact shown somewhat as in Niccolo dell'Abbate's picture in the Louvre with a reduction in the attendant nymphs and the inclusion of Mont Sainte-Victoire doing duty for Aetna in the background.

The nymphs were studied in at least one drawing (Ch. 199) and were used not dissimilarly in *Women dressing* (cat. 28) at about the same time. The controlled incandescence of colour in both pictures introduced a new potentiality to Cézanne's work while the figure invention followed a tradition extending from Tintoretto to Daumier which remained of lasting value to him.

PROVENANCE Emile Zola, Médan; Sale, Zola Collection, Hôtel Drouot, Paris, 9–13 March, 1903, no. 115; Ambroise Vollard, Paris; Durand-Ruel, Paris and New York, acquired for H.O. Havemeyer, New York; Sale, Havemeyer Collection, American-Anderson Galleries, New York, 10 April 1930; Galerie E. Bignou, Paris; Société La Peinture Contemporaine, Lucerne; Sale, Vente de la Dissolution d'une Société, Galerie Charpentier, Paris, no. 4, ill.; J. Maynard Keynes, London; Lady Keynes, London.

EXHIBITIONS New York, Arden Gallery, 1917, n.n; Paris, Galerie G. Petit, 1930, *Cent ans de peinture française*, no. 26; London, Reid & Lefevre, 1933, *Ingres to Cézanne*, no. 3, ill.; Cleveland, Cleveland Museum, 1934, *French Art*, no. 3; Ottawa, National Gallery of Canada, 1934, *French Painting of the 19th Century*, no. 10, ill. — Toronto, Art Gallery of Ontario, 1934, n.n. —; Montreal, Art Association, 1934, n.n; London, Reid & Lefevre, 1935, no. 1, ill.; Paris, Renou & Colle, 1935, n.n; Chicago, Art Institute, 1952, no. 6, ill. — New York, Metropolitan Museum, 1952, no. 6, ill.; Paris, Orangerie, 1953, *Baroque provençal*, no. 6; Edinburgh, Royal Scottish Academy, 1954, no. 4 — London, Tate Gallery, 1954, no. 4, pl. II.

BIBLIOGRAPHY J. Meier-Graefe, *Entwicklungsgeschichte der modernen Kunst*, Stuttgart, 1904, pl. 62; T. Duret, *Histoire des peintres impressionnistes*, Paris, 1906, p. 171, ill.; Meier-Graefe, 1910, p. 9, ill.; Meier-Graefe, 1913, p. 9, ill.; Meier-Graefe, 1918, ill. p. 86; Meier-Graefe, 1920, ill. p. 86; Meier-Graefe, Munich, 1922, p. 9, ill. p. 92; Meier-Graefe, 1923, p. 11, ill.; F. Burger, *Cézanne und Hodler* (fifth edition), Munich, 1923, pl. 45; Rivière, 1923, pp. 46, 198, listed; *H.O. Havemeyer Collection*, Portland, Maine, 1931, p. 501; P.G., Konody and the Countess of Lathon, *Introduction to French Painting*, London, 1932, p. 232, ill.; Rewald, 1936, fig. 14; Rewald, 1939, fig. 15; Barnes and de Mazia, 1939, no. 8; Rewald, New York, 1939, p. 24, ill.; J. Rewald, *The History of Impressionism*, New York, 1946, p. 140, ill.; W. Kuhn, 'Cézanne: Delayed Finale', *Art News*, April, 1947, p. 56, ill.; Dorival, 1948, pl. 11; Rewald, New York, 1948, fig. 24; J. Rewald, *The History of Impressionism* (second edition), New York, 1955, ill. p. 140; G. Berthold, *Cézanne und die alten Meister*, Stuttgart, 1958, pp. 45, 46, fig. 72; J. Rewald, *The History of Impressionism*, New York, 1961, p. 158, ill.; S. Lichtenstein, 'Cézanne and Delacroix', *The Art Bulletin*, March 1964, pp. 57, 58, fig. 3; P. Pool, *Impressionism*, New York, 1967, pl. 140; Schapiro, 1973, p. 26, ill.; Elgar, 1975, pl. 9; Wadley, 1975, pl. 81; D. Coutagne, *Cézanne au Musée d'Aix*, Aix-en-Provence, 1984, p. 184, ill.; B. Bernard, *The Impressionist Revolution*, London, 1986, p. 236, ill.; R. Pickvance, *Cézanne*, Tokyo, 1986, p. 27, ill.; Rewald, 1986, p. 79, ill. p. 50; F. Weitzenhoffer, *The Havemeyers: Impressionism comes to America*, New York, 1986, p. 147, pl. 116.

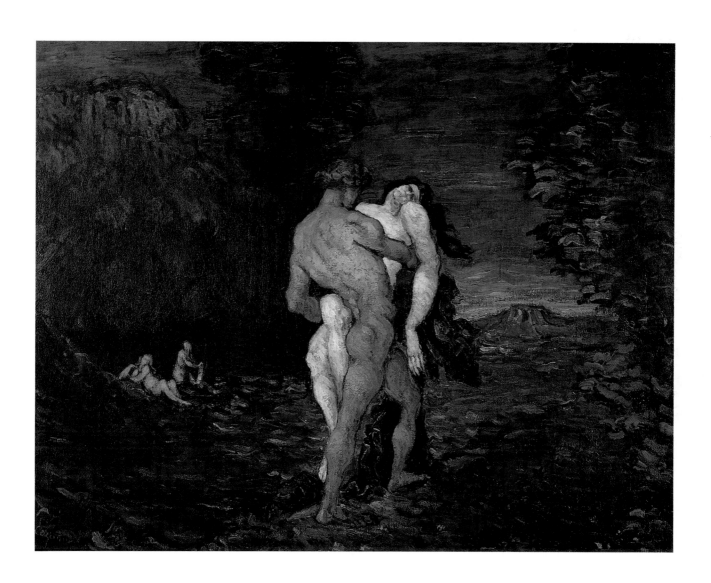

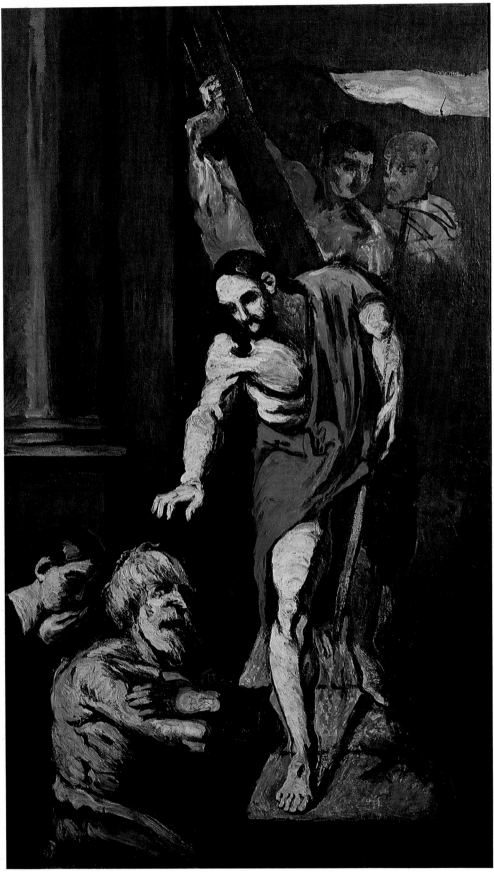

32

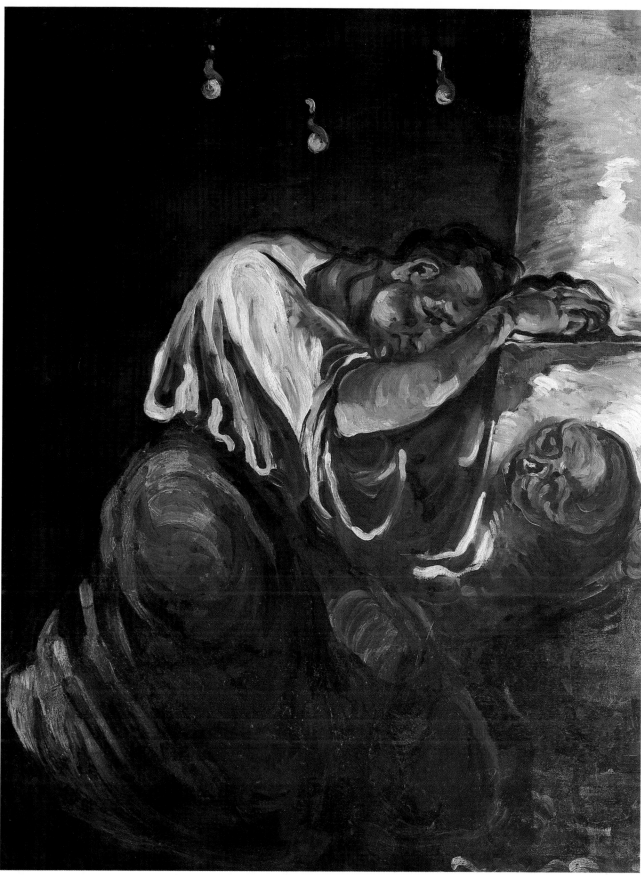

33

32 Christ in Limbo

(Le Christ aux Limbes)

c.1867
170 × 97 cm 67 × 38¼ in
V. 84
Private Collection

This and *Sorrow, or Mary Magdalen* (cat. 33) are the two parts of the picture which was divided when it was removed from the wall of the salon at the Jas de Bouffan. Mary Lewis has shown that the original picture in its entirety

was a perfectly orthodox Easter subject, if a rather ambitious and unbridled one, and that the separation of the two parts, ostensibly to rectify their disproportion, sacrifices an essential character of one of the most individual of Cézanne's early designs. The two parts are now perhaps destined to enter different collections. This must be accounted a grave loss.

The characteristics of the two parts are now well understood. The *Christ in Limbo* was derived from Charles Blanc's illustration of a picture in the Prado which is now known to be by Sebastiano del Piombo. It has been thought that the publication of Charles Blanc's book,

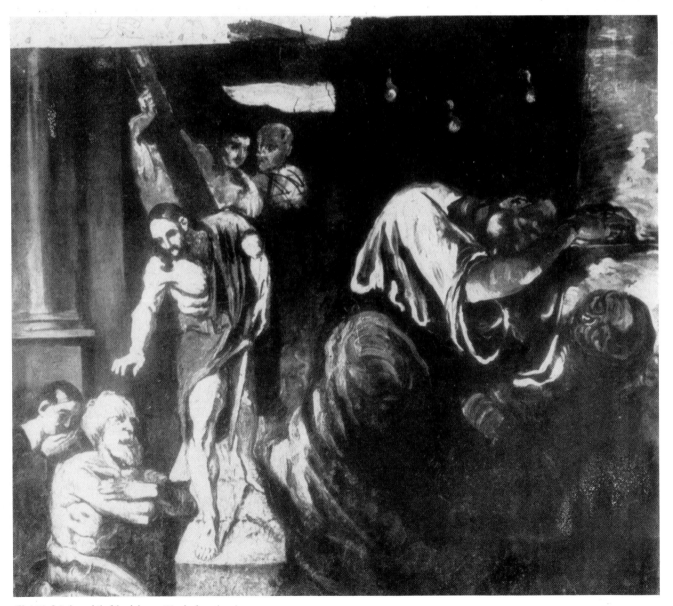

Christ in Limbo and the Magdalen, c.1867, before the picture was cut.

L'Ecole espagnole in 1869 established a terminal date before which Cézanne's original picture could not have been painted. This overlooks the fact that the illustration of the Sebastiano appeared in 1867 in one of the periodical parts in which the book was published. This is established by its recorded reception by the Library of Congress and by the fact that it also formed the source of a lithograph by Daumier which appeared in the same year, '*Non! mes enfants . . . vous n'êtes pas de cette pièce-la.*' (*Charivari*, 8 March 1867). The other part, *Sorrow, or Mary Magdalen*, which is now divided from it, must have been painted at the same time. It appears to the present compiler that for this Cézanne is likely to have drawn on a work of the same subject by Domenico Feti in the Louvre (fig. 9), although a number of other possible sources have lately been suggested.

PROVENANCE Jas de Bouffan, Aix-en-Provence; Louis Granel, Aix-en-Provence; Jos. Hessel, Paris; Auguste Pellerin, Paris; René Lecomte, Paris.

EXHIBITIONS Paris, Orangerie, 1936, no. 7; Paris, Orangerie, 1954, no. 11.

BIBLIOGRAPHY M. Denis, *Théories*, Paris, 1912, pp. 239–40; F. Burger, *Cézanne und Hodler* (fourth edition), Munich, 1920, pl. 188; Gasquet, 1921, ill. opp. p. 104; Meier-Graefe, 1922, ill. p. 99; F. Burger, *Cézanne und Hodler* (fifth edition), Munich, 1923, pl. 186; Rivière, 1923, p. 197, listed, ill. opp. p. 6 and detail p. 165; Fry, Dec. 1926, p. 390, ill.; Fry, 1927, pl. I; Pfister, 1927, fig. 15; Fry, *Samleren*, 1929, p. 102, ill.; R. Huyghe, *Cézanne*, Paris, 1936, pl. 13; J. Rewald, 'Sources d'inspiration de Cézanne', *Amour de l'Art*, May 1936, fig. 92; F. Novotny, *Cézanne*, Vienna, 1937, pl. I; Barnes and de Mazia, 1939, no. 11, ill. p. 153 (analysis p. 311); Dorival, 1948, pl. III; A. Malraux, *Les Voix du silence*, Paris, 1951, pp. 576–7, ill.; Schapiro, 1973, p. 11, ill.; M. Lewis, 'Cézanne's "Harrowing of Hell and the Magdalen"', *Gazette des Beaux-Arts*, April 1981, pp. 175–8, fig. 1; T. Reff, 'Cézanne: The Severed Head and the Skull', *Arts*, Oct. 1983, p. 94, fig. 12; D. Coutagne, *Cézanne au Musée d'Aix*, Aix-en-Provence, 1984, p. 116, ill.

33 Sorrow, or Mary Magdalen
(*La Douleur ou La Madeleine*)

*c.*1867
165 × 124 cm 65 × 48¾ in
V.86
Musée d'Orsay, Paris

See cat. 32.

PROVENANCE Jas de Bouffan, Aix-en-Provence; Louis Granel, Aix-en-Provence; Jos. Hessel, Paris; Marius de Zayas, New York; Alphonse Kann, Saint-Germain-en-Laye; Bokanowski, Paris.

EXHIBITIONS Zurich, Kunsthaus, 1917, *Französische Kunst des XIX und XX. Jahrhunderts,* no. 20; New York, Metropolitan Museum, 1921, *Impressionist and Post-Impressionist Paintings,* no. 2; New York, Modern Gallery (de Zayas), 1921 (*Group Exhibition*), n.n; Paris, Orangerie, 1953, *Baroque provençal,* no. 2, pl. XXIV; Paris, Orangerie, 1954, no. 12, pl. V; Paris, Orangerie, 1974, no. 1.

BIBLIOGRAPHY Coquiot, 1919, p. 41; F. Burger, *Cézanne and Hodler* (fourth edition), Munich, 1920, pl. 188; R. Carroll, *The Ledger (Philadelphia),* 8 Sept. 1921; Gasquet, 1921, ill. opp. p. 102; Meier-Graefe, 1922, ill. p. 97; F. Burger, *Cézanne und Hodler* (fifth edition), Munich, 1923, pl. 186; Rivière, 1923, p. 199, listed; Pfister, 1927, fig. 15; Ors, 1930, p. 50, ill.; H. Adhémar, *Catalogue des Peintures, Pastels, Sculptures Impressionnistes du Musée du Louvre,* Paris, 1958, p. 15, no. 29; G. Bazin, *L'Impressionnisme au Louvre,* Paris, 1958, pp. 114–15, ill.; H. Sterling and H. Adhémar, *La Peinture au Musée du Louvre,* Paris, 1958, fig. 246; Schapiro, 1973, p. 56, ill.; Elgar, 1975, fig. 14; G. Adriani, *Paul Cézanne, Der Liebeskampf,* Munich, 1980, pl. 10; N. Ponente, *Paul Cézanne,* Bologna, 1980, p. 23, ill.; M. Lewis, 'Cézanne's "Harrowing of Hell and the Magdalen",' *Gazette des Beaux-Arts,* April 1981, pp. 175–8, fig. 1; T. Reff, 'Cézanne: The Severed Head and the Skull', *Arts,* Oct. 1983, p. 92, fig. 9; C. Kiefer, 'Cézanne's "Magdalen": A New Source in the Musée Granet, Aix-en-Provence', *Gazette des Beaux-Arts,* Feb. 1984, p. 92, fig. 1.

34 The Murder

(Le Meurtre)

c.1867–8
64 × 81 cm 25¾ × 31½ in
V.121
National Museums and Galleries on Merseyside, Walker
Art Gallery

The violence of the subject unbalanced its presentation.
The artist has been content with a considerable degree of
distortion. It may be that the subject was drawn from a
popular broadsheet. A popular print of a scene of violence
was apparently represented on the wall behind the model
in the now lost *Femme nue* (see fig. 12), and *The Murder*
was probably derived from some such original.

PROVENANCE Ambroise Vollard, Paris; Paul Cassirer, Berlin; Sally Falk,
Mannheim; Paul Cassirer, Berlin; Dr Julius Elias, Berlin; Wildenstein
Galleries, Paris, London and New York.

EXHIBITIONS Cologne, Kunstverein Gemäldegalerie, 1913,
Eröffnungsausstellung, no. 8; Berlin, Berliner Secession, 1913, no. 24a, ill.;
Dresden, Galerie Ernst Arnold, 1914, *Französische Malerie des XIX.
Jahrhunderts*, no. 8; Berlin, Paul Cassirer, 1914, *Sommerausstellung*, no. 8, ill.;
Berlin, Paul Cassirer, 1915 *(Group Exhibition)*, no. 54; Berlin, Paul Cassirer,
1921, no. 1, ill.; Basel, Kunsthalle, 1936, no. 6; Chicago, Art Institute, 1952,
no. 2, ill.—New York, Metropolitan Museum, 1952, no. 2, ill.; Aix-en-
Provence, Musée Granet, 1953, no. 2, ill.—Nice, Musée Massénas, 1953,
no. 2—(?)Grenoble, Musée des Beaux-Arts, 1953, no. 2; Baltimore,
Baltimore Museum, 1954, *Man and his Years*, no. 95, ill.; Washington, DC,
Corcoran Gallery, 1956, *Visionaries and Dreamers*, no. 37; Zurich,
Kunsthaus, 1956, no. 5, ill.; Munich, Haus der Kunst, 1956, no. 2, ill.;
Vienna, Belvedere, 1961, no. 4, pl. 2; London, Institute of Contemporary
Arts, 1964, *Aspects of Violence*, n.n.; Tokyo, National Museum of Western
Art, 1974, no. 7; Liège, Musée Saint-Georges, 1982, *Cézanne*, no. 2—
Aix-en-Provence, Musée Granet, 1982, no. 2; Madrid, Museo Espanol de
Arte Contemporaneo, 1984, no. 6, ill.

BIBLIOGRAPHY M. Denis, 'Cézanne', *Kunst und Kunstler*, 1913, p. 279, ill.;
P. Schumann, 'Französische Ausstellung in Dresden', *Die Kunst für Alle*,
July 1914, p. 480, ill.; Meier-Graefe, 1918, ill. p. 92; A. Popp, 'Cézanne,
Elemente seines Stiles, anlasslich einer Kritik erortert', *Die bildenden Kunste*,
1919, ill. p. 179; Meier-Graefe, 1920, ill. p. 92; Meier-Graefe, 1922, ill.
p. 104; Rivière, 1923, p. 199, listed; Meier-Graefe, 1927, pl. VII; Pfister,
1927, fig. 21; Fry, *Samleren*, 1929, p. 99, ill.; Iavorskaia, 1935, pl. 10; Barnes
and de Mazia, 1939, no. 20, ill. p. 161; Rewald, New York, 1948, fig. 28;
Schapiro, 1952, p. 21, ill.; Badt, 1956, p. 226; F. Novotny, *Painting and
Sculpture in Europe 1780–1880*, London, 1960, p. 172, fig. B; P. Feist, *Paul
Cézanne*, Leipzig, 1963, pp. 12, 22, 54, pl. 6; Schapiro, 1973, p. 7, ill.;
D. Sutton, 'The Paradoxes of Cézanne', *Apollo*, August 1974, pl. 4;
A. Barskaya, *Paul Cézanne*, Leningrad, 1975, p. 19, ill.; Wadley, 1975, pl. 83;
Venturi, 1978, ill. p. 49; G. Adriani, *Paul Cézanne, Der Liebeskampf*, Munich,
1980, pl. 12; D. Coutagne, *Cézanne au Musée d'Aix*, Aix-en-Provence, 1984,
p. 186, fig. 4; B. Bernard, *The Impressionist Revolution*, London, 1986, p. 237,
ill.; Rewald, 1986, p. 52, ill.

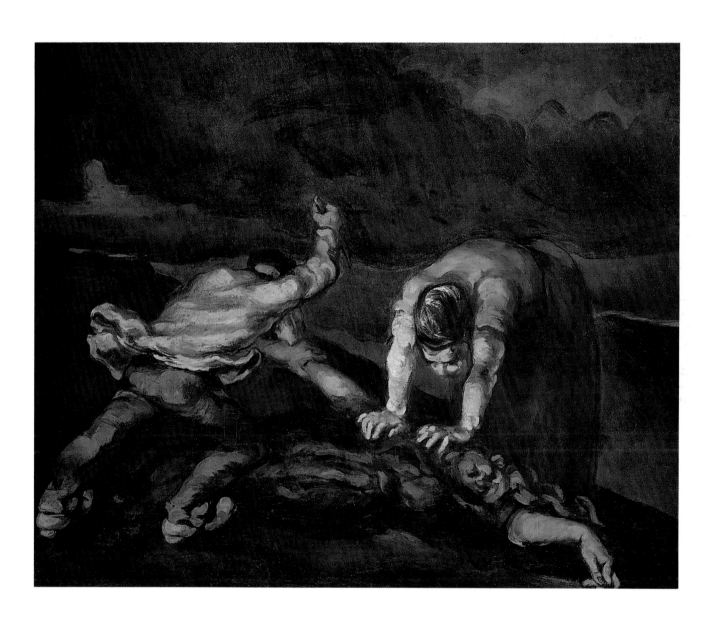

35 Preparation for the Funeral, or The Autopsy

(La Toilette funéraire ou L'Autopsie)

*c.*1868
49 × 80 cm 19¼ × 31½ in
V. 105
Private Collection

The subject was probably suggested by pictures of the *Entombment* by Ribera acquired for the Louvre in the 1860s. There is possibly a relationship with a work by Ribera exhibited from the beginning of 1869 and this may indicate the date of *Preparation for the Funeral*. There are also parallels with examples that became available earlier. The realism of the seventeenth century, which was of general interest in the 1860s, had a special value to Cézanne, although he is never thought of as a realist. The bald head, for example, is reminiscent of similar details in Caravaggio's *Death of the Virgin*; there is another resemblance in Cézanne's *Murder* (cat. 34). M.L. Krumrine (q.v. p. 22) points out the curious parallel between the bald and bearded figure in this picture and the painter, named Laurent, but evidently modelled on Cézanne, who murders the husband of Thérèse Raquin in Zola's novel of that name, then haunts the morgue in search of his victim's corpse. The unity of sombre tones, which was a common characteristic of advanced painting at the time, was clearly influenced by Spanish painting and by Manet.

The picture was also affected both by life drawings made at the Académie Suisse and by a drawing for an *Entombment* by Fra Bartolommeo in the Louvre, which Cézanne copied. Like no other painter, except perhaps his Russian contemporary N.N. Ge, Cézanne in the 1860s was seeking an identifiably tragic style.

PROVENANCE Ambroise Vollard, Paris; Auguste Pellerin, Paris; René Lecomte, Paris.

EXHIBITIONS Paris, Orangerie, 1953, *Baroque provençal*, no. 7; Paris, Orangerie, 1954, no. 14; Basel, Galerie Beyeler, 1983, no. 5.

BIBLIOGRAPHY C. Borgmeyer, *The Master Impressionists*, Chicago, 1913, p. 272, ill.; Vollard, 1914, pl. 48; E. Stuart(?), 'Cézanne and His Place in Impressionism', *Fine Arts Journal*, May 1917, p. 338, ill.; Meier-Graefe, 1918, ill. p. 87; Meier-Graefe, 1920, ill. p. 87; Meier-Graefe, Munich, 1922, ill. p. 98; H. von Wedderkop, *Paul Cézanne*, Leipzig, 1922 (pl. III); Rivière, 1923, p. 196, listed, ill. p. 67; Fry, Dec. 1926, p. 389, ill; Fry, 1927, pp. 15–16, pl. II; Meier-Graefe, 1927, pl. IV; Pfister, 1927, fig. 20; Fry, *Samleren*, 1929, p. 101, ill.; Ors, 1930, p. 13, ill.; Rivière, 1933, p. 5, ill.; Ors, 1936, pl. 37; Raynal, 1936, pl. V; F. Novotny, *Cézanne*, Vienna, 1937, pl. 8; di San Lazzaro, 1938, fig. 37; Barnes and de Mazia, 1939, no. 15, ill. p. 156; Cogniat, 1939, pl. 5; Rivière, 1942, p. 7, ill.; Dorival, 1948, pl. 12; G. Jedlicka, *Cézanne*, Berne, 1948, fig. 5; F. Jourdain, *Cézanne*, Paris and New York, 1950, ill.; L. Guerry, *Cézanne et l'expression de l'espace* (2nd edition), Paris, 1966, pl. 3; Elgar, 1975, fig. 10; G. Ballas, 'Paul Cézanne et la Revue "l'Artiste"', *Gazette des Beaux-Arts*, Dec. 1981, fig. 12; Rewald, 1986, p. 51, ill.

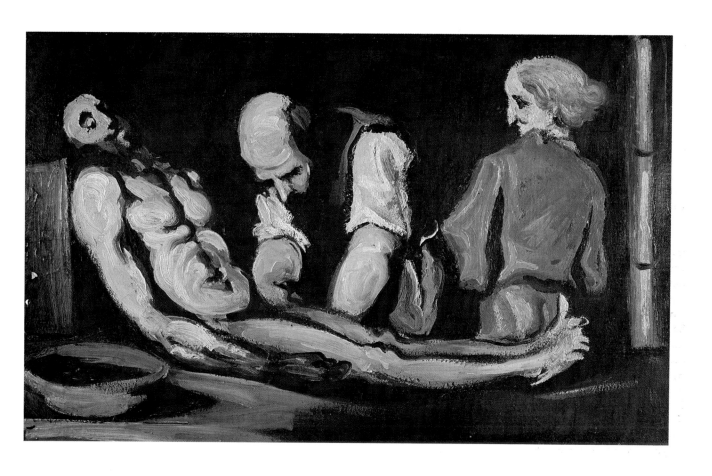

36 Winding Road in Provence

(Route tournante en Provence)

*c.*1868
91 × 71 cm 35⅞ × 28 in
V. 53
The Montreal Museum of Fine Arts; Adeline Van Horne
Bequest

In the later 1860s, Cézanne began to render his subjects
in patterns of flat, encrusted paint which he was to use
again in his first winter in Auvers.

PROVENANCE Ambroise Vollard, Paris; Bernheim-Jeune, Paris; William van
Horne, Montreal.

EXHIBITIONS Montreal, Art Association, 1933, *The Sir William van Horne
Collection*, no. 146b; New York, Wildenstein Galleries, 1959, no. 5, ill.

BIBLIOGRAPHY Rewald, 1986, p. 36, ill.

37 Standing Bather, drying her Hair

(Baigneuse debout, s'essuyant les cheveux)

*c.*1869
29 × 13 cm 11¼ × 5 in
V. 114
Private Collection

This is an early stage in the evolution of a pose which was frequently repeated in later compositions of bathers.

PROVENANCE Auguste Pellerin, Paris; René Lecomte, Paris.

EXHIBITION Paris, Orangerie, 1954, no. 18.

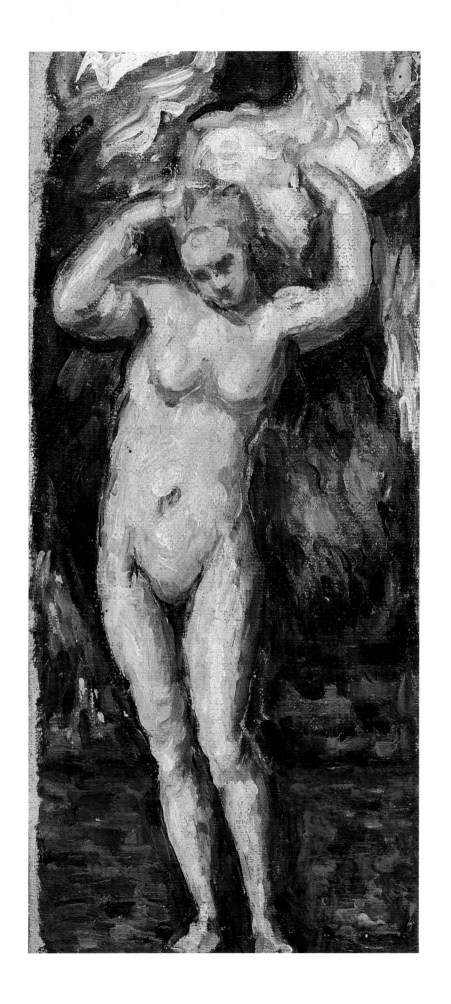

38 Bathers

(Baigneur et baigneuses)

*c.*1870
20 × 40 cm $7\frac{7}{8} \times 15\frac{3}{4}$ in
Signed lower left in red: *P. Cézanne*
V.113
Private Collection

The first of Cézanne's compositions of bathers, and one of the very few to include both sexes. He seems to have drawn the subject in the middle 1860s but the painting which shares the general lightening of palette after 1870 can hardly have been painted before that year. The potentialities of such bather subjects were fully realised after 1875.

PROVENANCE Ambroise Vollard, Paris; Marie Dormoy, Paris; (?) Galerie E. Bignou, Paris; Paul Petrides, Paris; Knoedler Galleries, New York; Charles Sessler; I.H. Vogel, Philadelphia; Sale, Parke-Bernet, New York, 22 April, 1954, no. 83, ill.; Private Collection, USA.; Stephen Hahn, New York and Knoedler Galleries, New York; Yul Brynner, Lausanne; Sale, Christie's, London, 14 April, 1970, no. 61, ill.; Wildenstein Galleries, New York.

BIBLIOGRAPHY G. Berthold, *Cézanne und die alten Meister,* Stuttgart, 1958, pp. 46, 47, fig. 71; S. Geist, 'Cézanne: Metamorphosis of the Self', *Artscribe,* Dec. 1980, fig. 7.

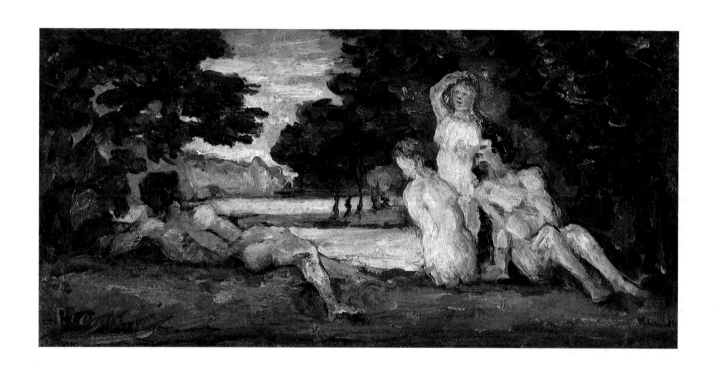

39 The Feast (The Orgy)

(Le Festin [L'Orgie])

*c.*1870
130 × 81 cm 51 × 31¾ in
V.92
Private Collection

The subject of this picture has been identified by Mary Lewis as the feast of Nebuchadnezzar in Flaubert's *Temptation of St Anthony*. Her studies are summarised in this book (q.v. pp. 32–6). The present compiler finds it easier to imagine the high tone and granular colour of this picture in Cézanne's development after 1870 than before. The theme from Flaubert adds a sense of terminal excess which supplements the action and the style. The phase of fanciful reverie in Cézanne's development was drawing to a close and within three years it had been entirely supplanted by the objective vision and analytical colour of his Impressionist contemporaries. The figures and such decorative details as the urn show numerous links with Cézanne's occasional fanciful subjects of the 1870s; the obvious affinities with Veronese (see fig. 24) evoke the adaptations of Venetian colour that were common in the Impressionist years. Cézanne attached special value to this picture and included it in his first one-man show with Vollard in 1895.

PROVENANCE Ambroise Vollard, Paris; Auguste Pellerin, Paris; René Lecomte, Paris.

EXHIBITIONS Paris, Galerie Vollard, 1895, n.n; Paris, Galerie Bernheim-Jeune, 1926, no. 21.

BIBLIOGRAPHY G. Geffroy, *La vie artistique,* Paris, 1900, pp. 215–16; Vollard, 1914, pp. 31, Gasquet, 1921, ill. opp. p. 28; C. Glaser, *Paul Cézanne* Leipzig, 1922, pl. 3 (as 'Bacchanal *c.*1870'); Meier-Graefe, 1922, ill. p. 95; Rivière, 1923, p. 198, listed; E. Bernard, *Souvenirs sur Paul Cézanne, une conversation avec Cézanne,* Paris, 1926, ill. opp. p. 94; Gasquet, 1926, ill.; Fry, 1927, pp. 10–13; Ors, 1930, ill.; Ors, 1936, pl. 40; Raynal, 1936, pl. XXI; di San Lazzaro, 1938, fig. 40; Barnes and de Mazia, 1939, no. 4 (listed); Dorival, 1948, pl. 10; Raynal, 1954, pp. 18 (detail), 20; F. Novotny, *Cézanne,* London, 1961, pl. 2; A. Chappuis, *Les Dessins de P. Cézanne au Cabinet des estampes du Musée des Beaux-Arts de Bâle,* Olten and Lausanne, 1962, fig. 2; T. Reff, 'Cézanne's "Dream of Hannibal"', *Art Bulletin,* June 1963, p. 151, fig. 1 (vol. XLV), *Art Bulletin,* March 1964, p. 58, fig. 5; S. Lichtenstein, 'Cézanne and Delacroix', *The Art Bulletin,* March 1964, fig. 5; M. Schapiro, 'The Apples of Cézanne: An Essay on the Meaning of Still-life', *Art News Annual,* 1968, pl. 4; R. Huyghe, *L'Impressionisme,* Paris, 1971, p. 224, ill.; Schapiro, 1973, p. 26 ill.; Elgar, 1975, fig. 5; Wadley, 1975, pl. 18; Venturi, 1978, ill. p. 54; Rewald, 1983, p. 88, ill.; R. Pickvance, *Cézanne,* Tokyo, 1986, p. 62, ill.

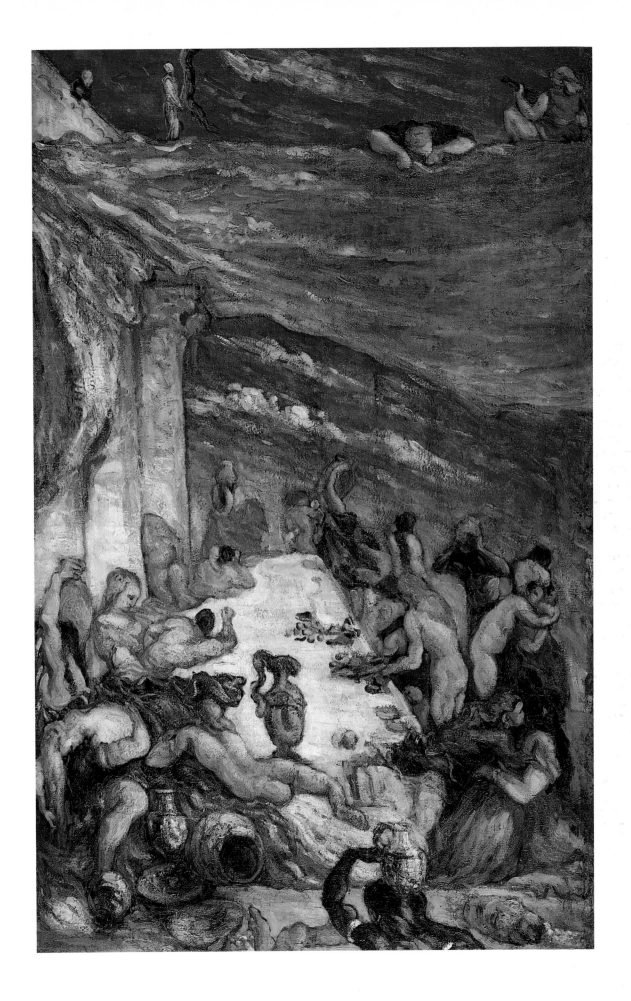

40 A Modern Olympia (The Pasha)

(Une Moderne Olympia [Le Pacha])

c.1869–70
56 × 55 cm 22 × 21⅝ in
V.106
Private Collection

Like his *Déjeuner sur l'Herbe* (cat. 51) of around 1870, Cézanne's *Modern Olympia* has an evident relationship to Manet's noted masterpiece which originated the title (see fig. 31). Yet the precise reference is not readily defined. Roger Fry observed that it was not easy to specify any but an ironic meaning in Cézanne's *Modern Olympia,* but that the vision 'clumsy and almost ridiculous as it is, imposes itself on us by its indubitable accent of sincerity.' In fact, the content of these pictures has been the subject of considerable doubt. It should be observed that all these variations contain an element which is lacking in the famous themes that they follow. They all contain, usually in the foreground, a figure that is identifiable as their painter, Cézanne himself. No figure that could be associated with Manet ever appeared in the canvases that initiated these themes. On the contrary, Manet was conspicuously absent and was perhaps open to criticism for that fact. Cézanne had no admiration for impersonality in painting. He and Zola felt rather that the signs of temperament that identified a painter were the essence of his contribution. Similarly, the reticence of Manet's *taches* and the neutrality of the atmosphere in which his subjects materialised were quite unlike the bulging volumes curvaceously outlined in Cézanne's modernisation of *Olympia,* and from the stormy evening light established with originality and beauty in the similarly modernised *Déjeuner sur l'Herbe* (cat. 51). The fact that Cézanne's versions of *Olympia* (see fig. 18) have always been described as 'modern', certainly by his wish, is significant. It implies that reticent tone painting seemed to Zola and Cézanne to be in the circumstances of the 1860s archaic, and the impersonality with which Manet

was felt to emit the tone, not using it to expressive purpose, but merely spitting it out, was certainly regarded as a criticism – a criticism that Cézanne's farouche compositions of 1870 implicitly launched and intentionally escaped. Manet was lacking in temperament and the fact pointed to a shortcoming in the endeavour to re-establish tone painting, painting in flat patches within defined contours on the model of the seventeenth century and particularly on the reticent pattern of Spanish painting.

The design of *A Modern Olympia* has in fact an astonishing boldness, embellished with grandiose grotesqueries, exactly the qualities that the historicist *belle peinture* of the nineteenth century avoided and Fry was not the only critic that it left at a loss. From the standpoint of Cézanne's Impressionist contemporaries, inventive boldness was a serious obstacle to appreciation and it was avoided by the more scattered notation of Cézanne's second version of the subject painted at Auvers with the advice of Dr Gachet in 1873 (fig. 18, Musée d'Orsay, Paris). M.L. Krumrine's perceptive commentary deals largely with that later version rather than the earlier which figures in this exhibition (q.v. pp. 28–9).

PROVENANCE Paul Cézanne fils, Paris; Ambroise Vollard, Paris and Bernheim-Jeune, Paris; Bernheim-Jeune, Paris; Auguste Pellerin, Paris; René Lecomte, Paris.

EXHIBITIONS Paris, Orangerie, 1936, no. 16; Paris, Orangerie, 1954, no. 19, pl. VIII.

BIBLIOGRAPHY Meier-Graefe, 1918, ill. p. 96; Coquiot, 1919, ill. opp. p. 144; Meier-Graefe, 1920, ill. p. 96; Meier-Graefe, 1922, ill. p. 109; C. Glaser, *Paul Cézanne,* Leipzig, 1922, pl. 4; Rivière, 1923, p. 202, listed, ill. opp. p. 50; Fry, Dec. 1926, p. 391, ill.; Fry, 1927, pl. III, pp. 16–17; Meier-Graefe, 1927, pl. XI; A. Burroughs, 'David and Cézanne, Presenting the case of thought versus feeling', *The Arts,* Sept. 1929, p. 111, ill.; Fry, *Samleren,* 1929, p. 103, ill.; Rivière, 1933, p. 53, ill.; Iavorskaia, 1935, pl. 11; Ors, 1936, pl. 46; Raynal, 1936, pl. XVI; di San Lazzaro, 1938, fig. 46; Barnes and de Mazia, 1939, no. 33, ill. p. 178 (analysis p. 314); Rivière, 1942, p. 53, ill.; G. Schildt, *Cézanne,* Stockholm, 1946, fig. 16; Dorival, 1948, pl. VIII; L. Guerry, *Cézanne et l'expression de l'espace,* Paris, 1950, fig. 3; Badt, 1956, p. 76; S. Løvgren, *The Genesis of Modernism,* Stockholm, 1959, p. 33, ill.; S. Lichtenstein, 'Cézanne and Delacroix', *The Art Bulletin,* March 1964, fig. 9; L. Guerry, *Cézanne et l'expression de l'espace* (2nd edition), Paris, 1966, pl. 1; Schapiro, 1973, p. 56, ill.; Venturi, 1978, ill. p. 52.

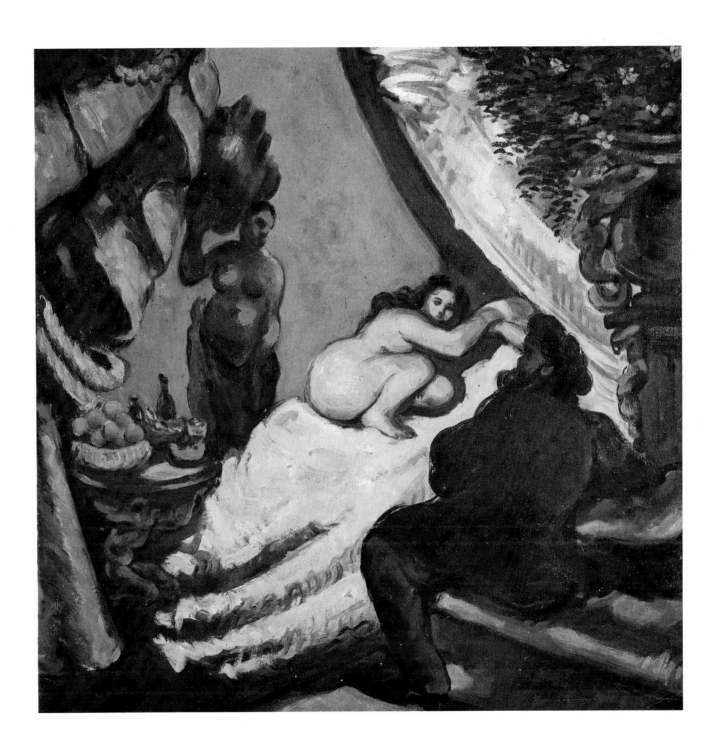

41 The Robbers and the Ass

(Les Voleurs et l'âne)

c.1869–70
41 × 55 cm 16 × 21¾ in
V.108
Civica Galleria d'Arte Moderna – Raccolta Grassi – Milan

Cézanne's paintings rarely entertain, as his drawings often do. The narrative figure pictures of around 1870 are in fact almost alone in being to any deliberate extent amusing. The painting which illustrates the story of 'The Robbers and the Ass' from Apuleius gives a clue to the source of this uncommon element because not only the story but the style, with an element of jocular Baroque, was certainly due to Daumier. This is the closest link with Daumier anywhere in Cézanne's work and leads one to ask whether the rhythmical flourish which recurs from time to time almost throughout his work was specifically Provençal in character. It was regarded in this light by some of his admirers, among them the Gasquets, and a serpentine rhythm combined with some of the most solemn qualities in his art. Such rhythms customarily carried an almost savage energy, akin to that which he later drew in the sculpture of Puget, a quality far removed from the sense of well-being which accompanied the buoyancy of his art. This is the only one of the 1870 landscapes which gives no sense of foreboding; for once the comedy is quite lighthearted.

PROVENANCE Ambroise Vollard, Paris; Auguste Pellerin, Paris; Bernheim-Jeune, Paris; Baron Denys Cochin, Paris; Ambroise Vollard, Paris; Paul Cassirer, Berlin; Adolf Rothermundt, Dresden; Hugo Perls, Berlin and Georg Caspari, Munich; Grassi, Cairo.

EXHIBITIONS Paris, Grand Palais, 1907, Salon d'Automne, no. 9; Munich, Moderne Galerie (Heinrich Thannhauser), 1912, no. 5; Berlin, Paul Cassirer, 1912 (Group Exhibition), no. 32; Cologne, Kunstverein Gemäldegalerie, 1913, Eröffnungsausstellung, no. 7; Berlin, Paul Cassirer, 1913 (Group Exhibition), n.n., ill.; Berlin, Paul Cassirer, 1921, no. 2; Berlin, Galerie Hugo Perls, 1925, Von Delacroix bis Picasso, no. 3; Berlin, Hugh Perls, 1927, Zweite Ausstellung, no. 7; Liège, Musée Saint-Georges, 1982, no. 3 — Aix-en-Provence, Musée Granet, 1982, no. 3; Milan, Palazzo Reale, 1983, Jarry e la Patafisica, n.n.; Madrid, Museo Espanol de Arte Contemporaneo, 1984, no. 5; Tokyo, Isetan Museum of Art, 1986, no. 6, ill.

BIBLIOGRAPHY Meier-Graefe, 1918, ill. p. 94; A. Popp, 'Cézanne, Elemente seines Stiles, anlässlich einer Kritik erörtert', Die bildenden Kunste, 1919, ill. p. 183; Meier-Graefe, 1920, ill. p. 94; Meier-Graefe, 1922, ill. p. 106; Rivière, 1923, p. 199, listed; Meier-Graefe, 1927, pl. IX; Pfister, 1927, fig. 22; Iavorskaia, 1935, pl. 8; R. Huyghe, Cézanne, Paris, 1936, pl. 46; Barnes and de Mazia, 1939, no. 18, ill. p. 158 (analysis pp. 307–8); L. Guerry, Cézanne et l'expression de l'espace, Paris, 1950, p. 25; R. Feist, Paul Cézanne, Leipzig, 1963, pp. 12, 22, pl. 4; Chappuis, 1973, vol. I, p. 198; Venturi, 1978, ill. p. 49; N. Ponente, Paul Cézanne, Bologna, 1980, pl. 4.

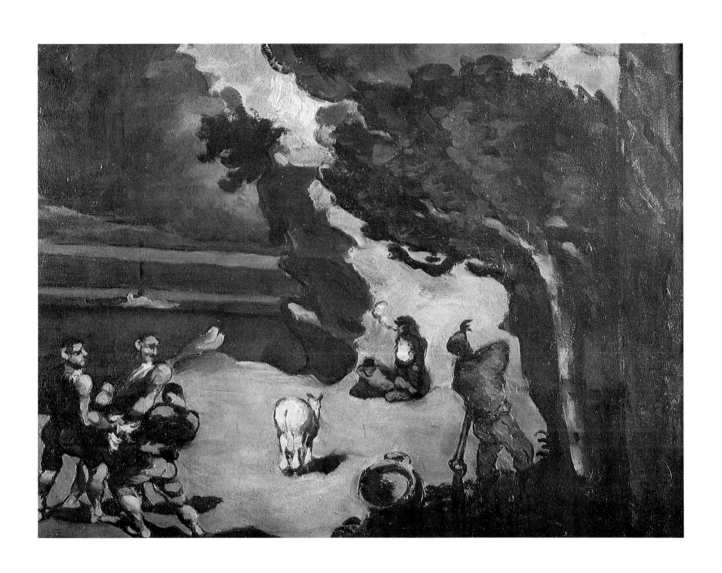

42 Contrasts

(Contrastes)

*c.*1869–70
50 × 40 cm 19¾ × 15¾ in
V.87
The Ian Woodner Family Collection, Inc.

The powerful contrast between the head of a bearded man and the silhouette of a woman in front of him originally formed part of the decoration of the salon of the Jas de Bouffan (see cat. 1, 4). Like *The Robbers and the Ass* (cat. 41), it is reminiscent of the rhythmical style of Daumier, though lighter and brighter in colour. It is also likely to have been painted towards 1870. The bearded man is evidently seen in the company of his lover, as in Courbet's *Young Lovers in the Country* (after 1844; Musée du Petit Palais, Paris).

PROVENANCE Jas de Bouffan, Aix-en-Provence; Louis Granel, Aix-en-Provence; Dr F. Corsy, Aix-en-Provence (Granel's grandson); Sale, Maître Blache, Versailles, 18 March, 1973, no. 93, ill.; Private Collection, France.

BIBLIOGRAPHY Coquiot, 1919, p. 41; E. Faure, *P. Cézanne,* Paris, 1926, pl. 1; Novotny, 1937, pl. 3; R. Fry, *Letters of Roger Fry,* London, 1972, pp. 473–4, no. 469.

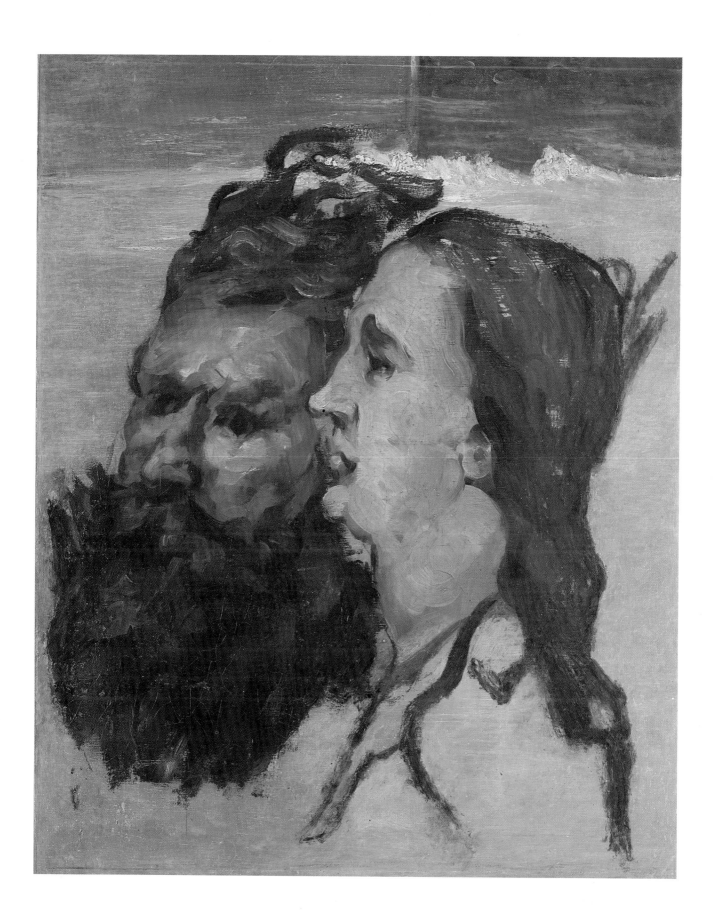

43 Paul Alexis reading at Zola's House

(La lecture de Paul Alexis chez Zola)

*c.*1867–9
52 × 56 cm 20½ × 22 in
V.118
Private Collection, Switzerland

If the amanuensis to whom Zola is shown listening or dictating is, as has been supposed, Paul Alexis, Cézanne's friend from Aix who joined Zola in Paris in September 1869, the picture must have been painted after that date and before the circle broke up at the outbreak of the Franco-Prussian War. However, this is far from certain and the picture (cat. 47) which undoubtedly shows this subject at this date is much more developed in style. The style of cat. 43 would in itself lead to the conclusion that it was painted between 1867 and 1869. A preparatory drawing (Ch. 222) gives ground for similar doubts and has been dated accordingly. It may well be that the date here was confused in the Zola household with that of the later picture. The heavily curtained interior deriving from Dutch genre painting perhaps owes something to Dou's *Dropsical Woman,* 'that wonderful picture', as Cézanne called it, if not to Vermeer, who had become known in 1866 and figured in one of Cézanne's sketchbooks.

PROVENANCE Emile Zola, Médan; Sale, Zola Collection, Hôtel Drouot, Paris, 9–13 March 1903, no. 113; Jos. Hessel, Paris; Auguste Pellerin, Paris; Jean-Victor Pellerin, Paris; Wildenstein Galleries, Paris, London and New York.

EXHIBITIONS Paris, Grand Palais, 1907, *Salon d'Automne,* no. 7; Paris, Galerie Bernheim-Jeune, 1936, *Cent ans de théâtre, music-hall et cirque,* no. 12, ill.; Paris, Bibliothèque Nationale, 1952, *Emile Zola,* no. 53; New York, Wildenstein Galleries, 1972, *Faces from the World of Impressionism and Post-Impressionism,* no. 12; Tokyo, National Museum of Western Art, 1974, no. 5.

BIBLIOGRAPHY A. Pératé, 'Le Salon d'Automne', *Gazette des Beaux-Arts,* 1907, p. 388; F. Lehel, *Cézanne,* Budapest, 1923, ill.; Rivière, 1923, p. 198, listed; Fry, Dec. 1926, p. 401, ill.; Fry, 1927, pl. IX, fig. 12; Ors, 1936, pl. 41; Raynal, 1936, pl. VIII; Rewald, 1936, fig. 20; Novotny, 1937, pl. 9; di San Lazzaro, 1938, fig. 41; Barnes and de Mazia, 1939, no. 23, ill. p. 154; Rewald, 1939, fig. 23; G. Schildt, *Cézanne,* Stockholm, 1946, fig. 11; Badt, 1956, pl. 25; J. Adhémar, 'Le Cabinet de Travail de Zola', *Gazette des Beaux-Arts,* Nov. 1960, p. 289, fig. 6; A. Chappuis, *Les Dessins de P. Cézanne au Cabinet des estampes du Musée des Beaux-Arts de Bâle,* Olten and Lausanne, 1962, fig. 24 and no. 54; L. Guerry, *Cézanne et l'expression de l'espace* (2nd edition), Paris, 1966, pl. 6; W. Andersen, *Cézanne's Portrait Drawings,* Cambridge, Mass. and London, 1970, p. 225, fig. 248a; R. Pickvance, *Cézanne,* Tokyo, 1986, p. 30, ill.; Rewald, 1986, p. 49, ill.

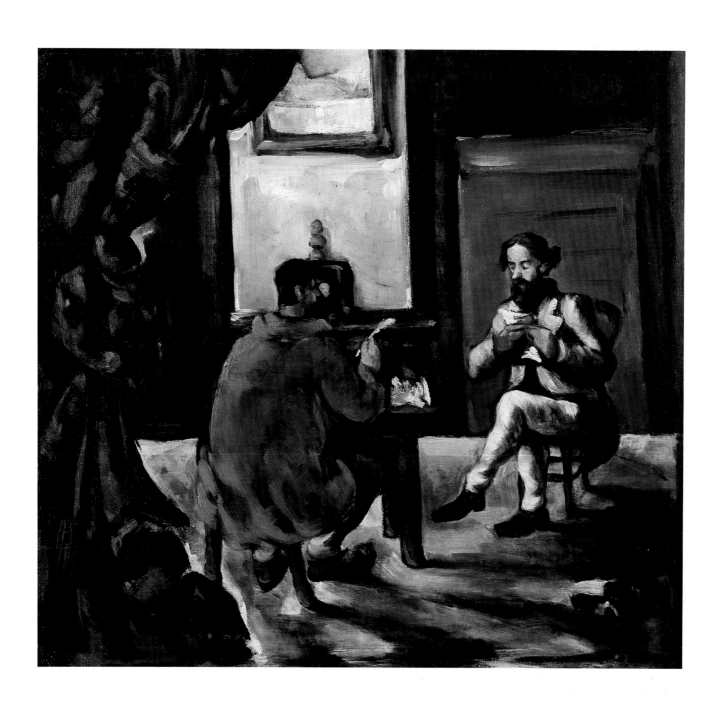

44 Young Girl at the Piano – Overture to *Tannhäuser*

(*Jeune fille au piano – L'Ouverture du* Tannhäuser)

c.1869–70
57 × 92 cm 22½ × 36¼ in
V. 90
Leningrad, The State Hermitage Museum

Correspondence between two of Cézanne's friends, Marion and Morstatt, the latter a German musician and admirer of Wagner, reveals that this was the third picture of this subject, the first two had been far advanced and abandoned between 1864 and 1868. The third was completed before the end of the decade. The letters did not identify the models for the figures in the picture and the woman engaged in needlework is not particularly like Cézanne's mother (as has been suggested), while the pianist, if his elder sister, Marie, would have been about twenty-eight years old while his second sister, Rose, was no more than fifteen. John Rewald has pointed out to the compiler that the young women who posed on occasion for Cézanne, usually identified as his sisters, could equally well have been his cousins, the daughters of Dominique Aubert, one of whom was a year younger and the other a year older than Paul.

Earlier versions of the picture included Cézanne's father seated in the armchair, thus increasing the resemblance to Degas' group portrait of the Bellelli family (Musée d'Orsay, Paris). The enlarged pattern of the wallpaper in the room is recognisable as the paper shown in other pictures of the Jas de Bouffan; transfigured, it became a grand invented arabesque of the kind on which advanced painting was to depend thirty-five years later. An admiration for Wagner was common to young Frenchmen of the 1860s and Baudelaire commended the *Tannhäuser* Overture, first played in Paris in 1860, as 'voluptuous and orgiastic'. Wagner's music was taken as a sign that moderation had no place in a vigorous artistic temperament. It stood, in fact, for the convictions that Cézanne shared with Zola in 1866.

PROVENANCE Ambroise Vollard, Paris; Ivan Morosov, Moscow; Museum of Modern Western Art, Moscow.

EXHIBITIONS Moscow, Museum of Modern Western Art, 1926, *Paul Cézanne – Vincent van Gogh*, no. 2; Paris, Orangerie, 1936, no. 8; Moscow, Pushkin Museum, 1955, *Art français du XV–XX siècles*, n.n., cat. p. 56; Leningrad, Hermitage, 1956, *French Art from the Twelfth to the Twentieth Century*, n.n., cat. p. 54; Leningrad, Hermitage, 1956, no. 2.

BIBLIOGRAPHY B. Ternovetz, 'Le Musée d'art moderne de Moscou (Anciennes collections Stchoukine et Morosoff)', *Amour de l'Art*, Dec. 1925, p. 466, ill.; Museum of Modern Western Art, *Catalogue*, Moscow, 1928, no. 554; L. Réau, *Catalogue d'Art Français dans les Musées Russes*, Paris, 1929, no. 736; Iavorskaia, 1935, pl. 4; E. Faure, *Cézanne*, Paris, 1936, pl. 13; R. Huyghe, 'Cézanne et son oeuvre', *Amour de l'Art*, May 1936, fig. 42; Novotny, 1937, pl. 14; Barnes and de Mazia, 1939, no. 19, ill. p. 157; Rewald, 1948, fig. 23; Dorival, 1948, pl. VII; C. Sterling, *Musée de l'Ermitage, La Peinture française de Poussin à nos Jours*, Paris, 1957, p. 110, pl. 87; *Great French Painting in the Hermitage Museum, Leningrad*, New York, 1958, pp. 106–7, pl. 87; P. Descargues, *The Hermitage Museum, Leningrad*, New York, 1961, p. 213, ill; P. Feist, *Paul Cézanne*, Leipzig, 1963, pp. 12, 21, pl. 2; L. Guerry, *Cézanne et l'expression de l'espace* (2nd edition), Paris, 1966, pl. 7; A. Barskaya, *Paul Cézanne*, Leningrad, 1975, pl. 2; S. Monneret, *L'Impressionisme et Son Epoque*, Paris, 1978, vol. 3, p. 64, ill; Venturi, 1978, ill. p. 14; J. Arrouye, *La Provence de Cézanne*, Aix-en-Provence, 1982, p. 19; B. Bernard, *The Impressionist Revolution*, London, 1986, p. 240, ill.; W. Bessonova, and M. Williams, *Impressionism and Post-Impressionism, The Hermitage, Leningrad. The Pushkin Museum of Fine Arts, Moscow*, New York and Leningrad, 1986, p. 152, ill.; Rewald, 1986, p. 63, ill.; R. Kirsch, 'Paul Cézanne: "Jeune Fille au Piano" and some Portraits of his Wife: An Investigation of his Painting', *Gazette des Beaux-Arts*, July–Aug. 1987, pp. 21–4, ill.

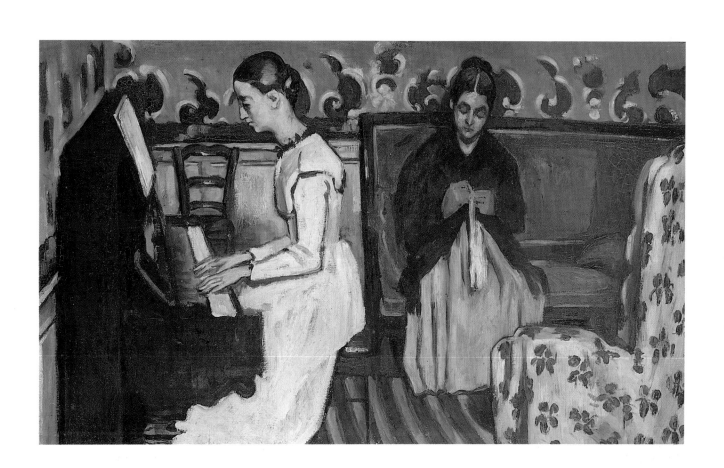

45 Still Life: Skull and Waterjug

(Nature morte: crâne et bouilloire)

*c.*1868–70
60 × 50 cm 23¾ × 19¾ in
V. 68
Private Collection

The still life objects in this unfinished picture were all painted on occasion by Cézanne. Moreover, underneath the present group traces can be seen of the beginnings of other pictures showing a fragment of blue sky with white clouds and, with the canvas on its side, a sketch of the kneeling *écorché* plaster statuette which also appears in later pictures and drawings by Cézanne. Apart from these similarities, which could connect the picture equally with any painter who possessed these common studio properties, and the excellent collections through which the picture has passed, the indications of Cézanne's authorship are not quite conclusive.

PROVENANCE Alfred Flechtheim, Berlin; Gottlieb Friedrich Reber, Lausanne; Robert von Hirsch, Basel; Sale, von Hirsch Collection, Sotheby's, London, 26 June 1978, no. 720, ill.

EXHIBITIONS Basel, Kunsthalle, 1943, *Kunstwerke des 19. Jahrhunderts aus Basler Privatbesitz*, no. 311; Zurich, Kunsthaus, 1956, no. 4.

BIBLIOGRAPHY Gasquet, 1921, ill. opp. p. 18; Meier-Graefe, 1922, ill. p. 96; Rivière, 1923, p. 198; Gasquet, 1926, ill.; Ors, 1930, p. 84, ill.; Ors, 1936, pl. 24; Raynal, 1936, pl. LXXXI; di San Lazzaro, 1938, fig. 24; Dorival, 1948, pl. 16; T. Reff, 'Cézanne: The Severed Head and the Skull', *Arts*, Oct. 1983, p. 90, fig. 6; Rewald, 1983, p. 228, ill.

46 Portrait of the Painter, Achille Emperaire

(Portrait du peintre Achille Emperaire)

*c.*1868–70
200 × 122 cm 78¾ × 48 in
Signed lower right in black: *P. Cézanne*
V.88
Musée d'Orsay, Paris

This picture was submitted to the Salon of 1870 with a reclining nude; both were rejected. In the antechamber of the Palais du l'Industrie Cézanne was interviewed and caricatured (fig. 12) on 20 March for the *Album Stock* which later printed the results (for the text of the interview, see Gowing, q.v. p. 15). In the defiant mood which *Stock* recorded it is evident that Cézanne would have scorned to submit anything but a recent picture. It can therefore be assumed that the portrait of Achille Emperaire was painted more than two years later than the previous portrait on the same scale showing his father in the same armchair (cat. 21). The contrast of styles is striking. The tonal impressionism of the previous picture gives place to a resolved and simplified scheme realising the sitter in areas and contours with all the clarity learnt from the two remarkable drawings of the subject. Every part of the subject achieved its own definite shape, every part became a thing in itself. The area, the folds and the parallel pleats of the sitter's dressing-gown, the chair with its pattern and the shadow cast on the wall behind, are all specific areas on the picture surface, painted a definite colour with a decided edge.

The reclining nude which was also rejected at the Salon of 1870 and caricatured in the *Album Stock* has disappeared. It belonged to Gauguin. He took it to Denmark with him in 1883, when it was described in detail by a critic. It was returned to France in 1884 and deposited in Tanguy's shop with the portrait. There it was seen, most notably by Emile Bernard in the Autumn of 1886, and subsequently by a younger generation of artists, which included Maurice Denis and the Nabis, in the early 1890s. The interest of this fragmentary information about a vanished and allegedly uninviting picture is that it seems to have represented the emergence of a pose and an attitude which was to echo through twentieth-century painting. If we discount the bias of the cartoonist it appears that the impression made by the lost picture was a positive, indeed, formidable one. The protruding hip and elbow suggested to Gauguin an alternative to academic idealisation, as in *Nevermore* (1897; Courtauld Institute Galleries, London) for instance, and the twist at the hip which threw the bony outline into prominence may well have been a source of the emotive disjunction which became mandatory to the avant-garde in the decades that followed, notably in drawings by Matisse. An *image populaire,* fastened to the grey wall behind, showed two figures approaching one another – apparently with the fell intent that often concerned Cézanne in the 1860s (see cat. 31, 34).

The lack of this picture, one of only two or three full-scale nudes in Cézanne's work (and this was somewhat above life size) is no doubt the most severe loss to our knowledge of Cézanne's achievement at thirty. At the time of the *Emperaire,* which so fortunately survived, Cézanne was at his greatest as a draughtsman and we may be sure that the apparent distortions which provoked the cartoonist were in fact so far from arbitrary, profoundly observed and felt. This must have been a long stride in the single-handed task, which was no more than incidental to his major purpose, of redefining the human image for the age to come.

PROVENANCE Julien Tanguy (le père Tanguy), Paris; Eugène Boch, Monthyon; Bernheim-Jeune, Paris; Auguste Pellerin, Paris; René Lecomte, Paris; Musée du Louvre, Paris.

EXHIBITIONS Paris, Grand Palais, 1907, *Salon d'Automne,* no. 45; Paris, Orangerie, 1953, *Baroque provençal,* no. 10, pl. XXIX; Paris, Orangerie, 1954, no. 13; Paris, Orangerie, 1974, no. 4.

BIBLIOGRAPHY *Mercure de France,* June 1891; Vollard, 1914, p. 31; Meier-Graefe, 1918, ill. p. 82; Meier-Graefe, 1920, ill. p. 82; Gasquet, 1921, ill. opp. p. 26; Meier-Graefe, 1922, ill. p. 90; Rivière, 1923, p. 198, listed; E. Bernard, *Sur Paul Cézanne,* Paris, 1925, pp. 50–51; Fry, Dec. 1926, p. 392, ill.; Gasquet, 1926, ill.; Fry, 1927, pl. IV, fig. 5; E. Waldmann, *Die Kunst des Realismus und des Impressionismus,* Berlin, 1927, p. 491, ill.; Meier-Graefe, London, 1927, pl. I; Fry, *Samleren,* 1929, p. 114, ill.; Rivière, 1933, p. 17, ill.; Mack, 1936, fig. 5; Raynal, 1936, pl. LVII; Rewald, 1936, fig. 11; Novotny, 1937, pl. 6; J. Rewald, 'Achille Emperaire, ami de Paul Cézanne', *Amour de l' Art,* May 1938, p. 152, ill.; Rewald, 1939, fig. 17; Barnes, and de Mazia, 1939, no. 9, ill. p. 150; Cogniat, 1939, pl. 16; Rewald, New York, 1939, p. 25, ill.; Rivière, 1942, p. 17, ill.; G. Schildt, *Cézanne,* Stockholm, 1946, fig. 61; Dorival, 1948, pl. 19; G. Jedlicka, *Cézanne,* Berne, 1948, fig. 4; F. Jourdain, *Cézanne,* Paris and New York, 1950, ill.; F. Novotny, *Cézanne,* London, 1961, pl. 1; J. Rewald, *The History of Impressionism,* New York, 1961, pp. 246–7, ill.; H. Pérruchot, *Dix grands peintres,* Paris, 1961, p. 118; A. Chappuis, *Les Dessins de P. Cézanne au Cabinet des estampes du Musée des Beaux-Arts de Bâle,* Olten and Lausanne, 1962, fig. 23; K. Leonhard, *Paul Cézanne in Selbstzeugnissen und Bilddokumenten,* Rheinbek bei Hamburg, 1966, p. 68, ill.; W. Andersen, *Cézanne's Portrait Drawings,* Cambridge, Mass. and London, 1970, fig. 6; Schapiro, 1973, p. 10, ill.; Elgar, 1975, fig. 15; Wadley, 1975, pl. 15; S. Monneret, *Cézanne, Zola . . . La Fraternité du génie,* Paris, 1978, ill. p. 79; B. Thomson, *The Post-Impressionists,* 1983, pl. 8; B. Bernard, *The Impressionist Revolution,* London, 1986, p. 238, ill.; J. Rewald, 'Achille Emperaire and Cézanne' in *Studies in Impressionism,* London, 1985, pl. VI; M. Laclotte, G. Lacambre, A. Distel, etc., *La Peinture au Musée d'Orsay,* Paris, 1986, p. 90, ill.; Rewald, 1986, p. 85, ill.; R. Kirsch, 'Paul Cézanne: "Jeune Fille au Piano" and some Portraits of his Wife: An Investigation of his Painting', *Gazette des Beaux-Arts,* July–Aug. 1987, p. 22.

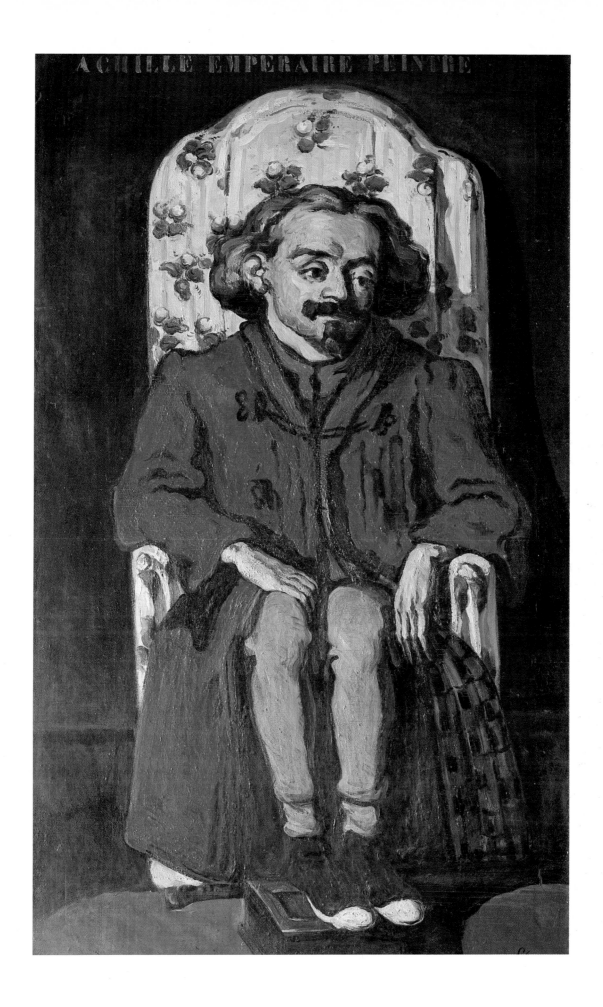

L

47 Paul Alexis reading to Emile Zola

(Paul Alexis lisant à Emile Zola)

*c.*1869–70
130 × 160 cm 51⅛ × 63 in
V.117
Museo de Arte, São Paulo

This picture, unlike the earlier version of a similar subject (cat. 43), though unfinished, is perfectly compatible with the style of 1869–70 when it must have been painted. It was executed in the garden at rue La Condamine where Zola was living and shows Paul Alexis, his new amanuensis, ministering to the morose pasha of realism. The canvas was identified, discarded in the attic, after Madame Zola's death in 1927.

PROVENANCE Emile Zola, Médan (found in Zola's attic at Médan several years after his death); M. Helm, Le Vesinet; Paul Rosenberg, Paris; Wildenstein Galleries, Paris, London and New York.

EXHIBITIONS New York, Knoedler Galleries, 1931, *Pictures of People, 1870–1930,* no. 5; Detroit, Detroit Institute of Arts, 1931, *Modern French Painting,* no. 17, ill.; Philadelphia, Pennsylvania Museum of Art, 1934, no. 2; San Francisco, San Francisco Museum of Art, 1935, *Opening Exhibition (Modern French Painting),* no. 4, ill; London, Wildenstein Galleries, 1935, *Nineteenth-Century Masterpieces,* no. 8, ill.; Paris, Orangerie, 1936, no. 178; New York, Wildenstein Galleries, 1938, *Great Portraits from Impressionism to Modernism,* no. 3, pl. 1; Columbus, Ohio, Gallery of Fine Arts, 1938, *Relationships between French Literature and Paintings in the Nineteenth Century,* no. 9; Lyon, Palais Saint-Pierre, 1939, no. 8; London, Wildenstein Galleries, 1939, no. 8; Paris, Indépendants, 1939, no. 5; New York, Wildenstein Galleries, 1947, no. 3, ill.; Minneapolis, Minneapolis Institute of Art, 1950, n.n.; London, Wildenstein Galleries, 1951, *Festival of Britain,* no. 16, ill.; Chicago, Art Institute, 1952, no. 14, ill.—New York, Metropolitan Museum, 1952, no. 14, ill.; Paris, Orangerie, 1953, *Baroque provençal,* n.n.; Paris, Orangerie, 1953–4, *Chefs-d'oeuvre du Musée d' Art de São Paulo,* no. 3, ill.; London, Tate Gallery, 1954, *Masterpieces from the São Paulo Museum of Art,* no. 45; Edinburgh, Royal Scottish Academy, 1954, no. 6—London, Tate Gallery, 1954, no. 6; Utrecht, Utrecht Centraal Museum, 1954, *Meesterwerken uit São Paúlo,* no. 46, ill.; New York, Metropolitan Museum, 1957, *Paintings from the São Paulo Museum,* no. 45, ill.; Tokyo, National Museum of Western Art, 1974, no. 6; Madrid, Museo Espanol de Arte Contemporaneo, 1984, no. 4, ill.; Tokyo, Isetan Museum of Art, 1986, no. 5, ill.

BIBLIOGRAPHY Iavorskaia, 1935, pl. IV; E. Faure, *Cézanne,* Paris, 1936, pl. 3; R. Huyghe, 'Cézanne et son oeuvre', *Amour de l' Art,* May 1936, fig. 43; Rewald, 1936, fig. 21; Vollard, 1937, pl. 12; Rewald, 1939, fig. 24; Barnes and de Mazia, 1939, no. 12, ill. p. 155; Cogniat, 1939, pl. 20; Dorival, 1948, pl. 26; Schapiro, 1952, pp. 8–9, ill.; J. Adhémar, 'Le Cabinet de Travail de Zola', *Gazette des Beaux-Arts,* Nov. 1960, p. 288, fig. 5; Schapiro, 1973, p. 33, ill.; D. Sutton, 'The Paradoxes of Cézanne', *Apollo,* August 1974, pl. 7; Elgar, 1975, fig. 20; S. Monneret, *Cézanne, Zola . . . La Fraternité du génie,* Paris, 1978, ill. p. 39; Venturi, 1978, ill. p. 15; G. Adriani, *Paul Cézanne, Der Liebeskampf,* Munich, 1980, pl. C; N. Ponente, *Paul Cézanne,* Bologna, 1980, p. 31, ill.; P. Bonafoux, *Les Impressionnistes, Portraits et Confidences,* Geneva, 1986, p. 21, ill.

48 Factories near Mont de Cengle

(Usines près du Mont de Cengle)

c.1869–70
41 × 55 cm 16 × 21¾ in
V.58
Private Collection

Towards 1870 Cézanne's vision of landscape altered. In place of solid masses there was a sense of movement, an impression of imbalance, wind and weather, of dissolution. He spent the winter of the war, 1870–71, in a little house which his mother had bought at L'Estaque (see fig. 14), dividing his time, as he said, 'between landscape and studio', which was to say, deliberately out of the public eye and not obvious to the conscription. His typical work there, unluckily not available to this exhibition, was *Melting Snow at Estaque*, the fearful image of a world dissolved, sliding downhill in a sickeningly precipitous diagonal between the curling pines which are themselves almost threateningly unstable and Baroque, painted with a wholly appropriate slipping wetness and a soiled non-colour unique in his work. Such a picture reveals by contrast the value of the solidity and stability to which the rest of Cézanne's life was devoted. A year or two before in a similar dashing, streaky style he had painted *Factories near Mont de Cengle*, showing a sizeable industrial installation pouring black smoke into a grey sky beside the long flank of the Mont

Sainte-Victoire. In it we can follow his course toward a formulation for a world that is in an incipient state of flux. In 1869 (q.v., pp. 13–14; fig. 11), he made a watercolour in grey and black of a much more formidable collection of factories belching smoke, for an incongruous setting in the cover of Madame Zola's elegant work box. There was evidently a phase in which Cézanne's realism in the sixties extended to include the industrial and social concerns embraced by Zola. It looks quite doubtful whether the fantastic aggregation of factories in the watercolour was realistic at all. There is no evidence of Cézanne painting such a subject out of doors at thirty or at any other age, and the subject of the watercolour, which has the extremism of a manifesto, looks at least as likely to have been invented.

John Rewald, who knows the country between Gardanne and Aix, tells me that there is no sign of this factory or its chimneys and no record of them. The buildings in the picture appear slightly toy-like. There is, in fact, no certainty that this strange glimpse of industrial Romanticism was ever observed in nature. It seems to represent Cézanne's attempt to see Provence through Zola's eyes. The streaky grey and black style, when it is applied to the portraits of 1871 (see cat. 56, 57), is seen to be akin to that of Manet, and the momentum which Cézanne brought to *Factories near Mont de Cengle* is equally reminiscent of him.

PROVENANCE Ambroise Vollard, Paris; Cornelis Hoogendijk, Amsterdam; Sale, Hoogendijk Collection, F. Muller & Cie, Amsterdam, 22 May 1912, no. 7; Auguste Pellerin, Paris; Jean-Victor Pellerin, Paris; Paul Rosenberg, Paris and New York; Sam Salz, New York; (Knoedler Galleries, New York); William I.C. Ewing; Knoedler Galleries, New York; Marianne Feilchenfeldt, Zurich; Emil G. Bührle, Zurich.

EXHIBITIONS Paris, Paul Rosenberg, 1939, no. 2, ill.; London, Rosenberg & Helft, 1939, no. 2, ill.; Los Angeles, Los Angeles County Museum, 1941, *Aspects of French Painting from Cézanne to Picasso,* no. 8; Manchester, N.H., Currier Gallery of Art, 1949, *Monet and the Beginnings of Impressionism,* no. 25; Zurich, Kunsthaus, 1956, no. 7, pl. 4; Aix-en-Provence, Pavillon de Vendôme, 1956, no. 2; Cologne, Wallraf-Richartz Museum, 1956–7, no. 4, ill.

BIBLIOGRAPHY Rivière, 1923, p. 198, listed; L. Venturi, 'L'Impressionismo', *L'Arte,* March 1935, fig. 13; E. Faure, *Cézanne,* Paris, 1936, pl. 4; Raynal, 1936, pl. XXXVI; Rewald, Paris, 1939, fig. 27; J. Rewald, 'Paul Cézanne: New documents for the years 1870–71', *The Burlington Magazine,* April 1939, pl. I, fig. A; Rewald, New York, 1939, fig. 33; Rewald, 1948, fig. 33; Rewald, 1986, p. 66, ill.

*Melting Snow at L'Estaque, c.*1870–71 (V.51). E.G. Bührle Foundation, Zurich.

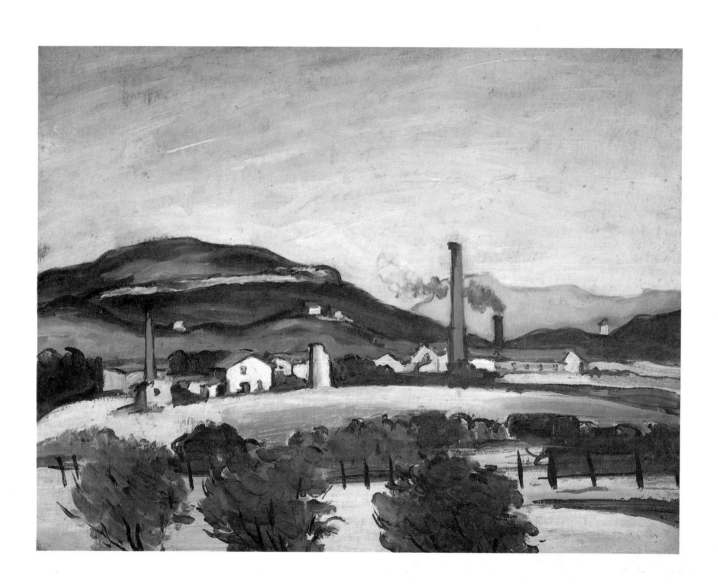

49 The Black Clock

(La Pendule noire)

*c.*1870
55.2 × 74.3 cm 21¾ × 29¼ in
V. 69
Private Collection

This picture represents a clock belonging to Zola and must have been completed before August 1870 when he and the painter left Paris. The dignity of the picture was possibly a tribute to the standing of his friend. The bright pink mouth of the shell is more specific and descriptive than any other object in Cézanne's still lifes and it has a quality of intimacy which agrees with the directness of the style. The four slabs of hanging tablecloth are unshakeably serene, like something in the natural world – like the rock-face of his native, Aix landscape. Writers have sought to interpret the fact that the clock face has no hands. To do so is to misconceive the breadth and comprehensiveness of this style. The hands would have been below the critical size for inclusion in this summary sweep of tones. In retrospect, this may seem to have been the first still life since the eighteenth century which was so great and grandly meaningful a picture. The fact that there was apparently no single detail in it that admitted a responsibility to petty descriptiveness had everything to do with this enormous distinction.

PROVENANCE Emile Zola, Médan; Sale, Zola Collection, Hôtel Drouot, Paris, 9–13 March 1903, no. 114; Auguste Pellerin, Paris; Baron Adolf Kohner, Budapest; Paul Rosenberg, Paris; Wildenstein Galleries, New York; Edward G. Robinson, Beverly Hills.

EXHIBITIONS London, Durand-Ruel Gallery, 1905, *French Impressionist Pictures;* Paris, Grand Palais, 1907, *Salon d'Automne*, no. 8; Berlin, Paul Cassirer, 1909 (*Group Exhibition*), no. 21; Budapest, Ernst Museum, 1913, *The Great French Masters of the XIXth Century*, no. 76; Budapest, Mucsarnok, 1919, *First Exhibition of Socialized Art Treasures*, n.n., Room 11; London, Royal Academy, 1932, *French Art*, no. 441, ill.; Chicago, Art Institute, 1933, *A Century of Progress*, no. 320; Paris, Orangerie, 1936, no. 11; New York, Museum of Modern Art, 1939, *Art in Our Time*, no. 55, ill.; Washington, D.C., Phillips Collection, 1941, *Functions of Color in Painting*, no. 5; Philadelphia, Philadelphia Museum of Art, 1950–51, *Diamond Jubilee*, no. 84, ill.; New York, Wildenstein Galleries, 1951, *Masterpieces from Museums and Private Collections*, no. 48, ill.; Chicago, Art Institute, 1952, no. 11, ill.—New York, Metropolitan Museum, 1952, no. 11, ill.; New York, Museum of Modern Art, 1953, *Paintings From the Edward Robinson Collection*, no. 5, ill.; Los Angeles, Los Angeles County Museum, 1956–7, *The G.L. and Edward G. Robinson Collection*, no. 7—San Francisco, California Palace of the Legion of Honor, 1956–7, no. 7; New York, Knoedler Galleries, 1957–8, *The Niarchos Collection*, no. 5—Ottawa, National Gallery of Canada, 1957–8, no. 5; Zurich, Kunsthaus, 1959, *Sammlung S. Niarchos,*

no. 29, pl. VI; Vienna, Belvedere, 1961, no.5; Washington, D.C., Phillips Collection, 1971, no. 2—Chicago, Art Institute, 1971, no. 2—Boston, Museum of Fine Arts, 1971, no. 2; Paris, Grand Palais, 1974, *Centenaire de l'Impressionnisme*, no. 5; New York, Metropolitan Museum, 1974, no. 5, ill.

BIBLIOGRAPHY Meier-Graefe, 1910, p. 77, ill.; H. Haberfeld, 'Die Französischen Bilder der Sammlung Kohner', *Cicerone*, 1911, p. 588, ill. p. 586; Meier-Graefe, 1913, p. 74, ill.; M. Denis, 'Cézanne', *Kunst und Künstler*, 1913, p. 208, ill.; F. Burger, *Cézanne und Hodler*, Munich, 1913, pl. 114; Meier-Graefe, 1918, ill. opp. p. 88; Meier-Graefe, 1920, ill. opp. p. 88; F. Burger, *Cézanne und Hodler* (fourth edition), Munich, 1920, pl. 119; A. Bye, *Pots and Pans or Studies in Still Life Painting*, Princeton, 1921, p. 137; A. Zeisho, *Paul Cézanne*, Tokyo, 1921, fig. 20; Meier-Graefe, 1922, ill. p. 117; Meier-Graefe, 1923, p. 29, ill.; F. Burger, *Cézanne und Hodler* (fifth edition), Munich, 1923, pl. 118; Rivière, 1923, p. 199, listed; J. Meier-Graefe, *Entwicklungsgeschichte*, Munich, 1925, p. 495, ill.; Meier-Graefe, 1927, pl. V; Pfister, 1927, fig. 25; E. Petrovics, ('Coll. of Baron A. von Kohner'), *Magyar Muveszet (Hungarian Art)*, 1929, p. 321, ill. p. 318 (vol. V); P. Jamot, *La Peinture en France*, Paris, 1934, p. 216, ill.; R. Huyghe, 'Cézanne et son œuvre', *Amour de l'Art*, May 1936, fig. 40; R. Huyghe, *Cézanne*, Paris, 1936, pl. 15; E. Ors, 'Crise de Cézanne', *Gazette des Beaux-Arts*, June 1936, p. 368, ill.; Rewald, 1936, fig. 17; Vollard, 1937, pl. 4; J. Laver, *French Painting & the Nineteenth Century*, London, 1937, fig. 111; Novotny, 1937, pl. 10; R. Goldwater, 'Cézanne in America', *Art News*, 26 March 1938, p. 140, ill.; C. Zervos, *Histoire de l'art contemporain*, Paris, 1938, p. 26, ill.; Rewald, 1939, fig. 20; Barnes and de Mazia, 1939, no. 14, ill. p. 162; Cogniat, 1939, pl. 14; S. Cheney, *History of Modern Painting*, New York, 1941, p. 213, ill.; E. Faure, *Histoire de l'Art*, Paris, 1941, p. 204, ill.; H. Graber, *Paul Cézanne*, Basel, 1942, ill. opp. p. 40; E. Jewell, *Paul Cézanne*, New York, 1944, p. 29, ill.; D. MacColl, *Life Work and Setting of Philip Wilson Steer*, London, 1945, p. 87; J. Rewald, *The History of Impressionism*, New York, 1946, p. 210, ill.; G. Schildt, *Cézanne*, Stockholm, 1946, fig. 22; J. Vaudoyer, *Les peintres provençaux*, Paris, 1947, p. 88, ill.; Rewald, 1948, p. 81, fig. 32; Dorival, 1948, pl. 17; L. Guerry, *Cézanne et l'expression de l'espace*, Paris, 1950, fig. 4; F. Jourdain, *Cézanne*, Paris and New York, 1950, ill.; L. Venturi, *Impressionists and Symbolists*, New York and London, 1950, fig. 121; Schapiro, 1952, pp. 37–8, ill.; R. Rilke, *Briefe über Cézanne*, Wiesbaden, 1952 (letter to Clara Rilke, Paris, 24 Oct. 1907); C. Sterling, *La nature morte*, Paris, 1952, p. 92, pl. 92; G. Bazin, *L'Epoque impressionniste*, Paris, 1953, pl. 26; T. Rousseau Jr., *Paul Cézanne 1839–1906*, New York, 1953, pl. 10; Raynal, 1954, p. 26; J. Rewald, *The History of Impressionism* (second edition), New York, 1955, ill. p. 210; I. Elles, *Das Stilleben in der französischen Malerei des 19. Jahrhunderts*, Zurich, 1958, p. 100; W. Hofmann, *Das irdische Paradies*, Munich, 1960, p. 146; S. Uchida, *Cézanne*, Tokyo, 1960, p. 19, ill.; J. Rewald, *The History of Impressionism*, New York, 1961, p. 248, ill.; Novotny, 1961, pl. 5; D. Cooper, *Great Private Collections*, London, 1963, p. 195, ill.; P. Feist, *Paul Cézanne*, Leipzig, 1963, p. 24, pl. 15; J. McCoubrey, 'The Revival of Chardin in French Still-Life Paintings 1850–1870', *Art Bulletin*, 1964, p. 52, fig. 19; L. Guerry, *Cézanne et l'expression de l'espace* (second edition), Paris, 1966, pl. 9; P. Pool, *Impressionism*, New York, 1967, pl. 141; J. Elderfield, 'Drawing in Cézanne', *Art Forum*, June 1971, p. 55, ill.; Schapiro, 1973, pl. 3, with comments; Elgar, 1975, fig. 19; Wadley, 1975, pl. 22; S. Geist, 'What Makes "The Black Clock" Run', *Art International*, Feb., 1978, pp. 9, 10, ill.; Venturi, 1978, ill. p. 57; N. Ponente, *Paul Cézanne*, Bologna, 1980, pl. 2; B. Bernard, *The Impressionist Revolution*, London, 1986, p. 241, ill.

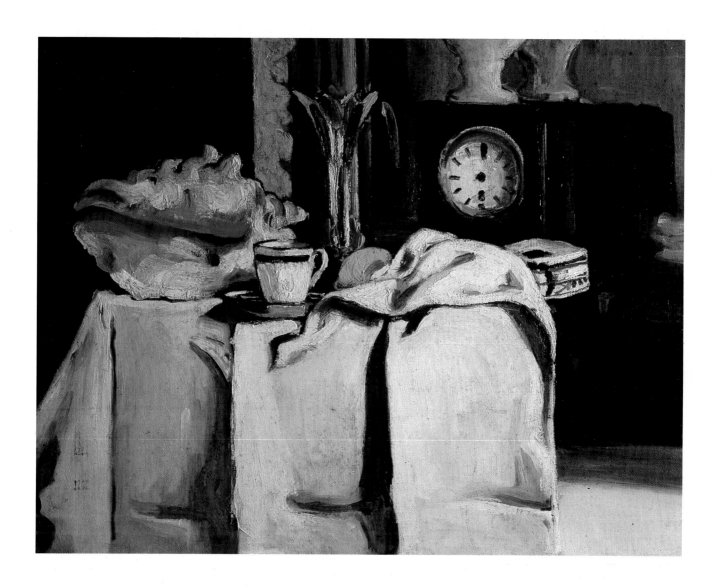

50 The Temptation of St Anthony

(La Tentation de St Antoine)

c.1870
54 × 73 cm 22¼ × 29¾ in
V.103
Foundation E.G. Bührle Collection, Zurich

The theme of the Temptation of St Anthony, and at least equally Flaubert's book, preoccupied Cézanne at intervals through his middle life. His first approach to the subject in about 1870 was quite unlike the classic form in which he imagined it later. There was no sign of the coherent and stately drama that he painted in the later seventies (V.240; V.241, fig. 26). The monastic saint with his individual tempter, like a dancing partner, are hardly noticeable far away on the left. The foreground is occupied only by a heavily built and unengaging trio of nude models linked by a common and evident origin in the poses that are set to a life-class. They are laboriously arranged in a triangle. It is hard to imagine an anchorite greatly tempted by them.

Yet the picture has a message which is unmistakably informative and truthful. It informs us that the austere discipline that had occupied Cézanne for a decade had become rewarding in itself, irrespective of human compensation, rewarding because only here could he forget everything that had been done before him. Only here in this lonely extremity without convention or palliative could the optical and intellectual sensations of life be re-imagined in his terms alone.

The *Temptation of St Anthony* exhibited here, uningratiating though it is, is our first sight of the bitter extremity of the terms on which Cézanne would choose to paint figure compositions. We gather that the *Temptation* in the Mannerist style was relegated to the background just because its traditionalism would no longer serve. The thunderous compositions of 1870, of which this is one, are the most original pictures of the time because they were essentially and necessarily rediscovered from within the artist himself. Inherited formulations for seductiveness were at one and the same time irresistible and forbidding.

PROVENANCE Ambroise Vollard, Paris; Alphonse Kann, Saint-Germain-en-Laye; Michael Stewart, London; (?) Private Collection, U.S.A.; Arthur Tooth & Sons, London; Knoedler Galleries, New York; Emil G. Bührle, Zurich.

EXHIBITIONS Zurich, Kunsthaus, 1917, *Französische Kunst des XIX. und XX. Jahrhunderts,* no. 18; Basel, Kunsthalle, 1936, no. 5; Amsterdam, Stedelijk Museum, 1938, *Honderd Jaar Fransche Kunst,* no. 2, ill.; Paris, Orangerie, 1953, *Baroque provençal,* no. 8, pl. XXVII; Edinburgh, Royal Scottish Academy, 1954, no. 5 —London, Tate Gallery, 1954, no. 5; Zurich, Kunsthaus, 1954, no. 204; Zurich, Kunsthaus, 1958, Sammlung Emil G. Bührle, no. 214, pl. 61; Munich, Haus der Kunst, 1958–9, *Hauptwerke der Sammlung E.G. Bührle,* no. 12; Edinburgh, National Gallery of Scotland, 1961, *Masterpieces of French Painting from the Bührle Collection,* no. 30—London, National Gallery, 1961, no. 30.

BIBLIOGRAPHY W. Hausenstein, *Die bildende Kunst der Gegenwart,* Berlin, 1914, ill. opp. p. 97; Vollard, 1914, pls 6 and 47; J. Meier-Graefe, *Entwicklungsgeschichte der modernen Kunst,* Munich, 1915, pl. 487; Meier-Graefe, 1918, ill. p. 97; Meier-Graefe, 1920, ill. p. 97; Meier-Graefe, 1922, ill. p. 111; J. Meier-Graefe, *Paul Cézanne* (fifth edition), Munich, 1923, p. 21, ill.; F. Lehel, *Cézanne,* Budapest, 1923, pl. 3; Rivière, 1923, p. 199; L. Larguier, *Le Dimanche avec Paul Cézanne,* Paris, 1925, p. 128, ill.; I. Arishima, *Cézanne,* Tokyo, 1926, pl. 41; Meier-Graefe, London, 1927, pl. XIII; Fry, *Samleren,* 1929, p. 132, ill.; L. Venturi, 'Paul Cézanne', *L'Arte,* July and Sept. 1935, pl. 3; Ors, 1936, pl. 49; R. Huyghe, 'Cézanne et son oeuvre', *Amour de l'Art,* May 1936, fig. 44; di San Lazzaro, 1938, fig. 49; B. Schildt, *Cézanne,* Stockholm, 1946, fig. 18; J. Seznec, 'The Temptation of St Anthony in Art', *Magazine of Art,* March 1947, p. 91, ill.; Dorival, 1948, pl. 13; G. Jedlicka, *Cézanne,* Berne, 1948, fig. 6; G. Berthold, *Cézanne und die alten Meister,* Stuttgart, 1958, p. 35 (cited); R. Cogniat, *Le Siècle des Impressionnistes,* Paris, 1959, p. 78; F. Novotny, *Cézanne,* London, 1961, pl. 4; T. Reff, 'Cézanne, Flaubert, St Anthony, and the Queen of Sheba', *The Art Bulletin,* June 1962, fig. 1; T. Reff, 'Cézanne and Hercules', *The Art Bulletin,* March 1966, fig. 9; Ikegami, Tokyo, 1969, pl. 3; K. Malevich, *Essays on Art, 1915–33,* New York, 1971, pp. 19–30, 116 (fig. 3); *Foundation E.G. Bührle Collection,* Zurich, 1973, p. 140, pl. 51; Schapiro, 1973, p. 44, ill.; Elgar, 1975, pl. 8; Wadley, 1975, pl. 20; T. Reff, 'Painting and Theory in the Final Decade' in *Cézanne: The Late Work,* New York, 1977, p. 18, ill.; Venturi, 1978, ill. p. 19, 21; G. Adriani, *Paul Cézanne, Der Liebeskampf,* Munich, 1980, pl. 8; N. Ponente, *Paul Cézanne,* Bologna, 1980, pl. 3; B. Bernard, *The Impressionist Revolution,* London, 1986, p. 239, ill.

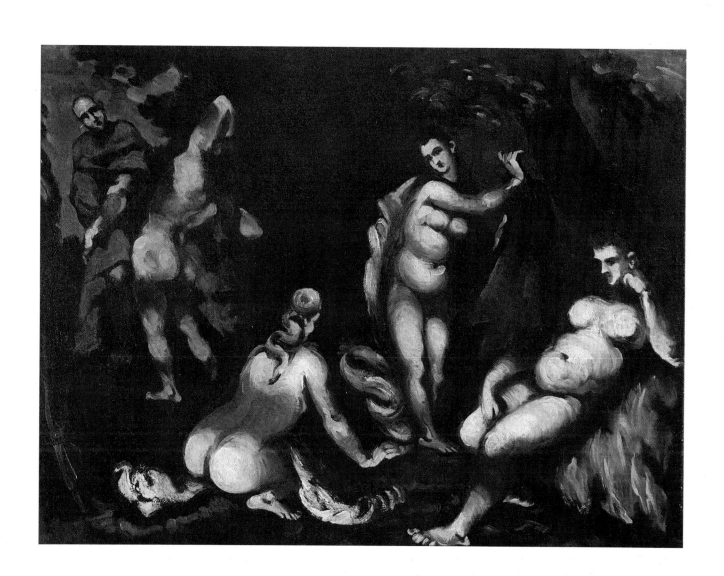

51 Le Déjeuner sur l'herbe

*c.*1870–71
60 × 80 cm 23¾ × 31¾ in
V.107
Private Collection

If the world of Manet was deficient in the place that it allowed to the artist's own temperament, the milieu in which the young Cézanne imagined himself certainly repaired the lack. He was unconcerned either with current propriety or its reversal. His *Déjeuner sur l'herbe* needed to flout no decency; the painter's offence was already implicit in the boldness that made every imagining his own. He dominated the foreground in the likeness of a Socrates. He was already learning to use his persona as his most private instrument. He gathered round him the tall women among whom he lived. Each figure materialised in a private pool of shadow, and there each was outlined with the curly caprice of a dream, in which every imagining takes leave to develop its own disquieting disproportion. This disquiet has now been studied by M. L. Krumrine, whose analysis has deepened all previous readings of the picture (q.v., pp. 25–7). Becoming familiar with Cézanne's imaginings of 1870–71 when he produced a number of consistently unrestrained private subject-pictures, we meet a great artist but a greatly perplexed and perplexing one.

It was Manet's spontaneous notation of his provocative subjects that led Cézanne to conceive a picture as an emotional imagining enacted in paint. At twenty-eight his way with paint had amounted to acting-out whatever extremity engrossed him. When he was thirty-one the smouldering urgency of such extremes formed the content of a succession of landscapes with figures which were by turns compelling or comic, then brooding and painful. The discomforts of this outcome and, we may imagine, the difficulty of realising in actuality, as well as in paint, his imperative requirements led him to a violent reaction and, in fact, to a conception of painting that was the reverse of imagined – retaining only the character of being directly acted-out in response to a situation that was real. Cézanne's passionate disquiet was on the verge of being sublimated into its opposite. The thunderous pictures of the later 1860s allow us to gather the emotional forces which were to be embodied in the new equilibrium. His recourse was to apprentice himself to his admirer, Pissarro, and to school himself in a closely observed definition of the natural environment and pictorial structures of the utmost stability – a definition in terms of irreproachably objective and emotionally neutral constituents. That is another story but the alternatives that Cézanne resolved retained throughout his life the motive force that had impelled his art through its terrific transformations in the 1860s.

PROVENANCE Ambroise Vollard, Paris; Bernheim-Jeune, Paris; Auguste Pellerin, Paris; René Lecomte, Paris.

EXHIBITION Paris, Orangerie, 1954, no. 17, pl. 7.

BIBLIOGRAPHY J. Meier-Graefe, *Entwicklungsgeschichte der modernen Kunst*, Stuttgart, 1904, pl. 62; Meier-Graefe, 1910, p. 11, ill.; Meier-Graefe, 1913, p. 11, ill.; Vollard, 1914, pp. 22, 23, 25, pl. 47; Meier-Graefe, 1918, ill. p. 95; Meier-Graefe, 1920, ill. p. 95; Meier-Graefe, 1922, p. 14, ill. p. 107; Meier-Graefe, 1923, p. 15, ill.; Rivière, 1923, p. 197, listed; Fry, Dec. 1926, p. 399, ill.; Meier-Graefe, 1927, pl. X; Fry, 1927, pl. VIII, fig. 11; Fry, *Samleren*, 1929, p. 101, ill.; Barnes and de Mazia, 1939, no. 21, ill. p. 160; Dorival, 1948, pl. 14; G. Jedlicka, *Cézanne*, Berne, 1948, fig. 7; L. Guerry, *Cézanne et l'expression de l'espace*, Paris, 1950, p. 24; Schapiro, 1952, pp. 34–5, ill.; P. Feist, *Paul Cézanne*, Leipzig, 1963, pp. 12, 22, pl. 7; Schapiro, 1973, pl. 2; A. Barskaya, *Paul Cézanne*, Leningrad, 1975, p. 13, ill.; Wadley, 1975, pl. 21; Venturi, 1978, ill. p. 51; G. Adriani, *Paul Cézanne, Der Liebeskampf*, Munich, 1980, pl. 6; W. Rubin, 'From Narrative to "Iconic" in Picasso: The Buried Allegory in "Bread and Fruitdish on a Table" . . .', *Art Bulletin*, Dec. 1983, fig. 16.

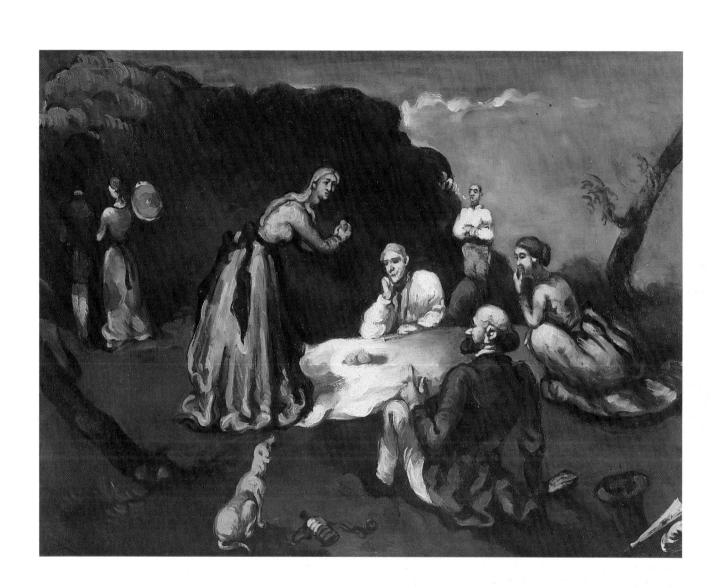

52 Pastoral (Idyll)

(*Pastorale [Idylle]*)

*c.*1870
65 × 81 cm 25¾ × 31¾
V.104
Musée d'Orsay, Paris

The peak of Cézanne's Romantic imagining shows the dreamer, recognisable again as the painter himself, to have journeyed (in a boat still under sail in the windless night) to an abode of love, which if it is not the Venusberg, is populated likewise by the naked personifications of passion. He lies down among them to indulge his reverie; round the lake the phallic symbols flourish. The atmosphere grows heavy with the climax that is impending, made vivid and urgent in the stormy colours, yet still insoluble and unending, like a long-drawn chordal paroxysm in opera – like Wagner in fact.

This most thunderous and intimate of the compositions bears a date on the hull of the boat which is probably to be read '1870'. The invention linked Cézanne to the tradition of pastoral painting from Giorgione and the *Concert champêtre* to Manet. A drawing for the composition survives (Ch. 250) and in another sheet (Ch. 249), the still life groups which were to provision the picnic were studied in detail. The women, as they appeared in this picture, recurred repeatedly in later compositions.

PROVENANCE Ambroise Vollard, Paris; Bernheim-Jeune, Paris; Auguste Pellerin, Paris; Jean-Victor Pellerin, Paris.

EXHIBITIONS Paris, Orangerie, 1936, no. 12, pl. X; Paris, Bibliothèque Nationale, 1952, *Emile Zola*, no. 344; Paris, Orangerie, 1953, *Baroque provençal*, no. 11; Aix-en-Provence, Pavillon de Vendôme, 1956, no. 3;

London, Tate Gallery, 1959, *The Romantic Movement*, no. 50; Paris, Grand Palais, 1985–6, *Anciens et nouveaux choix d'œuvres acquises par l'état ou avec sa participation de 1981 à 1985*, no. 128; Brooklyn, Brooklyn Museum, 1986, *From Courbet to Cézanne, A new 19th Century (Preview of the Musée d'Orsay, Paris)*, no. 2, ill.

BIBLIOGRAPHY J. Meier-Graefe, *Impressionisten*, Munich, 1907, p. 177, ill.; Meier-Graefe, 1910, p. 19, ill.; Meier-Graefe, 1913, p. 20, ill.; Vollard, 1914, pl. 7; F. Gregg, *Vanity Fair*, Dec. 1915, p. 58, ill.; J. Meier-Graefe, *Entwicklungsgeschichte der modernen Kunst*, Munich, 1915, p. 490, ill.; K. Scheffler, 'Die Maler 1870 und 1914', *Kunst und Künstler*, 1915, p. 206 ill.; R. Fry, '"Paul Cézanne" by Ambroise Vollard: Paris, 1915, A Review', *The Burlington Magazine*, Aug. 1917, pl. I; Meier-Graefe, 1918, ill. p. 93; Meier-Graefe, 1920, ill. p. 93; M. Denis, 'L'Influence de Cézanne', *Amour de l'Art*, Dec. 1920, p. 282, ill.; Meier-Graefe, 1922, ill. p. 105; Rivière, 1923, p. 202, listed; Meier-Graefe, 1923, p. 17, ill.; Fry, Dec. 1926, p. 398, ill.; Meier-Graefe, 1927, pl. VIII; Fry, 1927, pl. VII, fig. 10; R. Fry, *Samleren*, 1929, p. 101, ill.; Ors, 1936, pl. 45; R. Huyghe, 'Cézanne et son œuvre', *Amour de l'Art*, May 1936, fig. 48; R. Huyghe, *Cézanne*, Paris, 1936, pl. 16; Raynal, 1936, pl. XV; A. Vollard, *Recollections of a Picture Dealer*, Boston, 1936, ill. opp. p. 119; Novotny, 1937, pl. 15; di San Lazzaro, 1938, fig. 45; Barnes and de Mazia, 1939, no. 26, ill. p. 165; G. Schildt, *Cézanne*, Stockholm, 1946, fig. 17; Dorival, 1948, pl. 15; G. Jedlicka, *Cézanne*, Berne, 1948, fig. 8; L. Guerry, *Cézanne et l'expression de l'espace*, Paris, 1950, pp. 19–21, fig. 1; L. Venturi, *Impressionists and Symbolists*, New York and London, 1950, fig. 118; Schapiro, 1952, p. 22, ill.; Badt, 1956, pp. 77, 197, 224, pl. 38; L. Guerry, *Cézanne et l'expression de l'espace* (2nd edition), Paris, 1966, pl. 2; *Meddelelser fra Ny Carlsberg Glyptotek*, Copenhagen, 1957, p. 18; A. Chappuis, *Les dessins de P. Cézanne au Cabinet des estampes du Musée des Beaux-Arts de Bâle*, Olten and Lausanne, 1962, fig. 25; Badt, 1965, p. 103; M. Schapiro, 'The Apples of Cézanne: An Essay on the Meaning of Still-life', *Art News Annual*, 1968, pl. 5; Ikegami, Tokyo, 1969, fig. 7; Schapiro, 1973, p. 27, ill.; A. Barskaya, *Paul Cézanne*, Leningrad, 1975, p. 19, ill.; S. Geist, 'What Makes "The Black Clock" Run', *Art International*, Feb. 1978, p. 12, ill.; Venturi, 1978, ill., p. 55; S. Gache-Patin, 'Douze œuvres de Cézanne de l'ancienne collection Pellerin', *La Revue du Louvre et des Musées de France*, 2, 1984, p. 131, no. 4; Laclotte, Lacambre, Distel, etc., *La Peinture au Musée d'Orsay*, Paris, 1986, p. 90, ill.

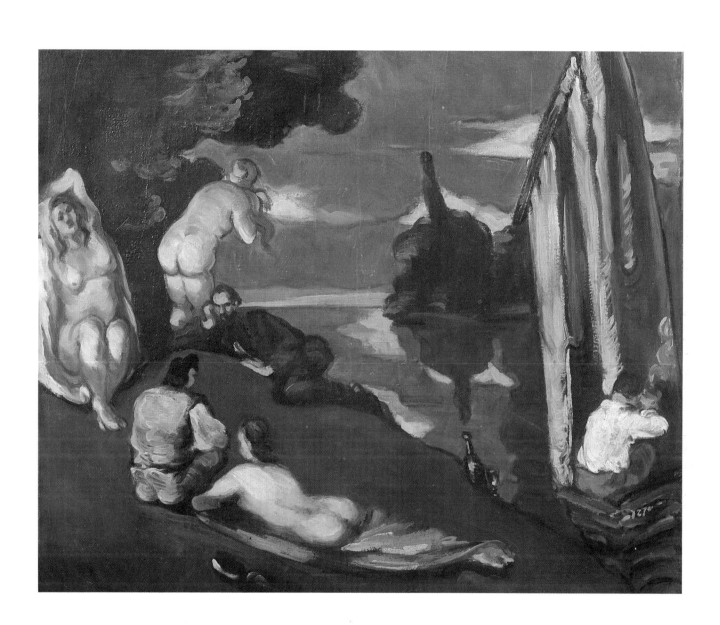

53 Still life: Green Pot and Pewter Jug

(Nature morte: pot vert et bouilloire d'étain)

c.1870
63 × 80 cm 24¾ × 31½ in
V.70
Musée d'Orsay, Paris

The way in which the common objects of a household composed into arrangements of the utmost grandeur, which in the course of thirty-five years effectively redefined the content and form of western painting, is among the miracles and mysteries of art. *The Green Pot and Pewter Jug* now in the Musée d'Orsay convinced Roger Fry of Cézanne's genius at one sight; *The Black Clock* (cat. 49) did somewhat the same for Rainer Maria Rilke. The clutter of pots, bottles and fruit now in Berlin (cat. 54), when they reappeared in the background of a *Smoker* (V.686) painted more than twenty years later revealed that the experience of order derived from them had been lastingly precious to Cézanne himself. Each aggregation constituted a unity so majestic as to be quite unquestionable and unforeseen. It seemed that the ordering of the everyday scene would never be commonplace again. Henceforward a napkin or a tablecloth could be depended upon to realise the structural nobility that rumpled linen had first achieved in company with the bread and eggs of 1865 (cat. 7).

PROVENANCE (?) Ambroise Vollard, Paris; Sergei (or his brother) Shchukin, Paris; Sale, La Collection d'un Amateur, Hôtel Drouot, Paris, 24 March 1900, no. 3; Bernheim-Jeune, Paris; Musée du Louvre, Paris.

EXHIBITIONS London, New Gallery, 1906, *Exhibition of the International Society*, n.n.; Paris, Manzi, Joyant & Cie, 1912, *Exposition d'Art Moderne*, n.n.; Zurich, Kunsthaus, 1917, *Französische Kunst des XIX. und XX. Jahrhunderts*, no. 33, ill.; Paris, Galerie Bernheim-Jeune, 1926, no. 49; Paris, Orangerie, 1936, no. 14, pl. XXI; Amsterdam, Stedelijk Museum, 1938, *Honderd Jaar Fransche Kunst*, no. 5, ill.; Chicago, Art Institute, 1952, no. 12, ill. —New York, Metropolitan Museum, 1952, no. 12, ill.; Paris, Galerie Bernheim-Jeune, 1960, no. 28; Paris, Orangerie, 1974, no. 3.

BIBLIOGRAPHY A. Alexandre, 'Exposition d'Art Moderne', *Les Arts*, Aug. 1912, p. VII, no. 9; Bernheim-Jeune (ed.), *Cézanne (with contributions by O. Mirbeau, Th. Duret, L. Werth, etc.)*, Paris, 1914, pl. XVII; Bernheim-Jeune (ed.), *L'Art Moderne et quelques aspects de l'art d'autrefois*, Paris, 1919, pl. 15; Rivière, 1923, p. 202, listed; G. Rivière, 'La Formation de Paul Cézanne', *Art Vivant*, 1 Aug. 1925, p. 3, ill.; I. Arishima, *Cézanne*, Tokyo, 1926, pl. 32; G. Charensol, 'Les Détracteurs de Cézanne', *Art Vivant*, 1926, p. 495, ill.; Iavorskaia, 1935, pl. 5; Ors, 1936, pl. 25; J. Combe, 'L'Influence de Cézanne', *La Renaissance*, May–June 1936, p. 31, ill.; R. Huyghe, *Cézanne*, Paris, 1936, pl. 14; Novotny, 1937, pl. 11; J. Rewald, 'A propos du catalogue raisonné de l'œuvre de Paul Cézanne et de la chronologie de cette œuvre', *La Renaissance*, March–April 1937, p. 55, ill.; di San Lazzaro, 1938, fig. 25; Barnes and de Mazia, 1939, no. 27, ill. p. 163; Cogniat, 1939, pl. 11; V. Woolf, *Roger Fry, A Biography*, London, 1940, pp. 111–12. J. Rewald, *The History of Impressionism*, New York, 1946, p. 139, ill.; Dorival, 1948, pl. 18; G. Jedlicka, *Cézanne*, Berne, 1948, fig. 11; L. Guerry, *Cézanne et l'expression de l'espace*, Paris, 1950, pp. 34, 69; J. Rewald, *The History of Impressionism* (second edition), New York, 1955, ill. p. 139; I. Elles, *Das Stilleben in der französischen Malerei des 19. Jahrhunderts*, Zurich, 1958, p. 100; J. Rewald, *The History of Impressionism*, New York, 1961, p. 157, ill.; Ikegami, Tokyo, 1969, pl. 5; M. Ginsburg, 'Art Collectors of Old Russia, The Morosovs and the Shchukins', *Apollo*, Dec. 1973, p. 470, ill.; Wadley, 1975, pl. 14; S. Geist, 'What Makes "The Black Clock" Run', *Art International*, Feb. 1978, p. 8, ill.; J. Arrouye, *La Provence de Cézanne*, Aix-en-Provence, 1982, p. 57; B. Bernard, *The Impressionist Revolution*, London, 1986, p. 243, ill.; Rewald, 1986, p. 81, ill.

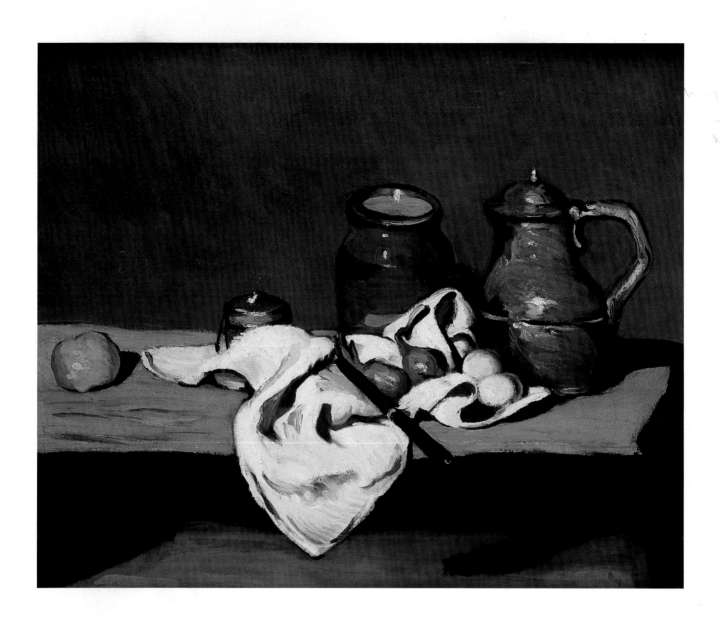

54 Still life: Pots, Bottle, Cup and Fruit

(Nature morte: pots, bouteille, tasse et fruits)

c.1871
64 × 80 cm 25⅛ × 31½ in
V.71
Nationalgalerie der Staatlichen Museen zu Berlin,
Hauptstadt der DDR

See cat. 53.

PROVENANCE Ambroise Vollard, Paris; (?) Paul Cassirer, Berlin; Edouard
Arnold.

EXHIBITIONS Paris, Galerie Vollard, 1899, no. 35; Berlin, Paul Cassirer,
1904, n.n.; Prague, Sternberg Palace, 1965, *French Painting from Delacroix
to Picasso*, no. 46, ill.; Berlin, Nationalgalerie, 1965, *Von Delacroix bis
Picasso*, n.n.

BIBLIOGRAPHY Bernheim-Jeune (ed.), *Cézanne (with contributions by
O. Mirbeau, Th. Duret, L. Werth, etc.)*, Paris, 1914, pl. XIV; Vollard, 1914,
pl. 1; Meier-Graefe, 1920, ill. opp. p. 92; Meier-Graefe, 1922, ill. p. 116;
Rivière, 1923, p. 205, listed; I. Arishima, *Cézanne*, Tokyo, 1926, pl. 23;
Meier-Graefe, London, 1927, pl. XIV; E. Waldmann, *Die Kunst des Realismus
und des Impressionismus*, Berlin, 1927, p. 494, ill.; P. Rave (ed.), *Die Malerei des
XIX. Jahrhunderts, Meisterwerke der Berliner Museen*, Berlin, 1945, no. 198,
ill.; K. Martin, *Die Tschudi-Spende*, Munich, 1962, p. 16; P. Feist, *Paul
Cézanne*, Leipzig, 1963, pp. 24, 28, pl. 8; A. Barskaya, *Paul Cézanne*,
Leningrad, 1975, p. 184, ill.; T. Reff, 'Painting and Theory in the Final
Decade' in *Cézanne: The Late Work*, New York, 1977, p. 19, ill.; S. Geist,
'What Makes "The Black Clock" Run', *Art International*, Feb. 1978, p. 8,
ill.; T. Reff, 'The Pictures within Cézanne's Pictures', *Arts Magazine*, June
1979, fig. 30.

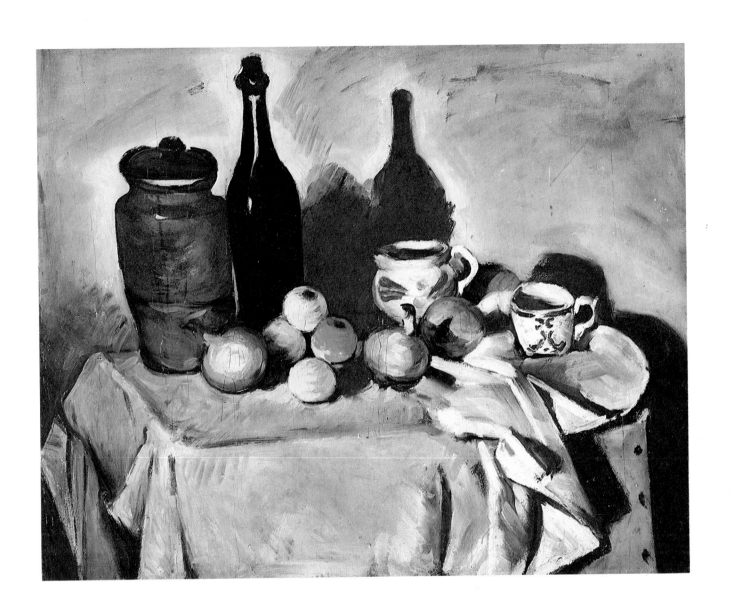

55 The Walk

(La Promenade)

1871
58 × 43 cm $22\frac{7}{8}$ × 17 in
V.119
Private Collection

This is a copy of a plate in an illustrated fashion magazine published in May 1871; the Franco–Prussian War does not seem to have interrupted its issue, but it may have hindered the artist's wish to work from observation.

It would not until lately have been easy to associate the maturity of a great painter with the habit of painting from fashion plates, but Cézanne had based a *plein-airiste* fantasy on such a plate around the middle of the decade (cat. 26) and in 1870–71 he turned back to plates from *L'Illustrations des Dames* and *La Mode Illustrée* as a basis for paraphrases of a closeness that suggests that not only the human material and the Parisian *chic*, which must both have been hard to come by at L'Estaque in the circumstances of the war, were of value to him, but that the fashion plate style was of interest in itself. Possibly the patterns of parallel pleats and frills reminded him of the formulation of the bulging solidity of Louis-Auguste, which he had invented years before (cat. 4). Neither has much in common with the styles between.

PROVENANCE Paul Cézanne fils, Paris; E. J. Van Wisselingh, Amsterdam; Knoedler Galleries, New York; Mr and Mrs Charles S. Payson, New York.

EXHIBITIONS Berlin, *Secession*, 1903, no. 36; Paris, Grand Palais, 1907, *Salon d'Automne*, no. 30; Paris, Orangerie, 1936, no. 21; Lyon, Palais Saint-Pierre, 1939, no. 10, pl. IV; London, Wildenstein Galleries, 1939, no. 10; Paris, Indépendants, 1939, no. 6; Kyoto, Municipal Museum — Tokyo, Isetan Museum of Art, 1980, The Joan Whitney Payson Collection, no. 34, ill.

BIBLIOGRAPHY E. Heilbuth, 'Die Ausstellung der Berliner Secession', *Kunst und Künstler*, 1930, p.308; Rivière, 1923, p. 203, listed; Barnes and de Mazia, 1939, no. 37, ill. p. 170; J. Rewald, *The History of Impressionism*, New York, 1946, p. 179, ill.; Dorival, 1948, pl. 25; J. Rewald, *The History of Impressionism* (second edition), New York, 1955, ill. p. 179; J. Rewald, *The History of Impressionism*, New York, 1961, p. 208, ill.; A. van Buren, 'Madame Cézanne's Fashions and the Dates of her Portraits', *Art Quarterly*, 1966, p. 124, note 2; M. Roskill, 'Letter', *The Burlington Magazine*, Jan. 1971, p. 46; A. Barskaya, *Paul Cézanne*, Leningrad, 1975, p. 162, ill.

56 Portrait of Antony Valabrègue

(Portrait d'Antony Valabrègue)

c.1871
58 × 48.5 cm 22¾ × 19 in
V.127
J. Paul Getty Museum, Malibu, Calif.

The portraits that Cézanne painted in 1871–2 are astonishing displays of his mature capacity. They were carried out with an *alla prima* vigour that exceeded even the Dominique pictures (cat. 18–20, 22, 23) and a refinement that was quite unprecedented in Cézanne's work. Most striking of all perhaps is the air of substance and dependability that he observed or imagined in his friends. It was as if the common disillusion that was felt with the régime and the generation that had brought the nation to disaster inspired those in early manhood to develop and display the required self-reliance in their place. The sobriety of these pictures has led some critics to detect a reversion to the style of Manet. The ebullient strength of character that they reflected was equalled among Cézanne's earlier sitters only by his father (see cat. 4, 21).

PROVENANCE Count Armand Doria, Chateau d'Orrouy; Auguste Pellerin, Paris; Jean-Victor Pellerin, Paris; Wildenstein Galleries, Paris and New York; André Meyer, New York; Sale, Meyer Collection, Sotheby's, New York, 22 Oct. 1980, no. 21; Galerie Beyeler, Basel.

EXHIBITIONS Stuttgart, Kgl. Kunstgebäude, 1913, *Grosse Kunstausstellung*, no. 330; Brussels, Palais des Beaux-Arts, 1935, *L'Impressionnisme*, no. 9; Paris, Orangerie, 1936, no. 17; London, Wildenstein Galleries, 1939, no. 9, ill.; Washington, D.C., National Gallery of Art, 1962, *Collection of Mr and Mrs André Meyer*, n.n., p. 16, ill.; Basel, Galerie Beyeler, 1982, *Portraits et figures*, no. 16, ill.; Basel, Galerie Beyeler, 1983, no. 6.

BIBLIOGRAPHY 'Kunstausstellungen', *Kunst und Künstler*, 1913, p. 583, ill.; M. Boyé, 'Cézanne et Antony Valabrègue', *Beaux-Arts*, 28 Aug. 1936, p. 1, ill.; R. Huyghe, 'Cézanne et son œuvre', *Amour de l'Art*, May 1936, fig. 39; Rewald, 1936, fig. 10; Rewald, 1939, fig. 14; Barnes and de Mazia, 1939, no. 42, ill. p. 169; Cogniat, 1939, pl. 27; Rewald, 1986, p. 53, ill.

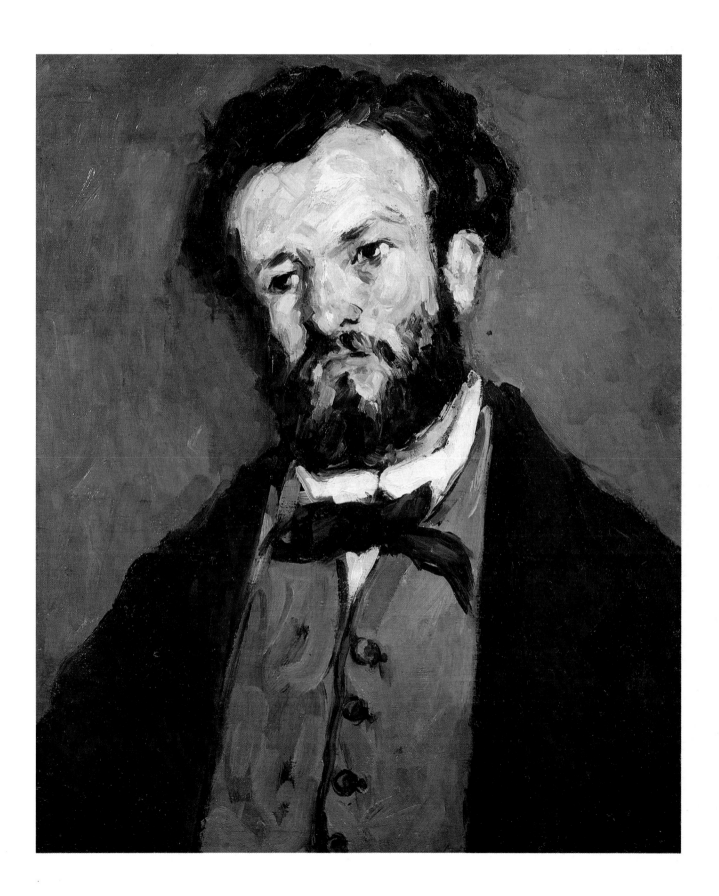

57 The Man with a straw Hat – Gustave Boyer

(L'Homme au chapeau de paille – Gustave Boyer)

*c.*1871
55 × 38.8 cm 21¾ × 15 in
Signed lower right in red: *P. Cézanne*
V.131
The Metropolitan Museum of Art: Bequest of
Mrs H.O. Havemayer, 1929; The H.O. Havemayer
Collection

See cat. 56.

PROVENANCE Gustave Boyer, (gift from the artist?); Ambroise Vollard, Paris (Durand-Ruel); H.O. Havemeyer, New York.

EXHIBITIONS New York, Metropolitan Museum, 1930, *The H.O. Havemeyer Collection*, no. 4; Paris, Orangerie, 1936, no. 15; Toledo, Ohio, Toledo Museum of Art, 1936, *Cézanne and Gauguin*, no. 23; Minneapolis, Minneapolis Institute of Art, 1950, n.n.; Chicago, Art Institute, 1952, no. 10, ill.—New York, Metropolitan Museum, 1952, no. 10, ill.; Aix-en-Provence, Musée Granet, 1953, no. 4, ill.—Nice, Musée Massénas, 1953, no. 4—Grenoble, Musée des Beaux-Arts, 1953, no. 4; Edinburgh, Royal Scottish Academy, 1954, no. 7—London, Tate Gallery, 1954, no. 7; Zurich, Kunsthaus, 1956, no. 10, pl. 1—Munich, Haus der Kunst, 1956, no. 6—The Hague, Gemeentemuseum, 1956, no. 5—Cologne, Wallraf-Richartz Museum, 1956–7, no. 2, pl. 17; Vienna, Belvedere, 1961, no. 6, pl. 3.

BIBLIOGRAPHY J. Meier-Graefe, *Impressionisten*, Munich, 1907, p. 181, ill.; Meier-Graefe, 1910, p. 48, ill.; Meier-Graefe, 1913, p. 46, ill.; Vollard, 1914, pl. 11; Meier-Graefe, 1918, ill. p. 102; Meier-Graefe, 1920, ill. p. 102; E. Bernard, 'La Technique de Paul Cézanne', *Amour de l'Art*, Dec. 1920, p. 277, ill.; Gasquet, 1921, ill. opp. p. 112; Meier-Graefe, 1922, ill. p. 120; C. Glaser, *Paul Cézanne*, Leipzig, 1922, pl. 1; Meier-Graefe, 1923, p. 41, ill.; T. Klingsor, *Cézanne*, Paris, 1923, p. 16; Rivière, 1923, p. 200, listed; I. Arishima, *Cézanne*, Tokyo, 1926, pl. 22; R. Fry, *Samleren*, 1929, p. 97, ill.; 'From Poverty to Riches at the Metropolitan', *Art News*, 15 March 1930, p. 43, ill.; Iavorskaia, 1935, pl. VIII; Mack (2nd edition), 1936, p. 183; R. Huyghe, 'Cézanne et son œuvre', *Amour de l'Art*, May 1936, fig. 46; Barnes and de Mazia, 1939, no. 30, ill. p. 168; Cogniat, 1939, pl. 28; E. Jewell, *French Impressionists*, New York, 1944, ill. on cover; E. Jewell, *Paul Cézanne*, New York, 1944, p. 11, ill.; Dorival, 1948, pl. 23; Schapiro, 1952, pp. 40–41, ill.; Raynal, 1954, p. 31, ill.; P. Feist, *Paul Cézanne*, Leipzig, 1963, pp. 23, 54, pl. 10; C. Sterling and M. Salinger, *French Paintings, A Catalogue of the Collection of the Metropolitan Museum of Art*, New York, 1967, pp. 97–8, ill.; Ikegami, 1969, pl. 4; W. Andersen, *Cézanne's Portrait Drawings*, Cambridge, Mass. and London, 1970, fig. 7; Schapiro, 1973, pl. 5; Elgar, 1975, fig. 17; K. Baetjer, *European Paintings in the Metropolitan Museum of Art*, 1980, p. 26, ill. p. 614; F. Weitzenhoffer, *The Havemeyers: Impressionism Comes to America*, New York, 1986, p. 147, pl. 117.

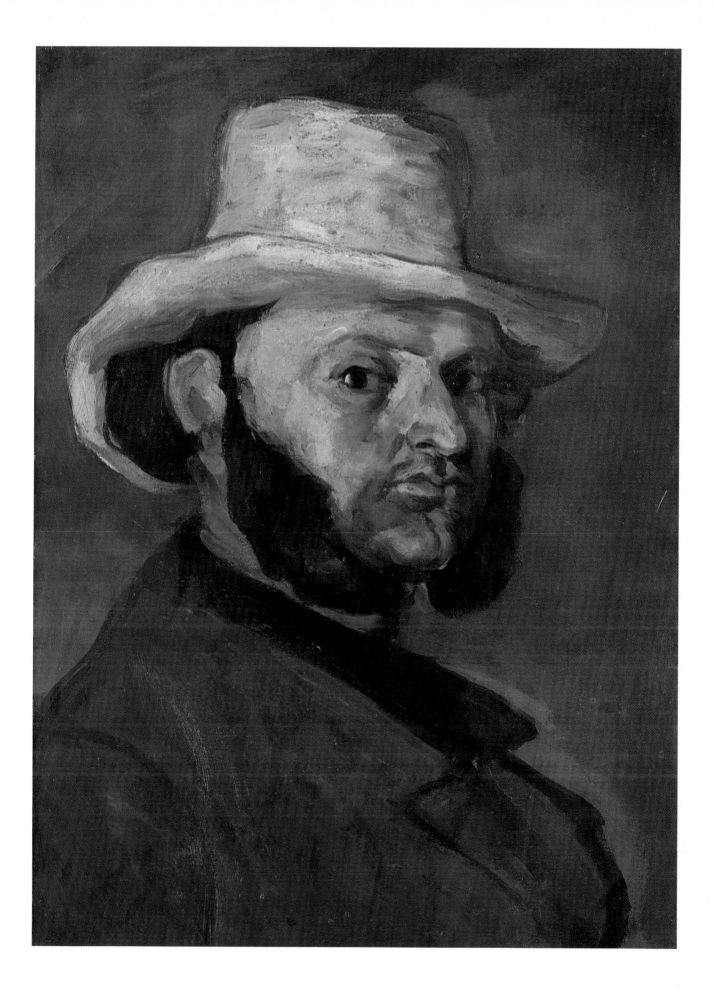

58 Landscape with a Watermill

(Paysage avec moulin à l'eau)

*c.*1871
41 × 54 cm 16⅛ × 21¼ in
V.48
Yale University Art Gallery, New Haven

The stability of Cézanne's new view of landscape was first apparent in the picture of *The Cutting* (V.50; see fig. 13) now at Munich and unfortunately in too fragile a state to be available for this exhibition. The mounting lines of the landscape slant upwards towards the top corners of the picture in an equilibrium which was constantly repeated in the landscapes of the next few years. Structures are wedged against the pictorial rectangle with a steady symmetry which is the more noticeable after the uneasy designs of the landscapes at L'Estaque of 1870–71. The angles echo one another in systems of responses which are both new and original in shifting the emphasis of a landscape subject away from its identifiable content towards the visual structure of a picture. The most remarkable of these new pictorial systems developed a pattern of parallels to brace the steep recession into the shadowed avenue of chestnut trees at the Jas de Bouffan (cat. 60). In handling, the picture is not far from the later works of the 1860s like the *Overture to Tannhäuser* (cat. 44). In spirit, in the maturity of its balance, it is utterly new. It would be good to be sure when it was painted. It is hard to imagine Cézanne taking his pregnant partner to the Jas de Bouffan in the teeth of his father's opposition or leaving her alone while he visited there in the late summer of 1871, but I cannot follow those who have regarded the *Chestnut Trees* (cat. 60) as a work of the middle 1870s, and it appears that we must be content to conclude that there were more occasions to visit Aix during these months than we know of.

PROVENANCE Ambroise Vollard, Paris; Bernheim-Jeune, Paris; Auguste Pellerin, Paris; Jos. Hessel, Paris; Moderne Galerie (Heinrich Thannhauser), Munich; Hugo Perls, Berlin; Gottlieb Friedrich Reber, Lugano; Sale, Dr Hans Wendland Collection and others, Ball & Graupe, Berlin, 24 April 1931, no. 72; Levin, Breslau; Richard H. Zinsser, New York; Walter Bareiss, New York.

EXHIBITIONS Berlin, Hugo Perls, 1927, *Zweite Ausstellung,* no. 2(?); Providence, Rhode Island, Rhode Island School of Design, 1954, no. 11.

BIBLIOGRAPHY *Moderne Galerie Heinrich Thannhauser, Nachtragswerk III zur grossen Katalogausgabe 1916,* Munich, 1918, p. 30, ill.; Meier-Graefe, 1918, ill. p. 100; Meier-Graefe, 1920, ill. p. 100; Meier-Graefe, 1922, ill. p. 118; Rivière, 1923, p. 200, listed; K. Scheffler, 'Breslauer Kunstleben', *Kunst und Künstler,* 1923, pp. 132, 138, ill.; F. Forster-Hahn, *French and School of Paris Paintings in the Yale University Art Gallery,* New Haven, 1968, p. 3, pl. 14.

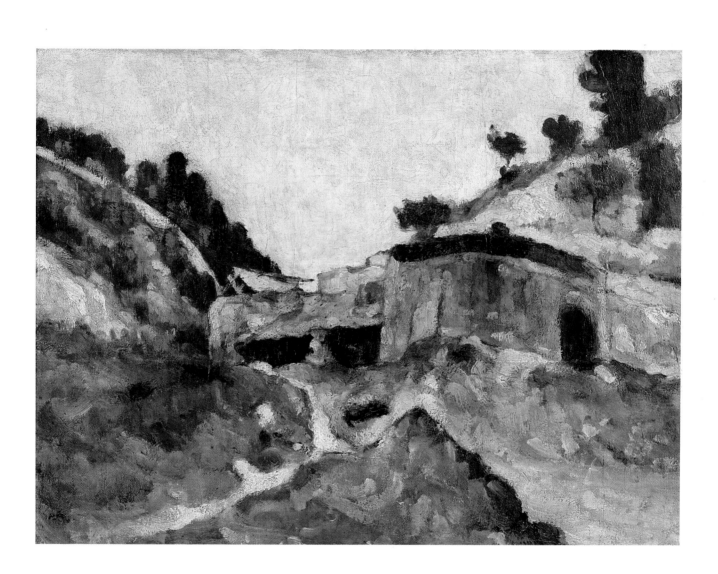

59 The Oilmill

(Le Moulin à l'huile)

*c.*1871
38 × 46 cm 15 × 18⅛ in
V.136
Private Collection, London

See cat. 58.

PROVENANCE (?) Ambroise Vollard, Paris; Bernheim-Jeune, Paris;
Bernheim-Jeune, Paris and Jos. Hessel, Paris; Paul Rosenberg, Paris;
Georges Bernheim, Paris; Ambroise Vollard, Paris; Galerie E. Bignou,
Paris; Reid & Lefevre, London; C.W. Boise, London; Sale, Sotheby's,
London, 24 April 1968, no. 70; Sir Jack Lyons, London; Sale, Sotheby's,
London, 30 June 1976, no. 47, ill., bought in; Sale, Christie's, London,
30 Nov. 1987, no. 36A, bought in.

EXHIBITIONS New York, Montross Gallery, 1916, no. 7; New York, Bignou
Gallery, 1936, no. 7; London, Reid & Lefevre, 1937, no. 4; Edinburgh,
Royal Scottish Academy, 1954, no. 9—London, Tate Gallery, 1954, no. 9;
Cardiff, National Museum of Wales, 1960, *How Impressionism Began,* no. 53.

BIBLIOGRAPHY 'A Representative Group of Cézannes Here', *New York
Times Magazine*, 2 Jan. 1916, p. 21; 'Cézanne and Montross', *American A A
News,* 8 Jan. 1916, p.3; W.H. Wright, 'Paul Cézanne', *International Studio,*
Feb. 1916, p. CXXX; T. Klingsor, *Cézanne,* Paris, 1923, pl. 13.

PW

60 The Chestnut Trees and the Pool at the Jas de Bouffan

(Les Marronniers et le bassin du Jas de Bouffan)

*c.*1871
38.1 × 46 cm 15 × 18⅛ in
V.47
The Trustees of the Tate Gallery

See cat. 58.

PROVENANCE Georges Bernheim, Paris; Bernheim-Jeune, Paris;
M. Wanamaker; Walter Berry, Paris; Mrs Edith Wharton, Saint-Brice-sous-
Forêt; H. J. Bomford, Aldbourne, Wilts.; Reid & Lefevre, London and
Matthiesen Gallery, London; The Hon Mrs A.E. Pleydell-Bouverie,
London.

EXHIBITIONS Paris, Galerie Bernheim-Jeune, 1920, no. 18, ill.; Paris, Galerie
Bernheim-Jeune, 1920, *Paysages impressionnistes,* no. 1; Paris, Orangerie,
1936, no. 24; London, Wildenstein Galleries, 1944, *Constable to Cézanne,*
no. 41; London, Royal Academy of Arts, 1949–50, *Landscape in French Art
1550–1900,* no. 312; Edinburgh, Royal Scottish Academy, 1954, no. 8 —
London, Tate Gallery, 1954, no. 8; London, Tate Gallery, 1954, *The Pleydell-
Bouverie Collection,* no. 8; London, Wildenstein Galleries, 1963, *The French
Impressionists and some of their Contemporaries,* no. 19, ill; Edinburgh, National
Gallery of Scotland, 1986, *Lighting up the Landscape: French Impressionism and
its Origins,* no. 93.

BIBLIOGRAPHY E. Faure, *P. Cézanne,* Paris, 1923, pl. 38; Rivière, 1933, p. 93;
R. Huyghe, *Cézanne,* Paris, 1936, pl. 9; Raynal, 1936, pl. XLII; F. Novotny,
Cézanne und das Ende der wissenschaftlichen Perspektive, Vienna, 1938, fig. 38;
Barnes and de Mazia, 1939, no. 41, ill. p. 174; D. Cooper, 'Two Cézanne
Exhibitions', *The Burlington Magazine,* Nov. and Dec. 1954, p. 349;
L. Gowing, 'Notes on the Development of Cézanne', *The Burlington
Magazine,* June 1956, p. 187; Schapiro, 1973, p. 7, ill.; A. Barskaya, *Paul
Cézanne,* Leningrad, 1975, p. 170, ill.

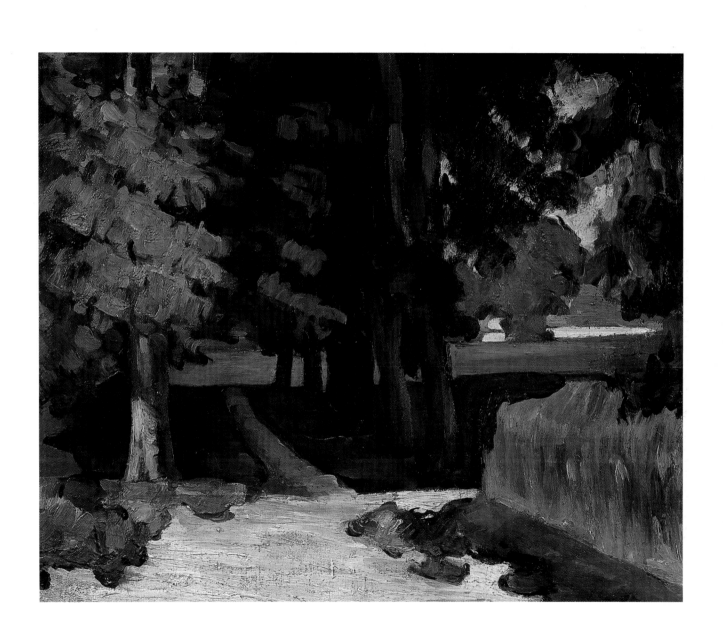

61 The Road

(La Route)

*c.*1871
59.8 × 72.4 cm 23½ × 28½ in
V.52
Private Collection, USA

See cat. 58.

PROVENANCE (?) Ambroise Vollard, Paris; (Count) Enrico Costa, Florence;
Lillie P. Bliss, New York; Museum of Modern Art, New York (Lillie P.
Bliss Bequest); Sale, Museum of Modern Art, Parke-Bernet, New York,
11 May 1944, no. 86.

EXHIBITIONS *Armory Show,* 1913, no. 1070; Chicago, *Armory Show,* 1913,
no. 49; Boston, *Armory Show,* 1913, no. 24; Philadelphia, Pennsylvania
Academy of Fine Arts, 1920, *Paintings and Drawings by Representative Modern
Masters,* no. 49; New York, Metropolitan Museum, 1921, *Impressionist and
Post-Impressionist Paintings,* no. 5; Brooklyn, Brooklyn Academy of Arts and
Sciences, 1926 (*Summer Exhibition*), n.n.; New York, Museum of Modern
Art, 1929, *Cézanne, Gauguin, Seurat, van Gogh,* no. 15, ill.; New York,
Museum of Modern Art, 1930, *Summer Exhibition,* no. 19; New York,
Museum of Modern Art, 1931 (Bliss Collection), no. 2, ill.; Andover,
Mass., Addison Gallery of American Art, 1931, no. 2; Indianapolis, John
Herron Art Institute, 1932, no. 2; Philadelphia, Pennsylvania Museum of
Art, 1934, no. 5; New York, Museum of Modern Art, 1934, *The Lillie P.
Bliss Collection,* no. 2, pl. 2; Pittsburgh, Carnegie Institute, 1935, *Paintings,
Drawings and Watercolors from the Lillie P. Bliss Collection,* no. 5;
Northampton, Mass., Smith College Museum of Art, 1935, n.n.; Paris,
Orangerie, 1936, no. 19; New York, Paul Rosenberg, 1948, *31 Masterpieces
by 7 Great Masters,* no. 1, ill.; Utica, Munson-Williams-Proctor Institute,
1963, *Armory Show – 50th Anniversary Exhibition,* no. 1070, ill. p. 53;
New York, Armory of the 69th Street Regiment, 1963, n.n.

BIBLIOGRAPHY G. René Du Bois, 'The Lillie P. Bliss Collection', *Arts,*
1931, p. 608, ill.; Barnes and de Mazia, 1939, no. 36, listed; *Painting and
Sculpture in the Museum of Modern Art,* New York, 1942, no. 84; M. Brown,
The Story of the Armory Show, New York, 1963, p. 229, no. 1070.

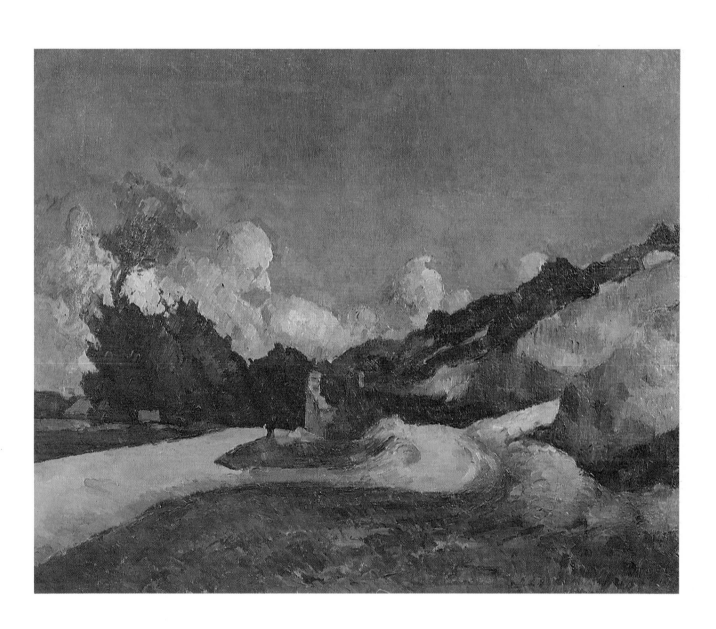

62 Paris: the Quai de Bercy – The Wine Market

(Paris: Quai de Bercy – la Halle aux vins)

*c.*1872
73 × 92 cm 28¾ × 36¼ in
V.56
Private Collection

The change in Cézanne's circumstances was soon to provide him with an altogether more consistent self-image and view of the world. At the end of 1871 he was confronted with a considerable emergency. He moved with his companion, Hortense Fiquet, into an apartment on the Quai de Bercy opposite the wine market, but when Achille Emperaire came to stay he found that the market made enough noise to awaken the dead. Moreover, Cézanne was behaving most strangely. Emperaire took himself off after one night. The mess in which Cézanne wrote that he found himself in February 1872 was probably nothing less than fatherhood; his baby son had arrived a month before and was possibly as disturbing as the market. In this situation we know that Cézanne withdrew from the apartment on the Quai and went to paint in the studio of his old friend Guillaumin, because the *Self-Portrait* (cat. 63) that he painted there shows in the background, naturally reversed in the mirror, Guillaumin's picture of the Seine with the distant Notre Dame, dated '1871' and now in the Beck Collection in the Museum of Fine Arts at Houston, Texas. The fury that is apparent in the picture was perhaps the rage at lost independence which more than one new parent has felt. The *Self-Portrait* is almost the last that we see of the turbulence of Cézanne's mood in the 1860s.

PROVENANCE Camille Pissarro, Paris; Auguste Pellerin, Paris; René Lecomte, Paris.

EXHIBITIONS Paris, Orangerie, 1936, no. 22, pl. XIX; Paris, Orangerie, 1954, no. 22, pl. IX.

BIBLIOGRAPHY R. Fry, 'Le développement de Cézanne', *Amour de l'Art,* Dec. 1926, p. 396, ill.; Fry, 1927, pl. VII, fig. 9; Rivière, 1933, p. 57, ill.; E. Faure, *Cézanne,* Paris, 1936, pl. 5; R. Huyghe, 'Cézanne et son œuvre', *Amour de l'Art,* May 1936, fig. 51; R. Huyghe, *Cézanne,* Paris, 1936, pl. 6; Novotny, 1937, pl. 16; F. Novotny, *Cézanne und das Ende der wissenschaftlichen Perspektive,* Vienna, 1938, p. 206, no. 113; Rewald, 1939, fig. 29; Cogniat, 1939, pl. 7; Rewald, New York, 1939, p. 37, ill.; Rivière, 1942, p. 59, ill.; G. Bauer, *Paris – Peintres et Ecrivains,* Lausanne, 1944, p. 93, ill.; Dorival, 1948, pl. 30; G. Jedlicka, *Cézanne,* Berne, 1948, fig. 10; K. Clark, *Landscape Painting,* New York, 1950, p. 121–2; Novotny, 1961, pl. 7; Rewald, 1986, p. 94, ill.

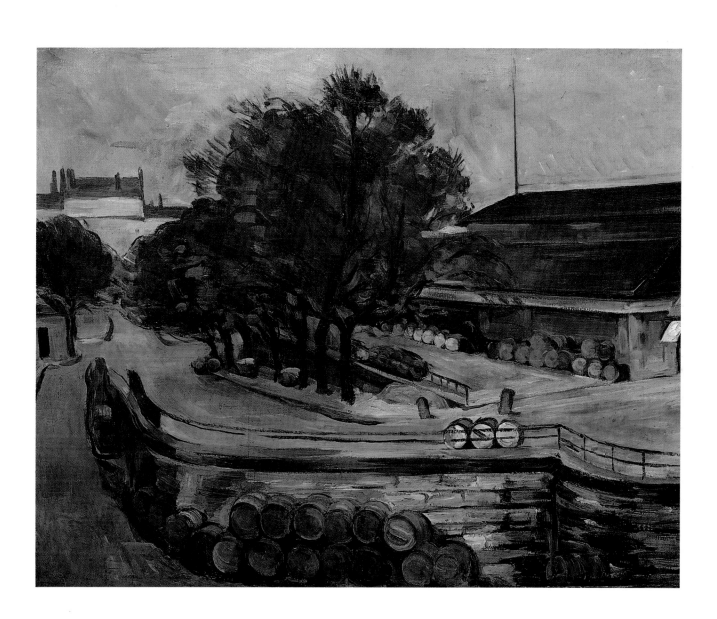

63 Self-Portrait

(Portrait de l'artiste)

*c.*1872
64 × 52 cm 25¼ × 20½ in
V.288
Musée d'Orsay, Paris

See cat. 62.

The art of Cézanne's twenties was a dream from which
he awoke in the furious temper that he portrayed in this
picture – awoke from a nightmare of loneliness and sexual
aggression to insist on being reconciled with life. He was
wakened not only by the grace of Hortense, the colossal
humility of Pissarro and the beneficent faithfulness of
truth to sensations – he was wakened by the clear sight
of genius, which at the crucial moment does actually
know its greatness.

PROVENANCE Ambroise Vollard, Paris; Cornelis Hoogendijk, Amsterdam;
Paul Rosenberg, Paris; Jean Laroche, Paris; Jacques Laroche, Paris; Musée
du Louvre, Paris (Gift of J. Laroche).

EXHIBITIONS The Hague, *Eerste Internationale Tentoonstelling,* 1901, no. 23;
Amsterdam, Stedelijk Museum, 1911, *Moderne Kunst Kring,* no. 1; Paris,
Paul Rosenberg, 1922, *Les Maîtres du siècle passé,* no. 5; Paris, 1924, *Première
exposition de collectionneurs, au profit de la Société des Amis du Luxembourg,*
no. 133; Paris, Galerie Pigalle, 1929, no. 31, ill.; Paris, Paul Rosenberg,
1939, no. 4, ill.; London, Rosenberg & Helft, 1939, no. 3; Paris, Pavillon
de Marsan, 1952, *Cinquante ans de peinture français,* no. 26; Paris, Orangerie,
1953, *Baroque provençal,* no. 19; Edinburgh, Royal Scottish Academy, 1954,
no. 11 — London, Tate Gallery, 1954, no. 11; Paris, Orangerie, 1974,
no. 17; Madrid, Museo Espanol de Arte Contemporaneo, 1984, No. 10.

BIBLIOGRAPHY *Catalogue des tableaux, miniatures, pastels, dessins encadrés, etc.
du Musée de l'Etat à Amsterdam,* Amsterdam, 1911, no. 688D; Fry, 1927,
pl. VI, fig. 8; T. Wencker, 'Chateau Noir', *Kunst und Künstler,* 1929,
p. 229, ill.; Rewald, 1936, fig. 42; Rewald, 1939, fig. 41; Rewald, New
York, 1939, fig. 56; J. Rewald, *The History of Impressionism,* New York,
1946, p. 290, ill.; Rewald, 1948, fig. 56; J. Rewald, *The History of
Impressionism,* New York, 1961, p. 362, ill.; 'Chronique des Arts', *Gazette
des Beaux-Arts,* Feb. 1970, p. 19, no. 95, ill.; R. Huyghe, *Impressionism,*
1971, p. 234, ill.; Schapiro, 1973, frontispiece; A. Barskaya, *Paul Cézanne,*
Leningrad, 1975, p. 165, ill.; Venturi, 1978, ill. p. 59; T. Reff, 'The Pictures
within Cézanne's Pictures', *Arts Magazine,* June 1979, fig. 6; P. Bonafoux,
Les Impressionnistes: Portraits et Confidences, Geneva, 1986, p. 96, ill.; Rewald,
1986, p. 104, ill.

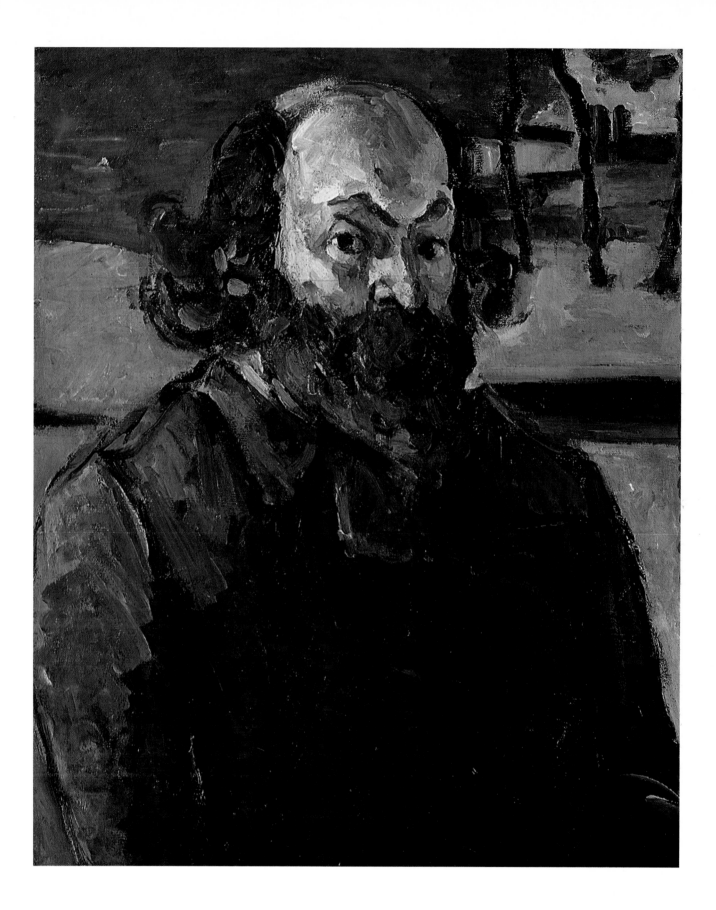

64 Seascape

(Marine)

*c.*1864
Pencil, watercolour and gouache on brownish paper:
17 × 22.5 cm 6$\frac{11}{16}$ × 8$\frac{7}{8}$ in
RWC.4
Private Collection

Authenticated by the artist's son and thought to have
been executed *c.*1864. Perhaps from the large sketch-book
with brownish paper, 18 × 24 cm, in which many of the
finest early drawings were made.

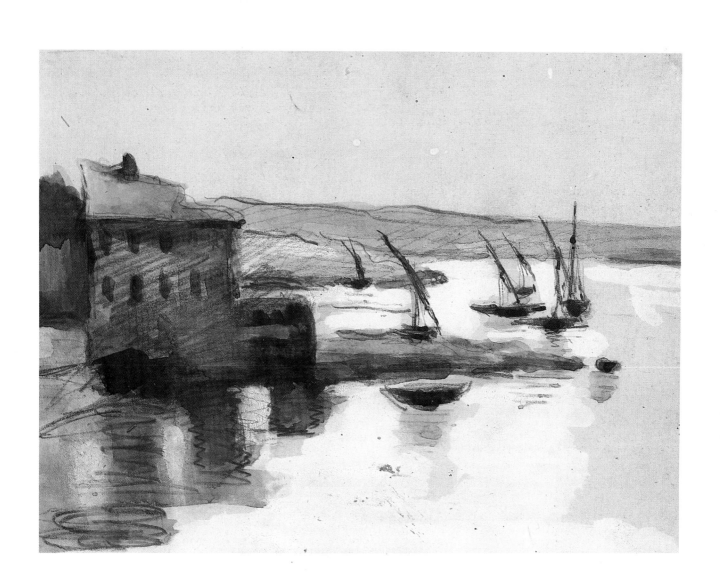

65 The Orgy or The Banquet

(L'Orgie ou Le Banquet)

*c.*1867
Pencil, black and coloured chalk, watercolour and gouache
on thin cardboard: 32.4 × 23.1 cm 12$\frac{3}{4}$ × 9 in
RWC.23
Private Collection, Stuttgart

Preparatory study for the painting, cat. 39.

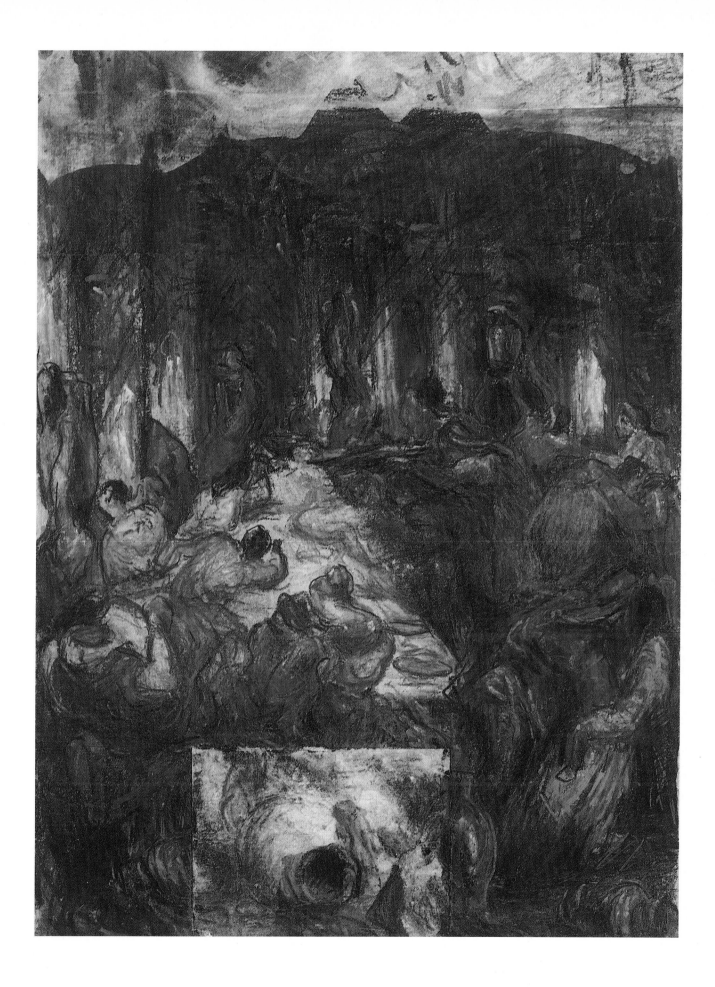

66 Woman diving into Water

(Femme piquant une tête dans l'eau)

*c.*1867–70
Pencil, watercolour and gouache on paper:
12.7 × 12.1 cm 5 × 4¾ in
RWC.29
National Museum of Wales, Cardiff

So entitled by Félix Fénéon. This glimpse of Cézanne's favourite pastime may well represent a youth. Like most of the early water-based studies, this is chiefly in body-colour.

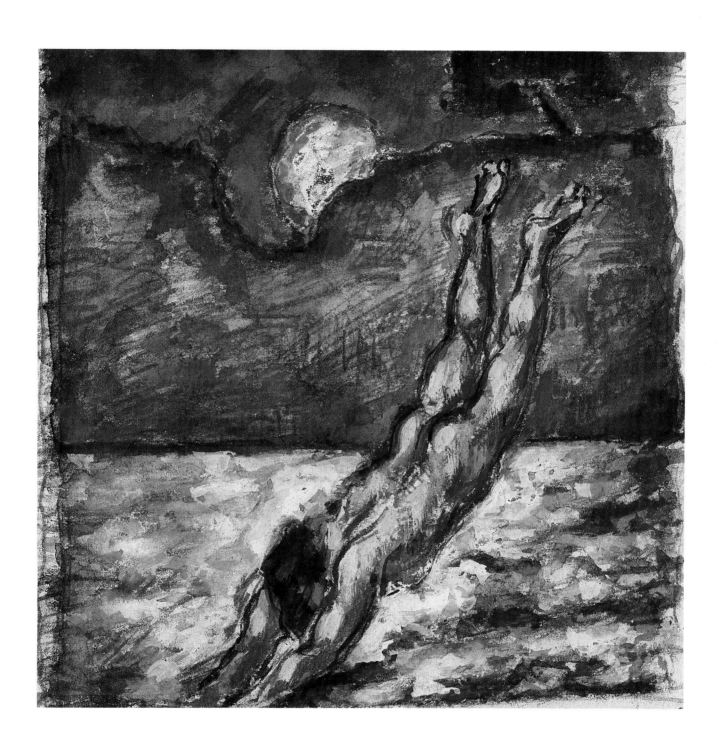

67 The Rum Punch

(Le Punch au Rhum)

*c.*1867
Pencil, pen, watercolour and gouache on thin cardboard:
11 × 14.8 cm $4\frac{3}{8} \times 5\frac{13}{16}$ in
RWC. 34
Private Collection, Stuttgart

Perhaps a study for the rejected submission to the Salon
of 1867 (cat. 27).

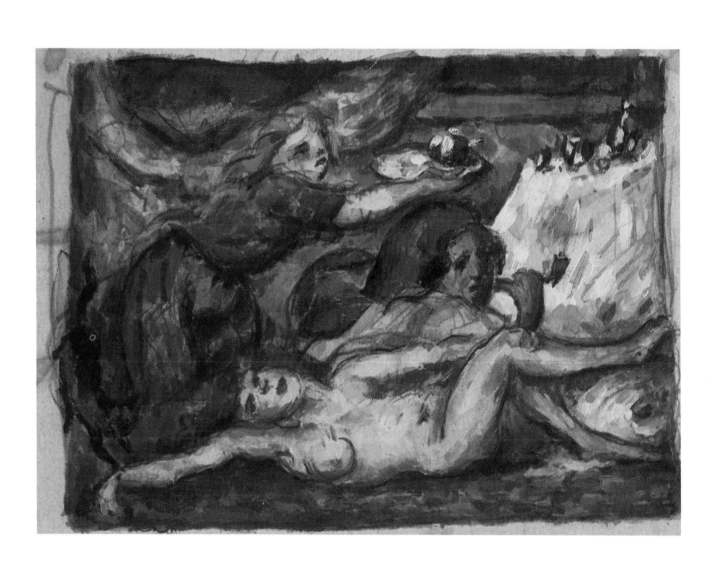

68 Male Nude

LW

1862
Pencil: 61 × 47 cm 24 × 18½ in
Signed and dated on *verso*: 1862
Ch. 76
Musée Granet, Aix-en-Provence

The drawings at the Ecole des Beaux-Arts at Aix
were more refined than those done at the Académie
Suisse (cat. 72, 75).

69 Man lying on the Ground

W

c.1862–5
Black chalk: 22.7 × 29.9 cm 8 5/16 × 11 3/4 in
Ch. 81
Museum Boymans-van Beuningen, Rotterdam

One of the freest of the Paris life drawings, evidently
used in later paintings.

70 Venus, after Raphael

*c.*1866-9
Pencil: 24 × 17 cm 6$\frac{7}{16}$ × 6$\frac{11}{16}$ in
Ch. 85
Private Collection, Zurich

An unexpectedly sympathetic drawing from a master whom Cézanne never lost an opportunity to compare unfavourably with Michelangelo.

71 Study of Nudes diving

*c.*1863-6
Pencil on yellowish paper: 18 × 27 cm 7$\frac{1}{16}$ × 10$\frac{5}{8}$ in
Ch. 96
Los Angeles County Museum of Art,
 Mr and Mrs W.P. Harrison Collection

A model or models posed lying on the ground to study the appearance of bathers diving.

72 Male Nude

*c.*1863–6
Charcoal heightened with white: 49 × 31 cm 19¼ × 12 1/16 in
Ch. 99
The Syndics of the Fitzwilliam Museum, Cambridge

Unusually soft and tonal. A model drawn by Cézanne, no doubt at the Académie Suisse, on several occasions.

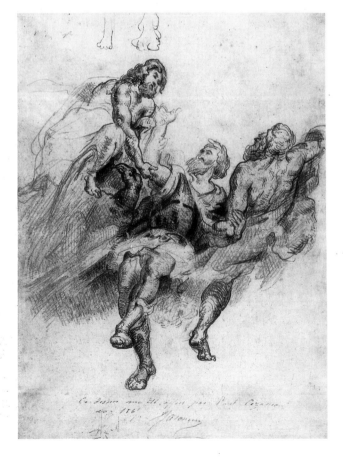

73 The Apotheosis of Henri IV, after Rubens

*c.*1864–5
Pencil: 40.5 × 30 cm 15 15/16 × 11 13/16 in
Ch. 102
Private Collection

Inscribed by Jacomin as 'given to me by Paul Cézanne in 1865'. The most highly finished of all his drawings but stopping short of the figure of Bellona which came to have most meaning to him in the picture.

74 Male Nude, back View

*c.*1863–6
Pencil: 23 × 17 cm 9¹⁄₁₆ × 6¹¹⁄₁₆ in
Ch. 103
The Picker Art Gallery, Colgate University.
Gift of Mr Joseph Katz.

An early example of Cézanne's continuing preoccupation with poses in which an arm, or both, is clasped to the head.

74 Sheet of Studies for *The Feast (The Orgy)*

Pencil and black chalk:
17 × 23 cm 6¹¹⁄₁₆ × 9¹⁄₁₆ in
non-Ch.
The Picker Art Gallery, Colgate University.
Gift of Mr Joseph Katz.

It has been pointed out by Mary Lewis ('A Life Drawing and an unpublished sheet of Sketches by Cézanne in the Picker Art Gallery', *The Picker Art Gallery Annual Report Bulletin*, 1985–6, pp. 18–27, ill. fig. 12) that this sheet contains studies for the figure group in the lower left foreground of Cézanne's painting *The Feast* (cat. 39).

PW

75 Male Nude

*c.*1865
Charcoal on light brown paper:
31 × 47.5 cm 12¹⁄₁₆ × 18¹¹⁄₁₆ in
Ch. 110
Art Institute of Chicago

A life drawing of a pose that was studied for the purposes of *La Toilette funéraire* (cat. 35). It is notable that the legs and feet were redrawn later (Ch. 171) to provide the extended, frontal view which unifies the painting.

76 Painter holding a Palette

*c.*1868–71
Pencil: 10.3 × 17 cm $4\frac{1}{16}$ × $6\frac{11}{16}$ in
Ch. 128
Kunstmuseum, Basel

Perhaps a copy of an illustration of Balzac's Frenhofer touching up a painting of St Mary of Egypt by Pourbus, an episode in '*Le Chef-d'œuvre inconnu*'.

77 The Painter

*c.*1868–71
Pencil: 17.1 × 10.3 cm $6\frac{3}{4}$ × $4\frac{1}{16}$ in
Ch. 129
Kunstmuseum, Basel

Perhaps also suggested by the story of Frenhofer (see cat. 76), but akin in viewpoint to Daumier, who caricatured the prevalence of Venus as a subject for painters in the Salon.

78 Male Nude

*c.*1864–7
Charcoal: 20 × 25.7 cm 7⅞ × 10 in
Ch. 208
Jim and Mary Lewis

A life model in a somnolent or emotional pose, studied with the utmost exploratory fluency.

L

79 Head of Achille Emperaire

*c.*1867–70
Charcoal: 43.2 × 21.9 cm 17 × 12⁹⁄₁₆ in
Ch. 229
Kunstmuseum, Basel

Emperaire was eighteen years older than Cézanne and a cripple. Perhaps a presentation drawing, this was a step towards the full-length portrait (cat. 46).

80 Portrait of Achille Emperaire

*c.*1867–70
Charcoal: 49 × 31 cm 19¼ × 12 1/16 in
Ch. 230
Cabinet des Dessins, Musée du Louvre, Paris

Cézanne's most spectacular drawing and successful essay in Baroque portraiture. Almost opposite in approach to the foregoing classic drawing (cat. 78), the two are complementary and both contribute to the result (see cat. 46).

81 Head of a Man

*c.*1867–70
Charcoal: 30 × 23.5 cm 11 13/16 × 9¼ in
Ch. 231
Private Collection, Paris

W

82 Portrait of the Painter Guillaumin

*c.*1869–72
Pencil and black chalk:
23.6 × 17.2 cm 9⁵⁄₁₆ × 6¾ in
Ch. 233
Museum Boymans-van Beuningen, Rotterdam

A generous supporter who lent Cézanne his studio to
paint in on more than one occasion (see cat. 62, 63).

83 Study for *Pastoral* or *Idyll*

*c.*1870
Pencil: 10.2 × 13.4 cm 4 × 5¼ in
Ch. 250
The Henry and Rose Pearlman Foundation

The drawing is unusually close to the picture of the same
title (cat. 52) and may have been intended to rehearse
possible variations in the background.

84 Study for *L'Eternel féminin*

*c.*1870–75
Pencil and black crayon:
17.7 × 23.6 cm 6$\frac{5}{16}$ × 9$\frac{15}{16}$ in
Ch. 258
Kunstmuseum, Basel

Typical of the kind of generative tangle in which Cézanne's early figure compositions originated. This one resulted in *L'Eternel féminin* which Cézanne painted several times in the seventies.

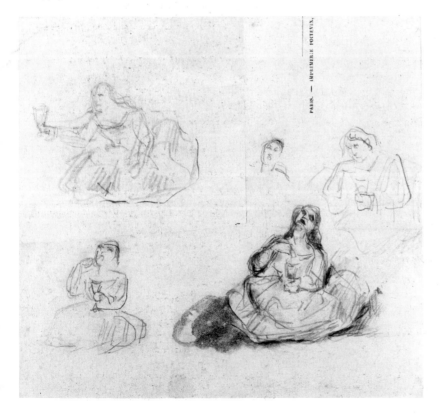

85 Studies of a Mourning Woman

*c.*1872–3
Pencil and watercolour:
16.2 × 17.2 cm 6$\frac{1}{8}$ × 6$\frac{1}{4}$ in
non-Ch.
Private Collection, New York

Death and mourning haunt the early sketch-books. This must be a study for a figure at the foot of the cross.

Chronology

□ painting included in exhibition
● cultural events
○ political events

1839 Louis-Auguste Cézanne, dealer and exporter of felt hats
establishes himself in Aix
19 January, birth of Paul Cézanne, 28 rue de l'Opéra, Aix-en-
Provence
22 February, baptism in the Church of Sainte Madeleine

1840 ● Birth of Sisley
● Birth of Monet, Zola

1841 4 July, birth of Marie Cézanne, 55 Cours Mirabeau, Aix
● Birth of Renoir, Bazille, Morisot

1844 29 January, marriage of Louis-Auguste Cézanne and
Anne-Elizabeth Aubert, mother of his children, in Aix

c.1844–9 Paul Cézanne at Primary School, rue des Epinaux, Aix

1848 1 June, establishment of the bank, Cézanne et Cabassol, in Aix
Louis-Auguste runs unsuccessfully for the municipal council
under the short-lived Second Republic
● Birth of Gauguin
○ February Revolution
○ July Revolution, Establishment of 2nd Republic

1849 Bequest by Granet of his paintings and drawings, enters the Aix
Museum; subsequently becomes accessible to Cézanne (date
unknown)

c.1849–52 Cézanne at the Ecole Saint-Joseph, Aix

1851 ○ December, Napoleon Bonaparte's coup d'état

1852 ○ January, Establishment of 2nd Empire

c.1852–8 Cézanne at the Collège Bourbon; friendship with Emile Zola and
Baptistin Baille

1854 30 June, birth of Rose Cézanne, 14 rue Matheron, Aix

1854–6 ○ Crimean War
1855 ● ○ Exposition Universelle, Paris; Courbet's 'Pavillon du
Réalisme'

1857 Cézanne's first inscription at the Free Municipal School for
Drawing, Aix
● Flaubert prosecuted for breach of morality with *Madame Bovary*
● Baudelaire fined for breach of morals with *Les Fleurs du Mal*

1858 February, Zola leaves Aix for Paris, but returns for his summer
vacation
Cézanne fails at the baccalaureat; 12 November, passes
November 1858–August 1859, Cézanne works at the Free
Municipal School of Drawing, Aix

1859 Cézanne studies law at University of Aix
Louis-Auguste Cézanne acquires Jas de Bouffan
Zola again spends vacations in Aix
November–August 1860, Cézanne once more works at Free
Municipal School of Drawing, obtains second prize for a painted
figure subject
Cézanne dreams of becoming a painter
At about this time, called up for military service, but his father
buys him a substitute

1860 Cézanne continues his law studies with increasing reluctance
Louis-Auguste initially agrees to his departure to Paris, then
refuses again
From November–Spring 1861, Cézanne again works at the Free
Municipal School of Drawing
□ *Begins work on decorative panels at Jas de Bouffan (cat.1)*

1861 Cézanne abandons his law studies
From April–Autumn, first sojourn in Paris, rue Coquillère, later
rue des Feuillantines
Visits the Salon
Meets Pissarro at the Académie Suisse
September, returns discouraged to Aix, enters his father's bank
November–August 1862, works once more at the Free Municipal
School of Drawing

□ *cat.2, 3*
● *Tannhäuser* mounted at Opéra, Paris
● Baudelaire article in defence of Wagner

1862 Leaves his father's bank
Takes up painting again
Friendship with Numa Coste
November, returns to Paris
Apparently fails examinations for the Ecole des Beaux-Arts
□ *cat.4*

1863 Probably in Paris for the entire year
January, father pays a short visit to his son in Paris
Exhibits at the Salon des Refusés; visits the exhibition with Zola
Works at the Académie Suisse, where he meets Guillaumin,
Guillemet and Oller
20 November, requests a student permit to copy in the Louvre, as
a pupil of Chesneau; his address, 7 rue des Feuillantines
□ *c.1863, cat.5*
● Salon des Refusés; includes works by Manet, Pissarro,
Jongkind, Guillaumin, Whistler, Fantin and Cézanne
● Death of Delacroix

1864 Rejected at the Salon
Returns to Aix in the summer
August, in L'Estaque, a fishing village near Marseilles

1865 Spends most of the year in Paris, 22 rue Beautreillis
Oller, 'pupil of Cezanne', lives at the same address
Rejected at the Salon
Works at the Académie Suisse
Summer, returns to Aix; friendship with Valabrègue, Marion and
the German musician, Morstatt
□ *cat.7*
□ *c.1865, cat.6, 8–11*
● Manet exhibits *Olympia* at Salon

1866 January, Guillemet spends month at Aix
February, Cézanne returns to Paris, again living at rue Beautreillis
Cézanne is complimented on his still lifes by Manet
Rejected at the Salon despite the intervention of Daubigny; writes
a letter of protest to the Director of Fine Arts
July, with Zola, Valabrègue, Baille, etc. at Bennecourt on the
River Seine: Cézanne begins to show an interest in working
out-of-doors
Plans huge painting
August–December, in Aix: late Autumn, embarks upon
extensive series of palette knife paintings
Guillaumin considers Cézanne superior to Manet
October and November, Guillemet in Aix; persuades
Louis-Auguste to increase Cézanne's allowance
November, Cézanne attempts to paint a large *Soirée de Famille*,
which he abandons (see cat.44)
□ *cat.16–22*
□ *c.1866; cat.12–15, 23–26*
● April–May, Zola publishes Salon criticism in *L'Evénement*
● Goncourt Brothers publish *Manette Saloman*

1867 January–June, in Paris, rue Beautreillis
Rejected at the Salon; Zola defends Cézanne in the Press
A painting exhibited at Marseilles is withdrawn for fear of it being
torn by an angry public
Autumn, returns to Paris
1867–8, becomes acquainted with fellow Provençal, Adolphe
Monticelli, at the Café Guérbois in Paris
□ *cat.31*
□ *c.1867; cat.27–30, 32–34*
● Exposition Universelle, Paris
● Death of Ingres, Baudelaire, Théodore Rousseau
● Zola publishes *Thérèse Raquin*
○ Opening of the Suez Canal
○ Execution of Emperor Maximilian of Mexico

1868 Rejected at the Salon
13 February, obtains renewed permission (as pupil of Chesneau)
to copy in the Louvre, address still 22 rue Beautreillis
May–December, in Aix, works at Jas de Bouffan

Friendship with Paul Alexis
Often paints with Marion
Excursion to Saint-Antoine at the foot of Mont Sainte-Victoire
☐ c.1868; cat.35, 36
● Zola publishes *Madeleine Férat*; 'Mon Salon', *L'Événement illustré*, May–June

1869 Spends most, if not all, the year in Paris
Rejected at the Salon
About this time, meets Hortense Fiquet (b.1850)
Cézanne reads Stendhal's *Histoire de la peinture en Italie*
☐ c.1869–70; cat.39–47, 51
● Manet and the 'Impressionists' gather at the Café Guérbois, Batignolles
● Zola begins work on the *Rougon-Macquart* series

1870 Spring, caricature by Stock of Cézanne's appears
31 May, Cézanne is a witness at Zola's wedding in Paris
Lives at 53 Notre-Dame-des-Champs
Cézanne avoids the draft to fight in the Franco-Prussian War; he works in Aix, later at L'Estaque, where he lives with Hortense Fiquet; joined briefly by Zola
Cézanne's father retires from the bank; is nominated member of the Municipal Council of Aix
18 November, Cézanne elected member of the commission for the Free Municipal School of Drawing but does not participate (commission dissolved 19 April 1871)
☐ c.1870, cat.48–50, 52–54
○ Franco–Prussian War; Napoleon III abdicates
○ 4 September, Proclamation of 3rd Republic with provisional government

1871 March, Cézanne leaves L'Estaque, apparently returning to Aix
Autumn, back in Paris, impatiently awaited by Zola; lives at 5 rue de Chevreuse, then in December, moves to 45 rue de Jussieu, opposite the Halle aux Vins, where Emperaire stays with him for a short time.
☐ c.1871; cat.55–61
● 1st volume of Zola's 20-vol. cycle, *Les Rougon-Macquart*
○ 28 January, Armistice signed
○ Paris Commune
○ Peace of Frankfurt

1872 4 January, birth of his son, Paul
Apparently rejected by the Salon; April, joins Monet, Pissarro, Renoir, Jongkind and 45 others to request a special hall for the Refusés
Moves to Pontoise with Hortense and Paul; lives at Hôtel du Grand Cerf, Saint-Ouen, across the river from Pontoise, works at Pissarro's side and sees Guillaumin frequently
Spring, Dr Gachet buys house at Auvers-sur-Oise
Late 1872, Cézanne and family leave Pontoise and settle in Auvers-sur-Oise, where they remain throughout the next year
☐ c.1872; cat.62, 63
○ War Reparations: business boom

1873 Friendship with Dr Gachet
Duret interested in his work
○ Economic Depression (until c.1879)

1874 Cézanne participates in first Impressionist exhibition
June, returns to Aix
Autumn, back in Paris
● 1st Impressionist Group exhibition

1875 In Aix part of the year
Meets Victor Choquet through Renoir
? has a watercolour rejected by the Salon
○ Confirmation of France as a republic

1876 Introduces Monet to Choquet
Rejected at the Salon
Exhibits in second Impressionist exhibition
End August, leaves Aix for Paris; works with Guillaumin at Issy-les-Martineaux
● 2nd Impressionist Group exhibition
○ Exposition Universelle, Paris

1877 Probably in Paris most of the year
Exhibits with the third Impressionist exhibition
Works with Pissarro in Pontoise
● 3rd Impressionist Group exhibition

1878 Works in Aix at L'Estaque throughout the year
Rejected at the Salon
Zola buys a house at Médan
● Duret publishes *Les Impressionistes*
○ Exposition Universelle, Paris

1879 Works in L'Estaque
Rejected at the Salon despite intervention of Guillemet, now a jury member
March, returns to Paris; April–December in Meleun with visit to Zola at Médan in autumn
● 4th Impressionist Group exhibition

1880 January–March in Meleun
March–December in Paris
Probably rejected by the Salon
Cézanne with Zola at Médan and meets J.-K. Huysmans
● 5th Impressionist Group exhibition
● Death of Flaubert, Duranty
● Zola publishes 'Le Naturalisme au Salon', *Le Voltaire*, June

1881 Rose Cézanne marries Aix lawyer, Maxime Conil
Cézanne in Paris until April
Probably rejected by the Salon
May–October in Pontoise with Pissarro; meets Gauguin
Cézanne caricatured in short story by Duranty (published posthumously)
● Creation of Societé des Artistes français (Salon des Champs-Elysées)
● 6th Impressionist Group exhibition
○ Freedom of assembly, and of the press

1882 Works at L'Estaque with Renoir
March–October in Paris
Admitted to the Salon as 'pupil' of Guillemet; exhibits a portrait of a man (? a Self-Portrait)
Spends 5 weeks in autumn at Médan with Zola
October, returns to Aix to work at Jas de Bouffan
● 7th Impressionist Group exhibition
● Manet exhibition *Bar aux Folies Bergères* at Salon
○ State primary education

1883 Works mostly in and around Aix
Probably rejected by the Salon
Apparently attended Manet's funeral, 4 May, in Paris
December, meets Monet and Renoir in the south
Gauguin buys two paintings by Cézanne from 'Père' Tanguy
● Death of Manet, Wagner

1884 Works mostly in and around Aix
Rejected by the Salon
Signac buys a landscape by Cézanne at 'Père' Tanguy
● 1st Les XX in Brussels (held annually until 1893)
● 1st Salon des Indépendants
● Huysman publishes *A Rebords*

1885 Most of the year in Aix except for June and July in the south; probably sees Monet at Giverny
Probably rejected by the Salon
● *La Revue Wagnérienne*

1886 Cézanne deeply hurt by *L'Oeuvre* and breaks with Zola
28 April, marries Hortense Fiquet in Aix in presence of his parents; 29 April, religious ceremony at Saint-Jean-Baptist, Aix
23 October, Louis-Auguste dies, leaving a sizeable fortune to his widow and three children
● 2nd Salon des Indépendants
● 8th and final Impressionist Group exhibition
● Zola publishes *L'Oeuvre*
● Moreas publishes symbolist manifesto
● Death of Monticelli

1886–9 ○ Boulangist Movement

1888 Huysmans publishes short article on Cézanne in *La Cravache*; from now on Cézanne's name begins to appear in symbolist periodicals; Aurier and Fénéon mention him

1889 Choquet manoeuvres *La Maison du pendu* into the Exposition Universelle in Paris
Invited to exhibit with Les XX in Brussels
○ Exposition Universelle, Paris; opening of Eiffel Tower

1890 January, exhibits 3 pictures in Les XX
Spring and Summer in Switzerland
Begins to suffer from diabetes
Autumn in Aix, probably working on his *Card Players* series

1891 Considers exhibiting with Les Indépendants
Wife and son settle in Aix
Becomes a devout Catholic
● Death of Victor Choquet

1892 Buys a house in Marlotte, near Forêt de Fontainebleau
21 February, lecture on Cézanne given by George Lecomte in Brussels, published in *L'Art Moderne*
Emile Bernard publishes article on Cézanne

1893 In Aix and Paris
● Death of Caillebotte, bequest of his collection to Musée du Luxembourg
● Death of 'Père' Tanguy

1894 In Aix and Paris
March, auction sale of Duret's collection; contains three Cézannes
Cézanne meets Clemenceau, Rodin, Gustave Geffroy, Mary Cassatt at Monet's 54th birthday
Ambroise Vollard buys works by Cézanne at auction of 'Père' Tanguy's stock
● 1st Libre Esthétique exhibition, Brussels
● Ambroise Vollard opens gallery, rue Lafitte

1894– ○ Dreyfus Affair (1898 Zola's *J'accuse*)
1902

1895 January–June in Paris.
Autumn in Aix with excursions to Bibémus quarry and Mont Sainte Victoire
November, begins to pay rent for the *Cabanon* at Bibémus quarry
November, first one-man show opens at Vollard's gallery, Paris; Cézanne sends him *c.*150 works
Two of five works by Cézanne enter Musée du Luxembourg via the Caillebotte bequest

1896 In Aix until June; works at Bibémus quarry
April, meets poet Joachim Gasquet
Zola publishes an article calling Cézanne an 'abortive genius'

1897 Vollard buys entire contents of Cézanne's studio near Corbeil after he had left at the end of May
June–end of the year, in Aix; works at Le Tholonet and at Bibémus quarry
25 October, death of Cézanne's mother
Two works by Cézanne hung in the Berlin National Gallery but banned by the Kaiser

1898 Aix, where works at Château Noir; summer in Paris and at Pontoise, Marlotte, etc.
● Death of Achille Emperaire

1899 Spends most of the year in and around Paris
Meets Egisto Fabbri, who owns 16 works by Cézanne
Jas de Bouffan sold; Cézanne tries unsuccessfully to buy the domain of Château Noir
Exhibits 3 paintings at Les Indépendants
Sales of the Choquet and Doria Collections bring good prices for Cézanne's work
Durand-Ruel buys many Cézannes from the Choquet sale
Vollard holds a one-man exhibition; writes to Gauguin in Tahiti to tell him that he has bought the entire contents of Cézanne's studio

1900 Spends the year in Aix
3 paintings hung in the Exposition centennale (through the influence of Roger Marx)
12 paintings sent by Durand-Ruel to Cassirer in Berlin; Cassirer holds first exhibition of Cézanne in Germany; *all* 12 paintings returned unsold to Paris in 1901

1901 Spends the year in Aix; 18 November buys land on the Chemin des Lauves, dominating Aix, to build a new studio
Exhibits at Les Indépendants and at La Libre Esthétique in Brussels
● Maurice Denis exhibits *Hommage à Cézanne* at the Salon

1902 January, Vollard visits Cézanne in Aix
Gaston Bernheim-Jeune visits Cézanne and buys works from his son
Exhibits 3 works at Les Indépendants
Makes his final will and testament (son exclusive heir after his widow has obtained her legal share)
● Death of Zola

1902–5 Combes reforms: Monasteries, church orders and schools dissolved

1903 Spends year in Aix
7 March, Zola's collection sale; Cézanne violently attacked in the Press
7 works exhibited at the Secession in Vienna and 3 in Berlin
● 12 November, Death of Pissarro in Paris

1904 Spends most of the year in Aix; he is visited there by Emile Bernard, with whom he corresponds after his departure
Bernard prepares new article on Cézanne
9 works exhibited at La Libre Esthétique in Brussels, and others at the Salon d'Automne, Paris
Cassirer organises second one-man show in Berlin
October–November, Impressionist exhibition at the Galerie Emil Richter in Dresden including works by Cézanne
Camoin, Bernheim-Jeune visit Cézanne in Aix

1905 Spends almost entire year in Aix
Spring/summer, watercolour exhibition at Vollard's
January, Cézanne visited by R. P. Rivière and Jacques Schnarb
10 works exhibited at the Salon d'Automne
Durand-Ruel includes 10 works by Cézanne in a big Impressionist exhibition in London at the Grafton Galleries

1906 In Aix
January, Maurice Denis and K.-X. Roussel visit Cézanne
March, Vollard exhibits 12 works
April, Cézanne visited by Karl Ernst Osthaus
Shows 10 works at the Salon d'Automne
23 October, dies at 23 rue Boulegon, Aix

Concordance of Works in the Exhibition

43	118	La Lecture de Paul Alexis chez Zola	Paul Alexis reading at Zola's House	*c.*1867–9
44	90	Jeune fille au piano – L'Ouverture du Tannhäuser	Young Girl at the Piano – Overture to Tannhäuser	*c.*1869–70
45	68	Nature morte: crâne et bouilloire	Still life: Skull and Waterjug	*c.*1868–70
46	88	Portrait du peintre Achille Emperaire	Portrait of the Painter, Achille Emperaire	*c.*1868–70
47	117	Paul Alexis lisant à Emile Zola	Paul Alexis reading to Emile Zola	*c.*1869–70
48	58	Usines près du Mont de Cengle	Factories near Mont de Cengle	*c.*1869–70
49	69	La Pendule noire	The Black Clock	*c.*1870
50	103	La Tentation de St Antoine	The Temptation of St Anthony	*c.*1870
51	107	Le Déjeuner sur l'herbe	Le Déjeuner sur l'herbe	*c.*1870–1
52	104	Pastorale (Idylle)	Pastoral (Idyll)	*c.*1870
53	70	Nature morte: pot vert et bouilloire d'etain	Still life: Green Pot and Pewter Jug	*c.*1870
54	71	Nature morte: pots, bouteille, tasse et fruits	Still life: Pots, Bottle, Cup and Fruit	*c.*1871
55	119	La Promenade	The Walk	*c.*1871
56	127	Portrait d'Antony Valabrègue	Portrait of Antony Valabrègue	*c.*1871
57	131	L'Homme au chapeau de paille – Gustave Boyer	The Man with a straw Hat – Gustave Boyer	*c.*1871
58	48	Paysage avec moulin à l'eau	Landscape with a Watermill	*c.*1871
59	136	Le Moulin à l'huile	The Oilmill	*c.*1871
60	47	Les Marronniers et le bassin du Jas de Bouffan	The Chestnut Trees and the Pool at the Jas de Bouffan	*c.*1871
61	52	La Route	The Road	*c.*1871
62	56	Paris: Quai de Bercy – la Halle aux vins	Paris: the Quai de Bercy – The Wine Market	*c.*1871

63	288	Portrait de l'artiste	Self-Portrait	*c.*1872

RWC

64	4	Marine	Seascape	*c.*1864
65	23	L'Orgie, ou Le Banquet	The Orgy, or The Banquet	*c.*1867
66	29	Femme piquant une tête dans l'eau	Woman diving into Water	*c.*1867–70
67	34	Le Punch au Rhum	The Rum Punch	*c.*1867

CH.

68	76	Male Nude	1862
69	81	Man lying on the Ground	*c.*1862–5
70	85	Venus, after Raphael	*c.*1866–9
71	96	Study of Nudes diving	*c.*1863–6
72	99	Male Nude	*c.*1863–6
73	102	The Apotheosis of Henri IV, after Rubens	*c.*1864–5
74a *recto*	103	Male Nude, back view	*c.*1863–6
74b *verso*	non-Ch.	Sheet of Studies for *The Feast (The Orgy)*	*c.*1863–6
75	110	Male Nude	*c.*1865
76	128	Painter holding a Palette	*c.*1868–71
77	129	The Painter	*c.*1868–71
78	208	Male Nude	*c.*1864–7
79	229	Head of Achille Emperaire	*c.*1867–70
80	230	Portrait of Achille Emperaire	*c.*1867–70
81	231	Head of a Man	*c.*1867–70
82	233	Portrait of the Painter Guillaumin	*c.*1869–72
83	250	Study for *Pastoral (Idyll)*	*c.*1870
84	258	Study for *L'Eternel féminin*	*c.*1870–75
85	non-Ch.	Studies of a Mourning Woman	*c.*1872–3

List of Exhibitions including Cézanne's Early Work

Months of the exhibitions are given where known.

1895 Paris, Galerie Vollard, *Paul Cézanne*, Nov.–Dec.

1899 Paris, Galerie Vollard, *Paul Cézanne*

1907 Paris, Grand Palais, Salon d'Automne, 5ème exposition, *Rétrospective de Cézanne*

1912 Munich, Moderne Galerie (Heinrich Thannhauser)

1916 New York, Montross Gallery, *Cézanne*

1920 Paris, Bernheim-Jeune, *Cézanne*, Dec.

1921 Berlin, Galerie Paul Cassirer, *Cézanne – Austellung*, Nov.–Dec.

1925 London, Leicester Galleries, *Paintings and Drawings by Paul Cézanne*, June–July

1926 Paris, Galerie Bernheim-Jeune, *Rétrospective Paul Cézanne*, June

1929 Paris, Galerie Pigalle, *Cézanne*, (? Dec.)

1934 Philadelphia, Pennsylvania Museum of Art, *Cézanne*, Nov.–Dec.

1935 London, Reid and Lefevre, *Cézanne*, July
Paris, Renou and Colle, *Aquarelles et Baignades de Cézanne*, June

1936 Basel, Kunsthalle, *Paul Cézanne*, Aug.–Oct.
Paris, Galerie Bignou
Paris, Orangerie, *Cézanne*, May–Oct.

1937 London, Reid and Lefevre, *Cézanne*, June
San Francisco, San Francisco Museum of Art, *Cézanne*, Sept.–Oct.

1939 London, Wildenstein Galleries, *Homage to Cézanne*, July
Lyon, Palais Saint-Pierre, *Centenaire de Paul Cézanne*
Paris, Galerie Paul Rosenberg — London, Rosenberg and Helft, *Cézanne*
Paris, Grand Palais, 50ème Exposition de la Société des Artistes Indépendants, *Centenaire du peintre indépendant Paul Cézanne*, March–April

1947 New York, Wildenstein Galleries, *Cézanne*, March–April

1950 Minneapolis, Minneapolis Institute of Art

1952 Chicago, Art Institute, Feb.–March — New York, Metropolitan Museum of Art, April–May, *Cézanne Paintings, Watercolours and Drawings, Loan Exhibition*

1953 Aix-en-Provence, Musée Granet, July–Aug. — Nice, Musée Massenas, Aug.–Sept. — Grenoble, Musée des Beaux-Arts, Sept.–Oct. *Cézanne, Peintures, Aquarelles, Dessins*

Paris, Orangerie, *Monticelli et le Baroque provençal*

1954 Edinburgh, Royal Scottish Academy Aug–Sept. — London, Tate Gallery, Sept.–Oct. *Cézanne's Paintings*
Paris, Orangerie, *Hommage à Cézanne*, July–Sept.
Providence, RI, Rhode Island School of Design, *Cézanne*, Sept.–Oct.

1955 New York, Wildenstein Galleries

1956 Aix-en-Provence, Pavillon de Vendôme, *Exposition pour commemorer le cinquantenaire de la mort de Cézanne*, July–Aug.

1956–7 The Hague, Gemeentemuseum, June–July — Zurich, Kunsthaus, Aug.–Oct. — Munich Haus des Kunst, Oct. — Cologne, Wallraf-Richartz Museum, Dec.–Jan, *Paul Cézanne*

1959 New York, Wildenstein Galleries

1960 Paris, Galerie Bernheim-Jeune, *Cézanne – Aquarelliste et Peintre*, May–June

1961 Vienna, Belvedere, April–June — Aix-en-Provence, Pavillon de Vendôme, *Cézanne*, July–Aug.

1963 New York, Solomon R. Guggenheim Museum, *Cezanne and Structure in Modern Painting*, June–Aug.

1971 Washington D.C, Phillips Collection, Feb–March — Chicago, Art Institute, April–May — Boston, Museum of Fine Arts, June–July, *An Exhibition in Honor of the Fiftieth Anniversary of the Phillips Collection*

1974 Paris, Orangerie, *Cézanne dans les musées nationaux*, July–Oct.
Tokyo, National Museum of Western Art, March–May — Kyoto, Municipal Museum, June–July — Fukuoka, Cultural Centre, July–Aug., *Paul Cézanne*

1981 New York, Metropolitan Museum of Art
Tübingen, Kunsthalle, *Paul Cézanne, Aquarelle, 1866–1906*, Jan–Mar.

1982 Liège, Musée Saint-Georges, March–May — Aix-en-Provence, Musée Granet, June–Aug., *Cézanne*

1983 Basel, Galerie Beyerler, *Paul Cézanne, Peintures, Aquarelles, Dessins*, June–Sept.

1984 Madrid, Museo Español de Arte Contemporaneo, *Paul Cézanne*

1986 Tokyo, Isetan Museum of Art, Sept.–Oct. — Hyogo, The Prefectural Museum of Modern Art, Oct–Nov. — Nagoya, The Aichi Prefectural Art Gallery, Nov.–Dec., *Cézanne*

Select Bibliography

1892 E. Bernard, 'Paul Cézanne', *Les Hommes d'aujourd' hui*, vol. VIII, no. 387, 1892

1899 G. Lecomte, 'Paul Cézanne', *Catalogue de la vente Eugène Blot*, 9 and 10 May 1899, pp. 81–7.

 G. Lecomte, 'Paul Cézanne', *Revue d'Art*, Dec. 1899, pp. 81–7.

1903 H. Rochefort, 'L'Amour du Laid', *l'Intransigeant*, 9 March 1903.

1906 DURET, 1906: T. Duret, *Histoire des peintres impressionnistes*, Paris, 1906.

1907 M. Denis, '*Cézanne*', *L'Occident*, Sept. 1907.

 T. Duret, 'Paul Cézanne', *Kunst und Künstler*, Dec. 1907, pp. 93–104.

 A. Pératé, 'Le Salon d'Automne', *Gazette des Beaux-Arts*, 1 Nov. 1907, pp. 385–90.

1910 BURGER, 1910: F. Bürger, *Cézanne und Hodler, Einführung in die Probleme der Malerei der Gegenwart* (1st ed.), Munich, 1910.

 MEIER-GRAEFE, 1910: J. Meier-Graefe, *Paul Cézanne*, Munich, 1910.

1913 F. Bürger, *Cézanne und Hodler, Einführung in die Probleme der Malerei der Gegenwart* (2nd ed.), Munich, 1913.

 A. Dreyfus, 'Paul Cézanne', *Zeitschrift für bildende Kunst*, June 1913, pp. 197–206.

1914 Bernheim-Jeune (ed.), *Cézanne* (with contributions by O. Mirbeau, Th. Duret, L. Werth, etc), Paris, 1914.

 VOLLARD, 1914: A. Vollard, *Paul Cézanne*, Paris, 1914.

1917 E. Stuart(?), 'Cézanne and His Place in Impressionism', *Fine Arts Journal*, May 1917.

1918 MEIER-GRAEFE, 1918: J. Meier-Graefe, *Paul Cézanne* (2nd ed.), 1918.

1919 F. Bürger, *Cézanne und Hodler, Einführung in die Probleme der Malerei der Gegenwart* (3rd ed.), Munich, 1919.

 COQUIOT, 1919: G. Coquiot, *Paul Cézanne* (5th ed.), Paris, 1919.

 MEIER-GRAEFE, 1919: J. Meier-Graefe, *Cézanne und sein Kreis*, Munich, 1919.

 A. Popp, 'Cézanne, Elemente seines Stiles, aus lassich einer Kritik erortet', *Die bildenden Kunste*, II, 1919, pp. 177–89.

 VOLLARD, 1919: A. Vollard, *Paul Cézanne* (2nd ed.), Paris, 1919.

1920 E. Faure, 'Toujours Cézanne', *Amour de l'Art*, Dec. 1920, pp. 265–70.

 MEIER-GRAEFE, 1920: J. Meier-Graefe, *Cézanne und sein Kreis* (2nd ed.), Munich, 1920.

1921 BERNARD, 1921: E. Bernard, *Souvenirs sur Paul Cézanne*, Paris, 1921.

 GASQUET, 1921: J. Gasquet, *Cézanne*, Paris, 1921.

 A. Zeisho, *Paul Cézanne*, Tokyo, 1921.

1922 MEIER-GRAEFE, 1922: J. Meier-Graefe, *Cézanne und sein Kreis* (3rd ed.), Munich, 1922.

 H. von Wedderkop, 'Paul Cézanne', *Cicerone*, 16 Aug. 1922.

 H. von Wedderkop, *Paul Cézanne*, Leipzig, 1922.

1923 T. Klingsor, *Cézanne*, Paris, 1923.

 F. Lehel, *Cézanne*, Budapest, 1923.

 MEIER-GRAEFE, 1923: J. Meier-Graefe, *Cézanne* (5th ed.), Munich, 1923.

 RIVIERE, 1923: G. Rivière, *Le Maître Paul Cézanne*, Paris, 1923.

1924 VOLLARD, 1924: A. Vollard, *Paul Cézanne* (3rd ed.), Paris, 1924.

1925 E. Bernard, *Sur Paul Cézanne*, Paris, 1925.

 J. Goulinat, 'Technique picturale: l'Evolution du Métier de Cézanne', *L'Art Vivant*, 1 March 1925, pp. 18, 22–4.

 L. Langrier, *Le Dimanche avec Paul Cézanne*, Paris, 1925.

 G. Rivière, 'La Formation de Paul Cézanne', *L'Art Vivant*, Aug. 1925, pp. 1–4.

1926 I. Arishima, *Cézanne*, Tokyo, 1926.

 E. Bernard, *Souvenirs sur Paul Cézanne, une conversation avec Cézanne*, Paris, 1926.

 J. Borély, 'Cézanne à Aix (1902)', *L'Art Vivant*, 1 July 1926, pp. 491–3.

 E. Faure, *P. Cézanne*, Paris, 1926.

 FRY, Dec. 1926: R. Fry, 'Le Developpement de Cézanne', *Amour de l'Art*, Dec. 1926.

 GASQUET, 1926: J. Gasquet, *Cézanne*, Paris, 1926.

 G. Rivière, 'Les Impressionnistes chez eux', *L'Art Vivant*, 15 Dec. 1926, pp. 925–60.

1927 FRY, 1927: R. Fry, *Cézanne. A Study of his Development*, New York, 1927.

 MEIER-GRAEFE, 1927: J. Meier-Graefe, *Cézanne*, London and New York, 1927.

 PFISTER, 1927: K. Pfister, *Cézanne, Gestalt, Werk, Mythos*, Potsdam, 1927.

1929 A. Bertram, *Cézanne*, London, 1929.

 A. Burroughs, 'David and Cézanne, Presenting the Case of Thought versus Feeling', *The Arts*, Sept. 1929.

 FRY, *Samleren*, 1929: R. Fry, 'Cézannes Udrikling', *Samleren*, 1929.

1930 ORS, 1930: E. Ors, *Paul Cézanne*, Paris, 1930.

1933 RIVIERE, 1933: G. Rivière, *Cézanne, le peintre solitaire*, Paris, 1933.

1935 IAVORSKAIA, 1935: N. Iavorskaia, *Cézanne*, Moscow, 1935.

 MACK, 1935: G. Mack, *Paul Cézanne*, New York, 1935.

 L. Venturi, 'Paul Cézanne', *L'Arte*, July and September 1935, pp. 298–324; 383–415.

1936 M. Boyé, 'Cézanne et Antony Valabrègue', *Beaux-Arts*, 28 Aug. 1936.

 E. Faure, *Cézanne*, Paris, 1936.

 R. Huyghe, *Cézanne*, Paris, 1936.

 R. Huyghe, 'Cézanne et son oeuvre', *Amour de l'Art*, May 1936, pp. 165–88.

 MACK, New York, 1936: G. Mack, *Paul Cézanne* (2nd ed.), New York, 1936.

 E. Ors, 'Crise de Cézanne', *Gazette des Beaux-Arts*, June 1936, pp. 361–72.

 ORS, 1936: E. Ors, *Paul Cézanne*, New York, 1936.

 REWALD, 1936: J. Rewald, *Cézanne et Zola*, Paris, 1936.

 J. Rewald, 'Sources d'inspiration de Cézanne', *Amour de l'Art*, May 1936.

 RAYNAL, 1936: M. Raynal, *Cézanne*, Paris, 1936.

 RIVIERE, 1936: G. Rivière, *Cézanne, le peintre solitaire* (2nd ed.), Paris, 1936.

 VENTURI 1936: L. Venturi, *Cézanne, son art, son oeuvre*, 2 vols, Paris, 1936.

1937 A. Barr and M. Scolari, 'Cézanne après les lettres de Marion à Morstatt', *Gazette des Beaux-Arts*, Jan. 1937, pp. 37–58.

E. Loran, 'San Francisco's first Cézanne Show', *Magazine of Art*, Sept. 1937.

NOVOTNY, 1937: F. Novotny, *Cézanne*, Vienna, 1937.

CEZANNE, CORRESPONDANCE, 1937: J. Rewald, ed., *Cézanne, Correspondance*, Paris, 1937.

J. Rewald, 'A propos du catalogue raisonné de l'oeuvre de Paul Cézanne et de la chronologie de cette oeuvre', *La Renaissance*, March-April, 1937, pp. 53–6.

VOLLARD, 1937: A. Vollard, *Paul Cézanne, His Life and Art*, New York, 1937.

1938 A. Barr and M. Scolari, 'Cézanne in the Letters of Marion to Morstatt, 1865–8', *Magazine of Art*, Feb., April, May 1938.

R. Goldwater, 'Cézanne in America', *Art News*, 26 March 1938, pp. 135–54, 156, 158, 160.

MACK, 1938: G. Mack, *Paul Cézanne*, Paris, 1938.

F. Novotny, *Cézanne und das Ende der Wissenschaftlichen Perspektive*, Vienna, 1938.

DI SAN LAZZARO, 1938: G. di San Lazzaro, *Paul Cézanne*, Paris, 1938.

1939 BARNES AND DE MAZIA, 1939: A. Barnes and V. de Mazia, *The Art of Cézanne*, New York, 1939.

COGNIAT, 1939: R. Cogniat, *Cézanne*, Paris, 1939.

REWALD, 1939: J. Rewald, *Cézanne, sa vie, son oeuvre, son amitié pour Zola*, Paris, 1939.

REWALD, New York, 1939: J. Rewald, *Paul Cézanne, a Biography*, New York, 1939.

J. Rewald, 'Paul Cézanne: New documents for the years 1870–71', *The Burlington Magazine*, April 1939, pp. 163–71.

1941 CEZANNE, CORRESPONDANCE, 1941: J. Rewald, ed., *P. Cézanne, Letters*, London, 1941

1942 H. Graber, *Paul Cézanne nach eigenen und fremden Zeugnissen*, Basel, 1942.

RIVIERE, 1942: G. Rivière, *Cézanne, le peintre solitaire* (2nd ed.), Paris, 1942.

1943 PISSARRO, LETTERS, 1943: J. Rewald, ed., *Camille Pissarro, Letters to his son Lucien*, London, 1943.

1944 E. Jewell, *Paul Cézanne*, New York, 1944.

RIVIERE, 1944: G. Rivière, *Cézanne, le peintre solitaire* (3rd ed.), Paris, 1944.

1946 G. Schildt, *Cézanne*, Stockholm, 1946.

1947 W. Kuhn, 'Cézanne: Delayed Finale', *Art News*, April 1947, pp. 15–16.

1948 DORIVAL, 1948: B. Dorival, *Cézanne*, Paris, 1948.

G. Jedlicka, *Cézanne*, Berne, 1948.

L. Johnson, 'The Formal Sources of Delacroix's "Barque de Dante"', *The Burlington Magazine*, 1948, pp. 228–32.

REWALD, New York, 1948: J. Rewald, *Paul Cézanne*, New York, 1948.

1950 L. Guerry, *Cézanne et l'expression de l'espace*, Paris, 1950.

F. Jourdain, *Cézanne*, Paris and New York, 1950.

1952 R. M. Rilke, *Briefe über Cézanne*, Wiesbaden, 1952.

SCHAPIRO, 1952: M. Schapiro, *Cézanne*, New York, 1952.

1953 T. Rousseau Jnr., *Paul Cézanne 1839–1906*, New York, 1953.

1954 RAYNAL, 1954: M. Raynal, *Cézanne*, Geneva, Paris, New York, 1954.

1955 D. Cooper, 'Au Jas de Bouffan', *Oeil*, 15 Feb. 1955.

1956 BADT, 1956: K. Badt, *Die Kunst Cézannes*, Munich, 1956.

L. Gowing, 'Notes on the Development of Cézanne', *The Burlington Magazine*, June 1956, pp. 185ff.

1958 G. Berthold, *Cézanne und die alten Meister*, Stuttgart, 1958.

I. Elles, *Das Stilleben in der französischen Malerei des 19 Jahrhunderts*, Zurich, 1958.

1960 J. Adhémar, 'Le Cabinet de travail de Zola', *Gazette des Beaux-Arts*, Nov. 1960, p. 288f.

S. Uschida, *Cézanne*, Tokyo, 1960.

1961 F. Novotny, *Cézanne*, London, 1961.

1962 A. Chappuis, *Les Dessins de P. Cézanne au Cabinet des estampes du Musée des Beaux-Arts de Bâle*, Olten and Lausanne, 1962.

REFF, 1962: T. Reff, 'Cézanne, Flaubert, St Anthony and the Queen of Sheba', *The Art Bulletin*, June 1962, pp. 113–25.

R. Walter, 'Cézanne à Bennecourt en 1866', *Gazette des Beaux-Arts*, Feb. 1962, pp. 103–18.

1963 P. H. Feist, *Paul Cézanne*, Leipzig, 1963.

R. Walter, 'Un vrai Cézanne: "La Vue de Bonnières"', *Gazette des Beaux-Arts*, May 1963, pp. 359–66.

1964 T. Reff, 'Cézane's "Dream of Hannibal"', *Art Bulletin*, June 1963, pp. 148–52.

W. Andersen, 'A Cézanne Self-Portrait Drawing Reidentified', *The Burlington Magazine*, June 1964, pp. 284–5.

S. Lichtenstein, 'Cézanne and Delacroix', *The Art Bulletin*, March 1964, pp. 55–67.

1965 BADT, 1965: K. Badt, *The Art of Cézanne*, transl. Sheila Ann Ogilvie, Berkeley and Los Angeles, 1965.

1966 R. van Buren, 'Madame Cézanne's Fashions and the Dates of her Portraits', *Art Quarterly*, 1966, pp. 111–12.

K. Leonhard, *Paul Cézanne in Selbstzeugnissen und Bilddokumenten*, Rheinbek bei Hamburg, 1966.

T. Reff, 'Cézanne and Hercules', *The Art Bulletin*, March 1966, pp. 35–44.

1968 R. J. Neiss, *Zola, Cézanne and Manet*, Ann Arbor, 1968.

C. Ramus, *Cézannes Formes*, Lausanne, 1968.

M. Schapiro, 'The Apples of Cézanne: An Essay on the Meaning of Still-Life', *The Avant-Garde Art News Annual*, XXXIV, 1968, pp. 35–53; reprinted in *Modern Art*, New York, 1978, pp. 1–38.

1969 IKEGAMI, Tokyo, 1969: C. Ikegami, *Cézanne*, Tokyo, 1969.

1970 W. Andersen, *Cézanne's Portrait Drawings*, Cambridge, Mass. and London, 1970.

C. Ikegami, 'Le Dessin de Paul Cézanne', *Bijutsushi* (Journal of the Japan Art History Society), no. 76, 1970.

1971 A. d'Harnoncourt, 'The Necessary Cézanne', *The Art Gallery*, April 1971.

M. Hours, 'Cézanne's Portrait of His Father', *Studies in the History of Art*, National Gallery of Art, Washington D.C., 1971, pp. 63–88.

J. Rewald, 'Cézanne and His Father', *Studies in the History of Art*, National Gallery of Art, Washington D.C., 1971–2, reprinted in J. Rewald, *Studies in Impresssionism*, London, 1985, pp. 69–101.

1973 CH./CHAPPUIS, 1973: A. Chappuis, *The Drawings of Paul Cézanne: A Catalogué Raisonné*, 2 vols., Greenwich, Conn. and London, 1973.

SCHAPIRO, 1973: M. Schapiro, *Paul Cézanne*, Paris, 1973.

1974 D. Sutton, 'The Paradoxes of Cézanne', *Apollo*, August 1974, pp. 98–107.

1975 A. Barskaya, *Cézanne*, Leningrad, 1975.

ELGAR, 1975: F. Elgar, *Cézanne*, New York, 1975.

S. Lichtenstein, 'Cézanne's copies and variants after Delacroix', *Apollo*, Feb. 1975, pp. 116–27.

WADLEY, 1975: N. Wadley, *Cézanne and his Art*, London, 1975.

1976 CEZANNE, CORRESPONDANCE, 1976: J. Rewald, ed., *Paul Cézanne, Correspondance*, Oxford, 1976.

1978 S. Geist, 'What makes "The Black Clock" Run', *Art International*, Feb. 1978, pp. 8–14.

D. Gordon, 'The Expressionist Cézanne', *Art Forum*, March 1978.

MONNERET, 1978–80: S. Monneret, *Cézanne, Zola . . . La Fraternité du génie*, Paris, 1978.

CEZANNE, CORRESPONDANCE, 1978: J. Rewald, ed., *Paul Cézanne, Correspondance* (Rev. ed.), Paris, 1978.

R. Schiff, 'Seeing Cézanne', *Critical Inquiry*, Summer 1978, pp. 769–808.

VENTURI, 1978: L. Venturi, *Cézanne*, Geneva, 1978.

1979 CEZANNE, CORRESPONDANCE, 1979: J. Rewald, ed., *Paul Cézanne – Briefe*, Zurich, 1979.

T. Reff, 'The Pictures within Cézanne's Pictures', *Arts Magazine*, June 1979, pp. 90–104.

1980 ADRIANI, 1980: G. Adriani, *Paul Cézanne. Der Liebeskampt*, Munich, 1980.

S. Geist, 'Cézanne: Metamorphosis of the Self', *Artscribe*, Dec. 1980, pp. 10–17.

N. Ponente, *Paul Cézanne*, Bologna, 1980.

1981 ADRIANI, 1981: G. Adriani, *Paul Cézanne, Aquarelle*, Cologne, 1981.

G. Ballas, 'Paul Cézanne et la Revue "L'Artiste"', *Gazette des Beaux-Arts*, Dec. 1981, pp. 223–32.

1982 J. Arrouye, *Le Provence de Cézanne*, Aix-en-Provence, 1982.

V. Bettendorf, 'Cézanne's Early Realism: "Still life with Bread and Eggs" re-examined', *Arts Magazine*, 19 Jan. 1982, pp. 138–41.

1983 T. Reff, 'Cézanne: The Severed Head and the Skull', *Arts*, Dec. 1983, pp. 84–100.

RWC./REWALD, 1983: J. Rewald, *Paul Cézanne: The Watercolours*, Boston and London, 1983.

1984 D. Coutagne, *Cézanne au Musée d'Aix*, Aix-en-Provence, 1984.

S. Gache-Patin, 'Douze oeuvres de Cézanne de l'ancienne collection Pellerin', *La Revue du Louvre et des Musées de France*, 2, 1984, pp. 128–46.

C. Kiefer, 'Cézanne's "Magdalen": A New Source in the Musée Granet, Aix-en-Provence', *Gazette des Beaux-Arts*, Feb. 1984, pp. 91–4.

CEZANNE, CORRESPONDANCE, 1984: J. Rewald, ed., *Cézanne, Correspondance*, New York, 1984.

R. Schiff, *Cézanne and the End of Impressionism*, Chicago, 1984.

1986 REWALD, 1986: J. Rewald, *Cézanne, a biography*, New York, 1986.

J. Rewald, 'Paintings by Paul Cézanne in the Mellon Collection', in *Essays in Honor of Paul Mellon, Collector and Benefactor*, Washington D.C., 1986.

1987 R. Kirsch, 'Paul Cézanne: "Jeune fille au piano" and some Portraits of his wife: An Investigation of his Painting', *Gazette des Beaux-Arts*, July-Aug., 1987, pp. 21–6.

M. Lewis, 'Cézanne's "Harrowing of Hell and the Magdalen"', *Gazette des Beaux-Arts*, April 1987, pp. 175–8.

Supplementary Bibliography (Literature)

H. de Balzac, *Oeuvres complètes* (1845), facsimile ed., Paris, 1967.

C. Baudelaire, *Oeuvres complètes*, C. Pichon, ed. (rev. ed.), Paris, 1960.

C. Flaubert, 'La Tentation de Saint Antoine' (1856), *L'Artiste*, 1856–7.

C. Flaubert, *La Tentation de Saint-Antoine*, Paris, 1874 (trans. K. Mrosovsky, Ithaca, 1981).

C. Flaubert, *Oeuvres complètes*, Y. G. Le Dautec and C. Pichon, ed., Paris, 1961.

E. Duranty, 'Le Peintre Louis Martin', *Pays des Arts*, Paris, 1881 (publ. posthumously).

M. Petrone, '"La Double Vue de Louis Séguin" de Duranty', *Gazette des Beaux-Arts*, LXXXVIII, 1976, pp. 235–9.

The Works of Théophile Gautier, F. C. Sumichrast, trans. and ed., New York, 1902.

D. Large and W. Weber, eds., *Wagnerism in European Culture and Politics*, Ithaca and London, 1984.

K. Korn, *Zola in seiner Zeit*, Frankfurt, 1980.

E. Zola, *Oeuvres complètes*, ed., M. Leblond, Paris, 1927–29 (vol. III, *La Curée*; vol. V, *La Conquête de Plassans*; vol. VI, *La Faute de l'abbé Mouret*; vol. XV, *l'Oeuvre*; vol. XVIII, *La Bête humaine*; vol. XXXIV, *Thérèse Raquin; Madeleine Férat*; vol. XLV, *Documents littéraires*).

J. C. Lapp, *Zola before the 'Rougon-Macquart'*, Toronto, 1964.

E. Zola, *Correspondance*, ed., B. H. Bakker, 5 vols., Montreal, 1978.

Index

Royal Academy Trust

Friends of the Royal Academy

BENEFACTORS

Mrs Hilda Benham
Lady Brinton
Sir Nigel & Lady Broackes
Keith Bromley Esq.
The John S. Cohen Foundation
The Colby Trust
Michael E. Flintoff Esq.
The Lady Gibson
Jack Goldhill Esq. FRICS
Mrs Mary Graves
D. J. Hoare Esq.
Sir Anthony Hornby
Irene & Hyman Kreitman
The Landmark Trust
Roland Lay Esq.
The Trustees of the Leach Fourteenth
 Trust
Hugh Leggatt Esq.
Mr & Mrs M. S. Lipworth
Sir Jack Lyons CBE
The Manor Charitable Trustees
Lieut.-Col. L. S. Michael OBE
Jan Mitchell Esq.
The Lord Moyne
The Lady Moyne
Mrs Sylvia Mulcahy
C. R. Nicholas Esq.
Lieut.-Col. Vincent Paravicini
Mrs Vincent Paravicini
Richard Park Esq.
Phillips Fine Art Auctioneers
Mrs Denise Rapp
Mrs Adrianne Reed
The Late Anne M. Roxburgh
Mrs Basil Samuel
Sir Eric Sharp CBE
The Revd Prebendary E. F. Shotter
Dr Francis Singer
Lady Daphne Straight
Mrs Pamela Synge
Harry Teacher Esq.
Henry Vyner Charitable Trust
A. Witkin, Vacuum Instruments &
 Products Ltd
Charles Wollaston

CORPORATE SPONSORS

American Express Europe Ltd
Arthur Anderson & Co. Foundation
Bankers Trust Company
Barclays Bank plc
Bourne Leisure Group Ltd
The British Petroleum Co. Ltd
Bryant Laing Partnership
Cable & Wireless plc
Christie Manson & Woods Ltd
Citibank
Clarkson Jersey Charitable Trust
P & D Colnaghi & Co. Ltd
Courage Charitable Trust
Coutts & Co.
Cox Moore plc
Delta Group plc
Durrington Corporation
Esso UK plc
Financial Corporation of North
 Atlantic Ltd
Ford Motor Company Ltd
The Granada Group
Grand Metropolitan plc
Arthur Guinness & Sons plc
Guinness Mahon Group plc
IBM United Kingdom Ltd

Imperial Chemical Industries plc
Johnson Wax Limited
Kodak Ltd
Lex Services plc
London Weekend Television Ltd
Marks & Spencer plc
Mars Limited
Martini & Rossi Limited
Worshipful Company of Mercers
Messrs Nabarro Nathanson
Metal Box plc
The Nestlé Charitable Trust
Norddeutsche Landesbank Grozentrale
Ocean Transport & Trading plc
 (P. H. Holt Trust)
Ove Arup Partnership
Pearson plc
Pilkington Glass Ltd
Priest Marians Holdings plc
Redfern Gallery
The Royal Bank of Scotland plc
RTZ Services Ltd
The Worshipful Company of Saddlers
Save & Prosper Educational Trust
J. Henry Schroder Wagg & Co. Ltd
Scott Mathieson Daines Ltd
Shell UK Limited
W. H. Smith & Son Limited
Sotheby & Co.
The Spencer Wills Trust
Thames Television Limited
J. Walter Thompson Company Limited
United Biscuits (UK)

INDIVIDUAL SPONSORS

Gerald M. Abraham Esq.
Richard Alston Esq.
I. F. C. Anstruther Esq.
Mrs Anne Appelbe
Dwight W. Arundale Esq.
Nick Ashley Esq.
Edgar Astaire Esq.
Brian A. Bailey Esq.
W. M. Ballantyne Esq.
Miss Margaret Louise Band
E.P. Bennett Esq.
P.F.J. Bennett Esq.
Miss A. S. Bergman
Mrs Susan Besser
P. G. Bird Esq.
Mrs L. Blackstone
Miss Julia Borden
Peter Bowring Esq.
Miss Betty Box OBE
Mrs Susan Bradman
John H. Brandler Esq.
Mrs K. Brewster
Mrs David L. Britton
Cornelius Broere Esq.
Lady Brown
Jeremy Brown Esq.
Richard Butler Esq.
Mr and Mrs R. Cadbury
Mrs L. Cantor
Miss E. M. Cassin
Mrs F. M. Cator
W. J. Chapman Esq.
Mrs Joanna V. Clarke
Henry M. Cohen Esq.
Mrs R. Cohen
Mrs N. S. Conrad
Mrs Elizabeth Corob
C. Cotton Esq.
Philip Daubeny Esq.

Miss C.H. Dawes
John Denham Esq.
The Marquess of Douro
Mrs Gilbert Edgar
Kenneth Edwards Esq.
Mrs Sylvia Edwards
Miss Beryl Eeman
Peter Ekelund Esq.
Charles & Lady Katherine Farrell
S. Isern Feliu Esq.
Mrs J. G. G. Firth
Dr Gert-Rudolf Flick
J. G. Fogel Esq.
M. J. Foley Esq.
Ronald D. Fowler Esq.
Miss C. Fox
Graham Gauld Esq.
M. V. Gauntlett Esq.
Robert Gavron Esq.
Stephen A. Geiger Esq.
Lady Gibberd
Mrs E. J. Gillespie
Michael I. Godbee Esq.
Michael P. Goodman Esq.
P. G. Goulandris Esq.
Gavin Graham Esq.
Mrs J. M. Grant
R. Wallington Green Esq.
Mrs O. Grogan
Mrs P. O. V. H. Grogan
Mr and Mrs Earl Guitar
J. A. Hadjipateras Esq.
R. Hamilton Wright Esq.
Miss Nona Hanes Porter
Richard M. Harris Esq.
Robert Harris Esq.
Rupert Harrison Esq.
Mrs Frances A. J. Hawkins
Miss Julia Hazandras
Mrs Penelope Heseltine
N. Hickmet Esq.
Mrs K. S. Hill
Reginald Hoe Esq.
Mrs Mark Hoffman
Charles Howard Esq.
Mrs A. Howitt
John Hughes Esq.
Norman J. Hyams Esq.
David Hyman Esq.
Mrs Manya Igel
Mr & Mrs Evan Innes
Mrs I. A. N. Irvine
J. P. Jacobs Esq.
Mrs J. C. Jaqua
Alan Jeavons Esq.
Ms S. Jenkins
H. Joels Esq.
Irwin Joffe Esq.
G. M. A. Joseph Esq.
Roger Jospe Esq.
Mr & Mrs S. H. Karmel
Peter W. Kininmonth Esq.
Mrs C. Kirkham
Andria Thal Lass
Mrs J. H. Lavender
Miss Ailsey Lazarus
Mr and Mrs N. S. Lersten
David Levinson Esq.
David Lewis Esq.
S. Lewis Esq.
Owen Luder Esq.
A. Lyall Lush Esq.
Mrs Graham Lyons
Ciarán MacGonigal Esq.

Peter McMean Esq.
Stuart MacWhirter Esq.
Mrs S. G. Maddocks
Dr Abraham Marcus
The Hon. Simon Marks
B. P. Marsh Esq.
R. C. Martin Esq.
Christopher Mason-Watts Esq.
Dr D. S. J. Maw
M. H. Meissner Esq.
The Hon. Stephen Monson
Mrs Alan Morgan
Mrs Angela Morrison
Steven Nemethy Esq.
The Oakmoor Trust
Mrs E. M. Oppenheim Sandelson
A. Osmond-Evans Esq.
Brian R. Oury Esq.
Mrs Jo Palmer
Mrs Rhoda Pepys
J. G. Pereira Esq.
Mrs Olive Pettit
Mrs M. C. S. Philip
Ralph Picken Esq.
G. B. Pincus Esq.
Harold Quitman Esq.
Mrs Margaret Reeves
Mrs M. P. Renton
F. Peter Robinson Esq.
Miss Lucy Roland-Smith
The Rt Hon. Lord Rootes
Baron Elie de Rothschild
Mr & Mrs O. Roux
The Hon. Sir Steven Runciman CH
Sir Robert Sainsbury
Mrs Bernice Sandelson
Friedhelm Schulz-Robson Esq.
Mrs Bernard L. Schwartz
Christopher Shaw Esq.
Stuart Shaw Esq.
Mrs Pamela Sheridan
Desmond de Silva Esq. QC
R. J. Simia Esq.
R. J. Simmons Esq.
Dr M. E. Sprackling
Cyril Stein Esq.
Mrs G. M. Stokes
James Q. Stringer Esq.
Mrs B. Stubbs
Mrs A. Susman
Robin Symes Esq.
Nikolas Tarling Esq.
C. J. A. Taylor Esq.
Gordon H. Taylor Esq.
J. E. Thomas Esq.
S. Tullah Esq.
W. Van Der Spek Esq.
Andrew Vicari Esq.
Kenneth J. Wardell Esq.
Neil Warren Esq.
Mrs V. Watson
J. B. Watton Esq.
Frank S. Wenstrom Esq.
R. A. M. Whitaker Esq.
Graham V. Willcox Esq.
Mrs Bella Wingate
B. G. Wolfson Esq.
W. M. Wood Esq.
Mrs S. Wood
Fred S. Worms
Mrs S. Young
John P. Zinn Esq.

Sponsors of Past Exhibitions

The Council of the Royal Academy thank sponsors of past exhibitions for their support. Sponsors of major exhibitions during the last ten years have included:

AMERICAN EXPRESS FOUNDATION
Masters of 17th-Century Dutch Genre Painting 1984
'Je suis le cahier': The Sketchbooks of Picasso 1986

ARTS COUNCIL OF GREAT BRITAIN
Clatworthy/Sutton 1977
Robert Motherwell 1978
Rodrigo Moynihan 1978
John Flaxman 1979
Ivon Hitchens 1979
Algernon Newton 1980
New Spirit in Painting 1981
Gertrude Hermes 1981
Carel Weight 1982
Elizabeth Blackadder 1982
Allan Gwynne Jones 1983
The Hague School 1983
Peter Greenham 1985

B.A.T. INDUSTRIES PLC
Murillo 1983
Paintings from the Royal Academy US Tour 1982/4, RA 1984

BECK'S BIER
German Art in the 20th Century 1985

BENSON & HEDGES
The Gold of El Dorado 1979

BOVIS CONSTRUCTION LTD
New Architecture 1986

BRITISH ALCAN ALUMINIUM
Sir Alfred Gilbert 1986

BRITISH GYPSUM LTD
New Architecture 1986

BRITISH PETROLEUM PLC
British Art in the 20th Century 1987

CALOUSTE GULBENKIAN FOUNDATION
Portuguese Art since 1910 1978

CANARY WHARF DEVELOPMENT CO.
New Architecture 1986

CHRISTIE'S
Treasures from Chatsworth 1980

COUTTS & CO
Derby Day 200 1979

THE DAILY TELEGRAPH
Treasures from Chatsworth 1980

DEUTSCHE BANK AG
German Art in the 20th Century 1985

ELECTRICITY COUNCIL
New Architecture 1986

ESSO PETROLEUM COMPANY LTD
British Art Now: An American Perspective 1980

FINANCIAL TIMES
Derby Day 200 1979

FIRST NATIONAL BANK OF CHICAGO
Marc Chagall 1985

FRIENDS OF THE ROYAL ACADEMY
Elizabeth Blackadder 1982
Carel Weight 1982
Allan Gwynne Jones 1983
Peter Greenham 1985
Sir Alfred Gilbert 1986

DR ARMAND HAMMER & THE ARMAND HAMMER FOUNDATION
Honoré Daumier 1981
Leonardo da Vinci Nature Studies & Codex Hammer 1981

JOSEPH GARTNER
New Architecture 1986

GLAXO HOLDINGS PLC
From Byzantium to El Greco 1987

ARTHUR GUINNESS PLC
Light Fantastic 1977

HOECHST (UK) LTD
German Art in the 20th Century 1985

IBM UNITED KINGDOM LIMITED
Post-Impressionism 1979
Summer Exhibition 1983

THE JAPAN FOUNDATION
The Great Japan Exhibition 1981

JOANNOU & PARASKEVAIDES (OVERSEAS) LTD
From Byzantium to El Greco 1987

LLOYDS BANK
Age of Chivalry 1987

LUFTHANSA
German Art in the 20th Century 1985

MARTINI & ROSSI LTD
Painting in Naples from Caravaggio to Giordano 1982

MELITTA
German Art in the 20th Century 1985

MELLON FOUNDATION
Rowlandson Drawings 1978

MERCEDES-BENZ
German Art in the 20th Century 1985

MIDLAND BANK PLC
The Great Japan Exhibition 1981

MOBIL
Treasures from Ancient Nigeria 1982
Modern Masterpieces from the Thyssen-Bornemisza Collection 1984
From Byzantium to El Greco 1987

MOËT & CHANDON
Derby Day 200 1979

NATIONAL WESTMINSTER BANK
Reynolds 1986

THE OBSERVER
Stanley Spencer 1980
The Great Japan Exhibition 1981

OLIVETTI
Horses of San Marco 1979
The Cimabue Crucifix 1983

OTIS ELEVATORS
New Architecture 1986

OVERSEAS CONTAINERS LIMITED
The Great Japan Exhibition 1981

PEARSON PLC
Eduardo Paolozzi Underground 1986

PILKINGTON GLASS
New Architecture 1986

PRINGLE OF SCOTLAND
The Great Japan Exhibition 1981

REPUBLIC NEW YORK CORPORATION
Andrew Wyeth 1980

ROBERT BOSCH LIMITED
German Art in the 20th Century 1985

SEA CONTAINERS & VENICE SIMPLON-ORIENT EXPRESS
Genius of Venice 1983

SHELL (UK) LTD
Treasures from Chatsworth 1980

THE SHELL COMPANIES OF JAPAN
The Great Japan Exhibition 1981

SIEMENS
German Art in the 20th Century 1985

SOTHEBY'S
Derby Day 200 1979

SWAN HELLENIC
Edward Lear 1985

JOHN SWIRE
The Great Japan Exhibition 1981

TRAFALGAR HOUSE
Elisabeth Frink 1985

TRUSTHOUSE FORTE
Edward Lear 1985

UNILEVER
Lord Leverhulme 1980
The Hague School 1983

WALKER BOOKS LIMITED
Edward Lear 1985

WEDGWOOD
John Flaxman 1979

WINSOR & NEWTON WITH RECKITT & COLMAN
Algernon Newton 1980